EXPLORING BLACK & WHITE P.H.O.T.O.G.R.A.P.H.Y

1	
•	

EXPLORING BLACK & WHITE P.H.O.T.O.G.R.A.P.H.Y

0

ARNOLD GASSAN OHIO UNIVERSITY

WM. C. BROWN PUBLISHERS DUBUQUE, IOWA

Book Team

Editor Meredith M. Morgan
Developmental Editor Raphael Kadushin
Designer Julie E. Anderson
Production Editor Linda M. Meehan
Photo Research Editor Mary Roussel
Visuals Processor Jodi Wagner

wcb group

Chairman of the Board Wm. C. Brown President and Chief Executive Officer Mark C. Falb

wcb

Wm. C. Brown Publishers, College Division

President G. Franklin Lewis
Vice President, Editor-in-Chief George Wm. Bergquist
Vice President, Director of Production Beverly Kolz
Vice President, National Sales Manager Bob McLaughlin
Director of Marketing Thomas E. Doran
Marketing Communications Manager Edward Bartell
Marketing Information Systems Manager Craig S. Marty
Marketing Manager David F. Horwitz
Manager of Visuals and Design Faye M. Schilling
Production Editorial Manager Colleen A. Yonda
Production Editorial Manager Julie A. Kennedy
Publishing Services Manager Karen J. Slaght

Cover Design by Jess Schaal

Cover photograph © Mike DuBose

Copyright © 1989 by Wm. C. Brown Publishers. All rights reserved

Library of Congress Catalog Card Number: 88-70900

ISBN 0-697-03491-7

No part of this publication may be reproduced, stored in a retrieval system, or transmitted, in any form or by any means, electronic, mechanical, photocopying, recording, or otherwise, without the prior written permission of the publisher.

Printed in the United States of America by Wm. C. Brown Publishers 2460 Kerper Boulevard, Dubuque, IA 52001

10 9 8 7 6 5 4 3

Contents

Preface viii

1 Getting Started 3

Black-and-White Photographs 4
Doing It Yourself 4
Basic Principles 5
The Camera 7
The Darkroom 9
Preparing a Film-Loading Darkroom 11

2

Expose and Develop a Negative 13

Choosing Film and Setting Your Camera 14

Deciding What to Photograph 15

Darkroom Clothing 15

Preparing Chemicals 16

Developing Film 17

Prewetting Film 18

Developer Temperature 20

Development Controls 20

Agitation and Time 21

Stop Bath 22

Fixing Film 22

Fixer Clearing and Washing Film 22

Final Rinse and Drying 22

Store and Identify Negatives 23

3

Expose and Develop a Contact Print 27

Contact Print as Record 28
Photographic Papers 28
Safelights 29
The Enlarger 30
Preparing the Darkroom 32
Expose a Contact Print 32
Develop the Contact Print 33
Stop, Fix, and Rinse the Print 34
Chemical Use 35
Washing and Drying Prints 35
Uses for the Proof Print 36
Evaluating Exposure 37
Evaluate Contrast 38

4

Expose and Develop an Enlargement 41

Prepare the Darkroom 42
Choose a Negative 43
Contact Proof as Exposure Meter 43
Making a Print 44
Trial Exposures 44
Develop the Test Prints 46
Making the Enlarged Print 47
Evaluate the Prints 49
Print Contrast Control 50
Printing Controls 51

5

Finishing Prints 55

Examine the Enlarged Proof 56
Negative Faults 57
The Damaged Print 57
Spotting Prints 57
Crop the Print 60
Mount the Print 62
Reexamine the Print 63
Store the Print 63

6

Camera Controls 66

Basic Camera 67 The Lens 67 Field of View 67 Choice of Lens 70 Zoom Lenses 70 Viewing and Focusing 71 Aperture 72 Depth of Field 74 Hyperfocal Distance 76 Zone Focusing 77 Lens Aesthetics 79 Exposure Law 80 Shutter Speeds 80 Shutter and F-stop Combinations 82 Focal-plane Shutters 82 Between-the-Lens Shutters 83 Light Meters and Exposure Metering Targets 84 Camera as Meter 84 Other Camera Controls 87 Summary 87

7 Looking at Photographs 89

Art Traditions in Photography 90
Straight and Manipulated Photographs 90
Subject and Composition 91
Figure and Ground 91
The Centered Image 94
Types of Photographs 94
Purpose of the Photograph 96
Response to the Photograph 98
Photographic Information 98
Classification of Photographs 99
Examples of Documentation 101
Hidden Meanings 103
Information and Emotions 105
Summary of Response 106

8

Talking about Photographs 108

Basics 109
Criteria for Judgment 109
Photographic Composition 109
Context and Content 112
Social Climate 114
Documentary Content 114
Point of View 115
Matters of Style 116
Symbolic Content 118
Deciding for Yourself 119
Critical Judgment 121

9

Negative Development 123

Compromises 124 Types of Film 124 Light and Film 125 Density Defined 126 Density Effects 127 Ideal Negatives 127 Estimating Density 128 Characteristic Curves 128 Matching Negatives to Paper 130 Developing Times 130 Negative Exposure Checks 133 Proof Exposure and Contrast 135 Printing for Highlights 135 Choosing a Developer 135 Pushing Film 136 Agitation 137 High Contrast Scenes 137 Summary 138

10 Developer Components 140

Introduction 141
Single-shot Chemicals 141
Measuring and Mixing Solutions 141
Storing Chemicals 143
Silver Process Developers 143
Water 144
Characteristics of Photo Chemicals 146
Two-tray Developer Experiment 146
Two-tray Results Described 148
RC Paper Experiment 148
Modifying Developers 150
Summary 150

11

Print Contrast and Development 151

Overview 152
Contrast Grades 153
Chemical Contrast Controls 156
Variable Contrast Controls 156
Summary of Print Controls 157

12

Modifying the Negative and the Print 159

Modification Effects 160
Intensification Defined 160
Selenium with Negatives 160
Chromium with Negatives 162
Farmer's Reducer 164
Reducing Negatives 164
Farmer's Reducer on Prints 165
Local Reduction 166
Intensifying Prints with Selenium 167
Selenium Toning for Color Change 167
Sepia Toning 168
Summary 168

13

Comprehensive Exposure-Development Controls 169

Exposure Law 170
Metering Light 170
Metering Assumptions 171
Metering to Determine Contrast 172
Contrast Control Exposures 174
Estimating Contrast by Eye 174
Grouping Exposure for Contrast
Control 177
Summary 177

14

Finishing and Protecting Prints 179

Justification 180
Permanence of Prints 180
Toning for Preservation 180
Drying Prints 181
Mounting Prints 182
Mounting Materials 183
Mounting a Print 183
Protective Storage 185
Window Mats 186
Helpful Hints 186
Summary 188

15

Lighting Basics 189

About Light 190
Qualities of Light 190
Existing and Modified Lighting 192
Compound Lighting 194
Lighting Ratios 194
Momentary Lights 194
Electronic Flash 194
Synchronization 198
Computing Flash Exposure 200
Inverse Square Law 201
Bounce Light 202
Flash Balance Problems 202
Summary 205

16

Filters and Films 206

Colors and Light 207
Filters and Colors 207
Film Color Sensitivity 208
Filter Factors 209
Colors to Use 210
Infrared Filters and Exposure 210
Polarized Light 213
Neutral Density 213
Summary 213

17

Darkrooms and Workrooms 215

Basic Needs 216
Establishing a Darkroom 216
Ideal Darkrooms 216
Work Area Considerations 218
Different Darkroom Spaces 218
Sinks 219
Planning the Darkroom 219
Safelights 221
Safelight Test 222
Ventilation 222
Print Drying and Finishing 223
Summary 223

18

Equipment Considerations 224

Basic Needs 225
Criteria 225
Kind of Equipment 225
Buying Used Equipment 227
Examining Lenses 227
Examining Cameras 228
Examining Meters 228
Tripods 228
Assessing Enlargers 229
Summary 230

19

Applied Photography and Photographic Arts 232

Redefining the Photographer 233
Professional Possibilities 233
Photo Services 236
Entering the Field 236
Education and Training 237
Photography in College 238
Networking 238
Presenting Yourself 239
Photographic Arts 239
Summary 242

20

Ethical and Legal Aspects 242

Restrictions 243
Privacy 243
Intrusion and Trespass 243
Publicity and Libel 245
Copyright 245
Who Owns the Picture 246
Obscenity and Pornography 246
Summary 246

Appendixes 247

- 1 Photographic Education and Workshops 247
- 2 Information 247
- 3 Books 248
- 4 Cameras and Other Equipment 248
- 5 Chemicals 249
- 6 Metol-free Developers 249
- 7 Packaged and Homemade Chemicals 250
- 8 Chemical Notes 251 Glossary 252 Index 254

Contents

PREFACE

Introduction

Exploring Black and White Photography is an introductory and intermediate text for black-and-white small camera photography. Most beginning and much professional photography is created with the small camera and this text concentrates on exposure, development, and printing controls for roll-film photography, although the controls suggested in the text apply to all formats of film.

The text is organized according to the way I have found photography to be most effectively taught: take a camera and make pictures of those events and objects in your life that are of importance, and when your imagination runs dry, outline a photographic project. Then develop the film and make prints. When working with new photographic materials, follow the suggestions made by the manufacturer but look critically at what you have made and think hard about how you wish to change the seeing or the craft. Finally, start again at the beginning. Each step of this cycle of intuition, craft, and analysis demands all the knowledge you have gained from life and art in order to improve.

Technical control is important because camera and darkroom skills are used to achieve a creative goal. Technical controls are a major problem faced by all beginning and intermediate photographers, and chapters 1 through 6 are a step-by-step outline of the exposing and developing film and prints, and camera controls. Possible health hazards are clearly noted in the text.

Photography is a production-generous medium. After learning basic craftsmanship, the photographer's challenge is to edit the pictures that appear so easily when the shutter is pressed. Chapters 7 and 8 address looking at and talking about photographs. Chapters 9 through 16 describe modifications of the negative and print, and how to use lights and colored filters. Planning darkroom, workroom, and equipment needs are explored in chapters 17 and 18. Finally, professional concerns about making a living, and some legal and ethical photographic problems are outlined in chapters 19 and 20. Appendixes list sources of equipment, information, and chemicals.

The general illustrations for the text have been chosen to provide a commentary on the text. The pictures are obtained from young photographers, from historical collections, and from the author's own files. For the most part they have not been reproduced before. It was felt that this text should offer new pictures and there are several excellent histories of photographic art which offer good reproductions of touchstone photographs. Although most of the contemporary pictures used here are 35mm, other formats are also included.

The organization and ideas of the text draws upon my thirty years of experience as a photographer, including a workshop and subsequent correspondence with Ansel Adams, several years of work with Minor White, the study of art history and painting at the University of Colorado and University of New Mexico, and doctoral research at Ohio University in projective testing and how photographs are perceived.

Once, in a summer workshop, Ansel Adams said you don't make a photograph just with a camera, you bring to the act of photography all the pictures you have seen, the books you have read, the music you have heard, the people you have loved. Minor White put it a bit differently another summer, in another workshop, when he said that if you let yourself really see what is in front of your camera, and are true to yourself, something magical often results when you expose the film.

Acknowledgements

Illustrations for this text have been made available with the generous assistance of the Ansel Adams Publishing Trust; the Library of Congress, and the American Folk Life Center of the Library; the National Archives; the New Orleans Collection; and the University of Louisville Photographic Archives. I was met with courtesy and generously helped at each of these busy places. Nikon Corporation lent me the cutaway single-lens reflex camera and zoom lens, and Wilson's Camera Shops lent many other pieces of equipment used to provide text illustrations.

Editing suggestions were asked of Julie Elman-Roche and Dr. Ray Lane, and both gave excellent advice. Those who helped produce special illustrations included Ann Elizabeth Nash, Kathy Johnson, and Laura Elliott, who modeled for the process illustrations. Gary Kirksey and Edward Pieratt assisted with the lighting illustrations. Terry Eiler and Chris Carr assisted me in learning the computer skills needed to create, revise, and illustrate the text. The graduate and undergraduate students who allowed me to use their pictures and who willingly experimented with many of the ideas in this book were constantly cheerful and helpful. The School of Visual Communication and the School of Art at Ohio University provided equipment, facilities, and a supportive environment that made the production and revision of the text possible.

Arnold Gassan

EXPLORING BLACK & WHITE P.H.O.T.O.G.R.A.P.H.Y

*1*Getting Started

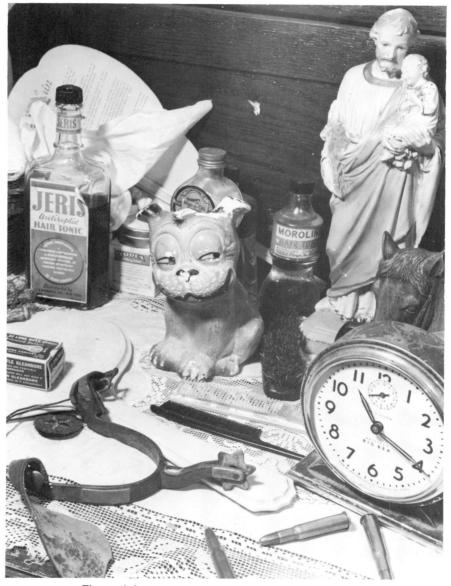

Figure 1.1
TOP OF STUART HABY'S DRESSER. TEXAS, 1945.
Esther Bubley.
This documentary photograph describes a way of life with great economy—it would take many pages to describe

great economy—it would take many pages to describe everything seen here and what the objects suggest.

(Esther Bubley, University of Louisville Photographic Archives)

Figure 1.2
On the Road, Lancaster City, Pennsylvania, 1974.
Jim Alinder.
A detail of Amish life captured in an instant. (Courtesy of the photographer)

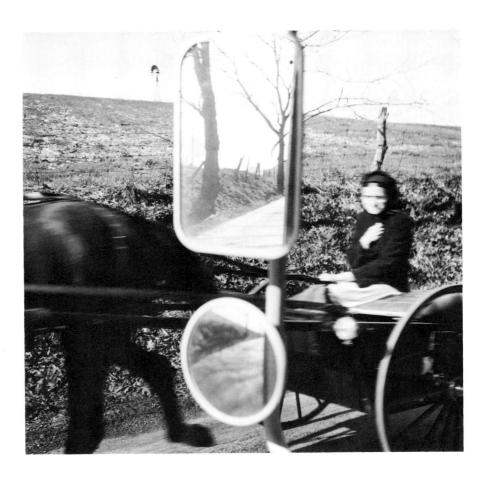

Black-and-White Photographs

Photographs permit us to communicate to the world what we see, and the things we find in our pictures symbolize what we feel, using the elements of value, form, light, space, color, and texture.

Photographic processes are constantly changing, and although electronic imaging is on the horizon, the silver photographic black-and-white print has continuing power and attraction. Making a black-and-white photograph is different from making a color photograph. In many ways, black-and-white photography offers and demands more control by the photographer. Black-and-white pictures are exciting for us in ways that differ from color pictures—perhaps it is the abstraction of form from the colorful world, which, strangely enough, often makes the black-and-white photograph visually exciting. Figure 1.1 shows details from a bureau that reflects a man's life, illustrating how commonplace things can become significant when seen by a sensitive photographer.

Doing It Yourself

Popular photography is said to date from George Eastman's perfecting the Kodak system in 1889, but the true "invention" of photography dates to 1839. Fifty years after this, George Eastman created a seemingly ideal way to make pictures: you bought a camera already loaded with film, pointed it at your personal world, pressed the shutter, advanced the film, cocked the shutter again, and when all the film was exposed, mailed the camera back to Kodak. There, the film was removed from the camera, developed, printed, and the camera reloaded and returned to you, along with the prints. This system freed photographers from photographic chemicals and the darkroom. But the price

Figure 1.3
Photo Outfit, 1869.
William Henry Jackson.
Early photographers had to carry camera, glass plates, chemicals, a darkroom tent, and even their own water for processing when making wet-plate photographs (before the 1880s). The photographer made this portrait of himself and his loaded pack mule beside a marker cairn in a southwest American desert. (National Archives)

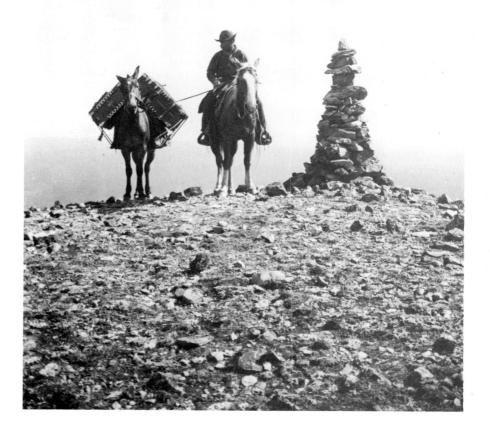

of this freedom was loss of control, and loss of the magic that comes with seeing your own pictures develop. Figure 1.2 shows how the camera can easily record moments of personal visual discovery.

For most photographers, there is something magical about developing film and making a print. First, there is the excitement of working in darkness while developing the film, then standing in a dimly lit room, moving white paper gently through a clear chemical solution in a shallow tray, and watching while a dim, ghostly image appears, becomes clear, and then is firmly realized. You decide how dark or light the image should be, what contrast should appear between the shadows in trees and the highlights in clouds. You decide whether the print would be better small—something to be held in the hand—or large and displayed on the wall.

Basic Principles

Photography is based on the fact that silver halides are sensitive to light. A halide is a compound of metal and certain gases. When exposed to light, the bond between these elements is weakened; in the developing solution, the weakened bonds are destroyed. The result is an image composed of silver metal, held in place by the gelatin of the emulsion.

Getting Started 5

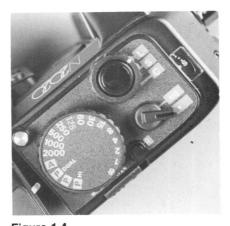

Figure 1.4a. Always check the frame counter before opening the camera back. Note that the frame counter is at S, which indicates that there is no film in the camera. The shutter control knob on this camera allows the photographer to select specific shutter

speeds, let through-the-lens (TTL) metering

automatically control the aperture (A), or choose a more complex exposure program.

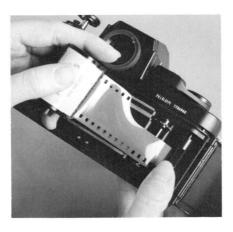

b. Insert the narrow tab of film sticking out of the cassette into the slot on the camera take-up reel. Be sure it is fully engaged. Lay the film across the back of the camera, with the film perforations engaged with the teeth on the take-up sprocket. Avoid putting pressure on the shutter (just to the left of the take-up spindle).

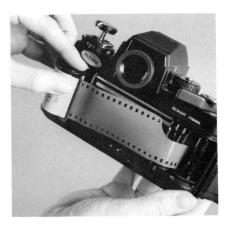

c. Pull a little of the film out of the cassette as you place it in the compartment to the left of the shutter. The cassette is held in place by the rewind shaft, which has been released and pulled out of the camera body. When the film is in place, close the camera back and gently turn the rewind crank to take up the slack in the film.

d. Advance the film and press the shutter button; then repeat. This will move fresh, unexposed film into position. Watch the rewind crank (at left). It will turn as the film advances. If it does not turn, the film was probably not threaded properly. Open the back of the camera and rethread the film in the take-up reel slot.

e. Confirm that the ISO number is correct for the film being used. New cameras adjust this automatically.

f. Locate the aperture control (set here at 5.6) and the shutter (set at 1/60 of a second). Exposure can be determined by using the TTL metering in a manual or automatic mode, or by using a hand-held meter.

Exposing any silver halide to a great deal of light will cause it to change color, from a white salt to brown or red, although today this effect is almost never used. On the other hand, exposing a silver halide emulsion to a little light and then immersing it in a developing solution causes a rapid and dramatic change. A little exposure to light produces an invisible, but real **latent** image. The latent image is then made visible by chemical development. The discovery of the latent image and chemical development is the basis of contemporary silver process photography.

The basics of photography have not changed since the early 1800s, when the first practical photographic processes were invented. Today's cameras are far more sophisticated, and modern film is far more sensitive to light and responsive to color, but the foundations of photography have not changed

g. Incorrect posture will degrade the sharpness of your pictures because the body support for the camera is inadequate. This posture is bad because the arms are away from the body, and there is little support for the camera.

h. Correct posture calls for arms placed under the camera and pressed comfortably against the body. The weight of the camera is then transferred to the body, and the pictures that result will be sharper at slower shutter speeds.

 A monopod supports the camera and permits you to make sharp pictures with longer exposures, yet leaves you free to move about easily.

j. When the last frame has been exposed, release the rewind control on the camera, and immediately rewind the film completely into the cassette with the rewind crank.

since 1839. Control of the photographic process is achieved by varying the exposure and manipulating the development of the silver halide. Excellence of control is gained only by experimenting with materials.

It is gratifying to develop film and print negatives in your own darkroom, but making your own black-and-white photographs requires much more involvement with photographic materials and processes than does color slides or purchasing prints from a photofinisher. Besides a camera and film, you need special photographic solutions, a darkroom in which to process the film and to print the negatives, and space in which to finish the prints.

The Camera

Figures 1.4*A-J* illustrate how to load and begin making pictures with a contemporary 35mm camera. In general, the following checklist should be observed when preparing to load a camera and make pictures:

- · check frame counter and rewind to be sure camera is empty
- · open camera back
- · insert film leader in takeup
- · place cassette in camera body
- · advance film a bit to verify loading
- · close back, take up rewind slack
- · advance film and trip shutter twice
- · watch rewind to be sure film is moving
- · set camera meter to correct film speed
- · set aperture and shutter
- · note your camera posture
- look
- expose film
- · rewind film immediately after exposing the last frame on the roll

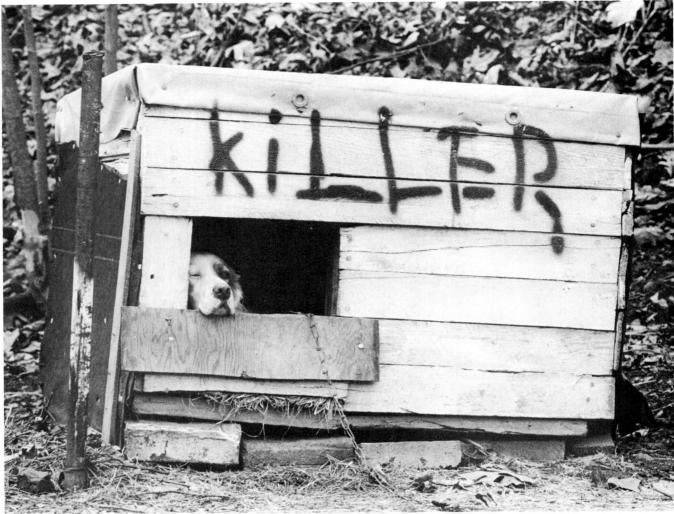

Figure 1.5
Killer.
Pam Berry.
Sometimes it is hard to let yourself photograph scenes such as this one because they seem obvious, and are not "serious" enough.
(Courtesy of the photographer)

Because your eyes do not see a black-and-white image, the photograph does not recreate what you see. Your eyes do not see a black-and-white, two-dimensional image. Each photographer learns to see what the camera sees. Let yourself concentrate on seeing with the camera at first, rather than worrying too much about making exposure calculations.

Most of us have had experience with a camera at some time, and are far more ready to begin making pictures than we realize. Almost all new cameras have some automatic exposure controls available. These controls make it very easy to begin making pictures, whether or not you have experience, and the automatic features should be encouraging. As you become more advanced, you may wish to use fewer of the automatic features, so it is important to choose a camera that allows you to take charge when you want to.

Begin photographing by trusting your camera; you may wish to use it in an automatic mode to determine both shutter and aperture settings, or you may control either or both when making initial exposures. If you can control the shutter, set the shutter at 1/60 or 1/125th of a second for the first roll of film you use. These shutter speeds will be fast enough to eliminate most blur when photographing outdoors, and still permit a reasonably small aperture setting.

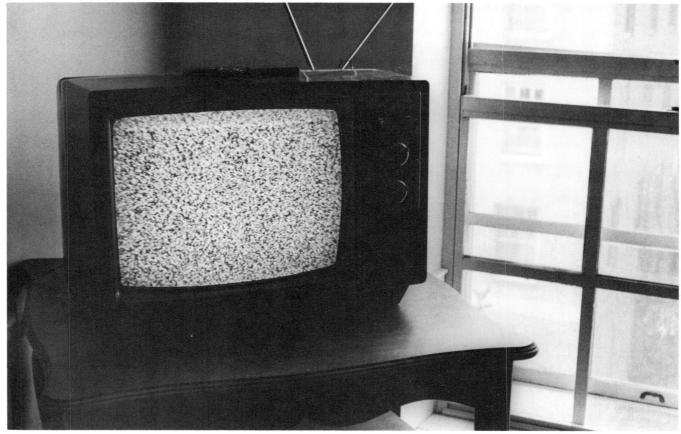

Figure 1.6
Untitled.
Ron Foth, Jr.
The sense of a bleak, empty dormitory room is underscored by the T.V. set showing only "electric noise"; the photograph can evoke a complex response with only a minimum of effort

(Courtesy of the photographer)

You will need to experiment with your camera, film, and printing materials in order to understand how they translate what you see into photographs. You will understand more fully what you want to photograph, and how you wish to photograph, after several rolls of film have been exposed, developed, and printed, and then you may want to take more control. Remember, the picture you make is not what your eye sees. It takes a lot of practice with the camera and in the darkroom to be able to predict what a photograph will look like.

The Darkroom

The darkroom is a place to work with photosensitive films and papers. For printing, it needs to have controlled, safe lighting, grounded electrical wiring, adequate ventilation, and both wet and dry work areas. But for just developing film, all that is needed is a dark place for loading a lightlight film developing tank; all the actual wet processing of film can be done in a lighted room.

You may have access to a photographic darkroom at school, but, if not, you can make other rooms function as darkrooms temporarily. The basic equipment needed to develop film and make enlargements is outlined in table 1.1. Simple, temporary darkrooms can be improvised (from bathrooms, basement wash rooms, closets). Figure 1.7 shows a darkroom in a bathroom. A darkroom does not even need to have running water, though that is more convenient. A "dry" darkroom can be improvised from almost any kind of room; a "wet" darkroom obviously requires plumbing. Eventually you may wish to create a permanent, personal darkroom.

Getting Started

TABLE 1.1

Darkroom Equipment

Although the use of 35mm cameras and film is presumed in this text, any camera format can be used and good results expected with the procedures outlined in this text.

Darkroom

Lighttight room with adequate ventilation

Grounded electrical system

Switches for white light and safelights well separated

Sink with hot and cold water and mixing faucet

Table for enlarger

Dry work area

Safelight(s) for enlarger and sink area

Processing timer (with fluorescent dial to measure time in minutes and

seconds)

Enlarging timer (measures time in seconds)

Enlarger and lens (50mm lens for 35mm negatives, 80mm for 6 x 6cm,

135-150mm for 4 x 5cm)

Negative carrier

11" x 14" Glass with sanded edges (to prevent cuts) and foam pad (11" x 14"

x 1") for contact proofs

Easel for holding photo paper

Variable contrast filters (for the paper used)

Camel's hair brush or Dust Off canister

Film cleaner

Cotton swabs

Enlarger focusing device

Contact proof and negative magnifier

Dodging tools

Soft lead pencil for marking prints

Printing record notebook

Film Processing

16 oz. Film developing tank (with two reels)

Can opener for film cassettes

Snap-type clothespins for hanging film

Blunt scissors

Sponge, Chem-Wipes, Photo-Wipes, or squeegee for film

Dust-free area in which to dry film

Negative storage sleeves

Print Processing

Photographic trays, 4, 11" x 14" Clear plastic graduates, 2, 1 liter Clear plastic graduate, 1, 500 ml Clear plastic graduate, 1, 50 ml

Plastic mixing bucket, 1 gallon size

Stirring rod

Plastic funnel, 1 quart size (minimum)

Plastic storage bottles, 3, gallon-sized

Print tongs, 4 pairs (or rubber gloves) Automatic Tray Siphon (or other print washer)

Photographic thermometer

Cotton towels, 3

Print Finishing

Dust-free area for drying prints

Print spotting dyes

Windsor & Newton sable brush (#00 or #000)

Work table, mat knife, metal straightedge, 24-36" scale

Logan or Dexter mat cutter

Print mounting materials: spray cement, dry-mount tissue, or linen tape and

mounting corners

Chemicals

Hazards arise from handling and using many photographic chemicals, and these are noted in the text.

The Kodak chemicals are noted because they are reliable, fairly inexpensive, and easily available, but there are many other excellent brands. Liquid concentrated chemicals are often suggested, as they eliminate many storage problems.

Film developer (Kodak D-76, T-Max, HC110 or Hobby-Pac Film, Edwal FG7, or other developer of choice)

Paper developer (Dektol or Hobby-Pac Paper, Ethol LPD, Sprint Print

Developer, or other developer of choice)
Kodak Indicator Stop Bath or concentrated acetic acid

Kodak Rapid Fix or Kodak F–5 fixer

Heico Perma-Wash

Wetting agent (Kodak Photo Flo, Edwal LFN, or another)

Film

High speed: Kodak T-Max 400, Tri-X, Ilford HP5, Fuji Isopan 100 Low speed: Kodak T-Max 100, Plus-X Pan, Ilford FP4, Fuji Isopan 400

Paper

8" x 10" Kodak or Ilford fiber base variable contrast; (or) Ilford, Kodak, Mitsubishi, or Seagull graded papers: 25 sheets in contrast grades #2 and #3.

Figure 1.7

A small bathroom converted into a darkroom. Film and resin-coated prints are hung to dry over the bathtub. A vent fan, which draws air from the darkroom, has been attached to a sheet of plywood in the window to ensure adequate ventilation. (Photo by Christine Keith)

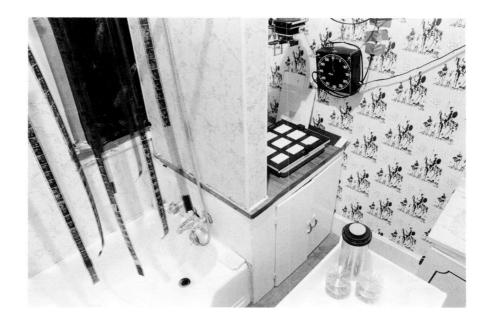

Preparing a Film-Loading Darkroom

Exposed film must be handled in total darkness while it is being removed from the cassette, loaded onto a processing reel, and placed in a developing tank. Special small darkrooms that are separate from the safe-lit printing darkroom with the enlarger are provided in many schools for doing this, but if necessary you can use an ordinary closet. A photographic changing bag can be used anywhere and can completely eliminate the need for a film-loading darkroom.

In any film-loading darkroom it is necessary to locate electrical switches so you can find them in total darkness, then arrange your film and developing equipment so it, too, can be found in the dark. Finally, be certain no one will open the door until you have the film protected from light.

When using an ordinary closet as a film-loading darkroom, first close the door and stand in the closet for several minutes, until you see where light enters. Usually, this is only under the door and, in older houses, through the keyhole. Mask keyholes with duct tape; place a rolled towel at the foot of the door to block light. If light leaks around the edge of the door itself, hang a blanket over the frame.

Contemporary films are too sensitive to light to be handled under any safelight. They must be removed from the protective canister, loaded onto reels, and put into developing tanks in complete darkness. If you have never worked in total darkness before, experiment with a test roll before you start working with your "real" film. Buy a 24-exposure roll of the cheapest film you can find (sometimes photo stores have special sales of "out-of-date" film) and use it for trial loading. You will want to practice handling film and the developing reels.

Film is most often damaged while placing it on processing reels. Improper loading will cause film to stick to itself and not develop properly, and crinkling the undeveloped film makes dense marks that show up in the print. When the first quarter-turn of the film on the reel is correct, the rest of the loading of the reel will usually follow smoothly.

11 Getting Started

Discussion and Assignments

Getting started always seems to take a great deal of time and emotional energy. At the beginning, one is not sure how much to do and what is absolutely necessary. These assignments explore practical aspects of getting started.

Assignment 1 If a school darkroom is available, examine it carefully and learn where the light and water controls are. If your school supplies chemicals, learn what kind of developer and fixer are being used.

If you are planning your own darkroom, find and examine two or three working darkrooms and see how wet and dry areas are created, how much space is actually needed, and ask the owners what they would keep and what they would do differently were they to start from scratch.

Assignment 2 Make up a comparison price list for the darkroom equipment listed in table 1.1. Divide the items into three categories: 1) capital equipment (enlargers, timers, etc.); 2) disposable items (cotton swabs, pencils, etc.); and 3) chemicals, film, and paper that will be used.

Obtain prices for all items on the first and third lists from a local camera store and from at least one mail-order source (see appendixes 2 and 4). Be sure to include tax and shipping expenses.

Determine which source would be most economical for you. If there is a big difference in price in favor of the mail-order source, discuss this with your local store; sometimes you can negotiate a better price.

Assignment 3 Assume you will expose two rolls of film a week for a school term. Other assumptions:

- every two rolls will use one package of Hobby-Pac Film developer, (or one ounce of FG7, or eight ounces of D-76)
- every two rolls will use 1/20th a gallon each of fixer and fixer remover solution
- each roll will usually require two sheets of paper to make a satisfactory proof print
- · from each roll, assume you will find four pictures to print
- each negative printed will probably require that you expose and develop three pieces of paper to produce a satisfactory print
- every fifteen prints will exhaust a package of Hobby-Pac Paper developer (or 16 ounces of Dektol), 1/8th a gallon of fixer, and one ounce of fixer remover concentrate

Calculate the total number of rolls of film, packages of developer, gallons of fixer and fixer remover solution, and sheets of paper needed for the term, and then estimate the cost.

2 Expose and Develop a Negative

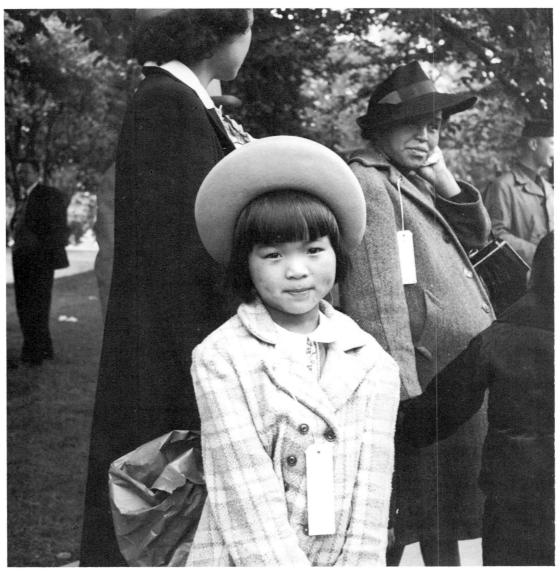

Figure 2.1JAPANESE FAMILY WAITING SHIPMENT TO MANAZAR, 1942.
Dorothea Lange.

The photographer used a low camera position to enhance the viewer's relationship to the girl. (National Archives, Bureau of Agricultural Economics)

TABLE 2.1

Starting Equipment

Camera and light meter

Darkroom to load and wet area to process film

Film developing tank and film reels

Photographic thermometer

Water at correct temperature to mix processing chemicals and wash film

Timer (fluorescent dial, measuring minutes and seconds)

Sponge, Chem-Wipes, Photo-Wipes, or squeegee for wiping film

Graduates, I liter capacity (at least two needed: one for developer and hypo clearing, one for stop and fix) Can opener and scissors

Film processing chemicals: standard film developer (any powdered developer should be mixed 24 hours before use): Indicator Stop Bath diluted 1:31 for use with film: standard fixer mixed to film strength; Heico

Perma-Wash (or Kodak Hypo Clearing Agent); and wetting agent (any standard product)

These items are part of standard darkroom equipment.

Choosing Film and Setting Your Camera

Purchase a 24-exposure roll of film. Any of the standard films are suitable: Kodak T-Max 100 or 400, Tri-X, llford FP4 or HP5, or Fuji Isopan 100 or 400. These are sensitive films that will permit your camera's automatic controls to quickly set shutter or small aperture adjustments, and allow you freedom to simply "point the camera and shoot." Slower films provide finer detail; faster films permit photographing with less light (although with more visible grain). These films also can be described as having **latitude**, a term used to describe photographic materials that are forgiving of most errors of exposure or development.

Many cameras require you adjust the meter in the camera to the correct film speed, but most contemporary 35mm cameras (those made since 1980) automatically adjust the meter to the film you are using. This is called **DX** coding—the pattern of silver lines on the cassette contact electrical sensors in the camera. The film's ability to respond to light, or film speed rating is indicated by the **ISO** number. Moderately slow, or less sensitive films like Kodak Plus-X, T-Max 100, or llford FP4 have an ISO rating near 100. Tri-X, T-Max 400, and llford HP5 have ISO numbers of 400, which indicates they are very light sensitive.

Today's high-speed films are also fine-grain films and will produce a fully detailed photograph, with excellent separation of values in shadows and highlights. If you do not have a meter (either hand-held or in the camera), use the exposure guide data printed on the inside of the film carton or on a sheet packed with the film. Manufacturers suggest shutter and aperture combinations for common outdoor lighting conditions. Your camera may have different programming possibilities, i.e., aperture priority or shutter priority, or be fully automatic and offer you no individual control. Most cameras permit the operator to be in control, but if your camera is fully automatic, then simply make pictures and see what happens.

Start by setting the shutter at 1/60th or 1/125th of a second, and allowing the camera to choose the aperture. This is called *shutter priority*, and light meter and exposure calculating systems in the camera will adjust the size of the lens opening to make correct exposures. Later, you may wish to change to *aperture priority*, where the shutter speed is varied according to the light that is available, but this is risky at first because shutter speeds longer than 1/60th of a second often produce visible blur unless special care is taken to keep the camera still during the exposure.

Figure 2.2
Rainy Day in Athens.
Ken Keefner.
This street scene illustrates the kind of picture that happens only for an instant, and is an ideal subject for 35mm camera photography.
(Courtesy of the photographer)

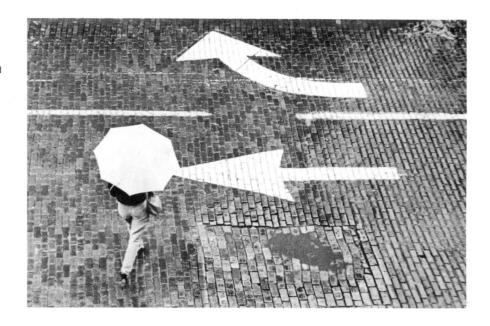

Deciding What to Photograph

What do you photograph? You can begin by giving yourself assignments, e.g., find interesting patterns, events, relationships, make pictures of people on the street—a number of subject assignments are offered at the end of this chapter. But don't feel constrained by assignments: photograph everything that interests you. Photography is a challenge to your seeing, for often the most moving visual discoveries are made by seeing the daily events through the eye of the camera. The act of photographing will change your perception. Since you do not know how the camera and film will change what you see, make experiments and have a good time.

Put aside thoughts of right and wrong ways of seeing and doing. The most exciting pictures are those that reveal your own daily life; they are the pictures no one else can make. Photographic problems inevitably will arise, but they can be solved. The first pictures "should" include different scenes: some may be dark, some bright, with subjects close to the camera or far away, with light coming over your shoulder or from behind the subject. Try photographing many different things, in different ways.

When you have exposed a roll of film, rewind it into the cassette. In the darkroom, you will load the film onto a reel and develop it in a tank.

Darkroom Clothing

Before beginning any darkroom work, you need to consider your work clothes. Photographic chemicals stain clothing; for example, fixer causes a brown stain, although it is water clear. The silver salts dissolved in it are discolored by heat and light, and often do not appear until after being washed. Use a chemist's apron to protect good clothes. Do not wear wool, polyesters, or other synthetics when handling film as these develop electrostatic charges that cause the film to attract dust.

Figure 2.3
Untitled.
Mark Lundquist.
A detail of an unfurled umbrella produces a vivid composition in this photograph made in the student's first photo class.
(Courtesy of the photographer)

Preparing Chemicals

You will need film developer, stop bath, film fixer, and water. The basic photographic solutions are outlined in table 2.2.

Powdered chemicals should be mixed in rooms with good ventilation, but should not be mixed in the darkroom itself. The chemical dusts are dangerous to all photographic papers and films. Avoid breathing chemical dusts! A plastic bucket may be used to mix powdered developers or fixers; the powders should be poured smoothly into the water, and stirred continuously until everything is dissolved. When mixing liquid concentrates, be careful about splashing them. No photographic chemical is benign; any of them will cause discomfort if splashed into the eyes, or if the fumes are inhaled.

Photographic developers and fixers are compounds of several different chemicals. Many standard developers are sold in concentrated solutions that are diluted when used, but a number of popular formulas are available only in powder. Fixers are sold in both liquid and powder versions. Both the liquid and the powder compounds store well at room temperature if they have not been opened or mixed with water. The effects of developer components are investigated in detail in chapter 10.

Liquid concentrates are provided in both bottles and packets. The Kodak Hobby-Pac packets consist of sealed envelopes that are cut open and added to water at the desired working temperature in order to make convenient, working quantities of film or paper developer. Edwal FG7 and the Kodak T-Max and HC110 developers are popular liquid concentrates with excellent storage qualities when kept at room temperature.

Mix film and paper developers twenty-four hours before you expect to use them, to be sure they are fully dissolved. Mixing ahead of time also lets them cool to room temperature before they are used.

Most photographic chemicals dissolve best in warm water, but some of the components may be weakened if the water is too hot. The best temperature for dissolving most powdered photographic chemicals is 100–125°F. If the water is colder, the chemicals will dissolve much more slowly, and may be reluctant to dissolve at all. Start with about two-thirds the total volume of liquid desired. For example, if a gallon package of D–76 is being mixed, begin with 70–80 ounces of water at 125°F. Cut open the package, pour in the

TABLE 2.2

Photographic Solutions

Dilutions

Most photo chemicals are sold or mixed to prepare **stock** solutions. These are highly concentrated and store well. They are diluted just before using, usually with tap water. Dilutions are always indicated as a ratio of *stock to water.* D–76 developer, for example, is usually used 1:1, meaning one part developer and one part water. Edwal FG7 developer is most often used 1:15, meaning one part developer and 15 parts water.

Developer

Many excellent film developers are sold. Kodak D-76 (sold in powder form), T-Max (in liquid concentrate), and Hobby-Pac (in individual packets of liquid concentrate) are suggested. These are very stable, dependable, and available chemicals, with excellent properties. D-76 is perhaps the most widely used developer formula available.

T-Max is a high-energy developer for both normal development and when "pushing" film. Hobby-Pac is an excellent developer that is packaged in single-shot envelopes and mixed only as needed.

All silver process developers begin to decay soon after they are mixed. This weakening is slowed if the solution is kept in the dark, at moderate temperatures (55–70°F), and away from air. Store developers in brown bottles in a cool place, and keep the bottles full (clear bottles may be used if stored in the dark). A partial gallon of D–76 will last much longer if divided and stored in quart bottles, each full to the top.

Stop

Acetic acid is used with film and prints to stop the developing action. The acid is sold in a concentrated form and diluted for use. A popular form of stop has a yellow pH indicator added, and is called Indicator Stop Bath. (Chemists use pH as a shorthand indication of the percentage of hydrogen ions in a solution, which is an index of acidity or alkalinity. The scale is from 0 to 14, and 7 is neutral. 0–7 is acid, 7–14 is alkaline. Strong acids "burn" skin by combining with the water and then carbonizing; strong alkali damages skin by combining with the fats. Most photographic chemicals are weakly alkaline or acid and will not do immediate damage, but all will irritate the skin over time.)

Fixer

Fixer is a mild acidic compound designed to remove the silver halides in the film or print emulsion that were not used to make the negative or print image. Fixer is made in powder and liquid forms. The powder uses sodium thiosulfate, and the liquid version uses ammonium thiosulfate, which works more quickly, and is, therefore, called rapid fixer.

Rapid fixer concentrate is used with less dilution for film, or with greater dilution for paper. Fixers may also contain hardening chemicals that toughen the emulsion, making it more resistant to scratching. Because hardener cannot be premixed with concentrated rapid fixer, a separate solution is provided, which must be carefully stirred in when the working solution is mixed. Print fixer is usually prepared without hardener.

powder in a smooth stream, and stir constantly until it is dissolved. Adding chemicals too fast often will produce insoluble lumps, which also means something is missing from the final solution.

Liquid concentrates should be mixed in the same way, except the water should be at working temperature. Liquid concentrates also need to be stirred well, to ensure that they are evenly dispersed.

Developing Film

Choose a flat work area in your film darkroom (this can be as simple as a large suitcase on end if you are working away from school). Place the film canister, developing reel, tank, blunt scissors, and the opener for the film canister in a dry, safe place where you can find them easily in the dark. Use a bottle opener to pry off the end cap from the film canister. Remove the spindle holding the film and the tapered end of the film (either tear it off or cut it), and load the developing reel. Put the reel in the developing tank and put on the lid. Since the lid makes the tank lighttight, all further processing can be done in regular light. See figure 2.4*A*–*J*.

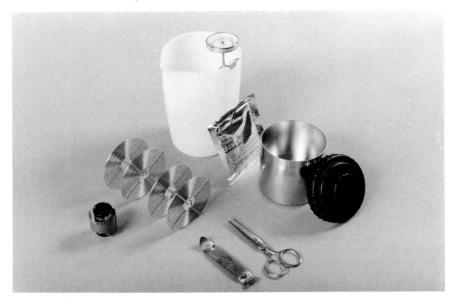

Figure 2.4a. Film, scissors, metal reels, daylight developing tank, film developer, graduate, and thermometer are all the equipment needed to develop film. Both reels should be used and the tank be filled with developer even if only one roll of film is being developed.

HEALTH HAZARDS

Avoid prolonged contact with all photographic solutions to minimize damage to your hands. Rinse your hands in running water after each immersion, and dry them frequently. If small white blisters appear on your hands, you may be sensitive to Elon, a chemical that causes skin rashes in about one in eight people, and you will have to avoid contact with developers that contain it.

Elon: Kodak D-76 and most other developers in powder form use Elon. The same chemical is sold by others as **Metol.**

Acetic Acid: The fumes of concentrated acetic acid (sold both as **glacial acetic acid** and as **Indicator Stop Bath** may cause severe irritation to your nose and mouth. Direct contact with the liquid could damage your eyes. Do not breathe fumes from the concentrate, and avoid splashing it.

Note: Never touch your contact lenses while working with any photographic solution until you have washed your hands thoroughly with soap and hot water.

Prewetting Film

If a wet darkroom is not available, the developer can be poured in through a lightlight opening in the lid (see figure 2.4*J*). But since there is a chance for irregular development when the developer is poured in on dry film, it is best to **prewet** the film by filling the tank with water through the small opening in the lid at the desired developer temperature. Prewetting also eliminates risk of air bubbles forming on the film—these can slow development and produce small black spots on the prints. Agitate during prewet by inverting the tank sharply for thirty seconds, then pour out the water through the lid.

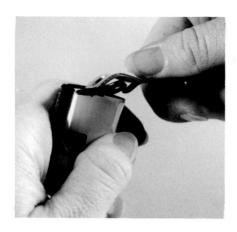

b. The metal end cap on the Kodak cassette can easily be removed with a standard bottle opener (Ilford cassettes can be opened by pressing down on the winding shaft).

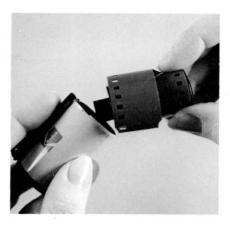

c. Remove the film from the cassette but do not allow it to unwind.

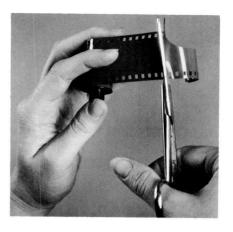

d. Cut off the tapered end of the film.

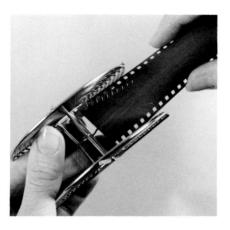

e. Find the opening in the film clip at the center of the reel and feel the film into it. Hold it in place with your thumb to maintain tightness and begin winding the film onto the reel.

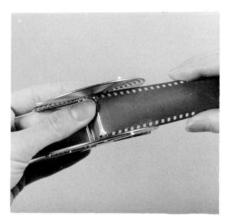

f. The first quarter-turn is critical: if the film is started well it will roll on easily, but if it is crooked here, the film layers will stick together later on the reel.

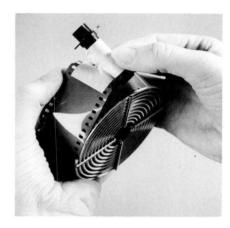

g. When all of the film is on the reel, tear off the spindle and discard it.

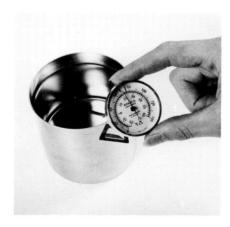

h. Before turning out the darkroom lights, measure the developer temperature. If a changing bag is used, the developer should be brought to temperature in the tank and stored in a graduate while the film is placed in the tank and the lid closed. Prewetting the film will maintain the tank temperature and prevent streaky development.

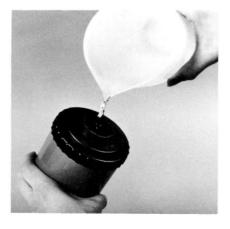

 Water, developer, stop bath, and fixer can be poured into the tank through the lighttight flanges in the cap, permitting all developing operations to take place in ordinary room light.

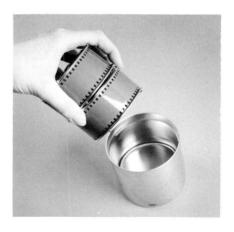

j. When a film darkroom is available, it is best to bring the developer to temperature in the tank and then, in total darkness, place the film reels in the tank, close the lid, and begin agitation.

Film Processing Time Table

This table outlines step-by-step times for processing T-Max 400 35mm film in Kodak T-Max developer. Kodak data guides offer recommended times for both 68°F and 75°F. If Kodak D-76 is used, the solution made from the powder should be diluted with equal parts of water shortly before developing the film, and the developing time increased to eight minutes. All processing steps other than developing time will remain the same, no matter what film or developer is used. When T-Max film is used, double the fixing time. Use Edwal Hypo Chek every three or four rolls to insure fixer strength.

Step	Time	Process
1	1 min.	Prewet: water at 75°F; agitate continuously
2	4–7 min.	T-Max developer at 75°F (shorter time=less contrast). Initial agitation 8–12 sharp inversions of tank. Rest until start of second minute, then 8–12 inversions each minute.
3	30+ sec.	Stop bath or water rinse, with continuous agitation
4	2–4 min.	Fix, with continuous agitation—T-Max requires twice the fixing time as other films, and rapidly exhausts fixer.
5	30 sec. to 1 min.	Fixer remover solution: use continuous agitation
6	1–2 min.	Fill developing tank, agitate, dump. Repeat ten times.
7	1 min.	Fill tank with distilled water and wetting agent: rock tank gently
8		Squeegee film and hang to dry

Developer Temperature

When a film darkroom is available, fill the tank with developer (see figure 2.4H) and, if necessary, bring it to the correct temperature by running hot or cold water around the outside of the tank. Then, in the dark, put the film on the developing tank reels and put the reels in the tank. Put on the lid and begin to agitate the tank. Pour developer smoothly into the tank. There is no need to bang the tank on the sink to displace bubbles when prewetting and correct agitation are used.

Figure 2.5 is a blank processing record sheet to use for your own system.

Development Controls

Different developers often produce slightly different results. Yet for all films there are similar controls:

- · developer formula
- · time
- temperature
- agitation

Each of these affect the development of your negative. The strength of the developer affects overall development. Time is controlled by using a clock. Developing time starts when you begin pouring the developer in, and ends when the last of the developer pours out of the tank. Temperature is easy to control by placing the developing tank in a tray of water at the desired temperature. Keep graduates with the stop and fixing solutions in the water, along with the developing tank. This **water bath** keeps the processing tank and all of the solutions at the same temperature.

Figure 2.5

A film processing record that can be photocopied and used to keep track of your own film processing.

Film Processing Record:		
Date	:	
Step	Time Process	
1	0 to 1 Prewet: water at• F	
2	drain prewet	
3	developer: temperature: • F	
	time:	
4	agitation notes:	
5	stop bath	
6	drain stop bath	
7	fix minute; clearing time:minutes.	
8	rinse (fill and dump).	
9	fixer remover forminutes.	
10	final wash (fill & dump 10 times)	
11	wetting agent	
12	dry	

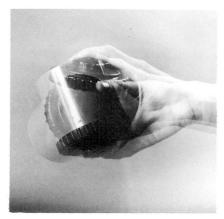

Figure 2.6
Correct small tank film agitation requires that the tank be inverted sharply about its own centerline, then immediately turned back straight. The effect of this is to stir the developer but not allow continuing movement.

Agitation and Time

Holding the tank and inverting it about its own center as shown in figure 2.6 produces very even development. Other kinds of tank agitation may produce density streaks in the film, caused by developer turbulence. Correct agitation replaces the developer in the film emulsion at regular intervals, but does not create excess turbulence around sprocket holes or reel wires, or interfere with the continuing motion of the developer in the tank. Correct agitation avoids turbulence near the edges of the film, which later appears on the print as irregular gray patterns. Agitation and development problems are shown in figures 2.11 through 2.15.

Agitation should be done for short times, at regular intervals, and in exactly the same way each time. There are subtle differences in the film image if agitation is done for ten seconds each minute, or five seconds each half minute. Either is acceptable. The effects of a particular agitation method are best answered by examining your pictures. Increased frequency or increased rate of inverting the tank during agitation will increase contrast in your pictures. Decreasing the vigor or frequency will decrease contrast. When lower contrast is desired, it is correct to agitate less (either by inverting the tank fewer times each minute, or by agitating less frequently, or both).

Prepare to stop development by opening the small lid of the developing tank; you should begin draining the developer ten seconds before the developing time is finished. The tank will be empty when the timer reaches zero.

Stop Bath

Development can be halted by rinsing the film in plain water or soaking it briefly with a very weak acetic acid solution, called **stop bath.** The stop bath is prepared from concentrated acetic acid and it overwhelms the basic pH developer solution. The stop bath may be reused until the pH indicator color turns from yellow to purple, which indicates that it is exhausted, but usually it is discarded at the end of the developing session. When the stop bath has been drained, fill the tank with fixer. No rinse is needed between the stop and the fixer, as they are both acidic.

Fixing Film

Film fixer removes the unused silver halides (also the antihalation dye in T-Max films) and it hardens the delicate gelatin. After the film is fixed, the image silver has been developed, and the remaining silver has been removed. The film is no longer sensitive to light, and, after using a **hardening fixer**, the negative is less easily scratched.

Fixer dissolves the unused silver halides, which are light gray in the emulsion. Removing these prevents the developed image from changing after development. The active chemical was originally called **sodium hyposulfite** and was given the nickname "hypo." Although the correct chemical name was **sodium thiosulfate**, the nickname is still often used. Removing the unused silver halides is called **clearing**, and the film should be fixed for *twice the clearing time*. The clearing time will vary from one film to another.

Fixer Clearing and Washing Film

After fixing the film, rinse it with plain water by filling the tank once with water and then dumping it. Refill the tank with a hypo clearing solution. Sodium thiosulfate is not very soluble in water, but it is transformed by the fixer clearing solution into a more soluble compound. Though it is often referred to as a "fixer remover," the clearing agent does not actually remove the fixer from the emulsion, but rather transforms it into a chemical that can easily wash out of the emulsion. By using the hypo clearing bath with both film and prints, it is possible to wash prints to a chemically safe state with little water. If left in the emulsion, the fixer itself would eventually destroy the silver image. Without these solutions, wash times are quite long, and even extended wash periods will not remove all sodium thiosulfate.

The most efficient way to wash a negative after using a hypo clearing agent is to fill the developing tank with water, agitate several times, and dump it out. Repeat this ten times. The negatives are now adequately washed. This procedure has been thoroughly tested. Putting the tank under a faucet and letting water run in it for some time is both inadequate as a washing technique and very wasteful of water.

Final Rinse and Drying

Water must be removed from both sides of the film to prevent spotting. This can be done by wiping the film and/or rinsing it in a wetting agent before hanging the film to dry. A wetting agent minimizes the risk of water drops standing on the emulsion. As a drop dries, a density pattern that cannot be removed is formed in the emulsion.

Prepare a final rinse by adding a wetting agent to water, per the instructions on the bottle. If you have hard water, use distilled water for the final rinse. Pour the wetting agent over the film in the tank and agitate gently for thirty seconds. Dump the wetting agent. (Be sure to wash the reels in hot water

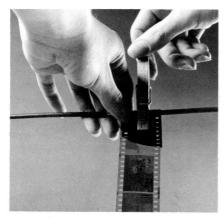

Figure 2.7a. Wet film can be folded over a drying line and held in place safely by an ordinary clothespin.

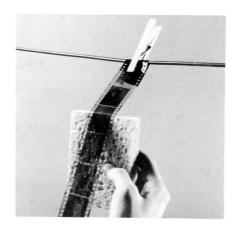

b. A plain viscose sponge is rinsed out in the final wetting solution used on the film, and is squeezed dry.

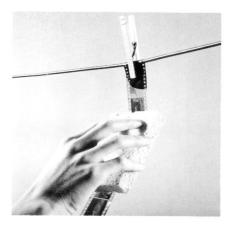

c. The sponge is then dragged down the film to remove all surface water and dirt.

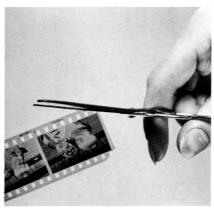

Figure 2.8
Film is cut into 5- or 6-frame strips, and the corners at one end of each strip trimmed.

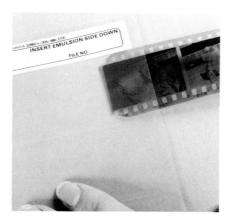

Figure 2.9
The film strip slides into a slot in the protective plastic film storage sheet.

Figure 2.10
Film storage sheets and contact proofs can be kept together in three-ring binders or storage boxes that keep both negatives and proofs safe from dust.

after the film has been dried or the reels will become hard to load.) The film may be dried on the reel in a forced air dryer, but it will be easier to store if hung straight. Hang your film in a dust-free place for drying, as shown in figures 2.7 A, B, and C. Ordinary snap-type clothespins will hold the film securely if the top of the film is wrapped over the drying line. If your wash water is quite clean, no further treatment is needed, but sometimes the water has solids in it. Although there is some risk of scratching, it is best then to carefully wipe down each side of the film with a clean, damp sponge, fresh Chem-Wipe, or Photo-Wipe to remove excess water.

Store and Identify Negatives

Take film from the line as soon as it has dried. Hold the film by the edges; never touch the image area (on either side). Dirt and skin oils can damage negatives. The image is contained in the emulsion, a thin layer of gelatin and silver. It is less reflective than the film base, or support side, of the film. To see what your picture looks like, the film should be viewed from the base side with the emulsion away from you.

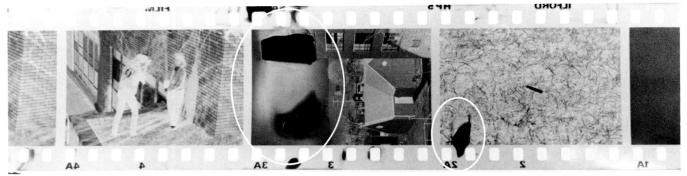

Figure 2.11
Failure to engage the film in the reel track in the first 1/4 turn will result in the film layers touching, and some places on the film not being developed and fixed. The unprocessed spots will look pink or gray, and be either clear or opaque.

Figure 2.12

When film has not been exposed (usually because it was not correctly engaged in the take-up reel) and is developed, it will be clear and have edge frame numbers and emulsion identification. These are printed with light at the factory. If the processed film was clear and did not have edge numbers, it has been processed in fixer first.

The film base often has a pale purple color. This is the remaining traces of the **antihalation** dye from the back of the film, put there in order to improve tonal quality. T-Max film may have some color after processing, but the dye has no noticeable effect on the print.

Store your film by carefully cutting it into strips of five or six frames. Place these strips in plastic storage sheet slots. Plastic protective sheets are a convenient way to store film. They are punched to fit regular three-ring binders. The storage sheets are so thin and transparent that good proof prints can easily be made without handling the negatives individually.

It is important to identify negative sheets as they are created. Descriptive titles are useful, and dates are usually important. Contact proof sheets can be punched and filed along with the negatives. A simple, but useful filing system is to date all negative sheets (and their proof prints) chronologically. For example, 01–14–88–A–32 would identify frame 32 of the first roll developed on January 14, 1988.

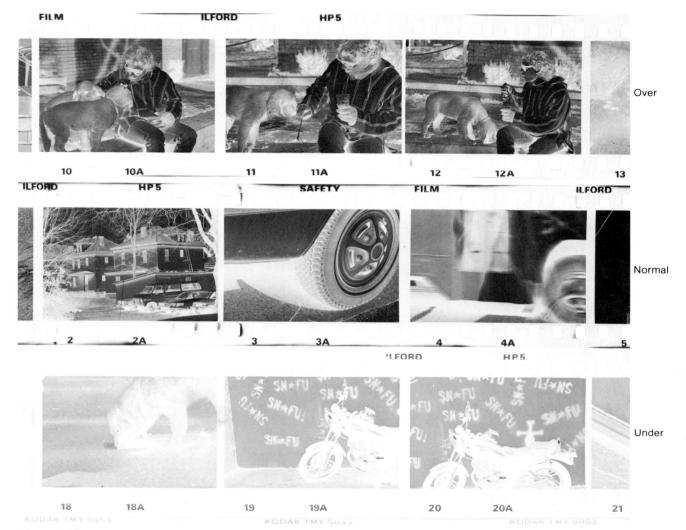

Figure 2.13

Comparison of under-, normal, and overdeveloped film. Underdeveloped film has little or no detail in subject shadow areas and the density in the white areas of the subject can be easily seen through. Correctly developed film has shadows that are a little darker than the unexposed edges of the film, and highlight areas that can just be seen through. Overdeveloped film has more obvious shadow details and opaque highlight areas.

Discussion and Assignments

Choosing a subject, finding the best moment, getting an effective angle of view, exposing and developing the film correctly—these are the basic problems in either black-and-white or color photography, whether small camera or view camera, photojournalism or art photography.

Assignment 1 Work with a friend or another student. Take a picture of her/him as your first picture. Now trade cameras and photograph your partner again. Feel the difference the camera makes, if it is a different make or model.

Assignment 2 Without going more than fifty feet from the front door of your house, dormitory, or classroom, find examples of these five photographic subjects:

- · patterns of light and shade
- a subject close to the camera relating to another subject far away from the camera
- · a central, visually isolated subject
- a person photographed with the sun over your shoulder, from one side, and from behind the subject
- · something photographed out of focus on purpose

Assignment 3 Photographic subjects exist everywhere. Make note of what time you get up in the morning and what time it gets dark at night. Calculate the number of minutes between these (in the winter it may be as little as 600, in the summer as great as 900); divide time by 36. This number will vary from about 15 to 25; this is your time between exposures.

The night before you begin this assignment, load your camera with a 36-exposure roll of T-Max 400 or HP5. The next day, expose a frame every unit time (15 to 25 minutes) for the entire day. This means that wherever you are when that unit of time is up, look and find a photograph. It may be an object, or a discovery of form, or a relationship between things (people, objects, light and shape, etc.). Avoid making judgments (saying to yourself "that's a good subject," or "that's a dumb thing to photograph") and try to remain visually open to the time and place that you are.

Assignment 4 Investigate development effects. Carefully expose a roll of film that has subjects with similar gray values in similar lighting, and then, in the darkroom, remove the film from the cassette and cut it with a scissors into three pieces about the same length. (Yes, you will probably destroy two frames by cutting through them while doing this, but you may save a lot of more important frames later for having done this test.) Store each third of the roll in the plastic film canister that the cassette comes in. (The Kodak canisters with the gray lids are lighttight; unfortunately, the llford canisters with the colored lids are not.)

Prepare to develop the film. Develop the three pieces separately, one at a time, at the same temperatures and for exactly the same times. Agitate the first strip of film as suggested in the text. Agitate the second strip by inverting it only twice (instead of 10–12 times) at the beginning of each minute. Agitate the third strip using another agitation technique (twisting the tank, pumping it back and forth . . . ask around, you will get lots of suggestions).

Fix, wash, and dry the films. Contact proof all of them together. Look for differences in contrast (separation of light and dark values), and in uneven densities near the edge of the film (especially near the sprocket holes). Try to figure out what effects are the result of the variations in development technique.

Assignment 5 Cut off the tapered end of an undeveloped roll of film and place it directly in the film fixer in ordinary room light. Agitate it frequently and keep track of the time while watching the fixer remove the gray undeveloped silver halides in the emulsion. Note the time when the last of the gray is dissolved. The correct fixing time for that kind of film and developer is *twice* the observed clearing time. T-Max films will take much longer than other Kodak films or the llford films.

3 Expose and Develop a Contact Print

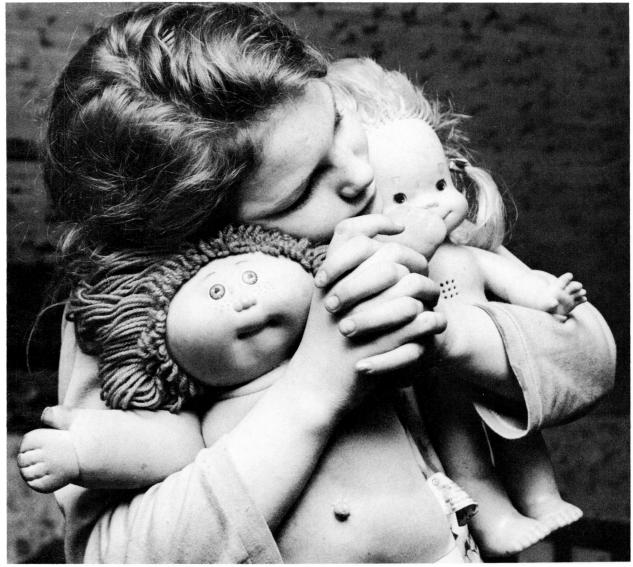

Figure 3.1
UNTITLED.
Christine Keith.
Documentary portrait of rural Appalachian child. The portrait was made with bounce flash using Tri-X at El of 400.
(Courtesy of the photographer)

TABLE 3.1

Contact Printing

Standard Darkroom Equipment

Photographic safelights with Wratten Series OC filter: (OC filter is recommended for most enlarging papers) Contact print frame: 10" x 12" piece of 1/4" thick plate glass and a sheet of low-density foam

Print tongs (reduce contact with photographic chemicals)

Clean, small towels

Photographic trays: Four 8" x 10" or 11" x 14"

Automatic Tray Siphon or other print washer

Rubber squeegee or viscose sponge

Photographic printing paper:

contrast grades 2, 3, or 4; or

Kodak or Ilford variable contrast paper and a set of printing filters for that brand of paper

Processing chemicals:

Kodak Dektol, Hobby-Pac Paper, Sprint Print Developer, or other paper developer

standard paper developer

Kodak Indicator Stop Bath, Sprint Stop Bath, or glacial acetic acid

Kodak Rapid Fix diluted for use with prints

Heico Perma-Wash, Sprint Fixer Remover, or other hypo clear

Drying screen for prints

These items are now part of standard darkroom equipment.

Contact Print as Record

The contact print is made by laying a set of negatives on the photographic printing paper (emulsion to emulsion) and exposing the paper to white light through the negatives. The most convenient light source in most photographic darkrooms is an enlarger.

A contact print is an economical way to discover what your camera has recorded. The contact proof sheet shows all the photographs on a roll of film at once, and these are easier to examine than the negative images. One can also study the contact proof to discover which frames have the best exposure, and evaluate printing contrast. Contrast describes the range from the brightest to the darkest area of a print or a negative.

Photographic Papers

Today's papers are either **fiber-based** or **resin-coated**. The resin-coated (RC) papers have a plastic seal that keeps processing chemicals from reaching the paper base, so that only the emulsion gets wet. Processing time is short because chemicals enter the emulsion and wash out quickly. The total wet time for RC papers should be kept short, preferably under ten minutes. Fiber-based papers lack the plastic seal. Washing chemicals from these prints takes longer. Fiber-based and resin-coated papers look and feel different, and each type has special uses. Resin-coated papers are commonly used when production speed is most important.

Printing papers are also made in **graded contrast** and **variable contrast** fiber-based and RC versions. Contrast grades are numbered 1 through 5, with 1 being a very low contrast and 5 a very high contrast. Contrast grade 3 is generally recognized now as being the normal grade for printing 35mm negatives.

Variable-contrast papers are exposed through numbered, colored filters, which produce contrasts equivalent to graded papers. The variable-contrast papers have both high- and low-contrast emulsions that are sensitive to different colors of light. Variable-contrast papers allow you to print negatives with areas of differing contrast, which are difficult to print with graded papers, but fiber-based papers are more responsive to manipulation during development.

Figure 3.2

- a. Cross section of typical fiber-based photographic paper.
- b. Cross section of typical resin-coated (RC) photographic paper.

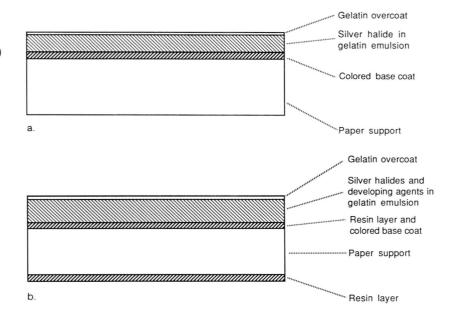

Figure 3.3 *Untitled.*Marianne Kelley.

Photograms are a way to create images without using a camera and are also a way to experimentally learn how photographic paper responds to light. Working in the darkroom, lay objects on print paper. Use the enlarger or a flashlight to expose the paper. Both the objects and the light may be moved during exposures. (Courtesy of the photographer)

Safelights

Photographic papers are very sensitive to light. But papers are not equally sensitive to all colors of light. Suitably colored filters are made to provide safe lighting for printing; for example, yellow-orange light of low intensity will usually not expose them. However, even these **safelights** will effect the paper if it is exposed for a long time, or if the light is too intense. Use the low-wattage lamp suggested by the safelight manufacturer. A *safelight test* is outlined in chapter 10. Finally, remember to open all photographic paper packages and handle the paper only under safelights.

Figure 3.4

The Omega and Beseler enlargers accommodate film sizes from 35mm to 4" x 5" format. The Omega enlarger sketched here has different condenser lens positions for each format.

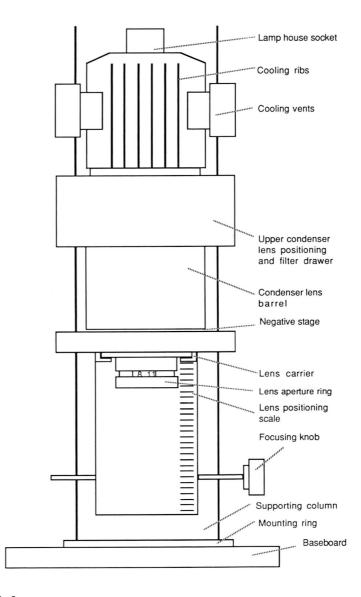

TABLE 3.2 The Enlarger

Purpose

To project light through a negative to form an image on other photographic emulsions

Components

Support: a rigid frame to position the head Head: contains the lamp house, negative stage, light diffusion or condensing system, focusing controls, and enlarging lens

Lamp house: contains an electric light Diffuser or condenser lighting system: condenser produces more contrast; diffusion requires more contrasty negatives

Filter drawer for printing contrast control filters

Negative stage to hold the negative carrier Elevation lock for the enlarger head Focusing control to adjust the enlarging lens Enlarging lens: controls brightness of projected light

Baseboard: flat platform

The Enlarger

The enlarger is an electrical machine that must be well-grounded, for safety reasons. Any enlarger can be damaged by rough handling. Never force controls, overtighten locking knobs, or let the lamp house fall shut. The enlarger should be on a firm table or bench, separated from the "wet side" of the darkroom in order to avoid damage to negatives and prints when liquids are spilled.

Use the enlarger as a calibrated light source when making contact proof prints. When preparing to make a proof print, place an empty 35mm negative carrier on the negative stage, and a 50mm lens in the enlarger. Find the *focus* and *time* switch on the enlarger timer and turn it to *focus*; if the equipment is plugged in, this will turn on the enlarger.

Figure 3.5
Leitz and some other enlargers are dedicated to 35mm format. In late model Leitz and in the Durst enlargers, the negative stage is a slot into which the film carrier slides.

Figure 3.6 Looking up from the baseboard at the enlarger film carrier and lens, which is open to full aperture.

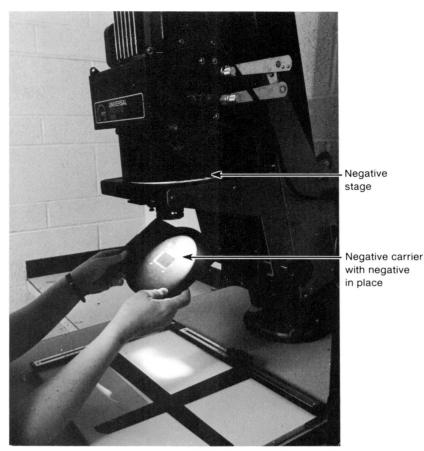

Figure 3.7The Omega negative carrier is placed in correct projection position by lifting the enlarger head.

Open the lens to maximum aperture by turning it gently, then raise the head of the enlarger until there is a rectangle of light on the baseboard just a bit larger than $8'' \times 10''$ paper. Focus the enlarger by moving the lens up and down with the focus control until the edges of the rectangle of light are sharp. Stop down the lens to f–11 by rotating the aperture control. A contact proof exposed on contrast grade 3 fiber base paper for 15–20 seconds at this aperture will generally produce usable prints from properly exposed and developed negatives.

Correctly exposed and developed negatives require approximately the same exposure whether one is making a contact proof (with the enlarger illuminating a $8" \times 10"$ area on the baseboard) or an enlargement. Most blackand-white enlargers now on the market create a field of light of about equal brightness. Knowing this, one can easily make a usable $8" \times 10"$ print from most enlargers on the first try.

When making a contact proof, you want:

- to expose the paper enough so that there are details in the light gray areas of the picture when it is developed
- to choose the right contrast grade of paper so that dark areas in the picture have some visible detail

Figure 3.8
Untitled.
Photographer unknown.
Photographs were used as a means to a personal inventory as soon as they became economical.

Preparing the Darkroom

The darkroom can be made ready in white light. All solutions should be at about 70°F. Adjust the water temperature to 70°F before starting. If the print washing water is cold, and it drains around or under the developer tray, it will cool the developer.

Place four photographic trays in the sink if you are printing with fiber-based papers; five if using RC paper. Although 8" x 10" trays can be used for 8" x 10" prints, many photographers find there is less risk of damaging prints while agitating them during development if a larger first tray is used. The first tray is for developer. There should be at least thirty-two ounces of developer in the tray. Dektol is usually diluted 1:2 (although it may be used in greater dilution or at full strength), which means eight ounces of Dektol stock and sixteen ounces of water are used. If you are using Hobby-Pac paper developer, pour a single package of paper developer into twenty-four ounces of water at 70°F, then add water to make one quart of developer. This makes a developer similar to Dektol diluted 1:2.

Developer temperature is important, and most photographic solutions function best at 68–70°F. Developing times and print contrast are affected by temperature. It is better to have the developer be a little too warm than too cool. Below 68°F, print developer contrast decreases rapidly, and prints processed in cold developer appear gray, with weak shadow values. Developer temperature should be measured frequently, and if the developer is cool it can be warmed by setting the tray in a larger tray filled with hot water.

The second tray contains stop bath, which neutralizes the print developer and prevents the image from developing further. Stop bath is prepared by adding 1/2 ounce of Indicator Stop Bath to one quart of water. This amount can be approximated by filling the bottle cap four times with the concentrated yellow stock. The stop bath is colored with a pH indicator that changes from orange to magenta when the solution has absorbed too much developer. If this happens, the stop bath will suddenly appear cloudy and dark under the darkroom safelight, and should be dumped and replaced.

The third tray is used for print fixer. It is important that the fixer be of the correct strength for paper, and that film fixer not be used for fixing prints. When using RC paper, the total wet time should be kept short. After development and stop bath, the print is fixed for two minutes in rapid fixer, rinsed for one minute in running water, agitated in fixer remover in the fourth tray for one minute, washed for 2–3 minutes under running water in the fifth tray and put to dry.

When using fiber-based paper, the fourth tray contains only water. This tray can be used for print storage and then for final washing. When a number of fiber-based prints are being made, rinse each print with running water for thirty seconds, and store it in the fourth tray. Each print carries some fixer with it and the storage tray can become a very dilute fixing tray, so it should be dumped and refilled after 6–8 prints have been added. At the end of the printing session, complete the processing of all fiber-based prints by cycling them through Perma-Wash solution for 2–4 minutes and then washing all prints thoroughly before drying.

Expose a Contact Print

Turn on a correct safelight, turn off the white lights, and switch the enlarger timer from focus to time. Open the paper package and remove a sheet of printing paper. The emulsion side is smoother than the back, and the paper will normally curl slightly toward the emulsion. Use a soft lead pencil to write the exposure, aperture, and exposure time on the back of each print. Write lightly and near the margin. Too much pressure will cause a pale image of your writing to appear in the picture.

Figure 3.9

Typical darkroom tray sequence. Four trays are needed for processing: developer, stop bath, fixer, and either water storage or washing.

Figure 3.10

a. A piece of thin plate glass with ground edges and a sheet of packing foam make an excellent contact printer. Put the foam on the enlarger baseboard, place paper emulsion up, and lay a sheet of negatives on the paper, emulsion down.

b. Lay the glass on the negative and print paper. The weight of the glass is sufficient to hold the negatives in close contact with the printing paper, producing a sharp, clear proof. The plastic storage sheets have little density and do not affect the print exposure or sharpness

Place the paper emulsion upon a cushion of foam on the enlarger baseboard and then cover the paper with the negatives in their plastic storage sheet, placed emulsion down (as shown in figure 3.9A and B). Cover the negatives with the sheet of glass. Use the enlarger timer to expose the paper through the glass and negatives for fifteen seconds. Remove the paper from the printing frame and develop it.

Develop the Contact Print

Use a timer to measure development. Normal developing time for most prints is 30 seconds, but there is a useful range of times. For RC papers it is from thirty seconds to one minute; many RC papers have developing chemicals in the emulsion and consequently these papers do not respond much to varying development times. Fiber-based papers are more responsive to development controls and may be usefully developed as little as one minute or as long as four or five minutes.

Slide the paper smoothly into the print developing solution, wetting it evenly and quickly. The print must be agitated during development. Agitation should be done constantly and in general, print agitation cannot be overdone.

Figure 3.11

Louisville, Kentucky, ca. 1905.

H. C. Griswold.

Photographers have always made moving photographs by documenting the daily life immediately at hand.

(H. C. Griswold Collection, University of Louisville Photographic Archives)

Inadequate agitation produces dull prints, with little contrast and a brownish color. Print agitation *can* be done by rocking the tray constantly from side-to-side and end-to-end, but more vigorous agitation consists of lifting the print, allowing it to drain for a second or two and then rewetting it.

Rocking the tray means to lift one edge of the tray sharply, then put it down. This creates a wave that scrubs the emulsion, replacing old developer with new. Lift all four edges of the tray in rotation. Mild back and forth rocking is not enough. Tongs can be used to lift the paper. An advantage of tongs is that they keep your hands out of the chemicals; a disadvantage is that using tongs carelessly will crack print emulsion.

Watch the photograph carefully during development. If images appear in less than fifteen seconds, the proof print is overexposed; if there is no sign of detail within individual frames after forty seconds the picture will need at least another half stop of exposure. Do not try to judge exposure or contrast under safelight in the darkroom. Until you have had a lot of experience, fully process your prints, unless it is obviously so dark or so light that you cannot see detail. Wait until the print has been fixed and rinsed, then examine it under white light. Evaluating wet prints takes a lot of practice.

Stop, Fix, and Rinse the Print

After development, lift the print and let developer drain back into the developer. It takes about five seconds to drain an 8" x 10" inch print. Slide the print carefully into the stop bath and agitate it there for 20–30 seconds. Drain it again, and lay it in the fixer. Agitate continuously for RC prints. Fiber-based prints should be agitated for 30 seconds, and then every 20–30 seconds until fixing is done. Fix the print for the time suggested by the manufacturer. The minimum recommended fixing time should be used; the longer the print is in the fixer, the shorter the print will last.

a.

b

Figure 3.12

a. The Automatic Tray Siphon is an excellent and economical print washer, but only a few prints can be washed at a time, and then they should be interleaved frequently.

 A plastic sleeve print washer isolates each print in a narrow slot and permits very thorough washing.

Chemical Use

About fifteen prints of good quality can be made from a quart of working solution. Many more prints can be made from the developer, but they will be progressively less strong, with weaker shadows and a brownish cast, and there is an increasing chance of stains appearing on the prints when they are dry.

Stop bath exhaustion is shown by the changing color of the pH indicator. The "feel" of the print can also be used to estimate working life. The print feels slippery when it comes from the developer tray; the acid stop bath changes this and the print surface will feel rubbery after 5–10 seconds agitation in the stop bath. If this does not happen, replace the stop bath.

Fixer removes the unused silver salts. A quart of fixer will safely fix about twenty-five 8" x 10" prints. The fixer does not obviously change color as it becomes exhausted (although if it is examined in daylight it becomes pale yellow), but prints treated in exhausted fixer may show tan spots within a few days, and will turn brown within a few months. Edwal Hypo Chek is an economical way to determine if the fixer is effective.

Place all the fiber-based prints in the fixer clearing solution and interleave them, pulling a print from the bottom and laying it on top, for the recommended time. Drain the prints and place them in the washing tray.

The fixer clearing bath has a pale purple color when exhausted, but the solution is relatively inexpensive and is best used once and then dumped.

A simple test can be made for residual fixer: place a drop of Kodak Rapid Selenium Toner on the white border of the emulsion. The toner has a pale tan color, but there should be no stronger discoloration after 2–3 minutes. If a visible stain appears, the fixer remover is inadequate and the print should be treated with fixer remover again and rewashed.

When the day's printing is done, dump the developer because it does not keep well. Dump the stop bath. The fixer is usually worth saving, but the amount of use should be monitored. A gallon of fixer can be used for about a hundred $8'' \times 10''$ inch prints before it is unsafe. Keep track of the number of prints processed in order to know when to replace the fixer. Prints fixed and washed as described here will last a long time.

Washing and Drying Prints

Because each print added to the wash water brings new fixer with it, safe print washing time is counted from the moment when the *last* print is placed in the water. Batch washers are not very effective and cannot be trusted to provide thorough washing. The best print washers consist of vertical slots in a plastic frame, where prints are isolated from each other and water flows upward past each print, but they are expensive and bulky. The best inexpensive print washer is the Automatic Tray Siphon. This simple device vigorously washes prints by letting water in at the top of the tray and drawing it from the bottom. The limitation of this washer is that no more than five or six prints should be washed at a time, and for thorough washing they must be interleaved frequently, moving the bottom print to the top. With the help of Perma-Wash or other washing aids the washing time for most prints can be reduced to five minutes. Drain each print at the end of the wash; put it face up on a sheet of plastic (you can use the bottom of a smooth tray), and wipe off the surface water with a squeegee or sponge.

Prints must be dried in a dust-free place. Fiber-based prints can be dried face down on clean nylon screens, or even on a clean, lint-free bedsheet. Photo grade blotters can be used, but it should be realized that eventually any blotter will become contaminated with fixer. Resin-coated prints can be dried on nylon screens or hung to dry like film.

Figure 3.13

After washing, excess water should be squeegeed or sponged from a print before it is hung to dry or place on a drying rack. This prevents water spots from marring the surface or causing uneven drying.

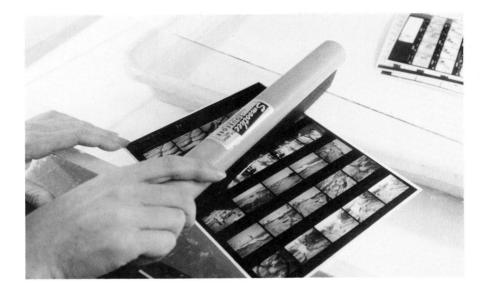

Figure 3.14

A drying rack can be tucked under a counter, utilizing what might otherwise be wasted space, and unattended prints can dry safely. This small rack will hold 40 8" x 10" prints, and if a fan is used, these can dry in an hour.

Fiber-based prints will begin to curl as they dry. Prints can be kept flat if they are taken from the drying rack as soon as they are dry to the touch, then placed face down on a glass or Formica surface and covered with a moderate weight.

Uses for the Proof Print

Examine the dried proof print carefully. The individual frames of the proof sheet will be similar in value if your negative exposures were correct. Take some time and study the pictures. The contact proof has several uses. It is:

- · a record of your pictures
- · an exposure guide for making enlargements
- · a predictor of printing contrast grade
- · a record of how you saw the subject

When the proof is poorly made, it fulfills only the first function (and if too dark or light it does not even do that well).

Figure 3.15

A well-made contact proof is exposed enough to reveal highlight details, and that exposure is noted on the back of the print. The right contrast grade of paper will produce a print in which the film sprocket holes are just barely visible against the black background. These negatives, when enlarged on the same contrast grade of paper, will produce a print of correct contrast.

Evaluating Exposure

The brightest subjects in your photographs probably had some visible detail, and this detail should be apparent in the print (see figure 3.15). If clouds, light concrete, white houses, or white shirts lack detail, the proof print did not have enough exposure (see figure 3.16). If there is no detail at all in these highlights, you may wish to make a second print and allow more light to pass through the negative. Increase the exposure by opening the lens to the next aperture, e.g., from f-11 to f-8, and expose another sheet. This exposure increase is called *opening up a stop*, a photographic shorthand term meaning to increase the lens opening so that twice as much light passes through. A full stop increase is often not needed, and it is easier to change the exposure time. Doubling the exposure time is the same as opening the lens a stop. If the highlights are almost visible, try increasing the exposure time by 50 percent, i.e., from fifteen to twenty-one seconds for the second proof print.

When highlights are all dark gray, and shadow areas black, the proof has been overexposed (see figure 3.17). Expose another sheet of paper, but *stop down*, (reduce the lens opening) to the next aperture setting to decrease the amount of light onto the printing paper. In the same way, cutting the exposure time in half is the same as stopping down a stop. A half-stop change would be a 25 percent reduction, or from fifteen seconds to eleven or twelve seconds.

Figure 3.16

Underexposed proof print lacks detail in highlight areas and also has a gray sprocket pattern.

Figure 3.17

Overexposed proof has dark highlight values and the pattern of sprocket holes has merged with the black surrounding density.

Evaluate Contrast

The contact proof print has inherently *less* contrast than an enlarged print would have if printed with a standard condenser enlarger. The difference is not quite a full paper contrast grade. Because of this, when the exposure is correct for highlight details in the contact proof print for a correctly exposed and developed negative, the 35mm film sprocket holes should be just visible against the black paper.

When the negatives have been developed too long and therefore have too much contrast, the sprocket holes may not be visible. The blank film base and the space between one strip of film and the next will all be black (see figure 3.18). When the contact proof has been exposed for correct highlight

Figure 3.18

Contrasty proof print has highlight values similar to those found in a correct proof, but the sprocket holes have merged into the surrounding blackness. There is nothing wrong with making proof prints that look like this, but a correct contrast proof print is inherently less contrasty than an enlarged print on the same contrast grade paper.

Figure 3.19

Low-contrast proof has adequate detail in highlights but lacks density in the darker areas, and the film around the sprocket holes is gray. This proof is usable. If both exposure and paper contrast grade are noted on the back, the proof can function both as a record of images and a predictor or enlarged print exposure and contrast.

details, but the negatives are underexposed, underdeveloped, or both, the pattern of the film perforations will be a clearly visible gray band, against a black or even gray-black background density on the proof sheet (see figure 3.19).

When these problems are severe, you may wish to remake the contact proof. When the negatives are too contrasty, and both the shadow detail and the film perforations are black, although you have exposed for correct highlights, make a new proof using a contrast grade 2 paper (or filter). In the same way, if the proof is flat and gray, remake the proof and use a contrast grade 4 paper (or filter). In any case, preserve a record of your work: use a soft lead pencil and write the contrast grade, exposure aperture, and exposure time on the back of the proof print. This information can be used to predict enlarged print times and contrasts.

Discussion and Assignments

The photographic process uses silver salts, which are changed by light and by the action of developing agents. But these salts are also changed by light alone, and this can be demonstrated, as in the following assignments.

Assignment 1 Take a piece of photographic printing paper and a strip of negatives. Place the negatives on the paper—emulsion to emulsion—and put them in direct sunlight, under a piece of glass to hold them together without movement. Over a period of several hours there will be a distinct color change, and a low-contrast image from the negative will formed on the paper. Examine the print you have made. This is an example of **printing out**, where the light breaks down the bond between the silver and the halide, producing a visible change. It was the way almost all prints were made from 1851 until the late 1880s, when "gaslight" or **developing out** paper was introduced. Printing out paper had more silver in it, and it darkened more quickly and produced a greater density.

Assignment 2 Make a duplicate copy of your proof sheet. Cut out each frame and glue *all* those individual pictures on plain $3'' \times 5''$ file cards, whether they look "good" or "bad." Spread the cards out on a table and discover the ways in which you saw your subject and the way you photographed:

- · look for repeated patterns in your pictures
- · how many times the same scene was photographed
- · discover pictures you had not seen in the whole proof sheet
- stack the cards in the order they were shot and study the sequence of pictures

4 Expose and Develop an Enlargement

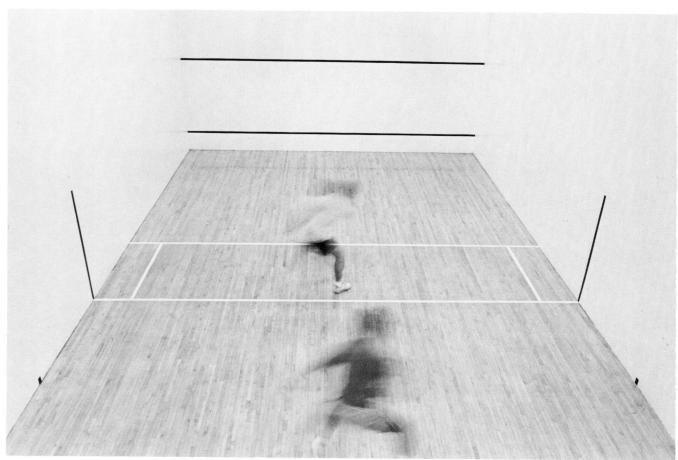

Figure 4.1
MOTION STUDY.
Barbara Pamp.
A moderately slow shutter speed and a carefully braced camera was deliberately used to create a blurred image of the racquetball players within the sharp pattern of the court. (Courtesy of the photographer)

Figure 4.2

Untitled.

Charles Saus.

The Plus X Pan 35mm negative was deliberately overexposed two stops from the indicated average meter reading and the negative underdeveloped 30% compared to the manufacturer's recommended time. The combination of the long exposure and short development produced a negative with good shadow detail and translucent highlight details in the white wall and window, which printed easily on contrast grade 3.

(Courtesy of the photographer)

TABLE 4.1 **Enlarging Equipment**

Standard darkroom equipment plus these items:

Magnifier to study contact proof sheet and negatives Easel to hold printing paper on baseboard Sheet of plain white paper for focusing Camel's hair brush, or Dust-Off

Focusing magnifier for enlarger

Cardboard, masking tape, stiff wire, and scissors to make dodging and burning tools These items are now standard darkroom equipment.

Prepare the Darkroom

When working in the darkroom, it is better to have only the chemicals and equipment actually needed out on the working space. This prevents damage by inadvertent spills to lenses, films, and papers. Remember that photographic materials will be damaged by even momentary exposure to ordinary room lights. Turn on the safelight and turn off the white light before opening paper packages.

The clothes you wear will affect your printing. Dust control is always a problem when enlarging small negatives. Synthetic fabrics generate large electrostatic charges, so it is best if you wear cotton clothes when handling negatives or making prints. In the same way, be sure your enlarger is electrically grounded, which will help minimize dust on negatives. Almost all darkroom preparations are the same for making the enlarged print as were needed for making the contact proof print. Standard darkroom equipment is needed. Set up the darkroom trays for printing. It is best to use the same kind of photographic paper for the enlarged print as for the proof print because exposure and contrast estimation can be made from the contact proof when the same kind of paper is used.

a.

Figure 4.3a. A proof sheet with the selected picture circled.

b. An enlargement of the picture in part a.

b.

Choose a Negative

Find a frame of film that interests you, and which also has good printing possibilities. Use the contact proof sheet to help you decide which negative to enlarge. When first learning to print, you might wish to consider the following when choosing a negative:

- · sharpness of focus
- · correctness of exposure (adequate shadow detail)
- · correct development (translucent highlights)

None of these are *necessary* for an interesting photograph, but when beginning to print, the choice of a correctly exposed and developed negative will make learning and understanding printing controls easier.

Contact Proof as Exposure Meter

A well-made contact print is a useful exposure guide when making an enlargement. Compare the contact print of the negative you have chosen to print to the other frames on the proof sheet. Figure 4.3A illustrates a typical proof sheet; the picture to be printed has been circled in white. Note that the adjacent pictures go in opposite directions, making it more difficult to choose a negative.

Figure 4.4
Removing surface dust by blowing it off. It is very important to keep the pressurized container vertical, and to avoid touching the image area of the negative strip with your fingers.

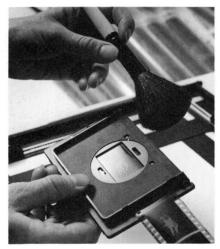

Figure 4.5Dust can be seen easily in the light of the enlarger lens and removed by using a soft brush.

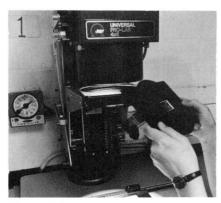

Figure 4.6Negative in a negative carrier, ready to be inserted in the enlarger.

Print exposure is determined by highlight details in the negative. These will print as light, textured gray values in the print. In figure 4.3A, the contact proof images have detail, and have the sense of being light and open. This means the exposure for the contact proof was correct, and the proof exposure time (fifteen seconds at f-11 for this picture) can be used for a trial enlarged print.

Examine the dark shadow areas in the proof. When a correctly exposed and developed negative is printed on a normal contrast grade of paper, there will be *some* detail in the shadows, but the shadow areas will be a little less dark in the contact proof print than in the enlarged print. Since the circled print in figure 4.3A has about the same values as any other on the page, and since it has adequate shadow detail, one can assume that the trial exposure for a full-frame enlargement on an $8'' \times 10''$ sheet will be about the same as the contact proof print exposure. In fact, the enlarged trial print shown in figure 4.3B was printed at the same exposure as the proof.

Making a Print

Remove the negative you are going to print from its protective sleeve, holding it by the edges. Turn the enlarger on and use the light coming through the lens to examine both sides of the negative for dust. Dust on the negative will make shadows that appear as white spots in the enlarged print. Use a soft brush or compressed gas to blow off the dust.

A cautionary note: when the enlarger is turned on and the negative stage open, light spills out, which might fog paper in your work area. Fog is non-image exposure of the photo emulsion, caused by light and heat. To avoid this risk, lift the enlarger head, place the carrier and negative onto the negative stage, and close the enlarger before turning it on.

Place the negative in the negative carrier, emulsion toward the paper. The carrier allows only light passing through the negative to reach the enlarger lens and will hold your negative flat during printing. Masking unwanted light from the lens reduces the flare of unfocused light within the enlarger, and helps make a sharper, more contrasty print.

Turn on the enlarger and center the printing easel on the projected image. Whether your easel is black or yellow, a piece of plain white paper in the easel will assist focusing. Raise or lower the enlarger head until the full frame of the negative is seen on the paper easel. Gently open the lens to full aperture, and carefully focus the negative.

You may wish to use a focusing magnifier to focus on the grain, which is the clumps of silver particles that form the image in the negative. Frame the negative image on the enlarging easel. For your first print, use the entire negative area, without cropping or eliminating any of it.

Trial Exposures

There are two different traditions of making test prints. One way is to use the contact proof sheet exposures as a guide and proceed directly to a trial exposure. A second way is to expose a trial print in bands or strips. These test exposures require making a guess about the exposure, and they range from too little to too much exposure for the print. The first method uses the contact proof as an exposure guide: set the enlarger lens to the aperture that was used for exposing the contact print, and set the enlarger timer to the time used to make the proof. Under safelight only, open the package of printing paper. Put a sheet of the same printing paper used for the proof sheet in the easel, with the emulsion side toward the enlarger. Use the timer to turn on the enlarger and expose the paper.

HEALTH HAZARD

Pressurized containers must be handled and used with care. Never puncture one, and dispose of them carefully when they are used up.

Both Dust-Off and Dust-Away contain hexane and either dichlorodifluoromethane or chlorofluorocarbon, gases used in refrigeration systems. If released quickly, these can cause damage to skin, due to freezing.

All gases under extreme pressure chill as they expand to normal atmospheric pressure. The gas in these containers has been pressurized until it is a liquid. If a container is tipped so that the liquid is released onto the skin, freezer burns may result. The negative can also be damaged by the liquid.

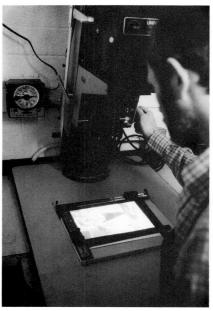

Figure 4.7The enlarger is adjusted to produce an image of the desired size on the enlarging easel.

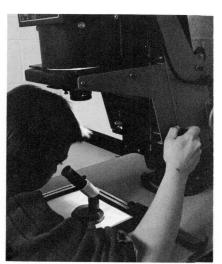

Figure 4.8
A focusing magnifier can be used to adjust the lens for maximum image sharpness.

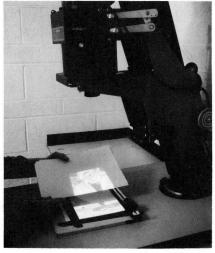

Figure 4.9
The enlarged proof is exposed a section at a time by moving a piece of cardboard every 3–5 seconds, uncovering a 2–3 inch strip each time.

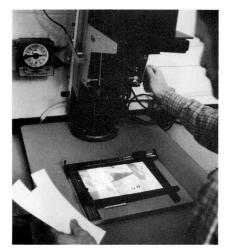

Figure 4.10
An alternative way of determining a trial exposure is to expose test strips, one at a time.

Making an exposure strip test can be used to establish exposure for any negative, whether it has been proofed or not. Focus the negative and set the enlarger lens at f-11. Place printing paper on the easel. Before the enlarger is turned on to expose the test paper, mask off three-quarters of the test strip with a piece of cardboard (as shown in figure 4.9). Expose the uncovered area for five seconds. Without moving the printing easel, move the cardboard until half the strip is uncovered. Repeat the exposure. Uncover another fourth of the strip, and repeat the five second exposure. Finally, uncover all of the strip, and repeat the exposure. The strips have been exposed for 20, 15, 10, and 5 seconds. One of these strips will probably show reasonably correct densities. If your negatives are much more dense, a larger lens opening will have to be used. A variation of this test is to expose two- or three-inch wide strips of paper, one at a time. Place them on the easel so that each captures the same important light, middle-gray, and shadow tones (sky, textured highlights, important skin tones, and shadows). Expose each strip for 5, 10, 15 . . . seconds. Develop the strips together for 1 1/2 minutes.

Figure 4.11

Untitled.

Arnold Gassan.

The reflection of a Georgetown, Colorado, volunteer fire company tower in the antique glass window requires subtle dodging to retain brilliance, while the surrounding sandstone must be burned in from the top of the frame for a more even value. (Photo by the author)

Develop the Test Prints

The test prints are developed just as the contact proof sheets were developed. After fixing the print, wash it in running water to remove the surface fixer, squeegee the water off, and examine it in white light. Do not try to evaluate the exposure or contrast of a print under safelight. Because wetting temporarily thickens the gelatin emulsion, the wet print looks more glossy, contrasty, and lighter than the same print will look when it is dry. This change is called **drying down**, and it takes much experience with printing, and with different papers, to predict how much change will appear. Test prints can be dried with a blow dryer to speed up evaluation.

TABLE 4.2 Exposure and Contrast

Examine highlights first:			
Highlights	Problem	Correction	
Dark	Overexposure	Close aperture or decrease time	
Light	Underexposure	Open aperture or increase time	
	If highlights are correct	, examine shadows:	
Shadows	Problem	Correction	
Dark	Excess contrast	Use lower filter or lower contrast paper	
Gray	Low contrast	Use higher filter or higher contrast	
		paper	

The correctly exposed and developed wet print will have only a trace of detail in highlights. If you can see full highlight detail in the wet print, it is already overexposed and the dry print will appear gray: what were sparkling highlights will dry too dark. Shadows in wet prints are often richly detailed, and have a lustrous black-on-black quality that is lost as the print dries. Shadow details merge in the dry print. The correct wet print looks a bit "thin" and a bit "flat." Complete the fixing and washing if you wish to keep the test print after you have examined it in white light; otherwise, throw it away. Never dry partially processed prints; the chemicals they contain will contaminate print dryers and cause later prints to be stained.

Making the Enlarged Print

Examine the first enlarged test print or the exposure test strips to determine a trial exposure. You often find that none of the test exposures are exactly right—the picture you want to see lies between the tests. Table 4.2 outlines the procedure to use between the exposure test and the enlarged print. Examine the highlights first to determine correctness of exposure, then examine the shadows to decide if contrast is correct.

Until you have a lot of experience, you do not know how much change in value will result from changing an exposure, and a small correction may not be enough. Correct exposure errors efficiently by attempting to make an opposite error on the second print. If the first is too light, deliberately attempt to make the second too dark. If successful, the third exposure can be easily gauged by studying the first two. In the same way, if the first print is too dark, try to make the second too light. Deliberately trying to make an opposite error is called **bracketing**; it shortens the path to accurate printing. A third print should have good highlight values.

Examine the highlights first; if you decide the print is too light, then increase the exposure. If it is *very* light (as in figure 4.12A), increase the exposure a full stop by opening the aperture to the next number (or by doubling the exposure time). When the highlights are too dark, decrease the exposure by a stop. When negatives are correctly exposed and developed to fit the lighting on the subject, they should produce adequately detailed shadows in the print when printed for correct highlights (as in figure 4.12B). Shadow values in the print are determined by the contrast of the negative and the contrast grade of the paper. When shadows are gray, increase print contrast by using a higher contrast grade of paper or by using a higher number filter. If the shadows are fully black, but lack any detail, use the next lower filter, or the next lower contrast grade.

- **Figure 4.12**a. First trial print. The print was developed for one and a half minutes. The exposure is about a full stop light.
- b. Second print. The exposure was increased a full stop and the development time kept the same.
- c. Contrast has been increased by extending developing time to three minutes. Some darkening of the perimeter of the picture was done by a one-stop burning-in. The right edge of the picture has been cropped to enhance the composition.

b.

Figure 4.13
Loch Shetland.
A.J. Meek.
A moderate wide-angle lens was used to capture this landscape in Scotland. The twillight sky produced the subtle gray values.
(Courtesy of the photographer)

The exposure will vary slightly from one paper grade to another because the paper emulsions have different sensitivities (indicated by the ISO number on the package). You may have to make a new exposure test for the highlights if you change from one contrast grade to another with either variable contrast or graded papers, though llford and Kodak variable contrast papers now have approximately the same printing speeds for filters 1–3, and require a stop increase for filter grades 4–5.

Examine the image, make whatever corrections you think might help, and then make a final print (as in figure 4.12*C*, where the picture has been cropped, the corners darkened, and the contrast increased slightly by extending the developing time to three minutes). Before developing a print, use a soft lead pencil to write the exposure (aperture and time), filter number or contrast grade, and developing time on the back. This information will save you having to repeat the investigation when you want to remake the print.

Evaluate the Prints

Dry the prints, examine the overall patterns and the gray values you have created, and ask yourself how changing the values might clarify the meaning of the picture. You can make individual parts of the print lighter or darker during printing. Study the contrast of the enlarged print. Beginners tend to make pictures that are very contrasty or very flat. Too much contrast often makes a picture look harsh, when a soft, luminous darkness is actually desired. Prints that are overall gray show all the details but are dull. A print may need only two or three well-placed values to be complete, as illustrated by figure 4.13.

Figure 4.14

a. A straight print, without dodging or burning, on contrast grade 3 paper.

b. A straight print, printed on contrast grade 4 paper.

а

h

Print Contrast Control

Large changes in print contrast are made by changing grades of paper (as can be seen in figure 4.14*A*, printed on contrast grade 2 paper and figure 4.14*B*, printed on contrast grade 3 paper). When using fiber-based papers, more subtle changes can be produced by varying developing time, or using a different developer. Print contrast can be decreased in any of the following ways:

- · developing for less than 30 seconds (RC paper)
- · diluting Dektol 1:3
- · diluting Hobby-Pac Paper developer in 40 ounces of water
- · using Kodak Selectol Soft

Figure 4.15
Untitled.
John Kuntz.
Simple dodging and burning were used to make this composite picture. An eye-shaped area in the water was held back, or dodged out, during the first exposure. The image of the eye, from a second negative, was burned in during a second exposure, in which the rest of the print was carefully kept from the light.
(Courtesy of the photographer)

Contrast can be increased by:

- developing longer (up to 4–5 minutes)
- using Dektol full strength or diluting it 1:1
- · diluting Hobby-Pac Paper developer in 20 ounces of water

Developing time (for fiber-based papers) can be decreased to as little as one minute to decrease contrast, or increased to as much as four minutes to increase contrast. The risks associated with shorter times are uneven development and washed-out, watery shadow values. With extended development, there is an increase in contrast, and a risk of graying the highlights, frequently due to safelight fog.

Printing Controls

Parts of a print can be made darker by **burning-in**, and made lighter by **dodging**. Burning-in an area means using a mask to add image light to the print before or after the overall exposure. Burning-in requires a mask with a hole for the enlarger image to pass through. The mask used for burning-in may be a piece of cardboard, or it may be your hands, shaped to cast a protective shadow on the rest of the print.

Dodging an area of the print means to hold back light from a part of the picture for a portion of the overall print exposure. Your own hand is a wonderfully flexible dodging tool, capable of assuming very intricate shapes. Dodging tools are often made of circular or oval pieces of cardboard taped or glued to handles of stiff wire. A dodging tool may be as small as a dime or as large as the print itself. The handles should be long enough to easily reach the middle of the picture.

Dodging and burning-in are traditionally used to achieve subtle control of local values and avoid obvious changes in the print. Too much burning-in produces obvious gray tones, values that have nothing to do with the picture. Clumsy or excessive dodging will also be quite obvious. But dodging and burning-in can be used to change the image completely if you desire. Figure 4.15 is an example of creating an entire new visual reality by combining two separate negatives on the same print through careful dodging and burning-in.

Figure 4.16
A dodging tool can be assembled from a piece of cardboard taped onto stiff wire and used to hold back light during the exposure.

Figure 4.17
The hand is a convenient dodging tool—it can be shaped to create a suitable shadow.

Figure 4.18
Burning-in can be controlled by using an opaque sheet of paper with a hole cut in it.

Figure 4.19Hands can be joined to form a variable aperture for burning-in an area of the print.

Figure 4.20

a. The full-frame negative has been proofed on contrast grade 3 paper in exposure strips of 5 seconds (i.e., the lightest area exposure is 5 seconds and the darkest is 20 seconds). The print was developed for 1 1/2 minutes.

b. After examining the enlarged proof, a trial exposure of 15 seconds was selected and a "straight" print made on contrast grade 3 paper (with no dodging and burning). The print was fixed, rinsed, squeegeed, dried, and examined. It was felt that the grays at the top and bottom were too light, and the vertical rock in the center a little dark. c. The overall, or primary, exposure was increased to eighteen seconds, but a small dodging tool (about the size of a dime) was passed constantly across the center, pausing briefly at the vertical rock at each pass. The photographer's hands were used to burn in the upper gray band and then to burn in a strip along the bottom for a full

stop (an 18-second exposure).

a.

h

C.

Expose and Develop an Enlargement

Discussion and Assignments

The silver print can be a very beautiful object, but it is also easily damaged by rough handling and improper chemical treatment. What constitutes a "good" print is always a decision based on tradition and experience. Seek out galleries or museums in your area that display prints by master photographers and see how they solved problems of contrast and print color.

Assignment 1 Choose a negative of your own that you like and that has interesting detail in both the dark shadows and the bright, highlighted areas (such as white shirts, or light-colored hair in the sunlight). Carefully make the best $5'' \times 7''$ print you can on your normal contrast paper grade.

Make careful prints on the next higher and lower contrast grade paper, printing in both cases for good detail in the highlights (without letting the print get "dirty" or gray-looking). Dry these prints and examine them. Decide which you like best.

On the basis of the contrast test, buy or borrow some "warm tone" paper (Agfa Portriga Rapid, or Oriental Center, for example) of the correct paper grade. Print the same negative on this paper. Trim away the white edges and place all four prints together on a clean, neutral white mount board. In a comfortable light, examine the prints slowly and carefully and decide which you like best and why you like it best.

Assignment 2 The photograph is a record of the light, not of the object in front of the camera. Investigate this by photographing three different objects in three different lights. The kinds of light you can easily find are controlled by direction of the light toward the subject:

- · front light
- · side light
- · back light

and by quality of light:

- · diffuse (soft shadows)
- · direct (harsh shadows)

Assignment 3 The photograph can be composed in the camera or in printing. This assignment is an investigation of alternate ways of seeing. Regardless of the subject of your picture, after you make the first picture, make these pictures on the following frames of film:

- rotate your camera 90° (from vertical to horizontal, or horizontal to vertical) and re-examine the same subject
- recompose the picture so the subject is no longer in the center, but is at one edge of the frame
- move closer to the subject so that it must be recomposed in the viewfinder
- move closer again and find three significant details from within the original picture

5 Finishing Prints

Figure 5.1
SLOAN SISTERS, 1930s.
Jean Thomas.
A documentary photograph of three musical young women photographed against a background of a zig-zag rail fence in the Kentucky hills. This kind of informal, personal document remains the most popular kind of photograph.
(University of Louisville Photographic Archives)

Figure 5.2
Untitled.
Gail Fisher.

This is an example of a pattern photograph, which also illustrates how the use of a black framing line, produced by a special negative carrier that reveals the entire negative plus a bit of the surrounding, unexposed negative, can enhance a picture.

(Courtesy of the photographer)

Examine the Enlarged Proof

A full-frame enlarged print invites evaluation of your photographic system:

- · negative exposure and development
- · print exposure
- · print contrast
- · dodging and burning
- · framing and cropping of the picture

Print and negative handling problems may also appear:

- · water spots or stains from chemicals
- · creases from handling
- · fingerprints
- · dust spots

Print cropping and dust spots can be corrected after the print is made; the other errors will require remaking the print.

TABLE 5.1

Spotting and Mounting Equipment

Spotting colors

Spotone (available in three-color sets or by the bottle; #3 is a good match for most contemporary papers)

Spotoff (for removing black spots on prints)

Windsor & Newton tubes of white and black watercolors

Spotting brush: Windsor & Newton #000 Sable

Xacto knife Utility knife

Steel straightedge

Plastic triangle (10", 45° or 30-60°)

Mounting materials:

Seal Dry Mount Tissue (requires heated press)

3M Photo Mount Spray Cement

rubber cement and thinner

These items are now part of standard darkroom equipment

Negative Faults

An unmanipulated, full-frame enlarged proof print helps in discovering most negative development problems. These include:

- irregular densities near the edge of the frame. These are usually caused by improper agitation and can be avoided by changing the agitation pattern.
- pinholes (small black spots in the print). Sometimes caused by airbells if the developer does not immediately wet the negative, but more often caused by inadequately dissolved sodium sulfite when powdered developers (D-76, or FG7 with added sulfite) are used.
 Sulfite dissolves poorly below 110°F, and partially dissolved sulfite in solution etches tiny holes in the silver during development.
- scratches on emulsion or support sides of the negative. Short, intermittent scratches usually are caused by dirt on the squeegee or wiping sponge when the negative was dried. Long, straight scratches extending over several frames are usually the result of dirt in the camera or the lips of the film cassette.

The Damaged Print

All negative densities cast shadows on the print, creating an image, but some densities are unwanted. Dust is the most common problem. Cleaning the film will not remove dirt or dust embedded in wet emulsion. Dust often clings to the dry film because of electrostatic attraction. This dust can be brushed or blown off before reprinting, although the white spots can also be repaired on the print.

Water droplets that dry on the negative also create density variations and white marks on the print. If the water spot is on the support side, it can often be removed with film cleaner and the print remade. Water spots on the emulsion side are permanent, but if not too extensive, they may be spotted out on the print.

Spotting Prints

Small white or black spots can be retouched without remaking the print. Spotting colors are used to paint a correct value on the print. Spotting makes a blemish inconspicuous, but it is rarely possible to hide the blemish entirely. Repairs can usually be seen when the print is held at an angle and examined by reflected light. In most cases, repairing a marred print requires remaking it.

Finishing Prints 57

TABLE 5.2

Printing Problems

Problem	Causes	Cure	Discussion
Small white spots on prints	Dust on negative	Use spotting brush to paint dyes on emulsion	Dusty negative drying area; sediment in wash water; failure to sponge negative; failure to wipe or blow dust off negative before enlarging; dirt in enlarger head (on the condenser lenses); enlarger not grounded; wool or polyester clothes worn when printmaking.
Irregular, blotchy gray areas	Water spots on negatives	None	Wetting agent not used; negatives not sponged; water drops allowed to dry on film.
Streaky, gray, or mottled print shadow areas	Uneven, short print development	Remake print	Agitate print vigorously; develop at least one minute
Gray edges of paper outside image area on print	Fogging	Remake print	Paper exposed to white light from open enlarger head; development too long; excessive exposure to safelight; white light turned on before print was fixed; paper old or storage temperature too high.
Fingerprints	Touching negative Fixer or developer on hands when touching print	Cleaning negative with film cleaner may help; wash hands, use clean darkroom towel and remake print	Skin oils etch film base: clean negatives promptly after they are touched. Wash hands frequently and use a clean darkroom towel. Brown stains result from developer, white fingerprints on prints are caused by fixer.
Brown or yellow stains	Exhausted stop bath Long development in exhausted developer Exhausted fixer Dirty drying racks Spilled chemicals	Use fresh chemicals Clean hand towel Wash all prints thoroughly Keep darkroom clean	Image color changes with developer exhaustion; chemical spills must be cleaned up immediately; exhausted fixer leaves silver and sulphur compounds that will not wash off but will discolor the print; drying racks must be kept clean of all chemicals.
Negative sharp, print not sharp	Negative "popped" from heat Enlarger head moved Enlarger bumped	Check focus just before printing; do not lean on enlarger table	General blurring often is caused by enlarger heat, which expands the negative so that it bows out of the plane of focus in the negative stage; a smeared or double image is caused by the enlarger table being moved during the exposure.

The equipment needed for spotting a print is shown in figure 5.3A. Start spotting the darker areas and continue with lighter areas until you reach highlights. Work on a flat print in a strong light that makes all defects visible. A protective cover sheet (an old print) is useful to avoid fingerprinting the emulsion (as shown in figure 5.3B). Clean, dry hands are a necessity, and cotton film-editing gloves will be needed if you have damp skin. You may wish to use a magnifier to see the details of the print.

Spotone and other spotting dyes penetrate the emulsion and are permanent. Test the spotting solutions on the white border of a throwaway print (of the same type of paper) to match dye value and color against the area to be spotted. Start by spotting the darkest areas. The dye will darken slightly as it dries. The spotting dyes can be used either with a full brush, and a bit

Figure 5.3

a. Spotting dyes and a very fine brush are needed to spot a photograph. Water should be used to thin the dyes, and a magnifier is often needed to spot fine lines in the print. b. A sheet of paper is used to protect the surface of the print from being spotted from skin oils.

a.

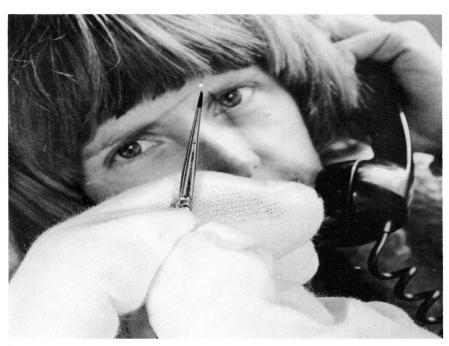

b.

of dye placed carefully in the center of a dust spot, or with an almost dry brush, and the dye laid in a crosshatch pattern. Spotting is a kind of painting and you will need to experiment.

The shape of the spot affects how visible it is, and also the technique needed to disguise it. If it is a wriggly line, try starting with a full brush and drawing a continuous line along the center, holding the brush parallel to the fault. Do not try to fill the line completely because it is easy to overspot, which may be as obvious as the original spot. For small, irregular areas, use less dye on the brush and stipple or cross-stroke the area. When you have worked with a difficult spot, wait until it dries, observe the results, and repeat if necessary.

Figure 5.4 Untitled. Arnold Gassan.

The running child was photographed in dim forest light. A Hasselblad camera, 150mm lens (1/30 at f-4) and Tri-X film were used. Note the shallow depth of field created by the long lens and the large aperture. Moderately high contrast is used to isolate the figure. (Photo by the author)

Black spots on fiber-based papers may be chemically removed by using Spotoff, or by etching the spot—stroking the surface with a sharp blade. This actually shaves away the emulsion and silver and requires practice to be successful (i.e., to reduce the value without visibly scarring the print) and it is very difficult on RC paper. Although watercolor pigments have a slightly different reflective surface, painting out black spots with opaque gray pigment is usually more easily done than etching them out, on either fiber-based or RC paper.

Crop the Print

Cropping is a way to make a picture more effective after the negative has been exposed and developed. In chapter 4, it was suggested that the entire frame of film be enlarged. There are three reasons for this. First, to help you learn *what* it is you are actually seeing when you press the shutter. Second, to help you discover negative development agitation faults, which often appear at the edge of the frame. A third reason is that the viewfinders of most 35mm cameras do not show all of the scene being photographed; only the most expensive professional cameras show you exactly what will be recorded on the film. Cropping the picture often intensifies the meaning of it by removing the unexpected edge image.

Make two L-shaped pieces of cardboard about three inches wide and with sides at least as long as the print. Lay them over the enlarged print to make a rectangle of varying proportions. Figure 5.5A shows a full-frame print, and figure 5.5B and 5.5C show other possible croppings. Cropping frequently reveals alternative photographic compositions within the detail the camera recorded.

Figure 5.5

- a. The full photograph as it was originally seen.
- b. Using cropping Ls, a different relationship can be constructed between the model and the shapes of the antique pitchers.
- c. Extreme cropping reduces the picture to portrait with a background pattern of the window frame and the paired pitchers.

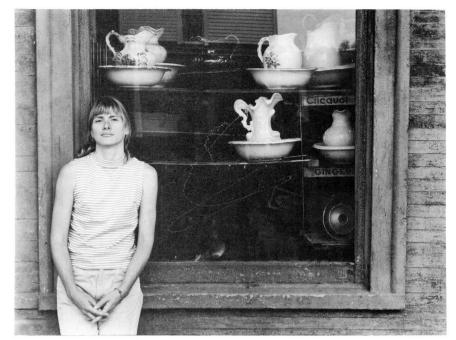

а

b.

C.

When you have found a useful composition with the cropping L's, use a sharp felt-tip pen to make a small mark just inside the corners of the L's to show where to cut. Physically crop the print, cutting it with a sharp mat knife and a metal straightedge (which makes a cleaner cut than most print cutters). Never cut a print lying on an unprotected table. For a very neat edge, trim the print on a plastic cutting mat, or on a piece of thick cardboard.

HEALTH HAZARD

Rubber cement and rubber cement thinners often contain toluene and other carcinogenic solvents. Both rubber cement and solvents are also very flammable. The chemicals should only be used in a well-ventilated space, and skin contact must be avoided.

Scotch Photo Mount spray adhesive contains hexane, acetone, and alcohol; all are neurotoxins. The propellant is propane, a liquified gas commonly used as fuel in portable heaters. Pressurized containers must be used with care as both the contents and the packaging have dangers. When the contents are used up, the cans are still dangerous, and must be disposed of carefully. Never puncture an empty spray can or put one in a fire. Avoid breathing vapor and overspray (the airborne adhesive mist). Spray only in well-ventilated spaces. Wash adhesives from skin with soap and water. If your eyes are exposed to the spray, wash thoroughly with water for ten minutes and see a physician.

Mount the Print

Dry-mounting the finished print is outlined in detail in chapter 14, but even trial prints need to be mounted flat in order to be seen correctly. A glossy print reflects light like a mirror. Reflections from a print weaken the shadow areas. Mounting a print holds it flat, and presenting it on a larger board isolates it and enhances its beauty.

There is no point in using expensive low-acid board for study prints; instead, use mounting board, which is more economical. When a full-frame 35mm is negative printed onto a sheet of $8'' \times 10''$ paper, the final trimmed print is no larger than $6'' \times 9''$, and will fit comfortably onto an $11'' \times 14''$ mount. Standard-size boards ($8'' \times 10''$ and $11'' \times 14''$), in white, cream, gray, and black surfaces are available at art or photo supply stores. The color of the mat board is important. The neutral white board is the least distracting. Black boards are frequently used by photojournalists, because the black border was found to make contest prints "pop" when hundreds of photographs were being reviewed in professional competitions. A black board also will generate an edge for a poorly composed picture.

There are several economical ways to mount dry prints, including photo corners, cement, and dry mounting. Photo corners have been popular for many years; unfortunately, the cheap black paper corners used in scrapbooks contain chemicals that will damage the photograph's silver image. Better quality corners are now available in white paper or clear plastic, and these are suitable for permanent print presentations as well as mounting study prints.

Lay the trimmed print on the mat board and move it around to discover where you want it to be. When satisfied with the placement, make light pencil marks at corners of the print to help position it when mounting. Photo corners can be glued or taped in place and the print slipped into them.

Prints may be cemented to mount boards with rubber cement, 3M Positionable Mounting Adhesive, or Scotch brand Photo Mount, a spray adhesive. None of these adhesives are recommended for longevity, but each are convenient for study print mounting.

Rubber cement contains sulfur compounds that will eventually destroy the silver print, so it should not be used for mounting pictures that must last. For best results, the rubber cement should be about as viscous as egg white. The cement in the can or jar is usually too thick to spread easily and it should be thinned. Pour some thinner into the jar with the spreader brush, screw on the lid and agitate until the thinner is absorbed. Place the print face down on a sheet of clean newsprint and paint the back with rubber cement. Put the mat board on a firm, clean working surface. Carefully paint rubber cement on the area of the mount board that the print is to be placed. Wait until the rubber

cement no longer looks wet on either the print or mount board, then place the print on the mount. Cover the print with a sheet of clean paper and, working from the center out, press the print firmly onto the board. Rubber cement on the board or at the edges of the print can be lifted without damage, by using a square of pure gum rubber, available at any art supply store.

When using spray cement, place the mat comfortably near where you are spraying the print, but safe from adhesive overspray. Protect your work area with sheets of newspaper. Place the print to be mounted face down on the newspaper. Hold the spray can about six inches from the paper and spray across the print and past it to avoid too much spray at the print edge. A single layer of adhesive is adequate for small prints; for a heavier bond, spray a second coat at right angles to the first.

Place the print carefully on the mat. Once the print touches the mat it cannot be moved. Put a sheet of clean, white paper over the print to protect it and apply pressure from the center out to the edges, using a rubber roller or the palm of your hand.

3M Positionable Mounting Adhesive is a mildly sticky sheet (sold only in a roll) that adheres to the back of the print. A protective sheet is removed from the mounting tissue just before the print is positioned on the mount board. A rubber roller is used to press the print to the mount and bond it permanently.

Reexamine the Print

Study your print in normal room light as well as under bright work lights to see what you have made and also to discover what might be changed. Ask yourself these questions:

- · do highlight areas have detail?
- · do shadows have detail and solidity?
- · is the contrast appropriate?
- · what areas need dodging?
- · what areas need to be burned-in?
- · what more could be cropped?
- · is the picture what I wanted?

Asking these questions completes the photographic cycle that began when you saw a possible subject for a picture. This cycle continued with framing the subject in the viewfinder, choosing an exposure, developing the film, making a print, and concludes with your assessment of what was done. On the basis of this assessment, you can now begin again by returning to a similar subject, bringing the experience of seeing how the camera changes reality to your photography.

Each step in this cycle can be modified. The type of camera used will change a photograph in many ways, as will the film and the way it is developed, resulting in variations in contrast, grain, and tonal separations in shadows or highlights. There are also major differences between papers. Finally, the size of the print, toning, mounting, and presentation each modify the meaning of each picture you make.

Store the Print

Safe storage is needed for proof sheets, work prints, finished but unmounted prints, and final prints. Prints are easily scratched and creased, and the silver in the print will be contaminated and eventually destroyed by acids found in all cheap paper. Print storage boxes must be kept in moderate temperatures and humidity. Do not store photographs where temperatures are above 80°F

Finishing Prints 63

Figure 5.6 Plastic print storage bags and acid-free boxes provide storage that protects the print from dust, moisture, and insects.

or humidity is high, e.g., in attics or basements. Proof sheets and negatives can be kept together in three-ring binders or archival plastic storage boxes with rings. The boxes and black plastic bags in which photographic paper is sold provide economical storage for unmounted prints. More elegant storage for finished prints is provided by acid-free storage boxes, sold by several manufacturers (see appendix 4). Prints should be stored flat and may be kept in plastic sleeves or interleaved with acid-free paper.

Discussion and Assignments

Understanding the content of a picture involves discovering what pictures are hidden within it. The print's surroundings are also an influence on its content. Meaning is affected by the context and arrangement of pictures. The finishing of a print includes not only spotting and mounting, but sequencing or arranging a group of pictures.

Assignment 1 Perform the following exercise for an entire roll of film:

- · see the picture you want to take, and expose the film
- immediately, turn your back on the subject and make a simple outline sketch, indicating carefully the composition of the picture you had made
- turn back to the subject and compare your sketch to the subject.
 You may wish to remake the picture to fit the sketch.

Assignment 2 Make three identical prints of a picture. Mount each one on a different color of mounting board: one a flat, hard white, one off-white, and one black. Over a period of several days, examine the pictures and see which one you liked at first and which one you like after a lapse of time.

Figure 5.7
Untitled Tintype.
Photographer unknow

Photographer unknown, ca. 1870. The tintype was a cheap, popular photograph from 1852 until the early 1900s. It is a byproduct of the collodion, or wetplate, process. Black lacquered metal was coated, sensitized, exposed, developed to high contrast, fixed, and washed in one continuous process. The resulting dense silver negative image looks pale gray against the black lacquer, producing a unique positive image. Note the painted backdrop and the frame, which braced the men so they could stay still for the exposure of 20 seconds or more.

Assignment 3 Bring together five or six prints and put them on a print rail or some other convenient place in line. Look at them in terms of relationships that are formed from one to the next or the implied narrative (the story line that develops as you look at the pictures). Write a brief outline of the relationships you have discovered. Pick up the pictures and shuffle them as though they were a deck of cards. Put out a new sequence of pictures and repeat the analysis. Note how the apparent content of any one picture is the product of its interaction with neighboring prints.

Assignment 4 Make four prints of a complex, interesting scene. Use cropping L's to see a picture, then physically trim the print. Repeat, finding a different composition with a different meaning. Mount all four prints and make a comparative study.

Assignment 5 Take a walk in an area that you think you might find photographic subjects. Make a picture. Immediately turn around 180° and without moving find and make another photograph. Repeat this over a period of a day or two, or however long it takes to complete the roll.

Finishing Prints 65

Figure 6.1
ELIZABETH FLETCHER, ca. 1910.
Kate Mathews.
A view-camera photograph of a bride, made by a female photographer who documented Kentucky community life from 1885 to the 1920s.
(University of Louisville Photographic Archives)

Figure 6.2
Untitled.
Laura Shagory.
A 300mm lens was used to photograph the person in a wheelchair on the jogging track beside the campus. The long lens flattens space and creates a dramatic and graphic background.
(Courtesy of the photographer)

Basic Camera

The contemporary small camera is a very distant descendant of the **camera obscura**, or darkened room with an image-forming lens in one wall that projected an image onto another wall. The small camera permits the photographer to use the camera in hand, rather than locked onto a tripod, to produce pictures of a quality rivaling those made by a view camera. Today's camera has motorized film advance, interchangeable lenses, automated aperture, and electronic shutter to control exposure, and a light metering system with programmed controls for both shutter and aperture.

The Lens

A lens consists of curved glass. As light leaves air and enters glass, it moves more slowly. A ray of light entering glass at an acute angle is bent. The curvature of the lens and the kind of glass used determine how the light will bend. Light coming from a great distance appears to travel in parallel lines, and a well-made lens will bend parallel rays of light so that they meet at a common point in a plane, called the **focal plane**. The distance from the optical center of the lens to the focal plane is called the **focal length**. For example, a lens that brings objects at a thousand yards into sharp focus when the lens is four inches from the film would be said to have a focal length of four inches.

Field of View

Early in photographic history, it was generally agreed that a lens field of view of about 38° was **normal.** This angle of view approximates the sharp area in focus when staring straight ahead with one eye closed. The normal focal length lens for any given film size is approximately the same measurement as the diagonal of that film format. A 35mm film frame measures 24×36 mm, with a diagonal of about 44mm, and the normal lens for a 35mm camera is 50mm. The normal lens for a 6 \times 6cm camera is 80mm.

Lenses with many fields of view other than "normal" are popular. A **wide-angle** lens is one that accepts light from an angle of more than 40°; modern wide-angle lenses have fields of view exceeding 90° (these are now commonplace and produce sharp images, with few obvious distortions). Lenses commonly available for 35mm cameras range from 18mm to 400mm, with both shorter and longer lenses available.

As the field of view of the lens increases, it becomes more and more difficult to avoid barrel distortion, in which parallel lines become convexly curved. Extreme wide-angle lenses, which have a field of view approximating 180°, are sometimes called **fisheye lenses**, because they present straight lines as circular curves.

The longer the focal length, the narrower the field of view (or, to put it another way, the shorter the lens the wider the field of view). Great magnifications of the subject can be produced by lenses with very long focal lengths. Lenses with simple long focal lengths have been replaced by telephoto lenses, which are complex lens systems that produce a magnified image but do not require a long barrel. A contemporary 400mm telephoto lens measures only about nine inches overall, yet if it were a conventional lens it would require a barrel about sixteen inches long.

Figure 6.3
Cropduster.
Ben Brink.
A 15mm lens was attached to the wing of the plane and triggered by an IR remote control. The very wide-angle lens shows a typical "fisheye" distortion in the curvature or the horizon.
(Courtesy of the photographer)

Figure 6.4 a. 24mm lens field of view.

b. 55mm lens field of view.

c. 105mm lens field of view.

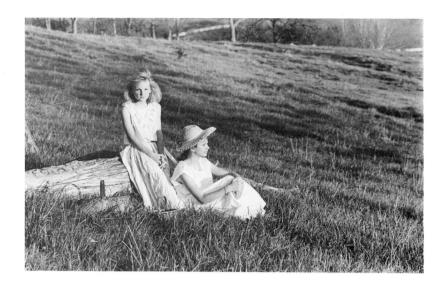

d. 180mm lens field of view.

e. 300mm lens field of view. (Photos by Chris Polydoroff)

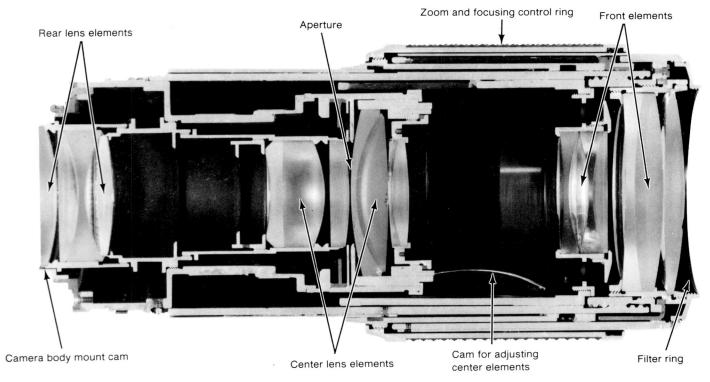

Figure 6.5
Cross section of a Nikon zoom lens.

Choice of Lens

The focal length of the lens controls angle of view and to some degree controls the apparent depth of space in the photograph. A long lens selects a smaller target area from the subject, and because the field of view is smaller, a long lens makes a picture with less vivid separation of near and far subjects. However, a photographer with a sensitive eye can produce photographs that enhance or minimize distance relationships with lenses of almost any focal length. Visual separation of objects at different distances from the camera is controlled more by composition, lighting, and value relationships, and by the aperture used, than by lens focal length.

Few photographers can afford all the lenses available for any given camera system. Most professionals now use a moderate wide-angle lens (either 35mm or 28mm) as the "normal" lens. As a rule of thumb, many professionals feel a 2:1 change in focal length is efficient and economical. Using this logic, supplementary lenses would likely be 18mm (half the 35mm), 80mm, 110–150mm, and 210–300mm. Much shorter (10–15mm) and much longer (500–1,000mm) lenses are available, but the price rises sharply for extremely long or short focal lengths.

Zoom Lenses

As a result of new glass technology developed in Japan after World War II, lens design changed dramatically in the 1950s. Computer-assisted design of lenses further accelerated the evolution of lens change, and one result was the production of economical and optically excellent variable-focus lenses. The effective focal length of the zoom lens can be continually adjusted by moving a sliding collar, producing the effect of lenses with different focal lengths. The internal complexity of a Nikon zoom lens is shown in figure 6.5. The position of the image plane remains reasonably constant, though zooming may require small adjustments in focus. Contemporary zoom lenses cover a wide range of focal lengths within a single unit, e.g., 28 to 85mm, or 70 to

Figure 6.6

Vesuvius.

Photographer unknown, ca. 1895.

A photograph made with a Kodak no. 1 camera, which had only an arrowhead printed on top of the camera as an aiming device.

210mm. The zoom lens permits you to have a wide range of focal lengths instantly available, although there is some loss of quality compared to a fixed focal length lens. Zoom lenses are made to cover a number of different ranges of focal lengths, but the 70–210mm lens has proven to be the most popular for professional work. This lens replaces at least two standard lenses, approximates the longest, and reduces both capital outlay and the physical effort of carrying extra lenses.

Viewing and Focusing

In one respect, large view cameras have not changed much since 1839, in that the photographer still hides under a black cloth and looks at the image projected on a groundglass. Viewing and focusing are parts of the same operation, since the photographer sees exactly what image the lens will make. The small camera has always depended on other viewing and focusing methods. Figure 6.7 shows a section through a typical 35mm camera, showing how the lens, reflex viewing, metering system, and shutter are placed.

Four different viewfinders have been widely used to help the photographer see what the camera will photograph. The most simple viewfinder is none at all, and that is what was provided for the first Kodak camera, marketed in 1889. The photographer pointed the camera toward the subject, aiming with an arrowhead imprinted on the top of the camera body. Despite this limitation, many wonderful pictures were produced. The wire *sportsfinder*, adapted from military gunsights, is a step above the Kodak arrowhead. A stiff wire frame is mounted on the front of this camera, and a locating post is mounted at the rear. Looking over the post and the wire frame, one sees approximately what the camera sees. Some sports and scientific cameras still use variations of this sighting device.

Figure 6.7Cross section of a 35mm single-lens reflex camera.

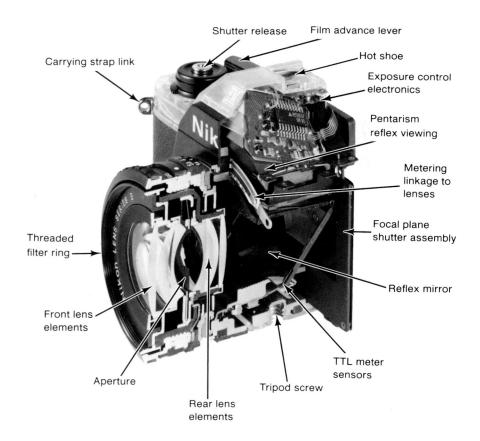

Optical viewfinders, which produce a *virtual* image (one that is not seen on a groundglass but exists only for the photographer's eye) are used on almost all simple cameras. Because there is no groundglass to absorb the light, the image is very bright. It is still used on the Leica, and was the standard for viewfinder for 35mm cameras until the mid–1950s. The serious limitation on virtual image viewfinders was that they did not provide focusing information. Initially, only the most expensive cameras included *rangefinders*, which were derived from military distance measuring devices. Most early 35mm cameras required one to guess at distances or purchase a supplementary rangefinder to measure focusing distance. Virtual-image viewfinders have found renewed popularity with *autofocus* controls available in many new cameras. The 35mm autofocus devices use infrared (IR) pulses that are directed toward the subject. The reflected IR controls small motors, which focus the lens.

A variation on groundglass focusing is found in the reflex camera. Introduced at the beginning of the century, this camera had a hinged mirror in the camera body that reflected light from the lens up onto a groundglass in the top of the camera. When the shutter was tripped, the mirror flipped up to cover the groundglass and uncover the shutter and the film. The mirror itself made the camera body lighttight. Figure 6.7 shows a cross section of a popular single-lens reflex camera, showing the lens, mirror, and shutter relationships. The reflex system was modified to use two lenses of the same focal length, one mounted directly above the other. One lens was for viewing, the other for exposing film. The twin-lens reflex camera was very popular for forty years, beginning in the 1920s. The lenses were attached to a common lensboard, so focusing one also focused the other. Twin-lens reflex cameras are still made and used for professional portraiture. The principal disadvantages of the twin-lens system are in the inherent parallax and lateral image reversal. Parallax is the compositional error created by the vertical spacing between the viewing and the taking lens, especially when photographing close to the subject. Image reversal occurred because the mirror corrected the vertical but not the lateral reversal of the image.

The 35mm camera did not become popular until the 1950s, when *pentaprism* reflex viewing and focusing, and lenses that could be interchanged were marketed. The pentaprism (a five-sided glass prism) fits on top of the reflex groundglass and corrects the left-to-right image reversal. The single-lens reflex camera excited both professional and amateur photographers because quick, precise focusing and viewing were combined. In the 1960s, TTL (through-the-lens) metering was added, as well as automatic electronic control of aperture and shutter.

Aperture

The amount of light a lens can pass is controlled by the aperture. The contemporary small camera aperture consists of several thin metal blades that overlap to form a calibrated centered opening in the lens system. Its purpose is to control the amount of light that can pass through the lens, and what part of the lens is actually used to make the image. The size of the aperture is usually set by an aperture control ring on the lens.

The actual brightness of the image made on the film is calculated by using the *f-number* of the lens. A lens that is six inches in diameter can obviously allow more light to reach the film than can a one-inch lens of the same focal length. In order to predict an exposure, one must be able to compare the light gathering power of a lens, regardless of its size. The f-number indicates the

Figure 6.8
Untitled.
Tom Roush.
A moderately fast shutter easily captures the gesture of throwing out a pail of water.
(Courtesy of the photographer)

ability of the lens to provide focused light on the picture plane, where the film will be placed. The f-number is the ratio of the focal length divided by the effective diameter of the lens.

$$f = \frac{\text{focal length}}{\text{diameter of lens}}$$

For example, a lens with a focal length of four inches is two inches in diameter, and the f-number would then equal 4/2, or f-2. But the whole area of the lens need not be used, and, in fact, is rarely used.

Lens numbers have been standardized; each of the following common fnumbers has a 2:1 ratio of light transmittance compared to an adjacent number:

f-1.1 1.4 2 2.8 4 5.6 8 11 16 22 32

This ten-stop range is rarely available on a single lens. Many 35mm lenses stop down only to f–16, though lenses designed for professional use may close down to f–32. Most contemporary lenses have *detents* in the aperture control ring, which physically indicate that one has moved from one f-number to the next, without having to look at the control ring. Almost all 35mm cameras now have automated apertures that remain fully open for maximum focusing screen brightness when the camera is being focused, "stop down" for an instant to control the light during exposure, then reopen to full aperture again immediately afterward.

Figure 6.9
Untitled.

Kim Hairston.
The narrow depth of field of a 300mm lens used at maximum aperture isolates the poster from the crowd.
(Courtesy of the photographer)

Depth of Field

Depth of field is defined as the range of distance from the nearest to the farthest subject from the camera that will appear acceptably sharp in a print. The depth of field is limited by the focal length of the lens, the aperture used, and the distance at which the lens is focused. The greatest depth of field available will always be when the smallest aperture is used on the shortest focal length lens. It should be remembered that the apparent sharpness of the image in the print is also affected by the grain of the film and the degree of enlargement: a fine-grain film and a 5" \times 7" print will produce a greater apparent depth of field than an overexposed and overdeveloped Tri-X negative enlarged to 11" \times 14".

The fact that the maximum aperture is used for focusing in single-lens reflex cameras is misleading, in that one does not see the actual depth of field used during the exposure. While the aperture controls the amount of light that can enter the camera when the shutter is open, it also controls the depth of field, i.e., what is seen as being sharp or unsharp in the picture. This affects both photographic content and aesthetics. In a print containing both blurred and precise representations, there is a tendency to reject the unsharp in favor of the sharp representation.

A wide-open lens has little depth of field, while a lens that has been stopped down to a small aperture has a much greater depth of field. Depth of field can be controlled to produce pictures where everything is apparently in equal focus, or to isolate an action by making it the only sharp, focused detail in the frame, as shown in figure 6.9. The depth of field for any distance and aperture can be calculated by using the depth-of-field scales on the lens, or can actually be seen and studied by using the *preview* control available on most reflex cameras, which permits you to manually stop down the lens to any desired aperture and see (although on a darkened screen) what the film will record.

Figure 6.10
China Cove, Carmel.
Arnold Gassan.
Depth-of-field controls were used to keep the area from the water and sand in the foreground to the distant island in focus. A slow shutter speed was dictated by the small aperture; the exposure was made as the small wave in the foreground reached its crest.
(Photo by the author)

Figure 6.11

 a. Lens focused at the hyperfocal distance has the greatest depth of field.

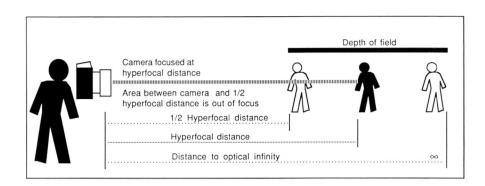

b. Lens focused at optical infinity has a reduced depth of field compared to one focused at the hyperfocal distance.

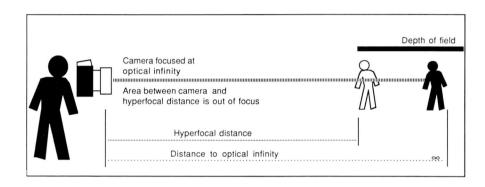

c. Lens focused on a subject close to the camera has little depth of field compared to the lens being focused on a distant subject.

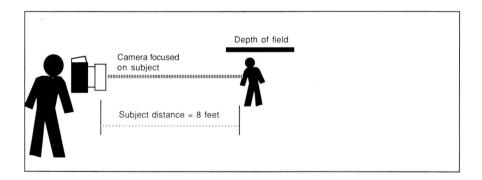

Hyperfocal Distance

Greatest depth of field is always produced by focusing on the *hyperfocal distance*, which is defined as the nearest distance at which objects at optical infinity are also in acceptable focus. This distance varies with the aperture. Depth-of-field marks are provided on all contemporary camera lenses. When the lens is focused at the hyperfocal distance, everything from half the hyperfocal distance to infinity is equally unsharp (another way of saying acceptably in focus). Optical infinity is indicated by the ∞ sign on the focusing ring and is defined individually for each lens; in practice, infinity (∞) is about fifty feet from the camera for wide angle and normal lenses, and three hundred feet for long lenses.

 d. Lens focused on a far subject has greater depth of field than a lens focused on a near subject.

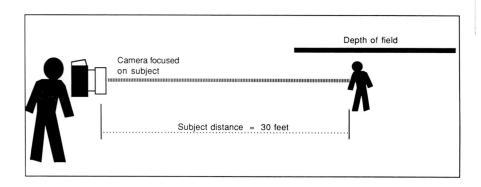

e. As the aperture is made smaller, the depth of field increases.

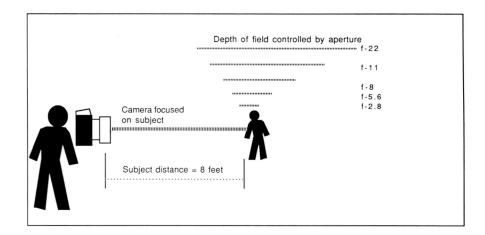

Zone Focusing

While it is true that the objects at the plane of focus are most sharply focused, it is often convenient to use *zone focusing*. Examine figure 6.12A and you will see that at the indicated aperture of f–5.6, when the ∞ sign is placed next to the line for f–5.6 (on the right half of the focusing control ring) then the f–5.6 line on the left half of the focusing ring is opposite ten feet (or three meters). This means that *everything between ten feet and optical infinity is equally sharp*. There is no need to refocus when photographing objects in that distance range: one can set the focusing control, compose, and shoot without refocusing.

A second example is shown in figure 6.12B. The ∞ mark has been set opposite f-16 on the right-hand half of the focusing control ring. Find the f-16 mark on the left-hand half of the ring and see how it lines up with the 5 in 3.5 feet. This means that if you set the aperture at f-16 and focused as shown in figure 6.12B, there would be no need to refocus for any subject between 3.5 feet and infinity. Zone focusing lets you photograph objects distributed through deep space without refocusing, knowing they are all in equal focus.

The least effective focus is shown in figure 6.12C, where the ∞ mark is placed opposite the \blacktriangle focusing reference. The depth of field at f–5.6 is only from ∞ to about twenty feet. If there were subjects in the scene closer than thirty feet from the camera they would be visibly out of focus in the picture. Refocusing and setting the thirty foot mark opposite the \blacktriangle would increase the depth of field at f–5.6 to include from 12 feet to ∞ , a much more effective use of the lens.

Figure 6.12

a. Note that the lens is set at f–5.6 and the focus is set on the hyperfocal distance (determined by setting the ∞ sign opposite the appropriate mark for the aperture being used). This setting produces the greatest depth of field for any given aperture; in this case, everything from ∞ to ten feet will be acceptably sharp.

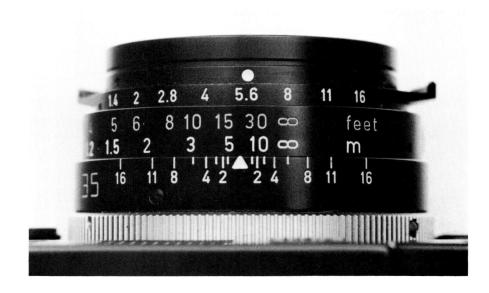

b. At the indicated aperture, the depth of field at f–5.6 is only from 6–9 feet, as the focus is now set. But if the aperture were reset at f–16 (the smallest opening for this lens), setting the ∞ mark opposite the 16 on the focusing ring would show that it is possible to make a picture in which everything from about 3.8 feet to ∞ will be equally (and acceptably) sharp.

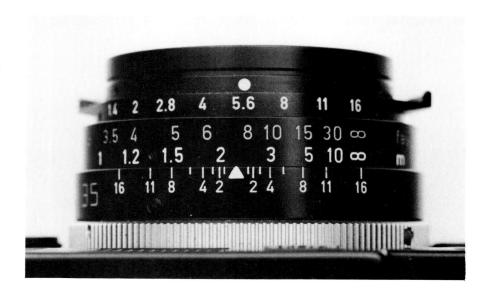

c. Setting the focusing ring at ∞ produces a comparatively narrow depth of field, from ∞ to about 20 feet.

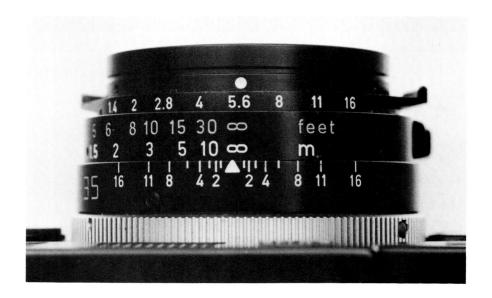

Figure 6.13

Rift Valley, Ethiopia.

Mike DuBose.

An aesthetic use of a 300mm lens to isolate the subject from the environment.

(Courtesy of the photographer)

Lens Aesthetics

The focal length of the lens inevitably affects photographic aesthetics. A lens with a long focal length has much less depth of field at any given aperture than a short (or wide-angle) lens. On one hand, a long lens (with very narrow depth of field) can isolate a narrow sharp slice, while a wide-angle lens (with great depth of field) will tend to make everything equally sharp. A shallow depth of field is easily achieved with the long lens, as is shown in figure 6.13. This is useful for focusing attention on a single subject. But a large aperture will create a limited depth of field with a lens of any focal length. In figure 6.14, a normal lens is used at a large aperture; the resulting narrow depth of field and soft-focus background interacts with the convergent pattern of the factory lights to direct your eye to the steelworker.

Figure 6.14
Laborer, J&L Tin Plate Department.
Ivan Massar.
Camera position, depth of field, placement of the man and the roll of steel, and the pattern of factory ceiling lights all direct the viewer's attention.

(University of Louisville Archives, Standard Oil Collection)

α.

Figure 6.15Both pictures have the same total exposure: *a* was exposed for 1/250 second at f–2.8, and *b* was exposed for 1/2 second at f–32. The camera was moved to follow the horse during the exposure.

Exposure Law

b.

As the aperture is opened up, the shutter speed must be shorter to maintain a constant exposure. Film exposure is the product of the lens opening and the shutter time, or

 $E = I \times T$

where **E** is exposure, **I** is light intensity, and **T** is exposure time. If **E** is to be kept constant, then an increase in **I** requires a decrease in **T**. This is called the *law of reciprocity*, and it is valid for exposure times between about one second and 1/1000 of a second. Figure 6.15A and B both have the same exposure in that the product (**E**) of the aperture and shutter speed is identical for both pictures, and the negatives have similar densities, though obviously the aesthetic effect of a short or a long shutter speed causes the pictures to have different effects.

Shutter Speeds

Shutter speeds are standardized to exposures that have a 2:1 change in time, one speed to the next. Standard contemporary shutter speeds are 1, 1/2, 1/4, 1/8, 1/15, 1/30, 1/60, 1/125, 1/250, 1/500, and 1/1000 of a second, though some new camera shutters offer longer and shorter speeds. Electronically controlled shutters actually provide exposures that are close to the indicated speeds; mechanical shutters may vary by half a stop from the indicated speed.

Shutter speeds can be chosen by the photographer to fit professional or aesthetic needs. Sports photography, for example, is usually concerned with "peak action" and that necessitates using very short shutter speeds, as shown in figure 6.16. But an absolutely stopped image is not the only possible representation; the photographer can often find a moment of comparative stillness, in which movement nearly ceases. During these pauses even a slow

Figure 6.16
Hockey Flip.
Annie Lennox.
Illustrating the effect of an ultrafast shutter speed to freeze peak sports action.
(Courtesy of the photographer)

Figure 6.17

Dance Master Class.

Arnold Gassan.

Despite inadequate light, it was possible to capture the essence of a modern dance master class by watching for those moments when the dancers paused before moving on.

(Photo by the author)

shutter may be used, as shown in figure 6.17. Sometimes, an alternative to freezing motion or catching a pause within a repetitive movement is to pan the camera with the moving subject and allow movement in the frame. This may result in a pleasing combination of sharp and blurred details, as shown in figure 6.15*B*.

Shutter and F-stop Combinations

Contemporary cameras have aperture and shutter settings which vary by 2:1 ratios. These easily permit you to transform any metered exposure to fit a variety of conditions, depending on whether a short or a long shutter speed is needed, or a large or a small aperture. For example, if a metered exposure is 1/60 at f-5.6, all the following exposures would produce equivalent negative densities:

and the question arises: which of these should you use? The answer depends on your aesthetics and your professional requirements. It is possible that a slightly blurred image may be more effective than a stopped action in communicating the mood of an event, as in figure 6.18. A very short exposure will "freeze" the subject, but usually require a large aperture, with little depth of field; a small aperture (f-16) will offer greater depth of field, with the risk of blurring.

Focal-plane Shutters

Two basic shutter designs appeared late in the last century, and both are still in use. The oldest is the focal-plane shutter, now standard on all 35mm reflex cameras. The original focal-plane shutter was a long, opaque cloth curtain with several slits of different widths across it. The curtain was rolled onto a spring-loaded spindle, much like a window blind.

The curtain shutter was placed just in front of the film, near the plane of focus. When it was released, springs pulled a slit in the curtain past the film at a constant rate of speed, exposing each area of the film evenly. By choosing a slit and adjusting the spring tension, one could create exposures varying from 1/1000th of a second to more than a second. By using a small slit and high spring tension, very short exposures for each area of the film were possible, although the curtain itself was clumsy and moved slowly.

The contemporary focal-plane shutter dates from 1924, when E. Leitz began manufacturing the Leica camera. The Leica focal-plane shutter used two curtains to form a slit of variable width. Both curtains travel across the film at a constant speed, but the second curtain follows the first after a specified delay, thus creating a slit with a variable width, and exposures that are variable also. In the original Leica shutter, the first curtain traversed the 36mm long opening in 1/60th of a second, regardless of the shutter speed setting. For an exposure of 1/125th of a second, the second curtain begins closing when the first is halfway across the film. No matter how "fast" the shutter is set, the curtains always travel at the same rate of speed; all that varies is the interval between them.

In recent years, the Leica cloth curtain has been rotated and now travels vertically. In other cameras, the cloth has often been replaced by thin metal blades that move vertically across the film. These perform in exactly the same way as the two cloth curtains. Because of the shorter distance to travel, the vertical focal-plane shutter requires half the time of the horizontal shutter. This is important because *synchronization* of flash lights can be accomplished at higher shutter speeds.

Figure 6.18 Untitled.

Edward Pieratt.

The anxiety of being threatened by mounted police is captured in this photograph, where a slow shutter speed enhances the impact. (Courtesy of the photographer)

Between-the-Lens Shutters

Popular amateur cameras (before the 35mm) that dominated the market almost always used metal blade shutters located behind or between the lens elements, next to the aperture. The early shutters were very simple, operating at only about 1/30th of a second. In the first decade of this century, the **Compur** shutter was perfected. It is a complex, clockwork mechanism with a range of speeds from one second to 1/500th of a second, and is still used in many professional cameras.

Shutter times were controlled by clockwork mechanisms until the late 1970s, when solid-state electronic circuits became cheaper. Although most cameras now use electronic timing, some professional cameras retain dependable mechanical systems. The electronic shutters have problems as well; they are very sensitive to moisture and cease to operate when there is a battery failure.

Light Meters and Exposure

A light meter is a device that measures the light available for a photograph and computes an exposure. There are two styles of meters. One measures light falling on the subject before the camera, and is called an *incident light* meter. The other kind measures the light reflected from the subject, and is called a *reflected light* meter. The incident meter is hand-held, separate from the camera; the reflected light meter may be an integral part of the camera.

The incident light meter integrates light falling on the subject through a 180° hemisphere. The meter is held in front of the subject, pointing toward the camera. The incident meter does not indicate to the photographer how much light is reflecting from any particular area in the subject, only how much light is available.

The reflected light meter can measure the light from any part of the subject; it can tell the photographer how much light is available from a dark surface or from a bright, white fabric. The fact that the reflected light meter measures a precise target is important for its use in large format photography, where each sheet of film can be exposed and developed separately.

Meters that need batteries are very sensitive to battery voltage changes, and as the battery ages, the meter indications will err toward overexposure. The light-sensitive element in most contemporary meters is a photosensitive grid, which requires a battery, although some incident meters still use photogenerative selenium to measure the light.

Metering Targets

The information offered by any meter can be misleading. The reflected light meter requires careful use to assure that the proper metering target for any given scene is being metered. One difficulty of using the reflected light meter is that it integrates the light being measured, depending on the angle of view of the meter. Most meters have a wide-angle view, and integrate light over about the same angle as a 35–40mm focal length camera lens. These meters are often used to measure reflected light from metering targets that are too small to be accurately metered, and this produces exposure errors. Other reflected light meters have special lenses and are called "spot" meters because they measure only a 1° or 2° field of view. They are, in effect, miniature telephoto cameras without film or shutter.

Camera as Meter

Almost all contemporary small cameras have integrated light meters. TTL (through the lens) metering is reflected light metering; the meter measures the light from the subject that will expose the film. The meter calculations are based on the ISO of the film. This may be accessed directly from the film canister, using the DX coding stripes.

Because the meter in the camera measures through the lens, the camera can be thought of as a spot meter. By pointing the camera at critical values in the photographic scene, and noting the exposure indicated for these, more exact contrast predictions and development plans can be made.

Figure 6.19

a. TTL metering is the most familiar reflected light measurement. This sketch illustrates how the averaged luminance is presented in the reflex camera viewfinder as a suggested exposure.

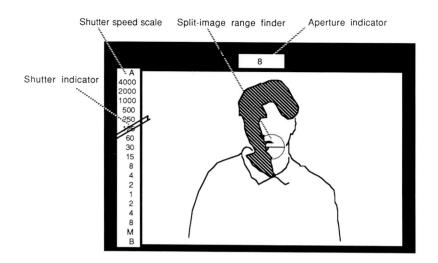

b. The incident light meter is held at or near the subject, and it measures the light falling on the subject. Contrast is determined by experience, though measuring the light on the bright and shadowed side of the subject offers some guides.

Most TTL meters are *center weighted*, meaning the area near the split-image focusing prism in the center of the field of view has more effect on the meter reading than light coming from the perimeter of the picture. This assumption is valid most of the time; most photographers "center" the subject of the picture. Figure 6.19A sketches a typical portrait scene, with light reflected from a dark shadow and brighter skin. A few degrees rotation up or down will significantly change the exposure for a center-weighted metering system.

When the subject of your picture is much darker than normal, the camera will tend to overexpose because it "thinks" the average value should be lighter. In the same way, if the subject near the center is very light (snow, fog, white fabric), automatic mode exposures will tend to under-expose the film. It is necessary to decide if the subject is markedly lighter or darker than a middle gray, then point the camera at a midvalue target *in the same light* to more accurately determine the exposure.

Figure 6.20 Exposure adjustment settings for DX-coded cameras permit varying EI from +2 to -2

Figure 6.21
Untitled.
Mel Curtis.
A photograph from a Widelux camera, which produces a 2¼-inch 35mm negative. The lens rotates during exposure, producing a panoramic picture with a single exposure.
(Courtesy of the photographer)

You can change the ISO number by using the meter override control located near the rewind knob on most 35mm cameras. This allows you to adjust the metering system from +2 to -2 stops of exposure, in half-stop increments (as shown in figure 6.20). Experience with your camera will tell you if the ISO value of the film is correct for your photographs. Changing the exposure from the DX-coded ISO to a greater or lesser exposure in order to create more correctly exposed negatives establishes your own individual Exposure Index (**EI**). The EI is a product of

- · the metering system in your camera
- · the way you meter the subject
- · the subject you photograph
- · the way the film is developed

Two photographers can use the same film in similar cameras and yet have personal El's that differ by a factor of four, and both may produce negatives with very similar printing characteristics.

Figure 6.22

Untitled.

Arnold Gassan.

This double-exposure of a New York street scene was made in-camera by pressing the rewind release and cocking the shutter without advancing the film. This is a way of combining two angles of a view in one photograph.

(Photo by the author)

Other Camera Controls

The modern camera offers powered film advance (motor-wind or motor-drive) coupled with the shutter; it is possible with many cameras to expose 4–6 frames of film each second. This is a remarkable change from the days of wet-plate photography, when each glass plate had to be coated, sensitized, exposed, and developed before the coating had fully dried.

Powered film advance is a mixed blessing. It is very useful for sports and other one-time actions. Powered shutters and film advance mechanisms are also a wonderful way to waste film, permitting you to expose three or four frames, when one well-considered picture would do.

Double-exposure was a constant threat to photographers until the 1930s, when cameras incorporated double-exposure prevention techniques. Contemporary small cameras automatically advance the film as the mirror is returned to viewing position or the shutter is cocked. On most cameras, double-exposure is possible if desired. After making the first exposure, take up slack in the film with the rewind crank, then press the film rewind locking button on the base of the camera and hold it in while the film advance lever (which actually cocks the shutter and returns the mirror to a locked position) is rotated. Release the rewind button. The film has not moved, but the camera is prepared to make a second exposure on the same frame.

If a double-exposure is planned with densities *evenly* split between the two exposures, the second exposure should be *twice* the metered exposure. The reason for this is theoretically complex but can be visualized as the first exposure using the most sensitive silver, leaving only less sensitive silver for the second exposure.

Summary

The simple camera has been replaced with a machine that measures the light, computes the exposure, and can be programmed to choose an aperture, shutter speed, or both. The aperture and shutter determine the exposure, and the combination chosen is determined by professional needs and personal aesthetics. Sharpness of moving objects is controlled by the shutter. The focal length of a lens controls both the angle of view and the apparent deep space in a picture. Depth of field is maximized by focusing on the hyperfocal distance. For any lens, the depth of field is determined by the aperture, and the smaller the opening, the greater the depth of field.

Light meters measure reflected or incident light. In-camera meters are reflected light meters, which average the light through the lens. Special cameras offer alternate format pictures. Multiple exposures are possible on most small cameras.

Discussion and Assignments

The small camera permits photographing easily almost anywhere, at any time, and makes changing point of view as easy as sitting down or standing up. Contemporary electronic shutter controls linked to an in-camera meter permit exposing film correctly under a wide variety of lighting conditions with almost no risk of failure.

Assignment 1 Tape a small piece of cardboard over the viewfinder of your camera. Set the focus by placing the ∞ symbol opposite the outermost fstop line on the aperture control ring. (The \blacktriangle in the center will point at a distance mark around 16–20 feet for a 50mm lens.) Use a piece of drafting paper tape and tape the lens so it will not change focus. You have now reinvented the box camera, except yours has a variable shutter.

Using an aperture priority mode, your camera will now set a shutter speed to fit the lighting of whatever scene you photograph. Go through a day, photographing whatever you want, but accepting the fact that you cannot focus on the scene and you cannot frame exactly what your camera is going to record. You respond directly to what is going on around you, looking over the camera rather than through it.

Deliberately choose to make some pictures in low-level lighting (indoors, late afternoon, etc.) where the shutter speed might well be long enough to cause blur. Follow the action with your camera. Develop the film and discover what you have seen.

Assignment 2 Load your camera with a 24-frame cassette. After you make the first picture, ask yourself what the subject of the picture is, then allow that subject to suggest the next subject, which you will then seek. For example, if you photograph a cat, then what might a cat seek, or where might it be going? Let each picture direct you to the next.

Assignment 3 Find several subjects to photograph (a person, object, building, etc.). Photograph it as you normally would. Stop the lens down to the smallest aperture and if the indicated exposure is a second or longer, make a picture, holding the camera as still as you can, knowing you cannot hold it still enough to make a picture without blur. Try to discover how deliberate blur can be used.

Assignment 4 Look at a subject which is too large to easily frame in your viewfinder. Without moving, make six photographs that break that subject into a horizontal strip picture. Find another that can be broken into a vertical array. Find another that can be photographed only by making a 5 print \times 6 print frame array. Develop the film and assemble the contact prints into composite views. Study them to see how space and your perception of the subject has been changed.

Assignment 5 Tape your camera's focusing control so that your knowledge of hyperfocal distance is used and the camera is in focus from five feet to ∞ . Tape a piece of cardboard over the viewfinder. Set the camera's controls to shutter priority. Go for a walk and when you sense something happening near you, immediately and intuitively point the camera and press the shutter. The event may be behind your back or over your shoulder. Trust your responses. Cut out a proof sheet and make $3'' \times 5''$ file card mounted prints to study.

7 Looking at Photographs

Figure 7.1
FIGURE FROM THE UNDERWORLD.
Clarence John Laughlin, 1951.
Documentary photograph of an eroded concrete funerary sculpture with an air of surreal fantasy—the photographer's willingness to see the suggestion in the subject was required, but no photographic manipulation was necessary.
(© Historic New Orleans Collection; print courtesy of the author)

Art Traditions in Photography

The first daguerreotypes were made by a painter. When they were presented to the public, another painter proclaimed that from that day, painting was dead! He meant that the painter's struggle to describe the visible world with such sufficient detail and exactitude that the eye could be fooled was no longer the principal aim of the artist. Photographs at first were cheap replacements for painted portraits, pictures of foreign cities, and exotic landscapes. It was nearly inevitable that painting traditions underlay most photographers' training. These traditions have always been slightly at odds with the documentary tradition in photography.

There are many different interpretations as to the role of the photograph as art. Alternative critical traditions exist, sometimes with incompatible criteria. Photographic aesthetics have undergone change in recent years and there is renewed interest in photographs that are closer to the traditions of painting and printmaking than to documentary photography of unmanipulated realities. While some critics believe art is concerned only with formal considerations, others note that art has multiple definitions, including making objects for daily use.

Photography differs from the other arts in that the time spent on the photograph is literally a fraction of a second. Unlike a painter who may work and rework until an aesthetic purpose becomes clear, the photographer usually makes the finished statement in 1/125th of a second or less. The photographer spends months and years training to respond to an instant of time, and in that instant exposes film. The choices recorded by the lens and shutter reveal what has been effective in the photographer's training and often disclose some unconscious influences.

The process of editing, organizing, reprinting, and sequencing photographs comes closest to the reworking of an image as done by a painter or a printmaker. Responsive decisions change the meaning of individual prints in a body of work, but do not deny the fleeting nature of the initial photographic vision.

A critical language can be used to describe and evaluate documentary photography, in which the intention of the photographer is to describe what exists when he or she is on the scene. A somewhat different critical language is used when the photograph itself is painted upon, or collaged into a mixed-media presentation, whereupon it becomes a painting by default. In such cases, the critical language of painting derived from art history is exactly appropriate.

Straight and Manipulated Photographs

The **straight** photograph is unmanipulated, details the world in an instant, draws relationships between objects with accuracy, and describes surfaces with fidelity. But the objects seen may well have been put there just to be photographed, and so the documentary power of the camera is often deceptive. Photographs can be made of objects assembled by the artist, just as still-life paintings are abstractions of artists' constructions. Art photography, from Edward Weston to the large Polaroid photographs by Starr Ockenga, Sandi Fellman, and others uses objects assembled for the purpose of being photographed.

This recent popularity of assembled and manipulated photographs recalls an earlier period in photographic art history. In the early 1900s there was a photography movement called **pictorialism**, which supported photographers who made pictures that resembled paintings. There was a reaction to pictorialism and manipulations in the 1920s when Paul Strand, Alfred Steiglitz, Ansel Adams, and Edward Weston fostered a new commitment to straight photography, but that, in turn, ended in the early 1970s.

Figure 7.2

Great Mother of Big Apples.

Steve Ballance.

The carefully lighted section of the apple poetically reveals the texture of the apple and the complex interior forms of the core.

(Courtesy of the photographer)

Subject and Composition

Art training used to offer "rules" for arranging shapes to guarantee a pleasing photograph or painting. These rules are effective in that by placing the horizon about one-third from the top or bottom of the frame, for example, a pleasant balance of forms is achieved; posing the portrait so that the subject's eyes are about one-third from the top also produces a pleasing result. This tradition is found even in surreal photographs like that by Clarence John Laughlin (figure 7.1), where the eroded statue is placed in the frame much as it would have been located by an eighteenth century portrait painter. Compositional traditions are useful, but they may supplant understanding of deeper relationships between the photographer and the photograph.1

Figure and Ground

The principal subject is often referred to as the **figure**, and the surrounding frame as the **ground**, with the relationship between them being the **figure/ground** dialogue. This notation is useful when describing the formal elements of the photograph, and it can help define some of the content. There are really only three photographic compositions:

- · closed, or simple figure/ground
- · multiple figure/ground relationships
- · open figure/ground

When the subject is centered, attention is automatic. Figure 7.2 is an example of a closed, superficially simple figure/ground relationship. The light shape of the apple floats in the solid black of the frame. And yet there is another figure/ground within the apple, as you discover the shadowy shape of the seed pocket within the apple itself. Rarely does one only find a single figure/ground relationship, though often there one shape is dominant, as in this illustration.

Figure 7.3
a. Indian Pueblo Church, New Mexico.
Ansel Adams.
A documentary photograph made under contract to the U.S. Department of the Interior. Depth-of-field controls and sensitive lighting were used to reveal the complex forms of the church entry.
(Print by National Archives; reproduction courtesy of the Trustees of the Ansel Adams Publishing Rights Trust. All rights reserved)

b. Figure/ground analysis of Adams' photograph of the Indian pueblo church.

Multiple figure/ground compositions often happen by default and they often weaken a picture, but creating complex figure/ground relationships can be an effective photographer's tool when used with care. Figure 7.3A is a photograph of an American Indian church in which a complex set of figure/ground relationships can be discovered. Part of the strength of this picture is in the complexity of the form relationships. One discovers rectangles within rectangles in the lower half of the picture detailed in figure 7.3B. All of the shapes in the lower half are also in a dialogue with the stairwell walls and the crosses in the upper half of the picture.

While a closed figure/ground composition directs our attention to the photograph itself, the open figure/ground composition often has a more subtle impact; it suggests we look past the photograph to the real objects that were before the photographer's camera. Figure 7.4A is an early documentary photograph of a great western valley and river. The dominant form in the picture is the loop of the river, which (as seen in figure 7.4B) creates an open shape closed only by the edge of the frame.

Figure 7.4
a. Green River.
William Henry Jackson.
A documentary photograph of the American west in which significant form is combined with accurate description of the vast spaces and specific geology.
(National Archives)

b. Figure/ground analysis of Jackson's landscape photograph.

Figure 7.5a. Photograph of rocks seen as a stable central cluster form in the frame.

b. Figure/ground analysis of a.

The Centered Image

The centered image (or an image firmly tied to a corner of the frame) is considered to be stable (compared to an eccentric placement in the frame), and something special happens when the figure is centered. It seems that the subject is influenced by the boundary of the frame more than the boundary being affected by the subject, as shown in figure 7.5A (which is diagramed in figure 7.5B). When the subject is dead center, it is not "dead" because there are tensions in all directions; to a sensitive eye, a subject in balance in the middle may sustain great tension. When the subject is dispersed, or moved away from the center, as shown in figures 7.6A and the diagram in figure 7.6B, then the entire frame becomes a pattern and that, in turn, becomes the apparent subject of the photograph.

Types of Photographs

The photographer may function as an artist as well as a documentarian. Paul Klee wrote that the artist made the invisible visible. The artist perceives underlying form and discloses hidden meaning. Photographs may do both—describe what is there and suggest what the photographer saw only in his mind's eye. Photographs are made to describe objects and events, to reveal significant form, and to disclose personal insights. Some photographs are more powerful as documents, others are effective as visual poems, and some can hardly be described in verbal terms, they are so singularly formal in content.

The camera does not seek out significant form. A camera thoughtlessly describes whatever is in front of the lens, and it is up to the photographer to select what the lens will record, by selecting a point of view and controlling the photographic process to produce significant form from chaotic events. The inclusiveness of the lens places great demands on the photographer; while a painter can make a scene tidy, the camera describes what is before it, and the photographer edits what the camera records.

Figure 7.6a. Photograph of rocks seen as a dispersed pattern within the frame.

b. Figure/ground analysis of a.

An ideal documentary photograph might be said to describe what was before the lens in as unbiased and transparent a way as possible. The choice of lens, contrast, and point of view enhance our sense of the print's transparency, and encourage us to look through the surface of the picture as though it were a magic window, as though the camera were casting a spell over time itself. For example, the nominally documentary photographs made by the FSA photographers reveal consistent personal traits interacting with their broadly defined documentary assignments. It is clear on examining the Library of Congress FSA collection that while most of those photographs obviously provide historically interesting cultural and social data, some are more clearly aimed at the emotions, some at our aesthetic sensibilities, and some hold all three aims in balance.

The photographs that have been selected to illustrate this text are drawn in part from large, public collections. Sizable photographic art collections can be seen at: the Museum of Modern Art, New York, New York; George Eastman House, Rochester, New York; Kuhn Memorial Library, Baltimore, Maryland; Chicago Art Institute, Chicago, Illinois; University of Nebraska, Lincoln, Nebraska; University of New Mexico, Albuquerque, New Mexico; Center for Creative Photography, Tucson, Arizona; Friends of Photography, The San Francisco Museum of Modern Art, San Francisco, California; The Library of Congress and the National Archives in Washington, D.C. Contact the staff at these collections for information and viewing schedules.

The Standard Oil collection is at the University of Louisville, Kentucky, along with the Griswold collection. Clarence John Laughlin's negatives and prints are in The Historic New Orleans Collection. Most states have accessible historical society collections.

The Library of Congress has catalogued more than 80,000 original Farm Security Administration negatives. Copy prints of many are on file, and may be studied by anyone. An even larger accumulation of photographs (including many of the same photographers) is available in the National Archives. Library of Congress files are alphabetical by photographer; National Archives files by U.S. government agency. Dorothea Lange, for example, not only worked for the FSA, but for the War Relocation Administration and the Agricultural Economic Administration. Copy prints can be purchased at moderate prices from either the Library or the Archives.

Beginning in 1935, the photographers of the FSA made documentary photographs for seven years. The project, which was started by the U.S. government, was headed by Roy Stryker, who had a clear sense of what the photographers ought to photograph. They, in turn, took pictures of almost anything they wanted to photograph, to help in fighting the Depression, with the belief that the camera was an effective tool for education. When the FSA project was disbanded, at the beginning of World War II, the project was continued, for a time, by Standard Oil. In the early 1970s, there was the short-lived Documerica project, a further photographic documentation of American life. Ongoing documentary photography of lifestyles continues under the aegis of the Library of Congress, American Folklife Center.

Purpose of the Photograph

An examination of photographs that have survived years of critical attention reveal that they:

- · describe a specific moment clearly
- · have a strong sense of form

Either the descriptive or the formal aspect of the photograph may dominate, but both usually exist. When one examines a large number of photographs, a pattern of **intention** may be discovered within most mature work.

Figure 7.8

Negro Cabins.
Russell Lee.

Documentary photograph of Mississippi plantation workers' housing, taken in 1936 for the Farm Security Administration.

(Library of Congress, FSA Collection)

Figure 7.9

Baytown Refinery, Texas, 1949.

Russell Lee.

Documentary photograph of refinery storage tanks made while working for Standard Oil, which continued the documentation begun by the Farm Security Administration.

(University of Louisville Photographic Archives)

Even when a specific intent is unknown, the work itself often reveals the intention, and that usually becomes clear when the photographs are examined in the context of their time. For example, the social and emotional suggestions of the subjects of photographs by Russell Lee in figure 7.8 and figure 7.9 are vastly different, yet his formal response to both the poverty of plantation housing and to the aesthetic excitement of dramatic sunlight on fuel storage tanks is almost identical.

Words that accompany the photograph also change or direct the viewer's attention and affect the meaning. Captions and other associated words must be scrutinized carefully, especially if they are out of the photo's own time. Identifying how the photograph was used by the photographer and

others in its own time will help in recognizing its original purposes. This effort needs to be made in order to isolate the photograph from editorial decisions made by others. The apparent content of a photograph is often a result of its context, as well as the words that appear in a title or caption that accompanies it. One needs to examine the original context for which a photograph was made.

Response to the Photograph

We are surrounded by picture sources, which offer us a constant supply of new images. The problem is that we often look without truly registering what it is we are seeing. Like other skills, it takes work to learn to see what we are looking at. Research on how the mind interprets visual information indicates that we look for differences in patterns, and largely ignore everything else.² We expect to see what we are trained to see. This training is a result of our daily experiences, what we willingly watch and what we turn away from. Some of our training is societal, culturally determined, and some reflects our reactions to deeply felt personal events.

The photograph in itself tells us nothing. Ultimately, the photographic print is only a record of the light available to the lens during the fraction of a second when the shutter was opened. In black-and-white photography, that information is further abstracted because the color is eliminated, and only value remains. All other information we ascribe to the photograph is either intellectual reconstruction of meaning, or emotional **projection**, which is a psychological term describing many otherwise inexplicable responses to photographs. Projection is a defense against self-disclosure. A viewer projects himself onto the picture and, when confronted by an ambiguous image, his own personality traits, needs, goals, desires, fears, etc., are perceived in the image.

The information presented in the photo may have little to do with your responses, feelings, and emotions. When the print is finished, one may wish to ask what is it for, what does it mean? Most photographers hope their photographs communicate clearly, but few realize that what others see is not what the photographer saw. Looking at pictures means to respond, and to understand the response, but it also means to discover the information contained in the picture.

Photographic Information

The information available from a photograph is very complex. A photograph's content is the sum of our knowledge of the original scene illustrated in the picture; our insight into art and photographic history; and personal needs, desires, and fears that we bring to the photograph and project onto it. This variability of content is true of all photographs. It has been said that a documentary photograph is only as good as its documentation. For example, a photograph from the mid–1860s may tell us about the clothes worn and the styles of hair. But a response to that photograph should also reflect the difficult and tedious daguerreotype or collodion wet-plate photographic procedures, where exposures lasted for minutes, and one could not ask for fleeting, and more charming poses.

Photographs are commonly accepted as being truthful and they are frequently allowed in court as legal evidence, but only after they have been validated as not distorting reality, and the court receives testimony regarding the conditions under which the pictures were taken. But the photograph is not a transcription of reality.

Looking at photographs provides information, and often is a pleasurable activity as well. Photographs permit us to look at the world without leaving home, and to stare at other's lives without risk of embarrassment.

The lens of the eye makes a retinal image that is interpreted by the brain; it is in that interpretation that "reality" is conceived. It is because of the congruence between our own visual experience and the photographic experience that most of us view the photograph as a magical window opening onto reality. The photograph is merely a two-dimensional construction of gray values, created by a lens system that approximates what our eyes see. The photographic experience is also largely a learned experience, in which simplification of forms, acceptance of wide-angle perspective, absence of color, juxtapositions of people and objects in the frame, and intrusions of points of view are accepted as replacements for the actual event.

Some people see in a photograph only the event that was in front of the camera; others see the photograph as pattern and light and dark shapes in the print; still others may see fantasies stimulated by the picture. Response to a picture is frequently an emotional reaction to the illusion of looking through the photo onto a separate reality; that illusion is at the heart of the photograph's power. Each viewer experiences a different photo because we each bring different life experiences to the picture.

Our unique life experiences color our responses, but there generally are commonplace responses as well. We frequently feel the same emotions many others do when we look at a picture; if we did not, there would be no universal meaning for any photograph. Nevertheless, each person's response to the photograph is dependent on cultural training and personal experiences.

Cultural traditions are deeply embedded in what is photographed, how it is photographed, which photographs are published, how the photographs are used, and how a photograph functions as a model by which you judge other photographs. To an anthropologist or sociologist, for example, the cultural event happening before the lens may be of primary importance, and the formal, aesthetic elements have little value, as compared to an artist's response, which may be to the aesthetic qualities of the print first.

Classification of Photographs

Classification is necessary in order to know what you are describing. A naturalist speaks of **taxonomy**, which is classifying according to the natural relationships between animals, or objects. Without classification, one is never sure what it is that is being examined. A naive response to a flower, a bird, or a photograph is all one can have without knowing the class of picture being examined. Any knowledge of the subject or of the photographic processes used will affect your response, as you look at any photograph.

A number of writers on photography have suggested ways of classifying and looking at the photograph, which you may wish to investigate. Suggested readings include:

- · Jonathan Green, A Concise History of American Photography
- · Naomi Rosenblum, World History of Photography
- John Szarkowski, The Photographer's Eye and Mirrors and Windows, American Photography Since 1960

Regardless of the system being used, the response to the photograph will always depend to some degree on its descriptive power. Recognizing that limit, the purposes of a photograph can be outlined as follows:

- · art
- · social documentary
- · scientific documentary
- · journalistic interpretation
- product and fashion figure
- · snapshots, personal inventories
- · self-therapy

Many photographs exist in more than one category, e.g., documentary photographs often also reflect a photographer's search for significant form. Not only the initial purpose but also the use to which a photograph is put will affect the standards by which it is evaluated. No matter what the photographer's intention may have been, a picture is responded to in terms of the viewer's needs of the moment.

Because each viewer rediscovers the photograph in light of what is often an unstated personal agenda, there need to be more neutral ways to describe the photograph. Here are three ways of classifying photographs:

- · functions of the subject being photographed
- · photographer's attitude toward the subject
- · traditions within the medium itself

These are categories that permit you to describe the photographic subject, the photographer's craft, and the photographer's relation to the medium itself.

First, when describing pictures by subject, realize that one can only photograph:

- · people (portraits, social landscape, fashion, nudes)
- · places (architecture, cities, landscapes)
- · things (abstracted details, scientific subjects)
- · the form relationships between shapes

Second, when attempting to classify photographs by the photographer's attitude toward the subject, attempt to discover whether

- · the object before the camera is most important
- · the photograph itself is the object of attention

One should note that the photographer often attempts to become transparent, so that the viewer remains most aware of the subject before the camera, rather than the photographic technique. But lighting, composition, lens and camera choices, and printing technique may call attention to themselves, and the photograph itself then becomes more important than the objects before the camera.

Third, because printing craftsmanship affects response to photographs, even when seen in reproduction in a book or magazine (although only some criteria apply to the original silver print itself), it is necessary to examine the effect of:

· camera and film:

focus and sharpness shadow detail exposure of negative development of print highlight detail and texture development of negative exposure of print

· print presentation:

full tonal range print color matting, mounting, framing sequence and set relations

Describing a photograph carefully in terms of these criteria can help you understand what you have seen. Of course, how you choose to evaluate the photograph after you understand it is a personal process.

Examples of Documentation

The photograph by Jacob Riis in figure 7.10 is an early example of a posed, flashpowder-lit photograph made by a sociologist in an effort to change the way the poor in New York were forced to live at the beginning of the century; it is also an emotionally evocative picture. By using the figure of the woman as a scale, one can estimate that the room in which she sits is probably no more than nine feet wide, filled with mattress, stove, and water pail. The steps on the crude ladder at the left are easily two feet apart; they would be awkward to climb. The picture implies that this claustrophobic room is all the woman and child have, that it is accessed by the ladder, that water and toilets are to be found elsewhere, and that it is cold. The social (and emotional) evocations of the image are profound, as one imagines living and caring for a baby in that space, and trying to get enough air, light, and clean water to remain healthy.

Figure 7.10Italian Mother and Baby, Jersey Street, ca. 1889.
Jacob Riis.

A flashpowder-lighted photograph made to document the lifestyles of immigrants in New York slums.

(Jacob A. Riis Collection, Museum of the City of New York)

Figure 7.11

Advertising, Woodbine, Iowa, 1940. John Vachon.

Although the photographers working for the FSA were directed to photograph scenes from the American way of life, Vachon frequently turned his camera toward details like this.

(Library of Congress, FSA Collection)

Figure 7.12

Boone County, Arkansas, Rehabilitation Clients, August 1935. Ben Shahn.

Shahn is one of the few FSA photographers who used a 35mm camera, though he often used his Leica with a lens prism, which permitted him to appear to be photographing at right angles to the subject. (Library of Congress, FSA Collection)

Photographs that exist in more than one category are found in figure 7.11 and figure 7.12. The woman in the dark doorway, the strong pattern made by the roof shakes, and the composition in the photographed advertisement are of almost equal importance. Notice the overall similarity of shapes in these two photographs, which are examples of aesthetic and documentary intentions having equal weight.

John Vachon worked for the FSA and then as a *Life* and a *Look* staff photographer. His photographic abstraction of a billboard is documentary in the most literal sense, a fragment of a small American town. Superficially, the photo does little to describe Depression America. But the effect of in-camera selection and editing creates a surreal arrangement of facial parts, and an aesthetically interesting pattern. This documentary photograph is a sample of a large body of work, which reveals a photographer concerned more with the creation of form than with social documentation. Documentary photography becomes art when the photographer's aesthetic sense dominates.

Figure 7.13
Untitled, 1936.
Arthur Rothstein.
(Library of Congress, FSA Collection)

Ben Shahn was a painter and designer who worked three years as a photographer for the FSA in order to make a living during the depths of the Depression. Figure 7.12 shows a woman standing in front of a log house. There is little information within the picture itself that can unequivocally tell us where and when the picture was taken. The proportions of the image are those of the 35mm camera, so the picture could have been made any time in the past sixty years. The woman is white, thin, and careworn. These are the facts of the photograph. The log cabin and the woman's appearance might lead one to suspect an Appalachian scene, but the picture could also have been made in Alaska or Canada. It is not clear from the picture itself just why these people were being photographed. It is only by examining the caption that one discovers the woman and girl are recipients of a Depression-era U.S. government aid program. This fact justified the documentation; the caption completes the photo.

Hidden Meanings

The meaning of the documentary photograph usually becomes clear when the viewer knows the implied social references. But sometimes the meaning may still be elusive, even though the picture seems dramatically self-evident.

Figure 7.13 shows a man peering under the hood of an old Ford truck. A puddle of liquid on the pavement implies the car has overheated. The model of the truck, the narrowness of the road, the bareness of the road shoulder, and the absence of guard rails or fences dates the scene. The tires are bald, and the sidewall of one tire is peeling away. The truck is piled high with household goods. At a glance, one might think this was a typical, migrating "okie" during the Depression years. But the man is wearing a solid leather coat and a good hat; he has a thick, hand-rolled cigarette in his mouth. The license plate is from Tennessee. He may just be moving from one place to another, and what we have is a dramatic photograph that entertains us, but we do not really know what is happening.

Figure 7.14
Feggen Jones and Family, 1936.
Arthur Rothstein.
(Library of Congress, FSA Collection)

Figure 7.15Bud Fields and His Daughter-in-law.
Walker Evans.
(Library of Congress, FSA Collection)

The two families shown in figures 7.14 and 7.15 show how misleading the apparent information in a photograph may be, and the difficulty of defining photographic intention when the picture is uncritically viewed, without knowledge of relevant social and historical information. Both these pictures are "straight," and "unmanipulated," and they both affect our emotions. They are documentary photographs, with all the ambiguity that is implicit in that term.

Both groups were photographed indoors, and the photographer used flash bulbs. (The quality of the highlights and the sharpness of the shadows reveal the flash light. Flash bulbs would have been required for the indoor family portrait in figure 7.14 because there was no electricity in the house, and electronic flash was not yet available when the picture was made.)

Figure 7.16Young Appalachian Woman, 1986.
Mike DuBose.
(Courtesy of the photographer)

Figure 7.17Wife of Tenant Farmer, Georgia, 1936.
Walker Evans.
(Library of Congress, FSA Collection)

Figure 7.15 shows what seems to be a very poor white family. The history of these people is vividly described in *Let Us Now Praise Famous Men.*³ The other photo shows a smiling, well-fed black family. The Fields' are solemn, badly clothed, dirty, and poorly fed; the Feggens' are cheerful, well-clothed and well-fed. The poverty of the white family is clearly revealed in the bedframe with peeling paint, the pillow without a case, the rough wooden walls without paint, the failed attempts at personal cleanliness, and the clothes they are wearing.

Walker Evans' picture (figure 7.15) seems to be a complete description of the people before his camera, posed in the solemn, passive way they might have been photographed almost a century earlier. A flashbulb was used indoors to record the family, in the intimacy of their house. Rothstein (figure 7.14) used a flashbulb to freeze a fleeting gesture: the familiar, happy grin we all know how to make for the camera. The black man and his wife are well-dressed, but posed against a plain, white wall that reveals nothing about where they live, or their daily lives. Seen in the historical context of the Depression, and against the history of the status of black people in America in the 1930s, this picture is at best an untypical idealization.

A final comparison illustrates how similar subjects offering similar information can arouse profoundly different responses. The well-nourished young woman in figure 7.16 is seen striding toward the camera. She is comfortably dressed in boots, soft blue jeans, and a work shirt. Her face and body are relaxed. Compare her to the tenant farmer's wife⁴ in figure 7.17 (the negative was cropped by the photographer). Her thin body is covered by a badly made dress that is stiff, coarse, torn, and dirty. She stands barefoot on bare earth, among debris. Her frozen, awkward stance can be seen as symbolizing the poignancy of the uneducated American poor during the Depression of the 1930s. The contemporary photograph records the health and comparative wealth and freedom common even in Appalachia a half-century later. These pictures reflect different styles of documentation, as well as different cultural generations. One is rigid and bound, the other free and casual.

Information and Emotions

Looking at photographs means responding. As you respond, feelings give rise to emotions. To understand the photograph, it is necessary to catalogue the information offered and to acknowledge your own emotions.

All photographs offer information and have aesthetic content. The "art" photograph is more clearly conceived as an aesthetic statement, but it too has descriptive information (unless its photographic underpinnings have been completely concealed or destroyed). The documentary photograph made for journalism, fashion, technical, or even medical and scientific purposes often reveals formal concerns.

No photograph is only about the subject in front of the camera. The person or event is the obvious subject, but as has been shown in these examples, is not the only subject. The photographer's training and the aesthetic traditions and conventions of the time (that the picture was made, and when the picture is viewed) inevitably affected the selection of subject matter, point of view, type of lens and film, print contrast, lighting, and composition, which in turn affected our response to the picture. Consequently, there is no way to predict what emotions any given photograph will produce in a particular viewer.

In a broad sense, a pattern of emotional response can be predicted, but ultimately content is individual to the viewer. Photographic content is a sum of the descriptive information, the cultural associations, and the personal projections triggered by the print. These, in turn, are dependent on the context in which the picture is seen, its position on the printed page and what is adjacent to it, the words associated with it, and its sequence in a group of photographs.

Summary of Response

Every photograph provides information. The photograph also offers emotional and aesthetic stimuli, patterns, and abstracted form, in addition to the detailed description of events. The response you have to the photograph is a mixture of what is obvious in the picture, what you know or understand about the events described, and what you project onto the picture. Projection is unconscious and involuntary, and most difficult to assess.

You also respond to photographs according to contemporary photographic technical standards. This response may or may not be appropriate. It would be foolish to criticize a daguerreotype portrait for flat lighting and a stiff pose, when only those were available to the medium.

In a broad sense, we always make photographs of people, places, or things. Yet each photographer responds to the most commonplace subject in an individual way. The more you reveal your own inner response to any subject, the more interesting your photograph will be—you are the only person who can reveal your vision.

Dull pictures are often the result of trying to make pictures that conform to a standard way of seeing, or by photographing only acceptable subjects, like sunsets or kittens or pretty girls. The photographs and the photographers that interest us most are those who look at common subjects and offer new insights, whether into the nature of the subject, the aesthetic form it might evoke, or a new way of presenting the subject in the print.

Discussion and Assignments

Consensual content can be discovered by discussion, when you and the others around you agree on what a picture means. Implied content is often not truly consensual. Content is affected by photographic techniques (lens, contrast, lighting, etc.), by the context in which the picture is seen, the sequence in which pictures are seen, and by the words that may be associated with the picture.

Assignment 1 Have a friend provide several mounted photographs (without titles) of people or places or events you probably do not know well. Without talking about these, examine one of these for exactly a minute, then turn it face down. Then do the following:

- · immediately write down words that came to mind while looking at the picture
- on a second sheet of paper, list everything you saw in the photograph
- on a third sheet of paper, make a careful sketch of the principal shapes in the photograph as you remember them

Turn the photograph face up and compare the contents of your three sheets of paper with your new perception of the photograph. Try to discover what you failed to see or remember, and what you have distorted or lost in your sketch. Repeat this for each of the other prints.

Chapter 7

Assignment 2 Take the most powerful (interpret that word as you will) photograph from the first assignment (or use another picture if you wish). Using transparent drafting paper and a black felt-tip pen, make careful tracings of the photograph, placing the tracing paper over the photograph and drawing the border of the print, in the following ways:

- draw complete outlines around all the important highlight areas (those places that are light gray to white) on the first tracing
- draw complete outlines around all the shadowed areas (middle gray to black) on the second sheet

Color the enclosed areas solid black on each drawing. Place these tracings on clean cardboard so they can be seen as objects for themselves. Put the original photograph away and compare the tracings to each other. Study what kind of patterns are made by the highlights and by the shadows.

Notes

- 1. Rudolf Arnheim, "Compositional structure also has been treated as though it consisted of rigid geometrical patterns that were to coincide with salient points of the pictorial design—an activity in which the intellect can rejoice as long as it pays no attention to the fact that the eye fails to discover any such mechanical relation between the compositions of the masters and the superimposed geometry," Toward a Psychology of Art (Berkeley, California: University of California Press, 1966), 20.
- 2. B. Julesz and J.R. Bergen, "Textons, the fundamental elements in preattentive vision and perception of textures," *The Bell System Technical Journal*, vol. 62, no. 6 (July–August 1983), 1619–45.
- 3. James Agee and Walker Evans, *Let Us Now Praise Famous Men* (New York: Houghton Mifflin, 1960).
- 4. The Library of Congress identifies the woman as Mrs. Tengle, but she is identified as Mrs. Ricketts in Stott, *Documentary Expression and Thirties America* (New York: Oxford University Press, 1978).

8 Talking about Photos

Figure 8.1 1401 LARIMER STREET, DENVER. Arnold Gassan.

A documentary photograph made shortly before the building was destroyed. There is a great deal of information in this photograph (in signs, prices, architectural details, quality of the light and clarity of the sky), but the meaning of the picture will vary with the photographic and life experience of each viewer. (Photo by the author)

Basics

It helps to write down, or to say out loud what you think of a photograph. If you do not have a classmate or a friend to talk with, write down your responses. Putting ideas and emotions into words is sometimes hard, but worth the effort. Talking about photos is a way to isolate the information available in the photograph from the associations and emotions you bring to the picture. Talking also means to come to apply specific criteria and critical judgment to the photograph.

Criteria for Judgment

The least useful response to a photo is "I like it." That response may be true, but it inhibits further discussion. The first task is to discover what information exists in the picture. The second is to learn how much of your response to the picture comes from within you and is projective in nature. This is often hard work, but dealt with rather casually. The photograph is always at the mercy of the viewer, who may not perceive what was intended. Talking is a good way to discover the intention, even though it is hard to do at first.

Many pictures that are successful and well-received are sentimental, in that they offer no new insight into the events they describe but only confirm what we already know and believe. Popular pictures are not always good pictures, if the criteria is to provide insight into aesthetic, political, or social realities. To ask if a picture is good or bad begs the reply, "good for what?" Photographs are made for many different reasons, but they are often used for purposes other than their original use. Evaluating a photograph means to determine what criteria to apply. A *good* photograph is one that serves its intended purpose; a *bad* picture does not.

Decide on appropriate criteria, examine the informational and the aesthetic qualities of the photograph, relate these to the purpose to which the photograph is being put, and then a critical judgment follows easily. Without criteria, acceptance or rejection is hard to justify. Critical confusion arises when criteria and object are not correlated, when painting-like compositions are expected of documentary photographs, or journalistic traditions are imposed on art photography.

Photographic Composition

Photographic composition is the result of training and reaction. A photographer inevitably carries painting, drawing, and graphic design traditions into the photographic act. Figure 8.2A is an example of a self-portrait in which the subject is centered, framed according to long-standing traditions drawn from painting. Figure 8.2B is an eccentric placement in the frame that relies on the shape of the barn at right to balance the form of the face to the left. These are carefully planned photographs, intended to communicate different emotional realities.

Some photographs are truly instantaneous; the photographer saw something beginning to happen and responded without conscious planning, as in figure 8.3. Sport and event photographers are trained to make peak action pictures; they use skills that are partly learned and partly intuitive to select the instant of play that is dramatic and well-composed. The event before the camera determines the composition of the picture.

Photographs are not paintings, and cannot easily be remade. A painted perception can be repainted or overpainted. Paintings and drawings are shapes, values, and colors assembled bit by bit over a long period of time. Photographs are records of the light available to the lens only at the moment of exposure. Once a photograph is exposed, *that's it!* (unless it is manipulated

Talking about Photos 109

Figure 8.2 a. A self-portrait with the subject centered.

b. Placing the subject at one end of the frame creates a sense of movement and tension. (Photos by Amy Boyer and Tom Jares)

Figure 8.3 Field Hockey.

Sid Hastings.

Sports action photography requires handeye coordination so that the photographer can simultaneously compose a picture and find actions that illustrate important moments in the game. A 300mm lens used at a large aperture helps isolate the players from what would otherwise be an intrusive

background. (Courtesy of the photographer)

Figure 8.4

Emergency Room Examination.

Arnold Gassan.

The child has just shed a tear after being examined in an emergency room at night; framing the picture with the doctor in the

examined in an emergency room at night; framing the picture with the doctor in the foreground creates a more complex, open figure/ground construction than would happen with a more direct portrait. (Photo by the author)

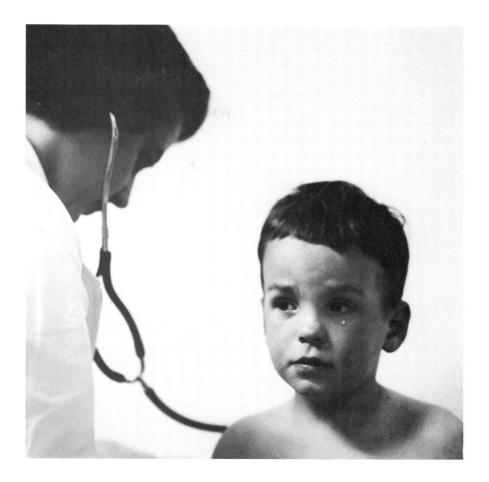

in printing). It is essential to remember this difference of imaging time when discussing or evaluating a photograph. It is silly to suggest to a photographer that a finished picture should have been composed differently, but it is not silly to suggest how changes in composition or lighting would modify the content. Those lessons can be applied in the next act of photography.

The content of most photographs is influenced by other arts. Photographers who do not plan their photos as two-dimensional compositions are rare. For example, compare the compositions by Cartier-Bresson, a photographer trained as a painter, with those of Garry Winogrand. Cartier-Bresson spoke of photographing the "decisive moment," but this, to him, was a planned moment. Winogrand photographed within the moment. Cartier-Bresson produced complex photographed designs; Winogrand reveals action in the process of taking on form. Other photographers who seem to respond to the instant (rather than primarily to formal concerns) are Geoff Winningham, Ralph Eugene Meatyard, and Mark Cohen. Compare their photographs to the carefully composed and fabricated pictures by Guy Bourdin, Helmut Newton, Robert Heinecken, Deborah Turbeville, or Bea Nettles.

In brief, event-oriented photographic composition tends to be object-centered (the camera is aimed like a gun, and the visual space is rather shallow), or a window of illusion. The window of illusion is frequently reinforced by placing a secondary object at the edge of the frame, as shown in figure 8.4. Filmmakers call this an ''over-the-shoulder'' shot, and it encourages the viewer to feel part of the picture.

Talking about Photos 111

Figure 8.5
a. Smith Feed Store, Powell, Wyoming, June 1944.

Edwin Rosskam.

The confrontive pose and use of direct flash are typical of the documentary style of the Standard Oil documentary project. (University of Louisville Photographic Archives)

b. Clinton and Mae Iroller, Patrick County, Virginia, 1978.

Carl Fleischauer

Although superficially similar to Rosskam's photograph (a), photographic convention now permits the subjects to act as though the camera did not exist in this flash-filled documentary picture made for the American Folklife Center Blue Ridge documentary project.

(American Folklife Center, Library of Congress)

Context and Content

All photographs are created within a technical, cultural, and art context:

- technical aids define what kind of picture can be made at a given point in history, i.e., camera type, lens and film speed, etc.
- · social conventions permit certain pictures; prevent or inhibit others
- aesthetic traditions in the arts interact, rewarding some images, discarding others

It is important to identify and name these influences before a picture can be fully understood and eventually evaluated in terms of its present and historical effectiveness. When any photograph is viewed out of its own time, both the subject and the photographic techniques used are reinterpreted. Today's meaning of a photograph is affected by its context. We tend to judge a picture by:

- · what is technically possible photographically to do now
- the history of art and photography
- · what is fashionable in today's art

Yet some traditions continue almost unchanged. Examine figure 8.5A and compare it with figure 8.5B. They were made almost half a century apart, and both use supplemental flash lighting to provide adequate exposure. Although superficially similar, the older picture reflects the tradition of the photographer confronting the subject, which dates from the beginning of photography, while in figure 8.5B the photographer and the subjects pretend the photographer is not present. In other words, the cultural conventions implicit in these photographs changed between the 1940s and the 1980s.

112 Chapter 8

Figure 8.6Cotton Town, Arizona, 1940.
Dorothea Lange.
(National Archives, Bureau of Agricultural Economics)

Figure 8.7

Abstraction.

L. Moholy-Nagy, ca. 1930.
(Library of Congress)

Figure 8.8

J&L Mill Building.

Ivan Massar.

(University of Louisville Photographic Archives)

The consensual content of a photograph is the information it provides: that content is always affected by contemporary references. Each photographer makes a choice as to how to frame a photograph, and no matter how hard one tries, all photographs record subjective editorial decisions. There is no objective photograph, but some photographic decisions are more obviously "aesthetic" and call attention to decisions made about style. Few photographers were as self-effacing as Dorothea Lange; most imposed a more obvious aesthetic frame on the subject, making you strongly aware of the photographer behind the camera, as well as the subject. Figure 8.6 is a picture by Lange from work done for a government bureau. It shows a truck stop—a place to buy gasoline, liquor, food. The information in the photograph includes architecture, automobile style, advertising, and the price for gas. The gas looks cheap, unless one realizes the picture was made in 1940 and one allows for inflation, which has eroded the power of the dollar. Gasoline at 21 cents in 1940 would cost about \$3.00 today. Figure 8.6 is a classic documentary picture, composed and photographed to allow the subject before the camera to be seen for itself.

Figure 8.7 is a **cliche-verre**² by Lazlo Moholy-Nagy. Form is the meaning in the Moholy-Nagy print, modified by the viewer's interest in the process used to make the print, and also by the art history references (to Cubism, to De Stijl painting) one brings to the picture. Figure 8.8 is a documentary photograph of the wall of a steel mill made in 1940 by Ivan Massar, working for Standard Oil. Except for the figure of the man, Massar's picture is as much an abstraction of form—a linear and tonal composition—as Moholy-Nagy's photographic print.

Moholy-Nagy, an Hungarian photographer/painter/filmmaker, struggled to move photography clearly into the professional art world, and to free photographers from the "factuality" of the world. Massar was a professional documentary photographer, yet obviously was aware of American painters' investigations of abstraction, which were soon to overwhelm mere representation in the arts. In both cases, the photographer interposed himself between the viewer and the print: formal aesthetic concerns were dominant.

Figure 8.9
Union Election, Local 600, 1938.
Arthur Siegel.
(Library of Congress, FSA Collection)

Figure 8.10
Cheyenne Woman, 1910
Edward S. Curtis.

Social Climate

Each photograph reflects the social climate of the time in which it was made, and your response to the photograph reflects awareness of those concerns. Study the photograph to discover:

- · what events and subjects are photographed
- · what is not being photographed
- · the photographer's attitudes toward the subject

Figure 8.9 is a photograph by Arthur Siegel of a union election. It is also an example of how photographic meaning changes with time. The picture shows a line of men waiting to vote in a union election, which is an event of political significance. In 1938, when the photo was made, unions were struggling to obtain recognition; their elections were emotional and often dangerous. By choosing a low camera angle, the photographer effectively generalized the subject by eliminating the environment. This line of men becomes typical of American workers of the time: the photograph transforms the line into a frieze, making the men larger than life.

Documentary Content

The photographer offers us the camera's reality. Any camera and film can be used to make the picture, but what is presented is always just a transcription, not the actual event before the camera. The art photograph and the documentary photograph are separated only by the photographer's intentions and aesthetics. The very definition of what is "documentary" is variable. Figure 8.10 is a portrait of a Cheyenne Indian woman, made around 1910 by Edward Curtis. Originally published in a multivolume photogravure portfolio, Curtis's commissioned photographs of vanishing Indian ways of life are examples of lustrous, beautiful printmaking. His portraits were also reconstructions rather than documentation of existing realities. He frequently had to make or supply appropriate costumes and ornaments to his impoverished subjects. Figure 8.10 is documentary, but is modeled on a series of painting portrait conventions standardized a century earlier. On looking at the photo, our response is to the style and to the aesthetics at least as much as it is to the woman.

Figure 8.11
San Ildefonso Pueblo.
Ansel Adams.
(Print by National Archives, Department of the Interior; courtesy of the Ansel Adams
Publishing Rights Trust. All rights reserved)

Figure 8.12 a. Untitled.

b. *Untitled.* (Photos by Sheila Flemming)

Compare the Curtis with figure 8.11, Ansel Adams' photograph of Indian festival dancers coming out of a modern building. The sense of drama created by careful lighting, somber tones, and shallow depth of field in Curtis' picture is missing from Adams' casual, documentary, yet historically accurate record of an afternoon performance. The awkward gestures, bland lighting, and intercepting forms add up to a **snapshot**³ in the sense the word was first intended.

Point of View

Meaning is also changed by changing point of view. Figure 8.12A is a photograph through an open doorway; compare it with figure 8.12B, the same entry hall and staircase, but seen from just within the doorway. The first photo is a record of the place, a casual encounter. The second is an abstraction of form, a complex pattern of light and shade. Both photographs describe the same place, but the difference in the point of view transforms the meaning.

Talking about Photos 115

Figure 8.13
Allie May Burroughs, 1935.
Walker Evans.
(Library of Congress, FSA Collection)

Figure 8.14Canal Point, Florida: "We never lived like hogs before."
Marion Post Wollcott.
(Library of Congress, FSA Collection)

The women seen in figure 8.13 and figure 8.14 also show how point of view influences the meaning of a photograph. Certainly, there are other effective photographic elements; lighting, camera, costume, and captions all modify meaning. But the point of view is dominant. In Walker Evans' photograph, the camera is centered on the woman's face, and there is an eye-to-eye confrontation: you look in and she looks back out. In Marion Post Wolcott's photo, the camera is at waist-level, looking up. The effect of the upward angle is to make the figure of the woman slightly ennobled, larger than life, and this point of view also permits Wolcott to include the details of the clothesline and palm tree. The other significant change from Evans' photograph is Wolcott's addition of a caption, which supposedly offers us the very words the subject was saying while the picture was being made. There is no way to avoid reaction to the words from affecting our reaction to the image.

Matters of Style

Identifying photographic style, and how it modifies content is part of preparing to talk about pictures. The transition from the view-camera to the twinlens reflex camera and the early 35mm miniature camera prepared the way for today's photographic freedom to photograph anywhere, in almost any light.

Style refers to changing modes of fashion in ways of making photographs. These affect meaning in the picture. Style also refers to costume, such as those worn by the women in figure 8.13 and figure 8.14, which affect meaning also. Both women wear dresses of traditional cut and material, but Evans' view-camera lends itself to passive confrontation, while Wolcott's picture was made possible by the twin-lens reflex, a camera that permitted her to choose an unusual point-of-view, and to focus and photograph quickly. The candid camera style suggests a mobile, restless, if not self-determining subject. The traditional view camera required the subject stand in place while the photographer disappeared under a dark cloth, and focused and prepared the camera. One had to remain still, a willing partner to the photographic dialogue until the film was exposed.

Figure 8.15a. Woman Feeding Chickens, Putnam County, Georgia, 1941.
Dorothea Lange.
(National Archives, Bureau of Agricultural Economics)

b. Schematic analysis of a, showing deep compositional space.

Figure 8.16a. *McKinley Brim Leading Betsy, 1978.*Terry Eiler.
(American Folklife Center, Library of Congress)

b. Schematic analysis of a, showing shallow compositional space.

Photographic equipment, documentary style, and pictorial composition all affect meaning. Figure 8.15*A* shows a neatly dressed woman wearing good clothes and a necklace, feeding chickens. She is fully conscious of the photographer's presence. Dorothea Lange had an open dialogue between her camera and subject. Figure 8.15*B* offers a schematic analysis of the picture, showing how the spatial relationships are affected by the great depth of field and the careful placement of the figure against the tree behind her. A slow shutter speed was used (evidenced by the blurred chickens). The subject of the photograph is the woman in her environment, and by suggestion the photograph is about the pattern of that life.

Figure 8.16A is a contemporary 35mm picture of a man leading a cow. The subject is the man and the cow and the chain, which are seen as a pattern within the frame; all else is reduced to blur. The photographer stood at a distance and used a long lens, with a narrow depth of field. The schematic analysis in figure 8.16B discloses clearly how the small camera with a long lens selects a thin slice of time and space, and the photographer remains at a distance.

Figure 8.17Resettlement Administration Housing, 1936–1937.
Paul Carter.
(Library of Congress, FSA Collection)

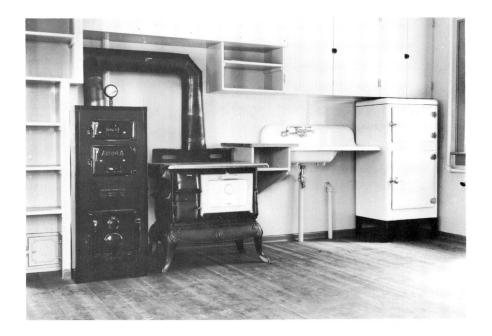

Figure 8.18
Corner of Bud Field's House, 1935.
Walker Evans.
(Library of Congress, FSA Collection)

Symbolic Content

A photograph may both describe and be symbolic. Figure 8.17 and figure 8.18 are documentary photographs of kitchens, made within a year of one another and in the same part of the United States. Paul Carter's picture describes an "ideal" farm kitchen of the time: one sees a coal-fired bake oven; stove; sink with running water; icebox for food storage; smooth, clean walls; storage cabinets; shelves; tight wooden flooring. Walker Evans' picture reveals the contemporary tenant-farmer's kitchen in Georgia: one sees a crude wood-fired stove; a ragged pile of kindling; old pots and pans, hung from the wall; wood walls with only traces of paint and cracks open to the weather; rough floor with large cracks; a chair without a seat.

Figure 8.19
a. Cotton Worker, Arizona, 1942 (hand raised).
Dorothea Lange.
(National Archives, Bureau of Agricultural Economics)

b. Cotton Worker, Arizona, 1942 (hand down).
 Dorothea Lange.
 (National Archives, Bureau of Agricultural Economics)

Both pictures are documentary, and each reveal clear aesthetic intent, in the way they are composed. The Carter photograph was propaganda, made to show what life could be like; in its time it was symbolic of an ideal way to live. The Evans photograph has becomes symbolic to us of the life of the rural poor during the Depression.

Symbolic content in photographs may not withstand scrutiny. Figure 8.19A is a dramatic picture of a man working in a cotton field in Arizona, photographed by Dorothea Lange. Hand held in front of his staring face, the worker's gesture holds the viewer at bay. The photo hints of fear, exhaustion, and anger. It is vivid, clearly a symbolic gesture, one that easily lends itself to emotional interpretation. This symbolic gesture may be nothing more than the action of a hot man wiping his mouth with the back of his hand. Figure 8.19B is another Lange picture from the same time. The same man is just resting, leaning against a rough timber, his cotton sack slung over his shoulder. The second picture is not melodramatic or threatening. Both pictures are suggestive, but the mood is different in each; the low point of view enhances the power of the figure in both, and the clear sky provides a neutral ground for the worker. The apparent symbolism of the first picture is a result of the photographer's skill in capturing a gesture that for a fleeting moment portrayed a feeling common to the times. This was enhanced by her editing and printing that selection; the gesture caught by the camera symbolizes the time.

Deciding for Yourself

The portraits in figure 8.20 and figure 8.21 can be used to explore how apparent content is influenced by composition, point of view, contrast, lighting, symbols, placement of the subject, and costume. In figure 8.20, the man is seen against a winter-dead tree, from below a normal horizon, through the dark frame of a water-streaked screen.

Talking about Photos 119

Figure 8.20
Untitled.
Frederick M. Schreiber.
(Courtesy of the photographer)

Figure 8.21
Untitled.
David Myers.
(Courtesy of the photographer)

Figure 8.21 shows the same man standing in the middle of an arena, in open light, clearly defined against the fence and the background trees. What you think is the content of each picture is actually an amalgam of the descriptive information found in these pictures; the cultural, aesthetic, and life-experience associations you may bring from experiencing similar scenes; and the involuntary projective emotional response each picture triggers in you.

Critical Judgment

Being willing and able to talk about what you see and what you feel, and the emotions aroused by those feelings is necessary for evaluating a photograph. Look for the information available in the photograph. Make a catalogue of it, to be sure you understand what is the physical subject of the picture. The apparent content of the photograph is the sum of:

- · consensual information
- personal associations
- · involuntary projections

Only the descriptive information is available to all viewers. The associations generated by a photograph may be similar for viewers raised in the same culture, in the same era, but even that is not guaranteed. And the projections are inevitably individual, variable, and cannot be compared; frequently, the projective content is not even directly available to the viewer, but must be inferred.

Content assessment is necessary to understanding the photograph. Critical judgment of a photograph means to determine its contemporary and historical value. Making a critical judgment means to evaluate the following elements:

- · the craftsmanship of the picture
- · the appropriateness to its use
- · the quality of insight into the event

Evaluating these requires suitable criteria, and knowledge of the medium and the historical context. Photographs can be good, and not be likable; they can be bad, and be quite pleasant to see. As you experience more and more photographs, work at becoming aware of how you make judgments, and how these evaluations change as your awareness of the visual world enlarges.

Discussion and Assignments

Discovering the limits of consensual knowledge about a photograph is not difficult, and often proves to be exciting.

Assignment 1 Work with four or five other photographers and have each person bring a photograph he or she is willing to investigate (these can be new or historical pictures). Do not talk about the pictures or offer any response before beginning the assignment. Keep the pictures well-separated, place them on a print rail or a table and then study them one at a time. Use a separate sheet of paper for each picture. Write answers to the following questions:

- · What is the mood of the picture?
- · What was the photographer trying to convey?
- · What do you think is the story of the picture?
- What technical or craft manipulations are present that affect the meaning (lighting, contrast, tone, etc.)?
- If the picture is not contemporary, can you tell from the picture when it was made?
- · What other question do you think is important to ask?

When you have each finished, tape all the answer sheets for a given picture to the wall above the print and compare the answers. Find out how much information was held in common within the group and how much divergence there was. If you feel comfortable about it, discuss the differing answers to discover where they came from.

Assignment 2 Choose three photographs of your own that you think are clear visual statements. Use prints that are not matted and that you are willing to have damaged by frequent handling. Over a week or ten days offer these three prints to at least twenty people; some of them may be people you know, but the majority should be comparative strangers, and at least half should not be artists or photographers or communications majors (i.e., people with special skill or training in visual communication). As you hand them the prints ask them to answer these questions:

- · What is the picture about?
- · Is there anything you would change in it?
- · Does it remind you of any other photograph?

Write down the answers as they are given to you. When the entire project is completed, see what kind of consensus your pictures achieve, and how you feel about the results.

Notes

- 1. Annie Dillard, "Sentimental art, for instance, attempts to force preexistent emotions upon us," *Living by Fiction* (Perennial Library New York: Harper & Row, 1982), 26.
- 2. Cliche-verre is literally "drawing on glass," and describes any hand-made negative. The first cliche-verre were apparently made in the 1840s by the French painter Corot, who scratched drawings into the emulsion of fogged plates provided by friends. They then made prints of his drawings. The cliche-verre is close to the photogram in that both are photographic printmaking without a camera.

Contemporary variations on the *cliche-verre* have been created by Man Ray, in the 1920s; Francis Bruggiere, who painted on glass; Henry Holmes Smith, who poured thin films of syrup on glass sheets, recorded the liquid forms on film, and made dye-transfer color prints of the abstract shapes; and by Frederick Sommer, who caught swirls of oily smoke on glass, then printed these to create surrealistic figures.

3. Snapshot was adapted to photography by Sir John Herschel, who used the bird-hunting term to describe an instantaneous photograph, made without careful consideration because the target was moving. Herschel also suggested, in 1839, that the original camera image of reversed values be called a **negative** and the subsequent print from it be a **positive**.

9 Negative Development

Figure 9.1
UNTITLED.
Darcy Bisker.
A 35mm Ilford HP5 negative was developed in Edwal FG7 with sulfite, and the negative printed on Agfa Portriga Rapid paper.
(Courtesy of the photographer)

a

Figure 9.2

a. Tri-X Pan silver halide crystals (3000X).
b. T-Max 400 silver halide crystals (3000X).
(Photos courtesy Eastman Kodak Company)

Compromises

The 35mm camera offers the photographer great freedom, but in exchange one gives up exposure-development control over individual pictures. Imagine that you have exposed thirty-two frames of photographs on the beach, where the sand and the water reflect light into the shadows, limiting the brightness range of the subject. You leave the beach, and on the walk back to your car pass through woods, where you expose the last four frames on the roll, on the dappled light coming through the branches. The brightness range of your subject is much greater.

In the darkroom, you must decide whether to develop the film for the beach scenes (low contrast) or for the wooded area pictures (high contrast) in order to make the best possible prints. Which to preserve; which to sacrifice? The high-contrast scenes are together and at the end of the roll, so they *could* be cut off and developed separately. But what usually happens is that photographers intermingle scenes of different brightness ranges. Small camera photography almost always involves a compromise between quantity and quality of exposures.

Types of Film

A number of excellent black-and-white films are available, and they all have these characteristics:

Sensitivity: Films are evaluated according to how little light is needed to produce a usable image. Several numbering systems have been used to indicate photosensitivity, or film speed. In recent years the ASA (American Standards Association) was replaced by ANSI (American National Standards Institute), and it in turn by the ISO (International Standards Organization). European films are marked according to the DIN (Deutsche Industrie Norm) numbers. Films with standard or experimental ISO ratings from about 25 to 3000 or more are now available. The ISO rating for the film is a starting point for exposure, but you may need to establish a personal Exposure Index (EI), which compensates for variables of exposure and development in your system.

Contrast: The density range a film produces from being exposed to a given luminance range determines the film's inherent contrast. All general-purpose 35mm films now are very sensitive to development control of contrast, through varying developing time, dilutions, or developer formula.

Acutance: Film is graded according to how many lines of information per millimeter it can **resolve.** The resolving power of a film is also called **edge sharpness,** which is a measure of the diffusion of light within the emulsion. Slow films have higher acutance than fast films, but acutance is also affected by development; e.g., developers with large amounts of sodium sulfite produce images with lower edge sharpness. High acutance developers produce negatives with more obvious grain but less acutance, compared to "fine-grain" developers. The distribution of silver halide grains in the emulsion controls the acutance. Figures 9.2A and 9.2B show how the silver salts are distributed in Tri-X and T-Max films.

Color sensitivity: Most contemporary 35mm films are **panchromatic**, meaning they respond well to all visible light. The principal exception is infrared film, which is sensitive to visible light and infrared radiation (the long-wave radiation just beyond the visible spectrum, which we perceive as heat). Ektagraphic HC film is **orthochromatic**, i.e., not sensitive to red or yellow light, as well as having very high contrast (though it can be processed for more moderate contrast by using a very dilute, or all-Elon developer).

Figure 9.3
Cross section of typical black-and-white film (not to scale).

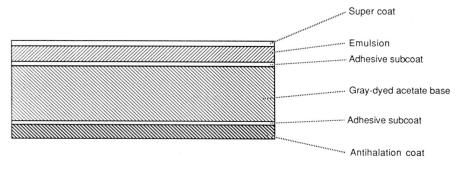

Figure 9.4Silver image, irradiation, and halation effects in photographic emulsion.

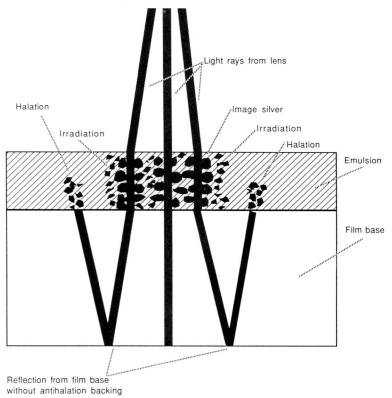

Light and Film

Light enters the emulsion when film is exposed and encounters silver halide particles. If there is enough light, the halides begin to break down into silver metal. Microscopic specks of instability caused by the impact of light are the basis of the latent image, which can be made visible by development. Some light passes on through the emulsion.

Figure 9.3 partially illustrates the complexity of contemporary films. The base is a gray-dyed plastic support. The emulsion may consist of two or more layers of gelatin. A very thin coat of chemically hardened gelatin (without any sensitive halides) protects the emulsion. The back of most films is coated with a darkened **antihalation** layer of gelatin to prevent an image formed by the reflected light. The dyes in the antihalation layer are absorbed during processing. The antihalation layer also helps keep film from curling by balancing the film's structure.

Figure 9.4 illustrates how a complex silver image is formed during an exposure. **Irradiation** is a secondary latent image created by the image-forming light. Large silver halide particles act as mirrors and reflect some light laterally onto smaller particles. Both irradiation and halation are undesirable because they reduce resolution.

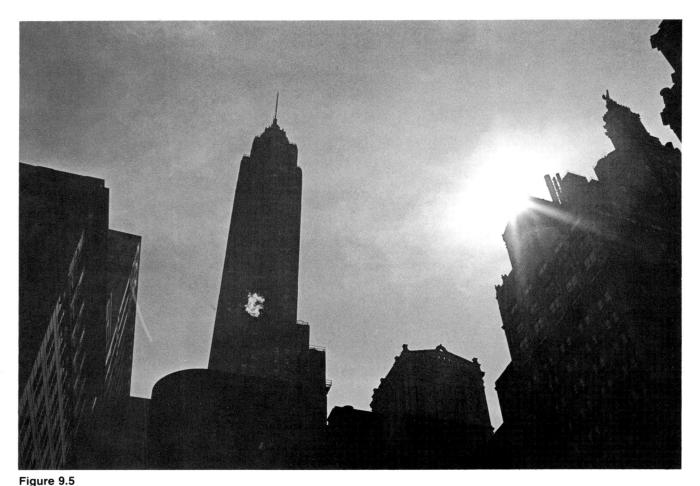

Untitled.

Arnold Gassan.
The sun, hidden behind a tall building, created the flare, which is used here as an aesthetic response to the New York skyline.
The faint light edge around the tall buildings left of center is an example of bromide desensitization at the interface between heavily and lightly exposed areas of film.

(Photo by the author)

Density Defined

Density is a measure of how much passes through the negative as compared to how much light is shining on it; i.e., a comparison of the transmitted light to the incident light. If the film absorbed no light at all, it would have a transmission of 100%, or an opacity of 0%. If it absorbed half the light, it would have a transmission of 50%, and an opacity of 50%. Opacities important to photography generally lie between 50% and 100%. Mathematically, this is expressed as:

$$\textbf{T} \text{ (transmission)} = \frac{\text{transmitted light}}{\text{incident light}}$$

The opposite of **T** is opacity:

opacity =
$$O = 1/T$$

Density is the logarithm to the base 10 of **O**, the **Opacity**. Logarithms provide a mathematical means of expressing large numbers in a very compact form. For example, a density of 1.0 is equivalent to a transmission of only 10%, a density of 2.0 is a transmission of 1.0%, and a density of 3.0 is a transmission of 0.1%. While you need not know logarithms, there are common density numbers that occur frequently and are convenient to know. These are the most important density numbers for 35mm negative films:

0.30 = typical minimum density

0.80 = typical middle gray density

1.20 = typical detailed highlight density

Figure 9.6Specular and diffuse effects in photographic emulsion.

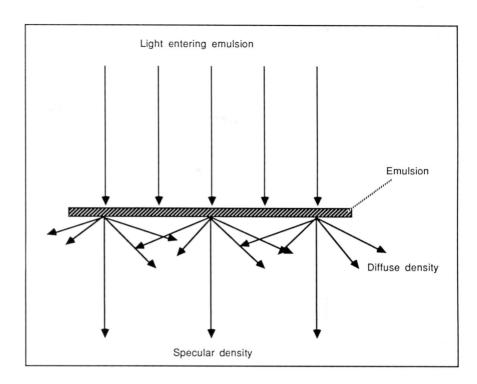

Density Effects

The apparent density is affected by *how* the light passes through the emulsion, as shown in figure 9.6. Parallel rays are used to measure **specular density**. Scattered or diffused light is used to measure **diffuse density**.

Contact printing (or enlarging with a diffusion enlarger) makes use of diffuse density. Condenser enlargers make more use of specular than diffuse light; this creates a contrast increase called the **Callier effect** (after Andre Callier, 1909) when printing with specular densities. The Callier coefficient is the ratio of specular density to diffuse density, and it is equivalent to almost a paper contrast grade increase when one changes from diffuse to specular density printing (as when changing from a contact print to an enlarged print made with a condenser enlarger). Another way of presenting this is to say a print made by a condenser enlarger is more contrasty than a print from the same negative printed by contact, or with a diffusion enlarger. This contrast effect must be allowed for when developing the negative; Kodak consistently recommends diffuse density developing times, which are much longer than condenser enlarger developing times.

Ideal Negatives

An ideal negative can be defined as one with a minimum image density, that will keep shadow detail, and will also have correct highlight densities. Correct exposure and development are required to produce such a negative. An ideal negative can also be defined as one that permits making a *full-substance* and *full-scale* rendering of the subject. A full substance print is one that adequately suggests surfaces in the original subject, from dark, shadowed leather to brilliant white shirts. Full scale means that the reflective range of the print is used, from paper white to the richest black possible with the silver in that paper. Full-scale, full-substance printing is an ideal that may not be suitable for all photographs.

Figure 9.7
The right way to examine negatives to evaluate printing characteristics is by using reflected light.

Estimating Density

You can train your eye to estimate negative densities quite accurately. First, do not try to evaluate negative densities by looking directly at a light source (see figure 9.7). The light itself becomes a distraction, but more important it misleads you into seeing detail in densities that cannot easily be printed.

Correct highlight densities are very slightly transparent when examined by reflected light. Evaluate a negative intended for a condenser enlarger by looking through the negative highlights at the print of a book or magazine printed on white paper, as shown in figure 9.7. Try to make out the shapes of the letters on the page. You should be just able to see text through the dense highlights, and the shadows should have obvious detail in them. The Technical Pan negative in figure 9.7 has a very clear film base, and will print on normal contrast grade paper. (A negative suitable for a diffusion enlarger will have highlight areas that are just opaque, but it is more difficult to visually estimate these densities.)

Characteristic Curves

Figure 9.8 shows how silver halides respond to increasing exposure. Basic research in silver halide photosensitivity was published in 1890 by Hurter and Driffeld. They determined that each silver halide emulsion has a **characteristic curve**, also called the density versus log exposure curve (or D log E curve, or the H & D curve).

The gelatin of the emulsion, the plastic film itself, the subcoatings, and the antihalation layer all absorb light, becoming the **film base** density. Even without deliberate exposure there is always some developed density because of heat, X-ray, and other radiation exposure. This non-image density is called **fog.** The cumulative opacity is the **film base plus fog** (FB+F).

The characteristic curve for any film is a product of the emulsion, the developer formula, and developing time, temperature, and agitation. Figure 9.9 illustrates how the density of an emulsion changes as developing time is changed. All four curves originate at FB+F. The units of exposure in figure 9.9 are each twice the previous one, i.e., if the *basic* unit is one second, then the *second* unit would be two seconds, the *third* unit would be four seconds, and the *fourth* unit would be eight seconds. These units can be compared to opening the lens of a camera a full f-number (or stop) for each new exposure.

Figure 9.8
Characteristic curve for all silver halide emulsions.

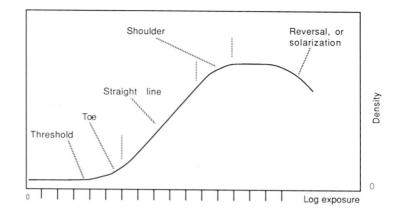

Figure 9.9A family of characteristic curves, showing how density for exposed film changes with developing time.

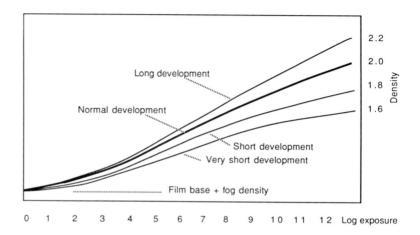

The exposure required to produce any increase in density above FB+F is a measure of the **threshold** sensitivity of the emulsion. The first exposures above the threshold describe the weak response of the halides to small exposures and this area is called the **toe** of the characteristic curve.

An increase of about three units or stops of exposure are required to move past the toe to where equal increases of exposure result in equal increases in density. This is the **straight-line** section of the curve, which has a linear response to light; it lasts for ten or more units (or stops) of exposure.

Emulsions produce less and less density increase despite continuing exposure when most of the silver halides have been made unstable by exposure to light; this area of diminishing response is called the **shoulder.** A great increase in exposure beyond this point will actually begin to decrease density as exposure increases, which is called **solarization.**¹

What the characteristic curve does not reveal clearly is that it is the result of various exposures but only a single developing time. As developing time is changed, important density variations appear in the curve, as shown in figure 9.9. This curve makes it clear that density in areas with little exposure (shadow values in the negative, or highlights in the print) do not increase much with increased development compared to heavily exposed areas.

In other words, increasing developing time always increases contrast (overall density range), but does not usually significantly increase useful shadow detail. The tabular grain technology of the Kodak T-Max films seems to provide *some* increase in lower densities with increased development, but the overall density range, or contrast change is still proportional to the development.

Negative Development 129

Figure 9.10 Negatives print best when their density range matches the contrast of the paper. The graph represents the idealized density correspondences between 35mm film negatives and printing paper contrast grades.

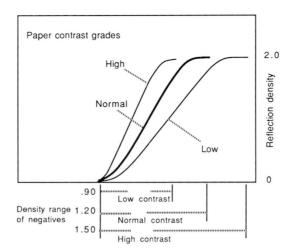

All contemporary high-speed films have a gentle slope of toe, which is significant in that a soft toe minimizes shadow detail separation. The only way to avoid this problem (which is a matter of aesthetics) with high-speed films is to *increase exposure* when dark shadow details must be clearly separated. Increasing exposure moves important shadow details up the curve, beyond the toe, but the extra exposure also increases grain size.

Matching Negatives to Paper

Each contrast grade of printing paper is designed to make good prints from negatives with a defined density range. Density numbers are useful in describing negative contrast exactly. They make comparison of negatives easy, and the numbers correlate negatives with paper contrast grades. Figure 9.10 shows idealized characteristic curves for enlarging paper. Note how these rise from near zero reflective density (where almost all the light is reflected) to a density of about 2.0 (the maximum black that most papers produce). The figure also shows density ranges for high-, normal-, and low-contrast 35mm negatives.

A print with both correct highlight and shadow values is produced easily when the negative density range matches the paper's characteristic curve. If the negative has a longer density range (is more contrasty), then either shadow or highlight details will be lost. For a flat negative, either the highlights are correct and the shadows are weak, or the shadows have the correct darkness and the highlights are gray.

Figure 9.11 suggests the compromises made when printing mismatched negatives and paper contrast grades. Given a high-contrast negative, either the highlight details may be printed correctly, and the shadows fall into black, or the shadows may be printed correctly and the highlights lose detail. This is not always bad. In figure 9.12, a slightly contrasty negative clearly separates the three runners from the background; the photographer chose to print for shadow detail and let the distant shoreline blend into the sky.

Developing Times

Manufacturer's recommended processing times are only suggestions, although they are based on rigorous testing. The recommended negative development times provided by Kodak are for diffuse density printing, and are usually 15–20% *longer* than needed to produce correct condenser enlarger printing densities.²

130 Chapter 9

Figure 9.11

When only one contrast grade of paper is available, then a compromise must be made when printing, and either the print will appear flat or detail will be lost, depending on the density range of the negative.

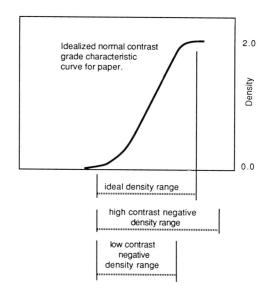

Figure 9.12
Marvin Hagler in Training. Ben Brink.

Tri-X film, a long lens, and full development produced this graphic image. Tonal detail is lost in both the very low and the light gray tones, but good separation of middle gray values results from moderate increase of development time.

(Courtesy of the photographer)

Figure 9.13

Characteristic curves for T-Max 400 35mm film developed in T-Max developer at 75 degrees F.

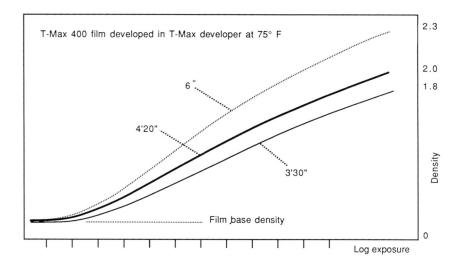

Negative Development 131

Figure 9.14

Testing a film and developer to find a correct EI and developing time requires only a sheet of white paper (or a standard 18% reflectance gray card) mounted in even light. The camera is focused on ∞ to avoid recording irregularities in the target.

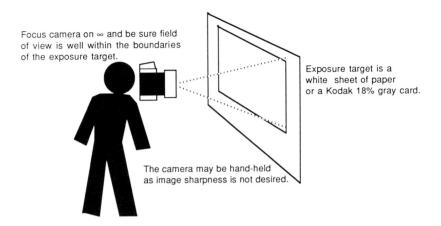

In the long run it is better to test a developer or film for yourself than unquestioningly accept data sheet recommendations. Also, it must be realized that small differences in agitation technique or developing temperature have significant effects on film contrast. Finally, a poorly exposed and developed negative will hardly ever yield a good print, despite the variety of printing controls that are available.

Expose and develop at least one experimental, test roll for any new film and developer combination to find a suitable developing time for your negatives. The degree of contrast you find pleasing in your prints, and the type of enlarger you use will affect development.

Any combination of film and developer can be easily tested and evaluated. Testing requires using five consecutive frames of film, on several rolls. Expose these as follows:

- A. Hang a large piece of white paper where it is evenly lighted. This may be in open shade or direct sunlight, pinned to a wall or hanging from a clothesline.
- B. Stand close enough to the target so that pictures can be made of only the paper; do not photograph your own shadow.
- C. Focus the camera on infinity, not on the paper; photograph only the reflected light, not the smudges and imperfections of the target sheet.

When the camera is pointed at the paper, write down the indicated meter exposure (just to have a record in case you make a mistake), but actually expose five frames as follows:

- 1: 5 stops less than indicated
- 2: 4 stops less than indicated
- 3: at the indicated exposure
- 4: 3 stops more than indicated
- 5: 4 stops more than indicated

Use the rest of the roll of film to expose the pictures you want, then process the new film and developer combination, using the manufacturer's recommendation. The film should resemble figure 9.15. If there is no recommended developing time available (which happens when using one manufacturer's film with another's developer), look for instructions for similar film/developer combinations. Films of similar speed often respond in similar ways. Make a careful contact proof of the film, and dry it. Expose the contact

Figure 9.15 Ideal five-frame exposure and development test film.

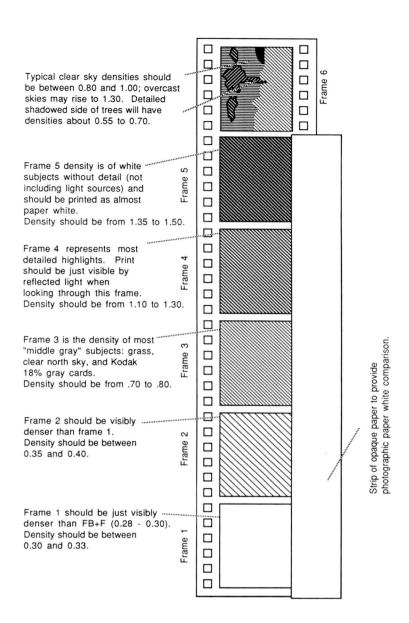

proof so that frame 5 is *just visible* (off-white) on the print. Because the wet emulsion will prevent you from seeing small differences in these gray values, rinse the print to remove fixer, and dry it quickly to evaluate the print exposure before continuing. See figures 9.16*A-D* for examples of printing errors that can mislead you in making a correct exposure-development assessment.

Negative Exposure Checks

Examine the film itself. Compare it to figure 9.16*A-D*. Frame 1 should be just visible, when compared to FB+F. If it is *fully* visible then the film is *overex-posed*, and future rolls should be given *less exposure*. To correct this problem, increase your camera El one half stop: if you were using 400, reset it to 600. If your camera is DX-coded, change the meter adjustment ring to decrease exposure 1/2 stop.

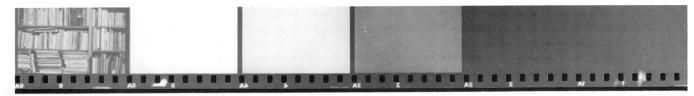

a

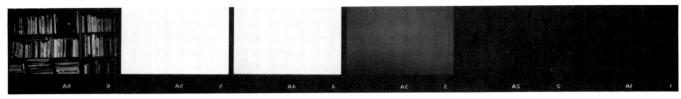

b.

C.

d.

Figure 9.16

- a. Underexposed and underdeveloped film: no separation between first two frames. Because the contact proof is exposed for correct highlight values (as determined by the most dense frame), the FB+F density does not even come close to the maximum black paper density.
- b. Underexposed and overdeveloped film: maximum density frames are printed for paper white and first visible separation, but the underexposed film produces no visible separation between the first frames and FB+F.
- c. Overexposed and underdeveloped film: printing for negative highlight values reveals the greater density in the shadows, which would be suitable for some scenes but would also make the grain more visible.
- d. Overexposed and overdeveloped film: this combination produces too much contrast and also creates more visible grain.

TABLE 9.1 Five-Frame Test Analysis

Negative	P	rint	Corrections
Exposure	Development	Shadows	
A: under	under	weak	intensify negative increase paper contrast
B: under C: over	over under	too dark weak	decrease paper contrast reduce negative densities
D: over	over	too dark	increase paper contrast reduce negative densities decrease paper contrast

Corrections for Future Negatives

- A: increase exposure 1 stop, increase development 15-25%
- B: increase exposure 1 stop, decrease development 10-20%
- C: decrease exposure 1 stop, increase development 15-25%
- D: decrease exposure 1 stop, decrease development 10-20%

*(for T-Max developer, use the smaller corrections; for D-76, use the larger corrections)

When frame 1 shows *no change* from the surrounding density, the film is *underexposed* and future exposures must be *increased*. Reset the camera meter EI from 400 to 300, or change the DX adjustment -1/2. When frame 1 and frame 2 are the *same value* as the surrounding film, you are *underexposing* a stop or more. *Decrease* the meter EI by half, or change the DX adjustment +1.

Proof Exposure and Contrast

The contact print is an example of diffuse density printing. When the contact proof on your normal contrast grade paper is correctly exposed and developed, the difference between frame 1 and the surrounding black should be slight, and the sprocket holes should be *just visible* when the print is viewed in good light. If there is correct highlight detail but *no separation* between negative FB+F and maximum black in the contact proof, the enlarged print made on the same contrast grade will be contrasty.

Frame 1 film should have slightly more density than the unexposed (FB+F) film surrounding it. It should be slightly more dense because a little error on the side of overexposure is better than a little error on the side of underexposure. It is better to have printable negative detail than to have a negative with minimum grain but no printable shadow detail.

When frame 1 is only a dark gray and is clearly visible in the print compared to FB+F densities, it indicates the film is underdeveloped (for that contrast grade paper). Future rolls must be developed longer or a higher contrast grade paper should be used. When frame 1 in the print is black as the FB+F, there is too much contrast. Develop future negatives less or print with a lower contrast grade paper.

In any case, frame 5 in the negative should be somewhat transparent. One can have correct density range *and* also have overexposed film; in fact, this is the most common error. Frame 5 should be transparent enough that you can just barely make out the shapes of type in a magazine or book when you look through the film by reflected light (see figure 9.7).

The five-frame test should be repeated until you have correct exposure and development for your film. Exposing similar test frames from time to time as you continue photographing will provide confirmation of correct exposure and development technique.

Printing for Highlights

All silver emulsions are similar. As the negative exposure is adjusted for correct shadow detail (where there is little silver density), print exposure is adjusted for highlights (where there is little silver density). Paper contrast grade (and/or developing formula, or developing times) may be varied to control shadow values. With most variable contrast papers and filters, the emulsions and filters are now adjusted so that similar exposures will produce similar highlight values when changing from one filter color (i.e., equivalent paper grade) to the next. The shadows become darker or lighter, according to choice.

Choosing a Developer

There are many good developers for sale; most photographers settle on one or two. Developers differ in subtle ways in how they transform silver halides into images. There are general purpose, fine-grain, and high-speed developers. In many cases a developer can be diluted or modified to approximate the effect of another developer.

Experiment carefully with a new developer by exposing test rolls on subjects that interest you. Make a five-frame test section; expose the rest of the film on typical subjects. Process the film and determine that it is, in fact, exposed and developed correctly, then print it. Compare the prints with prints made from negatives developed in your standard developer for differences in shadow area details, middle tone separation, highlight details, and overall contrast. Compare grain produced by the new developer and your old standby.

Negative Development 135

TABLE 9.2

Recommended Film Developers

General Use Developers

Kodak T-Max: med/fine grain (high Kodak Microdol-X (half ISO film energy and fine grain) Kodak D-76: med/fine grain (similar to Ilford ID-11) Kodak HC-110: med/fine grain (high acutance)

Kodak Hobby-Pac: med/fine grain (similar to HC-110)

Edwal FG7: med/fine grain (dilution Beutlera: fine grain, high acutance

Fine Grain Developers

speed) Edwal FG7b (1:15 w/ sulfite) Edwal Super 20 (best for Panatomic-X) Kodak Technidol (for Technical

High-Energy Developers

Kodak T-Max: fine grain, high energy Acufine Acufinec: medium (2-4 x ISO)

Acufine Diafinec: fine (3+ x ISO) Kodak Hobby-Pacb, c medium (w/ sulfite grain, speed = Acufine)

^aDeveloper must be prepared by the user. There are many other excellent film developers described in the literature. bTo prepare 500 ml of developer, almost fill a 35mm film plastic canister with sodium sulfite. cReduced agitation is used: invert tank three or four times in the first thirty seconds, then invert gently from one to four times at the beginning of each minute of development.

TABLE 9.3

Beutler Developer (Economical, fine grain, high acutance developer.)

For Maximum Storage Life

Bring to a boil in an enamel or glass pan the quantity of liquid noted. Let the water cool to about 125°F. Stir in chemicals in order listed, pour into bottles, and let cool. Cap them when at room temperature. Because most free oxygen has been removed by boiling, the storage life is excellent. The chemicals are listed in common measure: $\mathbf{t} = \text{teaspoon}$ and $\mathbf{T} = \text{tablespoon}$

Solution A

3 t Elon 2 T sodium sulfite water 1 liter

Solution B

sodium carbonate 8T + 2t1 liter water

To Use

At 68°F., add A and B stock and water to complete 500 ml of solution. The following dilutions are for normal contrast. The range of A is 25-45 ml. The range for B is from 20-50 ml, depending on the film and the contrast desired; increasing either developing agent or alkali increases contrast. Use standard agitation: developing times are five minutes at 68°F.

FILM	A	В
Pan F	45ml	20ml
FP 4	45ml	25ml
T-Max	45ml	35ml
Add water to make 500	ml. Use mixed solutions immediately bu	ut only once.

Finally, when you experiment with another developer, make test exposures of "unimportant subjects." Beginning photographers often expose important pictures based on hearsay, believing that they can safely expose at 2, 3, or even 4 times the standard ISO rating, and are disappointed at what actually develops.

Pushing Film

Film sensitivity (or film speed, or ISO) is determined by the silver halides in the emulsion; increasing the developing time or modifying the developer will usually only produce more useful images in the heavily exposed areas. Increasing developing time will not significantly increase the amount of usable silver density in the darkest shadows. Pushing film increases contrast in the middle and high values and makes a printable picture with very dark shadows.

Figure 9.17 *Untitled.*Blake Madden.

The swimmer was photographed with Tri-X rated at El 1600, developed in Edwal FG7 with sulfite. The result is an increase in both contrast and grain, producing a print with obvious grain and strong tonal separation. (Courtesy of the photographer)

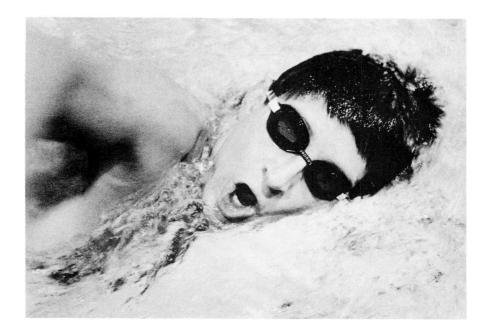

Figure 9.17 shows a typical "pushed" Tri-X negative print, with visible grain and good contrast in the middle gray values, but little or no separation in dark shadow areas. Pushing T-Max does increase mid-shadow densities but also inevitably raises highlight densities and increases contrast.

Agitation

Agitation is always an important processing control: note that not all film and developer combinations will respond well to standard agitation. Kodak's Technical Pan film in Technidol developer, and *any* high-speed film given push processing in Acufine's Acufine developer requires very gentle agitation (1–4 inversions per minute, rather than 10–15) or the result will be very uneven development and high contrast for Technical Pan, and large grain, for Acufine. In fact, with any developer, contrast may be raised or lowered significantly by halving or doubling the inversions of the developing tank in each minute of developing time.

High-Contrast Scenes

Many scenes that appear contrasty are in fact composed of two normal (or even flat) scenes: one brightly lit, the other in shade. These do not respond well to exposure-development control and both the brighter and darker scenes will suffer when development times are shortened to reduce contrast. Try to recognize this problem and compose the picture in a different way, separating bright and dark areas into separate photos.

High-contrast scenes require more exposure than flatly lit scenes. Many scenes are more contrasty than the eye sees. Almost all indoor scenes illuminated by artificial light are quite contrasty. Likewise, most outdoor scenes under direct sunlight and with sharp shadows are contrasty. The way to control contrast is to reduce the negative development time or agitation, or use a more dilute developer to limit development of highlight densities. T-Max developer can be diluted to 1:6 (with developing times approximately doubled) to achieve normal shadow detail while retaining printable highlights. Reducing development time will usually cause some loss of density in the middle-value shadows.

Negative Development 137

Some TTL metering systems will underexpose high-contrast scenes because the bright light sources in the picture unbalance light averaging calculations. When photographing indoors or in very contrasty outdoor lighting, and a full-scale, full-substance photograph is desired, reduce the EI setting by half; i.e., when using an ISO 400 film, set your meter at 200 or adjust your DX control to ± 1 . This is a one-stop correction and will usually provide a minimum safe exposure, and compensate for metering error.

Summary

Well-exposed and developed negatives enable one to produce acceptable prints with little manipulation during printing. The ideal 35mm negative is defined as having minimum density but printable shadow detail, and a detailed highlight density that is just translucent when viewed by reflected light. Such a negative will print easily on contrast grade 3 paper and produce a full-scale, full-substance transcription of the original scene.

Negative shadow densities are set mostly by exposure and typical highlight densities are adjusted by the developer formula, time, temperature, agitation used, and the developer dilution. Decreasing time, temperature or agitation, or increasing developer dilution will decrease contrast.

Discussion and Assignments

Exposure and development together affect grain structure, as do density and contrast. The following assignments investigate these relationships.

Assignment 1 Photograph a scene at four different exposures:

- · 1 stop under the metered exposure
- · at the metered exposure
- · 1 stop over the metered exposure
- · 3 stops over the metered exposure

Finish the roll of film and develop it for the contrast of the majority of the scenes on the roll. Carefully enlarge and print for identical highlight gray values an 8" x 10" section from the biggest enlargement you can produce of the full frame of each of the four test exposures. Compare the prints for grain size in the highlights, and for useful detail and correct blackness in the shadows.

Assignment 2 Expose a roll of film to similar contrasty scenes, using your usual metering method. In the dark, cut the film in half. Store both pieces (a Kodak film canister is lighttight and can be used for safe storage; Ilford canisters are not lighttight). Develop one piece in your regular developer, but for 20% less than your normal developing time. Develop the other piece in your regular developer, but agitate by inverting the tank sharply twice only at the beginning of each minute. Fix, wash, dry, and print scenes from both strips of film and compare them for adequate shadow detail and printable highlight densities.

Assignment 3 Expose a roll of film of normal scenes. Cut the film in half and develop one half in your usual developer for the normal time. Develop the second half in a developer that is new to you, for the time suggested by the manufacturer. Enlarge and print similar scenes and compare them for grain, contrast, shadow detail, and shadow separation.

Notes

- 1. Solarization is commonly (although incorrectly) used to describe partial tonal reversal of prints or negatives, caused by re-exposing them to light after partial development. This should be called the Sabbatier effect (discovered in 1862). Partly developed emulsion is desensitized by the developer itself, and re-exposure fogs only the original shadow areas; as development is continued, partial reversal of the original density scale is achieved.
- 2. Kodak technical literature states that reducing contrast for printing with condenser enlargers through shortening their recommended developing time requires "an increase in exposure of one stop" (Current Information Summary, CIS-88, October 1986, p.11). This implies that the ISO number of a film should be reduced by half when developing for printing with a condenser enlarger if full shadow detail is to be retained in the print.

10Developer Components

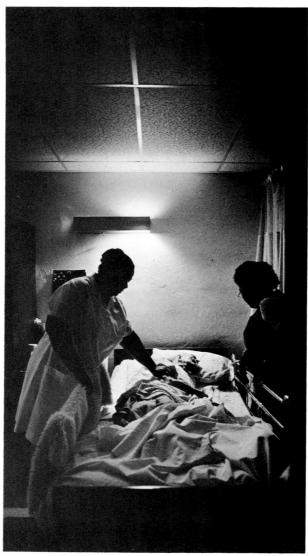

Figure 10.1

NURSING AIDES COMFORT WOMAN
DYING IN NURSING HOME.
Laura Elliott.
(Courtesy of the photographer)

Introduction

It is not necessary to mix your own developers, but making them for yourself will quickly teach you how the components of developer work. In addition, homemade developers are usually less expensive, and sometimes more responsive to your film developing or printing needs than packaged developers. There is a significant initial investment in chemicals (Elon and hydroquinone, for example, are sold only in one-pound units by Kodak), but this investment will pay off in understanding, as well by providing other controls of the medium.

Experiment with common formulas first. After the limits of these are reached, try the less commonplace formulas and chemicals. Differences between one developer and another are often very subtle.

Mixing a photographic formula poses no health risk as long as you avoid breathing chemical dusts and do not permit excessive skin contact with chemicals. As noted earlier, wash your hands before touching contact lenses after handling any photographic chemicals.

Single-shot Chemicals

Most popular photographic developers are prepared first in a concentrated (stock) solution, diluted with tap water just before being used, and dumped after being used once. This method is more expensive than replenishing a developer, which means to add new stock to replace what has been used, but **single-shot** (one-use) solutions minimize processing variations; there is less oxidation of reducing agents and the developer is a known balance of chemicals each time it is used. If you work at irregular intervals over a period of weeks, even more repeatability can be expected from using foil-packed liquid concentrates that make up to standard processing units for film or print developing.

Measuring and Mixing Solutions

Prepare to mix photographic chemicals by establishing well-separated wet and dry work areas. All the formulas in this text are presented in simple common measures of tablespoons and teaspoons, and also in metric units. The common measurements are not as accurate as using a gram scale, but they are adequate for photographic printmaking. Measure dry chemicals by spooning or scooping them out of the bulk container. All measurements are *level* teaspoon or tablespoons: fill the spoon and draw a straightedge across it to strike off the excess. Chemicals that tend to clump together must be broken up before being measured.

TABLE 10.1 Photo Chemical Equipment

Measuring spoons (plastic or stainless steel)
Gram scale (optional)
Stirring rod
Mixing container (1/2 or 1 gallon size)
Graduates (25ml, 100ml, 500ml, and 1—2 liters are good sizes)
Plastic storage bottles (1 quart and 1 gallon)
Large plastic funnel (available at an auto supply store)
Rubber gloves and safety goggles
Apron (or darkroom clothes)

Note: Photo chemicals should be mixed in glass, plastic, or stainless steel, and stored in glass or plastic. Avoid pans with exposed aluminum or zinc.

Figure 10.2
Untitled.

Kate Keller

Strong backlight required that a meter reading be made of the floor near the camera to obtain adequate detail in the floor and ceiling, and then the development time kept short to keep printable densities in the window and curtains.

(Courtesy of the photographer)

Figure 10.3Portrait of Clarence White, ca. 1905.
Gertrude Kasebier.

Kasebier was a professional portrait photographer who was also a member of the Photo Secession, a group of creative photographers who helped define art photography in this century. Clarence H. White, a notable photographer in his own right, was both a founding member of this group, and founder of the Clarence White School of Photography in New York. (Library of Congress)

TABLE 10.2

Common Measures for Photo Chemicals

Chemical Volum Borax 1 t = 8	e/Gram
Borax $1 t = 5$	-,
	5 grams
Hydroquinone 1 $t = 3$	3 grams
Metol 1 $t = 3$	3.5 grams
Phenidone 1 $t = 2$	2 grams
Potassium bromide 1/8 t =	= .8 gram
Potassium ferricyanide 1 $t = 5$	5.5 grams
Sodium carbonate 1 $t = 6$	grams
Sodium sulfite 1 T =	23 grams
Sodium thiosulfate 1 T =	18 grams

If you wish to mix more complex formulas (where the common measures will not serve), use a balance scale, after placing it on a firm, level surface. Treat any scale gently and protect the platforms: weigh chemicals onto half-sheets of clean typing paper (or use styrofoam cups for large quantities). All scales can be zero balanced to cancel out the weight of the paper or cup, or you may prefer to subtract the weight of paper from the gross chemical weight. Never use a piece of paper for more than one chemical: if you weigh out too much and wish to return extra to the bulk container, you could easily contaminate the bulk chemical from the paper.

Use a plastic stirring paddle to speed mixing; never stir with a thermometer. A stirring paddle dissolves chemicals effectively while drawing in very little air, which preserves the reducing agents. Pour dry chemicals into the water in a smooth stream and stir constantly; avoid adding chemicals faster than they will dissolve.

HEALTH HAZARD

Developing Agents

Hydroquinone is highly toxic by ingestion, and is an eye irritant. **Elon** (Metol) is moderately toxic and a definite allergen. **Phenidone** is capable of triggering allergenic reactions.

Preservatives

Sodium sulfite is moderately toxic by inhalation or ingestion; some people are sensitive to sulfite, and respond to it with respiratory distress.

Accelerators

Sodium carbonate is moderately toxic and an irritant to mucous membranes and eyes.

Inhibitors

Inhalation or ingestion of **potassium bromide** can cause mental confusion or depression.

NOTE: None of these chemicals should be a source of danger if they are handled carefully, and solutions are mixed in well-ventilated rooms. Never breathe chemical dusts, and avoid all unnecessary bare skin contact with solutions.

TABLE 10.3

Common Developing Agents

There are many other developing agents besides those listed below, but almost any print or negative desired can be produced with the following three.

Elon (Metol)	Hydroquinone	Phenidone-A (Kodak BD-84)
Neutral gray image appears quickly but density and contrast increase slowly; energetic developer with long storage life.	High contrast, brownish image but weak by itself and requires very long development if used alone; synergetic with Elon; becomes ineffective below 60°F; has short storage life.	Resembles Elon but works well in weaker concentration; acts as superadditive agent in conjunction with other developers; has long storage life.

Note: See appendix 5 for sources of these and other chemicals.

Hardness is a term that describes the amount of calcium, magnesium, or iron salts in water. Very hard water can cause nonsoluble precipitates to form as scum on negatives. Water softeners are used to sequester minerals, but the softening process may produce water that has too little chemical for film or paper emulsion. The ideal water is near pH 7 and has from 150–250 ppm (parts per million) of calcium carbonate. When the amount of calcium carbonate falls below this, print emulsion fixed in non-hardening fixers may scratch easily.

Tap water is heavily oxygenated when the tap has an aerating filter (a small screen screwed on the end of the tap, common to almost all kitchen and bathroom faucets). The filter adds air to the water, improving its taste, but the extra oxygen is not good for your chemicals. Usually the filter can be removed to supply less aerated water.

Most chemicals dissolve better in warm water. Sodium sulfite, for example, appears to dissolve easily at room temperature but actually dissolves only partially in water below 85°F, then floats as nearly invisible particles for many hours before completely entering solution. Although developing agents are weakened by very hot water, a mixing temperature of 125°F is not harmful.

Characteristics of Photo Chemicals

Chemicals are made with different amounts of water.

- · crystalline: contains much water
- monohydrated: crystalline form of the chemical, containing one part water
- · anhydrous: without water
- desiccated: equivalent to anhydrous, meaning most water has been removed

Anhydrous is the strongest version of the chemical (by weight); monohydrated the weakest. The change is significant, as monohydrated sodium carbonate is about 1/3 as effective as anhydrous. Be sure the specifications of the formula are met.

Purity is usually not an issue, but it is safer to use *photo* than technical or commercial grade chemicals. The *analytical* or *reagent* grades are more highly refined, but the extra expense of them is not justified.

Developers usually indicate age by changing color, though some (FG7 and Selectol-Soft for example) always have a tan color, even when fresh. Hydroquinone breaks down most quickly and turns reddish-brown in solution (as well as smelling slightly of rotting leaves). A developer that has decayed may continue to make visible prints but they will be weak and gray compared to those developed in a fresh solution.

Store concentrated stock in full bottles to reduce exposure to air. (If you mix a gallon of D-76, for example, and are not using it within a month, fill quart bottles to the top and it will keep for several months.) Partial bottles of print or paper developer will weaken noticeably within two weeks if temperatures much exceed 70°F.

Fixers are damaged by heat; if stored for 24 hours at temperatures above 80°F, a rapid fixer will lose about half its capacity to remove silver. There is no change of color, or other visible warning to indicate loss of effectiveness. Weak fixer will be apparent with film because the clearing time will increase markedly, but there is no obvious warning sign for paper; therefore, Edwal Hypo Chek should be used frequently.

Two-tray Developer Experiment

The following experiment demonstrates how developer components work. What you see in the print also happens in the negative. (Note: Fiber-based paper must be used for this experiment, as many RC papers have developers in the emulsion, which will be discussed later in the chapter.)

Begin by choosing a negative that prints easily on normal contrast grade paper, using a picture with full detail in both shadows and highlights. Expose an enlarged normal contrast grade test print and develop it in your usual developer; repeat and correct it if the exposure is off. When you have a valid exposure, expose five identical sheets (but do not develop them yet). Mark the sheets on the back with a pencil before cutting four of them in half (making 5 1/2" x 8" pieces). Store all the sheets in a lighttight place while you prepare the darkroom. Save your print developer in a graduate for use again later.

Use two clean trays for the following experiment. Stir in the chemicals in the order noted until they are dissolved.

Figure 10.6

Untitled.

Arnold Gassan.

Looking past a surviving tree at the new skyline of a city permits the photographer to create a formal dialogue of shapes that is also a commentary.

(Photo by the author)

TABLE 10.4

Two-tray Experiment

Step 1 Tray A	Tray B
1 quart hot water	1 quart hot water
2 teaspoons Elon	1 tablespoon sodium sulfite
1 tablespoon sodium sulfite	2 tablespoons hydroquinone
1 quart cold water	1 quart cold water

Mark the two halves of a print 1–A and 1–B with pencil on the back. Develop 1–A in tray A and 1–B in tray B (be sure each print is in its correct tray). Agitate frequently as you develop both prints for two minutes. Stop and fix both prints. Place them in a tray of plain water until all prints are made. Go on to step 2.

Step 2	
Step 2 Tray A	Tray B
nuy A	nay 5

1 tablespoon sodium carbonate 2 tablespoons sodium carbonate

Mark the two halves of a print 2–A and 2–B. Develop the prints for two minutes in their respective trays with frequent agitation. Stop and fix the prints. Go on to step 3.

Step 3 Tray A	Tray B
1/4 teaspoon potassium bromide	1/4 teaspoon potassium bromide
Mark the two halves of a print 3-A and 3-B. D store in the water storage. Go on to step 4.	evelop these prints in their respective trays. Stop, fix, and

Step 4 Tray A	Тгау В
1 tablespoon sodium carbonate	1/4 teaspoon Elon

Mark the two halves of a print 4–A and 4–B. Develop prints 4–A and 4–B for three to five minutes. Finally, pour *half* of tray A and *half* of tray B into a common tray. Develop the last print (a full sheet) for 2–3 minutes in this mixture. Fix, wash, and dry all the prints. Compare them in a good light, and study the differences in contrast and color.

Developer Components 147

Two-tray Results Described

Step 1 provides only sodium sulfite, a preservative, and separate developing agents. Sulfite also acts as a weak alkali, establishing a basic pH sufficient to energize Elon. Print 1–A should be a fairly complete, gray picture, lacking solid blacks or vitality in the highlights. Print 1–B will have little or no image, except in the darkest shadows, and what there is will be pale reddish-brown.

Step 2 adds alkali, in the form of sodium carbonate; this raises the pH to about 7.5 and energizes the developers. Print 2–A, from the Elon tray, will be stronger but will still lack strong blacks. The highlights may be gray, and there also may be visible fog in the unexposed white borders.

Print 2–B usually lacks highlight details. A weak, high-contrast print should appear, with distinct shadow values. You may wish to expose another sheet of paper and develop it in the B tray for a much longer time, to discover how the hydroquinone will eventually produce a complete image.

Step 3 introduces a restrainer in the form of potassium bromide, which inhibits development of the latent image into a visible image. Print 3–A should have clear highlights and more contrast than earlier prints, but nothing has been added to help shadow density. Print 3–B will show a sudden loss of density because the inhibitor has a powerful effect on the weak hydroquinone, and even the deep shadows often are pale brown.

Step 4 illustrates the synergetic action of Elon on hydroquinone. (Similar interaction takes place when phenidone is added to a hydroquinone solution.) Both trays have alkali, increasing the effectiveness of the developing agents. Print 4–A should be similar to 3–A, but have more density overall. Print 4–B should be a strong print with good contrast and shadow detail. The amount of highlight detail will vary, depending on the paper used.

The developer produced by mixing the two trays produces a cold tone print when compared to a warm tone print developed in D-72 (equivalent to Dektol). If you compared the actual chemistry of D-72 and this tray of developer, you would find that D-72 has about twelve times as much bromide, but is otherwise quite similar.

RC Paper Experiment

The following experiment investigates the fact that many (but not all) RC papers incorporate developing agents to permit rapid machine processing. Use a negative with an enlarger exposure you know and expose two pieces of RC paper, using the correct contrast grade filter. Store these sheets in a paper box while you prepare the darkroom.

Add three tablespoons of sodium sulfite and three teaspoons of sodium carbonate to one liter of water at about 75°F; stir until fully dissolved. The sulfite and carbonate create a chemical environment in which any developer in the emulsion can function, and an image should result if there is developer present. In normal safelight conditions, immerse one exposed print in this solution and develop for 3–4 minutes. If there is developer in the emulsion there will be some developed image, though it will be faint (see figure 10.7A). Stop, fix, and wash the first print.

Add a *pinch* of Elon to the tray (this is a fairly precise measure of about 1/10th of a gram), and stir until it dissolves. Develop the second exposed RC print in this weak developing solution. If there is developer in the emulsion the Elon will act synergically and quickly produce a low-contrast gray image overall (see figure 10.7*B*).

Expose a piece of fiber-based paper with the same negative and develop it in the weak Elon solution. A weak, gray image should result (see figure 10.7*C*), showing by comparison how effective the developer incorporated in the RC emulsion is, and also demonstrating how powerful Elon is as a reducing agent. Make a final print from the negative and develop it in a regular, balanced developer to see how the developing agent incorporated in the emulsion interacts with the balanced developer (as shown in figure 10.7*D*).

Figure 10.7a. Ilford Multigrade RC paper developed in a solution of sodium sulfite and sodium carbonate: the faint image is a result of the hydroquinone in the paper emulsion being activated by the alkaline solution.

b. Ilford Multigrade RC paper developed in a liter of water with sodium sulfite, sodium carbonate, and a pinch of Elon (producing a 10% normal Elon concentration). A low-contrast, overall gray print results with gray, fogged highlights.

c. Ilford Ilfobrom paper developed in a liter of water with sodium sulfite and 10% normal Elon. A weak, low-contrast print results, with clean paper whites.

d. Ilford Multigrade RC paper, developed in Hobby-Pac paper developer to produce a normal print.

Modifying Developers

Developers can be used as they come from the package or bottle, or they can be modified to meet your printing needs. The two-tray experiment illustrates how each developer component functions, and you can use the results of that experiment to change any developer:

- use Elon, sodium sulfite, and sodium carbonate to make a complete, low-contrast developer
- · add hydroquinone and sodium carbonate to increase contrast
- add potassium bromide to increase contrast, or to make a warm tone print
- · add potassium bromide to keep paper whites clear of fog

Standard developer formulas are buffered to produce constant pH over a working life of several hours. Adding extra accelerator or developing agent is always permissible but will shorten working life of a solution. The developer affects the way the developed silver image reflects and refracts the light, causing it to appear more brown-black (warm tone) or more blue-black (cold tone). This change in color is slight but aesthetically significant. The color changes are often subtle and require good working light and some printing experience to evaluate.

Summary

Silver process developers are similar in composition and vary most in pH; paper developers have more alkali. Water should be clean and of appropriate hardness. Elon (Metol) and hydroquinone are the two reducing agents used most often, although phenidone replaces Metol and is much less allergenic. Photo chemicals decay quickly in heat and light and should be stored in a dark place at moderate temperatures. Developers can be mixed from bulk chemicals, and the weights can be easily estimated by using common measures. The effects of developer components are demonstrated in a two-tray experiment; many RC papers will respond differently to development controls because they have a developing agent in the emulsion. Modifying developer chemistry will often change the color of a print.

Discussion and Assignments

All silver process developers function in similar ways, yet even small differences in pH, ratios between developing agents, percentage of restrainers, or the type of restraining agent used will create changes in the formation of the silver image and therefore in the way the print looks, its color, and the apparent separation of one value from another.

Assignment 1 Prepare a tray of your regular paper developer. From experience, place an identifying mark on the back of a piece of photographic paper, expose it correctly, and develop it for exactly two minutes. Finish the processing and set the print aside. Continue using the developer for the day's printing, developing at least 15 prints for each liter of liquid in the developer tray. Place an identifying mark on the back and expose a second print from the test negative and develop it for exactly two minutes. Now add 1 tablespoon of sodium carbonate and 1 teaspoon of hydroquinone to the tray; stir with a stirring paddle until the chemicals are dissolved. Identify, expose, and develop a third print for exactly two minutes. Process and dry all prints. In a good light examine the three test prints and see what differences can be observed. Especially examine the shadows. What conclusions can you draw?

Chapter 10

11 Print Contrast and Development

Figure 11.1
UNTITLED.
Arnold Gassan.
Because of the diffuse light reflected from the snow, the scene was of almost normal contrast, despite the crisp shadows. An overall meter reading and normal development produced a negative with correct shadow and highlight densities.
(Photo by the author)

Overview

Photographic papers are redesigned frequently to reflect changes in photographic technology and fashions in photographic printmaking. Mitsubishi and Oriental papers have recently entered the marketplace that was once dominated by Kodak, Ilford, and Agfa-Gevaert. The resulting competition has produced a greater range of print color and quality.

Contemporary photographic paper consists of silver halide crystals in a gelatin emulsion, supported by the paper. Between the paper and the gelatin is either a thin layer of baryta, a special clay, or a layer of polyethylene, a plastic. The baryta in fiber-based and the plastic in RC papers provide a reflective base color controlled by the manufacturer; the plastic also prevents chemicals from penetrating the photographic paper.

The baryta or the plastic subcoat in contemporary papers usually contains a fluorescing agent that brightens the photograph by capturing ultraviolet light and transforming it into white light. The subcoat is usually pigmented to provide a base color for the highlights. Agfa Portriga Rapid and Oriental Center, for example, have a pale tan color; Kodak Elite is neutral to cool white; llford Gallerie is very slightly green, llford Multigrade and Oriental Seagull are slightly creamy, and Mitsubishi Gekko is a brilliant white. The differences are significant and obvious, and affect the aesthetic impact of the photograph. Both Portriga Rapid and Center tend to exaggerate high value separations and produce bold, though less detailed, dark values.

Figure 11.2
Cross section of a typical print, illustrating how reflection and absorption of light produce intermediate valves and limit black and white values.

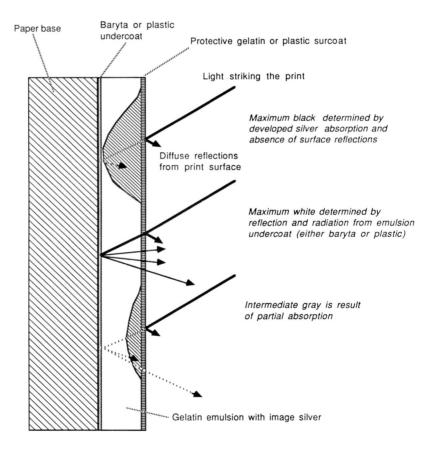

Contrast Grades

Paper contrast grades are numbered from 0 to 5 to indicate increasing contrast. A contrast grade will produce maximum black in the print from FB+F when highlight densities are exposed to produce textured highlight values in the print. The contrast grade does not predict how a given paper will respond specifically in shadow or highlight areas. Because of individual variations, a "normal" paper contrast grade from one manufacturer may be more appropriate for your negatives than another. Figures 11.3A, B, and C show a negative printed to illustrate the change in shadow values when the print is exposed to produce similar highlight values on contrast grades 2, 3, and 4. Contrast grade 3 is the *normal* grade for small camera negatives because of differences in the shape of the negative characteristic curve and the shorter density range used in 35mm photography (though the "normal" grade for large camera negatives is grade 2).

The apparent contrast of a print is determined to some degree by the lighting environment in which it is viewed. Wet prints studied under darkroom work lights seem to have lustrous shadows, but they often dry under ordinary room light into dull prints without shadow detail and gray highlights. There is a real risk of overprinting (making a print too contrasty and dark) if the darkroom white light used for viewing wet prints is of too much intensity. This loss of brilliance is exaggerated when a print is framed under glass. If intended for an exhibit, a more brilliant and contrasty print may be desired than the print intended for a hand-held portfolio.

TABLE 11.1 Paper Contrast Controls	
Fiber-based, Single Bath Development Increasing Contrast	Decreasing Contrast
Increase potassium bromide	
Increase hydroquinone Increase carbonate	Increase Elon
Increase developing time	Decrease developing time
	Flash exposed print
Fiber-based, Two Bath Development	
Increase time in low-energy developer	Inrease time in high-energy developer water bath development
Fiber-based or RC, Either Development Plan	
Increase contrast grade	Decrease contrast grade
Increase filter number	Decrease filter number
Selenium intensification	

Figure 11.3a. Printed on Ilfobrom contrast grade 2 paper.

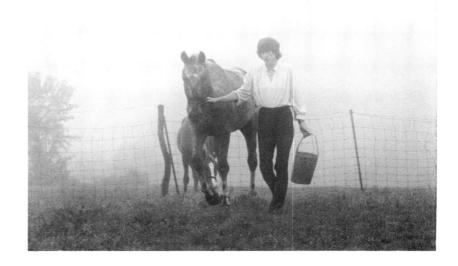

b. Printed on Ilfobrom contrast grade 3 paper.

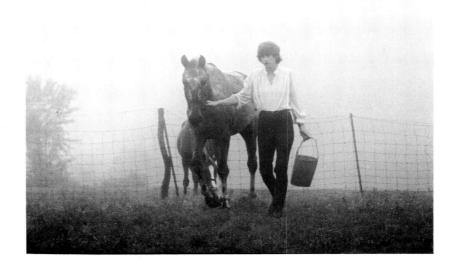

c. Printed on Ilfobrom contrast grade 4 paper.

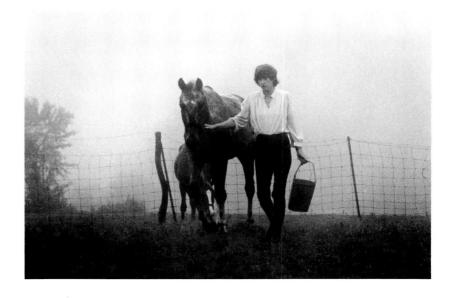

TABLE 11.2

A Beers Paper Contrast Control Developer Formula

onomou quammo	s are listed in metric and com Solution A		Solution B		Contrast Control Mixtures						
Water at 125°F Elon Sodium sulfite	750 ml (24 ounces) 8 grams (2 1/4 teaspoons) 23 grams (1 tablespoon)	Water at 125°F Sodium sulfite Hydroquinone	750 ml (24 ounces) 23 grams (1 tablespoon) 8 grams (1 tablespoon)	A B	Low 500	435	372	-	250	190	High 128 ml 872 ml
Sodium carbonate	23 grams (1 tablespoon + 3/4 teaspoon)	Sodium carbonate	32 grams (1 tablespoon + 2 teaspoons)	Water	500			500			
Potassium bromide Cold water to make	1.5 grams (1/4 teaspoon) 1 liter (1 quart)	Potassium bromide Cold water to make	2 grams (3/8 teaspoon) 1 liter (1 quart)								

Figure 11.4
Self-portrait.
Donald R. Anderson.
A studio portrait of the child and fragmentary mirrored image of the man are combined in a single exposure to produce a composite self-portrait. This optical montage is accomplished in-camera rather than through double printing, and indicates one of the many possibilities available to the photographer.
(Courtesy of the photographer)

Chemical Contrast Controls

Incremental changes of contrast between paper grades can be achieved for fiber-based papers by modifying the developing process. There are four ways of doing this:

- · two-tray development
- · mixing high-and-low energy developers
- · witch's brew
- · water bath

Two-tray development separates high-energy, Elon-based, and low-energy hydroquinone-based developers. Partial development takes place in one solution and is completed in the second. First development is usually in a developer containing only Elon (either Beers A, Kodak Selectol Soft, or some other paper formula without hydroquinone). See appendix 7, table A.2. The thing to learn when using this method is to establish a correct exposure for the total combined developing time required in order to produce rich shadow values without graying highlights. Development is initiated and the print carefully watched. When the dark gray values are established, the remaining development is completed in a high-energy developer (Beers B, Kodak Hobby-Pac diluted in only 16–24 ounces of water, or Dektol full strength or diluted 1:1).

Other variations of two-tray processing are practical. One convenient method is to use the Hobby-Pac Paper Developer concentrate to modify Selectol Soft (in normal dilution). Minimum contrast (about half a paper grade less) is obtained by developing in Selectol-Soft alone. Contrast can be increased up to the normal for that paper grade by adding Hobby-Pac concentrate in 5–10ml increments. No additional increase of contrast will be noted after more than 40ml of Hobby-Pac concentrate is added to a liter of Selectol Soft working solution. A variant is to begin with a liter of low-energy developer (Beers A or Kodak Selectol Soft) and add 50ml increments of Dektol *stock* as needed. After 350ml of the Dektol stock has been added to a liter of low-contrast developer, the effect is the same as using Dektol alone.

Sometimes it is convenient to make a "witch's brew," and modify a working tray of developer to produce changes in one or two prints. This is best done after the limits of standard solutions have been achieved. For more contrast, add one tablespoon of extra hydroquinone and two tablespoons of sodium carbonate to a tray with a liter of developing solution, producing a high-energy, although short-lived, developer.

Figure 11.5
a. The slightly contrasty Technical Pan
35mm negative was exposed on Kodak Elite
contrast grade 2 paper for 17 seconds at
f-11, then developed for 3 minutes in 2 liters
of working-strength Kodak Selectol Soft to
produce a fully detailed, but gray, print.

b. Exposure was reduced by 15% to allow for an anticipated density increase caused by using a more active developer and the print was developed in Selectol Soft with 30ml of Kodak Hobby-Pac print developer concentrate to produce a full-scale print.

Contrast can also be increased by adding 1/8 teaspoon of potassium bromide. The bromide will cause a slight shift of color (toward a warm tone), and if you are making a portfolio of prints this may be important. Print exposure will also have to be increased, and the developing time often must be increased to allow for the effect of the inhibitor. The same effect can be achieved without color change by using Edwal Liquid Orthazite.

Very contrasty negatives can sometimes be successfully printed with fiber-based papers by using a water bath development. Develop the print normally in a standard print developer until the middle gray values are just realized (about thirty seconds). Remove the print from the developer and slide it in a second tray containing a 10% solution of sodium carbonate. Allow the print to stand in the second solution *without agitation* for 1–2 minutes.

The developer retained in the paper quickly exhausts itself in heavily exposed areas but continues working in the highlights (where there is little image silver) until all available reduction is accomplished, producing a print with adequate highlights and open shadows. The developer/water bath cycle may be repeated. Eventually, of course, a normal print would result. The print color may be affected (because the reduced silver color changes slightly with the changed developer dilution) and a warmer print may result. This may be corrected by toning, which is described in chapter 12.

Variable Contrast Controls

Dodging and burning can be combined with variable contrast filters to produce good prints from complex negatives. The correct contrast grade filter is used to correctly expose the larger area of the picture, while exposure for the smaller area (which may need more or less contrast) is partially held back

Figure 11.6

Jack O'Lantern.

Arnold Gassan.

A carved pumpkin, photographed in ambient light. Longer than normal development was used to provide clear separation of the highlight values.

(Photo by the author)

with a dodging tool. Without moving the enlarger in any way, the contrast filter is changed and a second exposure is made, this time with the control area burned in and little exposure allowed elsewhere. The printer's problem is to balance the two exposures.

Summary of Print Controls

Printing papers are made in a wide range of contrast grades (from 0–5, very soft to very hard) that permit the photographer to produce full-scale prints from a wide range of negatives. Variable contrast filters provide accurate contrast grades only for their own paper system. Print exposure and development controls will usually not modify the contrast grade of a print much more than half a contrast grade up or down. Major manipulations of the contrast are best accomplished on the negative. Other manipulations of the print (intensification, toning, and reducing) are described in chapter 12.

Discussion and Assignments

Although the text has discussed only a few print developers, there are a number of excellent commercial developers on the market. The following manufacturers for both print and film chemicals are suggested (see appendix 5 for addresses): Edwal, Sprint, Ethol. You may find others available at your local camera store.

Assignment 1 Using contrast grade 2 paper, expose a normal contrasty negative and develop a print for two minutes, using constant agitation. This will be a reference print; the exposure and development should produce correct highlights, but the shadows may be somewhat lighter than you want, and will lack substance. Expose a second sheet about 10% less and develop it for five minutes in total darkness, agitating for the first minute, then with no agitation the rest of the time. Expose a third print (also a little less than the reference print). Before you develop it, add 2 tablespoons of sodium carbonate, 1 tablespoon of hydroquinone, and 1/4 teaspoon of potassium bromide to the tray of developer. Develop this print for three minutes, with constant agitation. When the prints have been processed and dried, examine them in a good light. Compare shadow values, print color, and overall contrast.

12 Modifying the Negative and the Print

Figure 12.1
THE PHOTOGRAPHER'S HAND.
Kate Keller.
(Courtesy of the photographer)

HEALTH HAZARD

Selenium is a known carcinogen and skin contact should be avoided. The selenium seems to be inert in the toning solutions used, but there may be risk. (Note that even cosmetic products containing selenium are on restricted sale in Canada and the United Kingdom.) Work in well-ventilated spaces, as selenium toner can release hydrogen sulfide, hydrogen selenide, and sulfur dioxide gases. Wear rubber gloves or use print tongs.

Potassium ferricyanide can release cyanide if heated or mixed with an acid. Dispose of the exhausted solution carefully. If your school has an approved chemical disposal system, use that. If not, flush the trap of your sink with running water before pouring away the cyanide mixture, and flush the trap again afterward.

Potassium dichromate (or bichromate) is a skin irritant and continued exposure will produce an allergenic rash ("bichromate poisoning"), which is irreversible. Avoid contact and wear rubber gloves. When combined with hydrochloric acid, potassium dichromate forms chromic acid, a suspected lung carcinogen.

Modification Effects

Processes described in this chapter are used for both the negative and print. Changing the molecular form of the silver image almost always results in a change in color of the silver image; this is not usually important for the negative but it is for the print. After development, the print or negative may be chemically modified, either increasing or decreasing the density, or changing the image color. Possible modifications of the negative include removing silver overall to produce either less density or contrast, or adding metal to the negative to increase contrast. Modifications of the print are similar, though local reduction is more common with the print.

Intensification Defined

Intensification adds metal to the existing silver image to increase density so that more light is absorbed. If the negative lacks contrast, intensification may help. No intensification process can increase density where an original silver image does not exist. If the negative is underexposed, it is underexposed, and intensification will not create shadow detail.

Chemical intensification of the negative should be regarded as a last resort because of the risk of damage in handling, and the chance of staining the negative. If intensification must be done, be sure that the negative has been fully fixed (it is best to re-fix in plain thiosulfate), or at least prewetted, and that all equipment is chemically clean.

Chromium and selenium are the metals used in popular, simple intensification of the negative, and selenium alone is used for the print. Uranium and mercury have also been used to intensify negatives, but they are no longer popular (in part because they are not available in packaged form).

Selenium with Negatives

Selenium bonds easily to an existing silver image, increasing the density. Where there is little silver, there is little or no increase in density; with more silver, there is more density change. Selenium toner can be used to intensity negatives without increasing the apparent grain. The maximum change is approximately a paper grade increase in contrast. Figure 12.2A is a straight print before intensification, and figure 12.2B is a print on the same contrast grade of paper after intensification. Negatives that are well-exposed but underdeveloped and lacking in adequate contrast are good candidates for selenium intensification.

Figure 12.2

a. Straight print on normal contrast paper from a negative with adequate shadow detail but lacking in contrast (due to the double exposure of the negative).

b. Straight print on normal contrast grade paper after intensification in Kodak Rapid Selenium Toner (1:8) for 10 minutes. Note the effect of intensification on middle and upper gray values.

TABLE 12.1

Selenium Intensifier for Negatives

Pre-fix

1 cup sodium thiosulfate crystals dissolved in 1 quart of water at 100°F; hypo is *endothermic*, i.e., absorbs heat as it dissolves and will chill the water.

Intensifier

16 ounces of freshly mixed Perma-Wash or Kodak Hypo-Clearing Agent 2 ounces Kodak Rapid Selenium Toner Use both solutions at 68-70°F.

Figure 12.3 Chromium intensification can increase contrast about two contrast paper grades, but at the expense of visibly enlarged grain. Selenium intensification is less effective, but does not appear to affect grain.

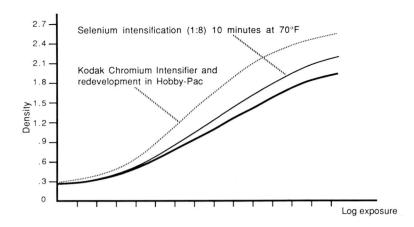

Because usually only short film strips are intensified, and there is more risk in handling, it may be safer to process these in reels and tanks than in trays. Either tank or tray should be clean, and trays examined for rough places that might damage the emulsion. Avoid touching the wet emulsion. When processing in tray, a Patterson film clip or a Kodak No. 6 film hanger should be used as a handle to protect the film. Work may be done in ordinary room light. Maintain all solutions at 68–70°F.

- 1. Dissolve sodium thiosulfate crystals in warm water.
- 2. Prepare water, pre-fix, and intensifier solution.
- 3. Presoak the film 1-3 minutes in water.
- 4. Agitate film in thiosulfate solution for two minutes.
- 5. Drain, and place film in the selenium intensifier.
- 6. Agitate continuously for 3-10 minutes (for maximum change).
- 7. Agitate in fresh Perma-Wash solution for one minute.
- 8. Wash for two minutes (or fill and dump tank ten times).
- 9. Wet with wetting agent, and dry the film.

Chromium with Negatives

This popular intensifier works by adding chromium to the silver image. The maximum change in density is approximately a two contrast grade increase. It produces a permanent increase in density, and is simple to use, although it also increases visible grain. Chromium intensifier is packaged by Kodak. Two packets are provided, each making 16 ounces of solution. The **A** solution contains the dichromate and an acidifying agent; the **B** solution is a pH neutralizer. Bleaching, neutralizing, rinsing, and redevelopment are done in ordinary room light.

The negative is "bleached" in a weak acid solution. Acidity is neutralized in metabisulfite (prevents staining and weakening of the redeveloper). Redeveloping is done in Dektol, Hobby-Pac, or other paper developer.

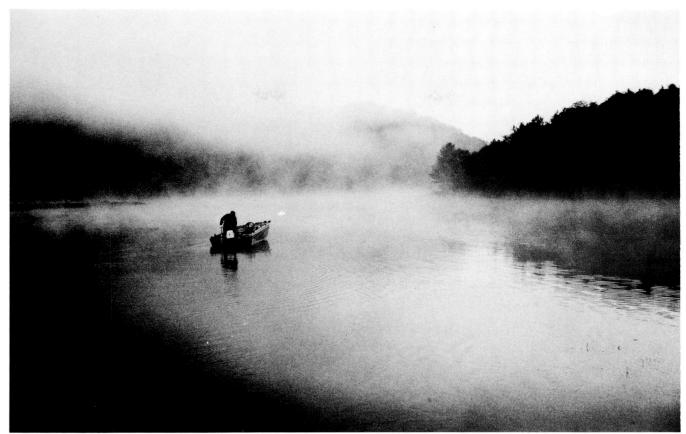

Figure 12.4
Untitled.
Ben Brink.
The atmosphere of the misty, early morning fishing scene is enhanced by careful ferricyanide bleaching.
(Courtesy of the photographer)

TABLE 12.2

Chromium Intensification of Negatives

This process is done in normal room light.

Pre-wet:

Soak negative strip in water for 5 minutes with intermittent agitation.

Bleach

Kodak Chromium Intensifier packet A is dissolved in 16 ounces of water at 68-70°F. Stir vigorously, using a stirring rod. Avoid skin contact. Immerse negative strip in bleach bath for 3-5 minutes. Agitate every 20 seconds. The image will turn yellow as it is acidified. Rinse in plain water for 30 seconds.

Clearing Bath

Packet B is dissolved in 16 ounces of water at 68–70°F. Immerse negative in clearing bath for 2 minutes. Agitate every 20 seconds. **Rinse** for 20–30 seconds.

Redeveloper

Use Hobby-Pac, Dektol, or other standard paper developer at normal dilution. Redevelop until silver is black (from 1–3 minutes).

Final Wash

10-20 minutes in running water.

Figure 12.5

The print was deliberately printed down (i.e., overexposed) slightly to produce strong shadow values, but this also slightly grayed the highlights. The dry print was placed in a cutting reducer and agitated vigorously for 15 seconds, then re-fixed, washed, and dried

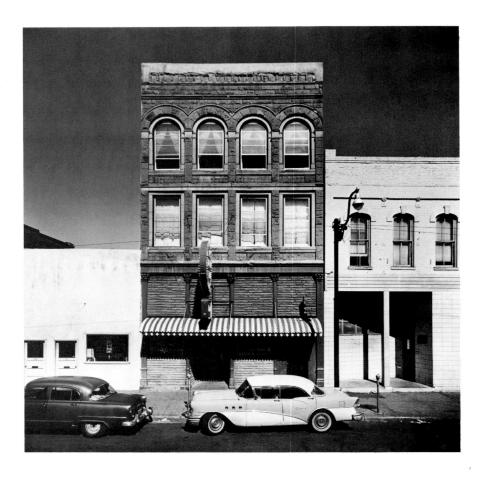

Farmer's Reducer

Farmer's Reducer is composed of ferricyanide and thiosulfate stock solutions, which are kept separate until used. Once combined, they interact destructively and have a working life of only a few minutes. The stock solutions can be combined or used sequentially. When they are combined, the solution is called a **cutting** reducer, one that reduces overall density and slightly changes the contrast because there is more reduction of lightly exposed areas than densely exposed highlights.

A two-bath sequential treatment produces **proportional** reduction. The emulsion is wetted with the thiosulfate solution first. The ferricyanide solution then interacts with all the silver, causing a loss of density proportional to the original silver content.

Reducing Negatives

Farmer's Reducer uses a cyanide compound to remove some of the image on the negative or print. Potassium *ferri*cyanide in the solution changes metallic image silver in the emulsion into silver *ferro*cyanide, which is *not soluble* in plain water but *will dissolve* in a sodium thiosulfate solution. By using a ferricyanide solution and a thiosulfate solution (either sequentially, or by mixing them together), silver can be removed from the emulsion.

Reduction should not be used on contrasty negatives with thin shadows. However, negatives that are overexposed can be treated in variations of Farmer's Reducer to lower density, and negatives that are both overexposed and overdeveloped can be treated to somewhat reduce contrast as well as density.

TABLE 12:3

Stock Solution A

make 500 ml

Farmer's Reducer Solutions

Both metric and common measures are listed: t = teaspoon; T = tablespoon

Stock Solution B

Farmer's Reducer (Kodak R-4a) for overexposed negatives

Potassium ferricyanide, 37.5 grams, 2 T + 1 t and water to

Sodium thiosulfate (hypo), 480 grams, 1 1/2 cups and hot water to make 2 liters

Use solutions at 70°F. Have clean trays and a good working light. Prewet negative for at least 1 minute in water. Add 30 ml of A to 120 ml of B and add water to make 1 liter. Immerse the negative immediately after mixing. Agitate constantly. Watch the change in density, and remove the negative well before the desired reduction is achieved. Rinse negatives thoroughly in running water. Re-fix in hardening film fixer, use hypoclearing agent, and dry normally.

Directions

Directions

Note: These solutions are stable when kept apart but interact destructively and have a short working life after being combined. Store stock solution A in a dark bottle, and avoid working in intense daylight.

Farmer's Reducer (Kodak R-4b) for overdeveloped negatives Stock Solution A Stock Solution B

Potassium ferricyanide, 7.5 grams, 1/2 T water to make 1 liter

Sodium thiosulfate (hypo), 200 grams, 1/2 cup hot water to make 1 liter

Presoak the negative at least 1 minute. Immerse negative in stock solution A for 1–4 minutes (depending on the amount of reduction desired), using constant agitation . Drain, and immerse in stock solution B for 5 minutes. Repeat if more reduction is needed. Fix, clear, and wash before drying.

Farmer's Reducer on Prints

Farmer's Reducer may be used on a print to lower density in small areas or lighten it overall. Using the Kodak R-4a Farmer's Reducer on a dry print (that has been slightly overdeveloped, with good maximum black values and slightly veiled highlights) will produce a *slight* intensification because the reducer etches away silver in the lightly exposed areas before it visibly removes density from dark areas. The result is a brightening of the highlights without weakening the shadows. Follow these steps:

- 1. Immerse the dry print in fresh reducing solution.
- 2. Agitate vigorously for 10-20 seconds.
- 3. Remove print and flood with running water.
- 4. Re-fix print, use a hypo-clearing bath, and dry the print.

A prewetted print immersed in the same solution will be lightened evenly, with the silver removed proportionally from both highlights and shadows.

Figure 12.6a. A straight print was made from the negative without dodging or burning.

b. Local reductions of the shadowed areas of the child's face and left arm, and the wood fence just above his head were done by painting these areas with a dilute ferricyanide solution. A cotton swab was used to spread the bleaching agent.

Local Reduction

Black spots on the print are most easily removed by using Spotoff, but large areas of a print are easily lightened by using Kodak R-4b Farmer's Reducer, or a variant of it. The print is first soaked in thiosulfate solution and then treated with the ferricyanide solution. See the comparison figures 12.6A and 12.6B, in which the following procedure has been used:

- 1. Soak the print in the sodium thiosulfate (solution B).
- 2. Drain the print.
- 3. Place it face up on smooth work surface.
- 4. Squeegee the surface damp dry.
- 5. Paint the area to be reduced with solution A.
- 6. When reduction is achieved, rinse with running water.
- 7. Re-fix, use fixer remover, wash, and dry.

Just before the desired density has been achieved, the print is flooded with water. Because the density reduction continues for a time, solution A is often diluted 1:5 or more (as in the illustration). It may be used full strength, but only when vigorous reduction is desired. The ferricyanide solution may be painted on with a brush or applied with a cotton swab or a small sponge.

TABLE 12.4

Selenium Intensification of Prints

Water (@ 125°F) 80 ounces Sodium thiosulfate 32 ounces Sodium thiosulfate 32 ounces Cold water to make 1 gallon Fix for 3 minutes at 68°F. Agitate prints constantly (by interleaving). Drain, and transfer directly to selenium bath. Fix for 3 minutes at 68°F. Agitate prints constantly (by interleaving). Drain, and transfer directly to selenium bath. Fix for 3 minutes at 68°F. Agitate prints constantly (by interleaving). Drain, and transfer directly to selenium bath. Fix for 3 minutes at 68°F. Agitate prints constantly (by interleaving). Drain, and transfer directly to selenium bath. Fix for 3 minutes at 68°F. Agitate prints constantly (by interleaving). Drain, and transfer directly to selenium bath. Fix for 3 minutes at 68°F. Agitate prints constantly (by interleaving). Drain, and transfer directly to selenium Toner diluted 1:10 Torain the prints and interleave 3 minutes in a working strength Perma- Wash or Hypo-Clearing Agent solution. From 5 minutes to 1 hour, depending on print washer used and degree of permanency desired.	Pre-fix (This also can be the last fixer bath for any print)		Intensification	Clearing	Final Wash
	Sodium thiosulfate Sodium sulfite Cold water to make Fix for 3 minutes at 68°F constantly (by interleaving	32 ounces 4 ounces 1 gallon F. Agitate prints ng). Drain, and	to 1:20 in Perma-Wash working solution or Kodak Hypo-Clearing Agent. Interleave prints constantly. Prints may tone adequately for intensification (increase of density only in the black and near-black tones) in as little as one minute, or they may take as long as ten minutes. Warm tone papers contain more silver chloride and will tone quickly; cold tone papers use silver bromide and tone slowly. Toning beyond intensification will	minutes in a working strength Perma-	on print washer used and degree of

It is a common practice to prepare only a ferricyanide solution, dilute it for daily use, and keep it in a small graduate near the fixer tray. When local reduction is needed, the print is taken from the fixer, squeegeed dry, and painted with this diluted solution. When this is done, it is very important to rinse the print thoroughly with running water before returning it to the fixer tray to minimize contamination of the fixer. Fixer with hardener may leave a yellowish stain.

Intensifying Prints with Selenium

A weak solution of selenium toner may be used to intensify a print, with a slight change of color and addition of density only to the dark shadows. The change is significant to the eye as an increase in blackness and a color shift but not strong enough to be represented in a printed reproduction, therefore, no illustration is offered here.

Prints to be intensified are treated in a series of solutions (as outlined in table 12.4). First, the prints are re-fixed (preferably in a plain sodium thiosulfate solution), drained, and then placed in a solution that combines selenium toner and hypo-clearing agent solution, which acts as a buffer and prevents the toner from staining the print.

An experimental validation of the amount of selenium deposited can be made by bleaching a toned print in Farmer's Reducer. The final image consists only of selenium, and shows where and how much selenium has been deposited.

Selenium Toning for Color Change

A strong selenium solution will cause significant color change overall and will also reduce the print's contrast. Silver prints will tone to a dark red-brown color with selenium. The change from a black to a red-brown image will darken highlights somewhat and apparently weaken shadow densities: the heavily toned print appears somewhat flat when compared to an untoned print from the same negative. The same sequence suggested for intensification is used for changing the print color, but the toning solution now consists of 1:3 toner to hypo-clearing agent. Toning should be done under a strong white light, in order to watch for the color desired: the longer you tone, the more red-brown the final print color.

Sepia Toning

The silver image is transformed into a silver salt by immersion in a solution of potassium ferricyanide and potassium bromide. The iron and cyanide are displaced, leaving silver bromide in the emulsion. The silver bromide redevelops as silver sulfide, a stable compound that appears yellow-brown (rather than the neutral gray-black of plain silver). Kodak Sepia Toner is a packaged version of a traditional bleach-redevelopment color change chemistry that has been popular for more than a century. Kodak's Brown Toner and Polytoner are also sulfide-based toners. As noted earlier, ferricyanide interaction with image silver produces a silver compound that is not soluble in water but is soluble in a hypo solution. Because of this, some of the image will be lost if the print to be toned has any residual thiosulfate. Photo books written before hypo-clearing agents were in common use cautioned the photographer to make prints that were slightly darker than the desired final print to compensate for this bleaching action.

Summary

Contrast in negatives and prints can be increased by post-development chemical treatments. Selenium intensification can be about a paper grade increase in contrast, and the intensifier has little effect on apparent grain. Chromium intensification can produce more contrast increase but also visibly increases grain.

Negative density can be reduced by using Farmer's Reducer to chemically remove silver, and contrast can be reduced as well. Overall print reduction is rarely desired but highlight etching is convenient and easily accomplished.

Some print intensification is possible with selenium toning. Large changes in print color (with inevitable loss of contrast) are achieved by heavy selenium toning or by sepia toning, which involves bleaching and sulfide redevelopment.

Discussion and Assignments

There is always risk when intensifying or reducing negatives because the film is being rewetted, but not in the format that you are used to handling. A print can also easily be damaged, but more often there is a risk of overtoning and overreducing, rather than physically damaging the print.

Assignment 1 Mix the two Farmer's Reducer (R-4a) stock solutions. Locate (or make) a print with good, solid shadow values but veiled highlights. Cut the print in half, so the cut passes through the important highlight areas. Wet the print, drain it, and squeegee it dry. Swab the highlight areas with B stock (using a small sponge), and sponge damp-dry. Dilute the A stock 1:8 and (using a small sponge, or a cotton swab), lightly and quickly paint the highlights. After 30 seconds, rinse the print in running water, re-fix, wash, and dry. Place the print halves edge to edge (holding them down with a sheet of plastic or glass) and see how much change has been effected by the local reduction.

Assignment 2 Take a small bottle of rubber cement and thin it until it will paint smoothly onto a print. Paint out an interesting area and let the cement dry. Tone the print for color change in selenium toner. When the print is dry, use a small block of gum rubber to lift the film of rubber cement from the print without damaging the gelatin surface. Study the way the color change within the picture affects its aesthetic impact.

13 Comprehensive Exposure-Development Controls

Figure 13.1 UNTITLED.

Nancy Roberts.

TTL metering might or might not indicate correct exposure, depending upon how it averaged the intense highlights from the fence and the open shadows. An incident meter held at the fence and pointed toward the camera would indicate an approximately correct exposure but would indicate nothing about the scene.

(Courtesy of the photographer)

TABLE 13.1 Long Exposure Reciprocity Corrections

Metered Exposure	Actual Exposure T-Max Other Film		Development Decrease T-Max Other Film			
1 sec. 10 sec. 30 sec.	1 sec. 15 sec. 1 min. 1 min., 30 sec.	2 sec. 50 sec. 3 min. 10 min.	none 10% 10% 15%	5% 20% 20%25%		

Exposure Law

The term **exposure** describes the amount of light that the shutter and aperture allow to reach the film. Exposure also describes the act of making the picture and the effect of light on the photographic film. Film exposure is usually (but not always) the product of the exposure time and the intensity of light focused on the film. Exposure described by this reciprocal equation:

$$E = I \times T$$

where E is exposure, I is intensity, and T is time. Intensity is usually controlled by the aperture, and time is controlled by the shutter.

The equation states that if the intensity of light is doubled and the time is halved, the exposure will stay constant. Within wide limits, this reciprocity is true. The reciprocity of the exposure equation fails when intensity is very weak and the exposure long (more than a second), or when light intensity is great and the exposure time is very short (less than 1/1000 of a second). Then the exposure necessary to produce adequate minimum density will differ from calculations because of the **reciprocity effect**. Additional exposure is needed to correct for reciprocity failure, and the correction varies with the kind of film used; T-Max films, for example, are less sensitive to reciprocity failure than other Kodak films.

Metering Light

Most meters use arbitrary number scales (rather than offering a direct measurement of light in standard units). Because of this, a meter reading of 10 on one meter does not always equate to a 10 on another meter. All of them do use a log exposure scale, which means that a meter scale change from 10 to 11 indicates the presence of twice the light energy, from 10 to 9 means that half the light is present. Because of this, it is often more convenient to speak of the meter measurements in terms of **stops**.

Light reflected from a subject can be measured as **luminance**, a term that describes light energy in terms of candelas per square meter. The physics of light measurement is beyond the scope of this text, but luminance is a precise way to describe the intensity of light sources in the photograph, whether they are reflected or self-luminous (flames or electric lights). Luminance range is an objective measure of the brightness range of a subject, and this appears to the eye (and eventually in the print) as contrast. The luminance range of a subject provides a measure of contrast, as a given film and development will create printable densities for only a certain subject luminance range.

Experience and common sense are required to adjust film development to fit the contrast of the scene. Correct metering simplifies this, and allows you to determine correct minimum density exposure and predict suitable negative development. You can meter shadows to estimate correct exposure and you can also meter highlights to estimate the luminance range, or contrast,

Figure 13.2
Untitled.
Arnold Gassan.
Plus-X Pan film was used with TTL metering El of 64 because only contrasty scenes were planned for the entire roll. The film was developed at only 80% of normal time.
(Photo by the author)

of the scene. Reflected-light meters can measure the actual luminance range of the photographic subject; incident meters do not. Yet either kind of meter can provide excellent exposure and development guides if the limits of the meter are understood.

Metering Assumptions

Through the lens (TTL) meters are reflected-light meters. Accepting a total scene, TTL meter indicated exposure means that you assume light from all shadow and highlight areas (including direct light sources) will *average* to produce satisfactory densities on your negative. This assumption is generally true only if the scene is of normal contrast; i.e., the luminance range from the darkest area to the brightest is correct for the film being used and the development planned. You may wish to adjust the indicated exposure to a greater or lesser value, because you evaluate contrast and wish to expose more or less. Consult the instruction manual for your camera for detailed operational instructions, as some of the popular small cameras do not allow exposure manipulations except on a "manual" mode. While this mode will inevitably permit you to make more mistakes, it also allows you the chance for creative exposure control.

The indicated exposure when you meter a shadow is greater than what the actual exposure should be. TTL metering generally assumes the target is a middle gray.² Photographers can use TTL meters to determine correct exposure for important shadows by coming close to the subject, pointing the camera at the shadows, and using the *indicated* shadow exposure to calculate the *actual* exposure.

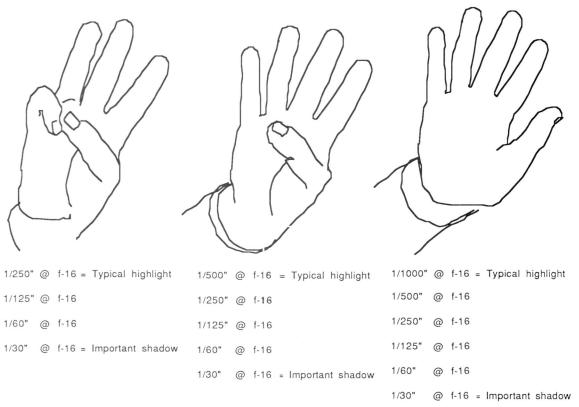

Figure 13.3

- a. Three-finger rule: the scene is flat when there is only a three-stop range between important shadow area meter reading and highest textured highlight area indicated exposure.
- b. Four-finger rule: the scene is normal when there is a four-range stop between important shadow area meter reading and highest textured highlight area indicated exposure.
- c. Five-finger rule: the scene is contrasty when there is a five-stop range between important shadow area meter reading and highest textured highlight area indicated exposure.

Metering to Determine Contrast

A hand-held or TTL meter permits precise estimations of contrast. You can:

- locate the brightest subject areas with detail. These highest textured highlights (HTH) are the brightest area that must have detail (i.e., be printed as a pale, detailed gray) in the print.
- locate dark areas with important shadow details. These important shadow areas (ISA) can be defined as large, dark areas that should retain detail in the print, such as dark blue jeans, black leather jackets, and the bark of darker trees in open shade.
- locate meterable targets within these defined values. The size of metering target is dictated by the meter; a spot meter can measure smaller targets, but for a typical hand-held meter the smallest safe target is at least 5" x 5" inches.

Many incorrectly exposed negatives are the result of trying too hard to locate the darkest detailed shadow. Also, shadow values in small camera photography are crushed together and lose detail by interaction between the soft toe in the characteristic curve for high-speed films, the desire for minimum density negatives, and the characteristic curve of contrast grade 3 paper. All these combine with the tendency for beginning photographers to push the limits of the medium. Experience with small camera photography indicates that using the ISA as a metering target is safer than looking for the *darkest* detailed shadows.

172 Chapter 13

Figure 13.4
Untitled.
James Montiero.
TTL metering would indicate an underexposure because the white fog would be presumed by the meter to be much darker. The scene itself is somewhat flat, and longer than normal development was necessary.
(Courtesy of the photographer)

Meter both critical highlight and shadow areas and write down the indicated exposures. Count the number of stops between the important shadow and the highest textured highlight area to determine the scene's contrast. Look at figure 13.3A through 13.3C to see the relationships between the exposure range and estimated contrast, keeping in mind the following:

- a scene is **flat** when there are only *three* stops range between the ISA and HTH.
- · a scene is **normal** when there is a *four* stop range.
- · a scene is **contrasty** when there is a *five* stop range.

Developing times noted in the text are for normal scenes. If a flat scene has been found, the negative contrast may be increased by more developing, to make a correct negative for printing on normal contrast grade paper. This is called **expansion** development. Longer developing time quickly increases density in heavily exposed areas of the film with little increase of the density in the shadows.

If a contrasty scene has been found, negative highlight density and contrast can be reduced by shortening the developing time. This is called **compression** development. It is used to limit contrast and negative highlight density.

Contrast Control Exposures

The actual shutter and aperture settings used for critical exposure/development controls are neither the shadow nor the highlight meter readings. It can easily happen that subjects of differing contrast have identical ISA meter readings. Those readings were taken merely to calculate the luminance range, or contrast, and they must be converted to actual exposures. It is important to remember that film exposure is determined by the scene's shadow areas, and the meter's indicated exposure is not the actual film exposure. If the indicated ISA exposure were used, the film would be overexposed because the meter "thinks" it is measuring a middle-gray value. The actual exposure given the film is usually a stop less than the ISA indicated exposure.

Look at the characteristic curve in chapter 9 again and observe how middle value and shadow densities (just left of the mid-point of the curves) also decrease as development time is decreased. Contrasty scenes require shortened development and the reduced development time will thin even important shadow densities somewhat. This means that you should compensate for reduced shadow density in contrasty scenes (caused by shortened development) by increasing exposure slightly. This EI reduction can be done easily by either resetting the ISO number of the camera manually, or changing the DX adjustment to a minus number when contrasty subjects are photographed. The corollary of this is that when flat scenes are photographed and the development is increased to compensate, *less* exposure is needed; therefore, expose one stop less than the ISA indicated exposure. Put another way, a flat scene requires less exposure and more development than a normal scene, while a contrasty scene requires more exposure and less development.

Estimating Contrast by Eye

Nothing can replace the accuracy of a precision meter used close to the subject when estimating contrast, but the educated eye can approximate the results of metering. In sunlight, contrast can be adequately estimated by examining shadows cast by the subject:

- · normal scenes have visible, but soft-edged shadows
- · flat scenes have shadows with little or no definition
- · contrasty scenes have wire-sharp shadows

Figure 13.5*A* is a normal scene, as the shadow of the tree is just visible. Figure 13.5*B* and figure 13.5*C* show the exposure indicated by two incident meters. The meters do not indicate that this is a normal contrast scene: the photographer must make that estimation. The same scene was recorded late in the day, with some cloud cover. The overall assessment of the scene is now flat, as determined by the absence of shadows on the grass. The same exposure was indicated by TTL and incident meters for this illustration and figure 13.5*A*, and the resulting negatives were printed for similar middle gray values. Note that both the distant field and the trees at right are darker in figure 13.5*D* than in 13.5*A*, because of the lower luminance.

Figure 13.5

- a. A normal contrast scene, when evaluated by the presence of defined shadows with soft edges.
- b. Selenium cell, meter-movement incident light meter. Exposure calculations are made in three steps. First, the light reading (the white meter indicator between 160 and 320, or about 200) is noted. Second, the middle arrow on the circular computer dial is set opposite 200. Third, a choice is made from the shutter/aperture combinations revealed at the bottom edge of the computer dial. The exposure of 1/60th of a second at f-11 was used.
- c. A digital-display, silicon-cell, batteryoperated incident light meter. This meter can be programmed to compute ambient light or electronic flash light exposures, as well as remember and compare exposures. The shutter speed is chosen and the meter indicates an appropriate f-stop.
- d. A flat contrast scene, when evaluated by the presence of defined shadows with soft edges. Developed on the same roll as *a*, the scene was printed for similar middle gray values, resulting in darkened shadows.

а

b.

d.

Figure 13.6 Untitled.

Paul Teeling.

A chair at Ellis Island with an abandoned flag presented a contrasty subject. A handheld reflected light meter was used to calculate an exposure, based on the shadows to the left, and the film was given reduced (or compressed) development to retain detail in the sunlit patch in the foreground.

(Courtesy of the photographer)

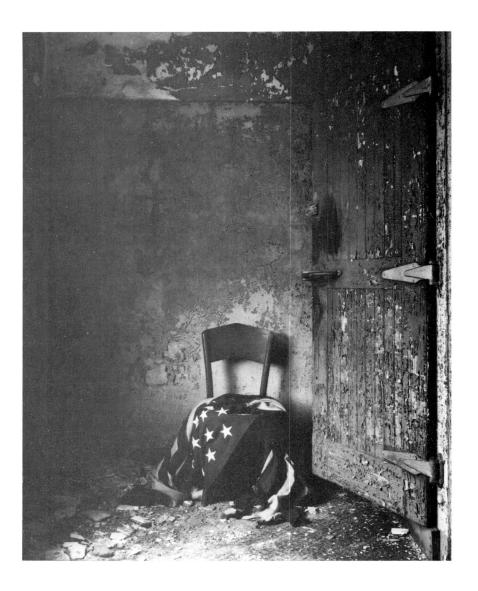

TABLE 13.2 Small Camera Contrast Control Compromises

Scenes of similar contrast can often be clustered on a single roll of film; a compromise development will permit good prints to be easily made. Use the first development ratios for T-Max films, and the second for other films.

Description of Scene	Development Ratio	Paper Grade
Very flat		4
Flat	110-125% normal	3
Normal		2
Flat		4
Normal	normal	3
Contrasty		2
Normal		4
Contrasty	90-80% normal	3
High contrast		2
Contrasty		4
High contrast	80-70% normal	3
Very contrasty		2

Grouping Exposure for Contrast Control

Compromise development (see table 13.2) will allow negatives from a variety of lighting situations to print easily, even though roll film does not permit developing each negative to fit a different luminance range. When you begin photographing with a roll of film, make a note of the contrast conditions and complete the film with a choice of similar scenes, i.e., ones that are within one contrast grade either way. Develop the film for the *average* condition.

Keep careful notes on exposure ranges and contrast predictions until your system is working correctly. Contrast control requires you to keep developer temperatures and agitation patterns the same from one roll to the next.

Summary

Meters are used to evaluate subject luminance range (or contrast) to determine correct development. Both reflected-light and incident light meters are useful, although an incident light meter often suggests more accurate overall exposures, given TTL metering design criteria. Reflected-light meters can be used to measure shadow and highlight luminances and contrast calculated by counting a range of exposures, stated in f-stops. Contrast may be estimated without a meter when the subject is in daylight by examining the sharpness of cast shadows.

Extended development is suggested for low-contrast scenes, and shortened development (with compensating increases in exposure) is suggested for contrasty scenes. Contrast grouping is suggested as a means of producing 35mm negatives that print easily and well.

Discussion and Assignments

Many exposure errors blamed on light meters are in fact errors of interpretation, or operator errors. Some photographers simply cannot seem to use a reflected-light meter and produce accurate exposures, while others have similar problems with incident light meters.

Assignment 1 Compare gray card readings made by your TTL meter and at least two different reflected-light meters. Compare the meters in sunlight and tungsten light. Make careful notes of the indicated exposures, and analyze which meter is indicating a greater or lesser exposure.

Assignment 2 Assuming you have TTL metering, borrow an incident light meter and a hand-held reflected-light meter. If you can, work with a friend and dictate the exposures you will use and the frame numbers on the film, rather than writing them down yourself.

Find a scene of normal contrast, which has large, easily meterable target areas, and reasonably stable light (where the conditions are not changing minute by minute). Using the in-camera meter, calculate an exposure for the scene the way you normally would, and expose two identical frames. Cover the lens and expose a blank frame. Use the incident meter and calculate a new exposure without referring to your previous exposure calculations. Expose two identical frames and one blank frame. Finally, using the reflected-light meter, calculate a new exposure, and shoot two frames and one blank. Repeat this with contrasty and flat scenes. Develop the roll normally and examine the developed film.

Refer to your exposure notes and see which metering method has produced the most accurate exposures for each of these scenes. When there is an error, analyze what you did and why that result occurred.

Assignment 3 Ansel Adams popularized the **Zone System** as a way of previsualizing the final print while in the presence of the photographic subject. Subject luminances, negative densities, and print values are linked by "zones," of which there are eleven, from 0 (black) to X (white). These names suggest a mental image of equal density steps: black, almost black, dark gray, and so on to almost white and white. But the changing gray values created by equal changes of exposure are not regular. Instead, they are crushed together in the shadows and the highlights, and are very much stretched apart in the middle values.

Carefully photograph a large sheet of plain paper, pinned to a wall or hanging from a line, illuminated by very even light. The camera is focused on infinity, not on the paper. Expose ten consecutive frames on a roll of film. This is an extension of the five-frame test done earlier. (You might wish to expose eleven frames, exposing the first frame at the metered exposure, just to create a definite starting place on the film for the test strip.)

The first frame is exposed five stops less than the indicated meter exposure, the second four stops less, etc. Continue until you have exposed ten frames, the last being exposed five stops more than the original indicated exposure. These exposures will produce printing densities that describe Zones I through X in your photographic system. Use the rest of the roll for other photographs and then normally, fix, wash, and dry the film.

Use a mat knife and straightedge to cut off the perforations and unexposed film along both sides of the test frames. Carefully cut apart the individual frames and reassemble them with their long sides together, taping them neatly together at the edges with Scotch Magic tape. (This tape has very low printing density, compared to glossy acetate tapes.) This assembled strip of film is a record of the actual negative zone values created by your photographic process.

Make a contact print of the assembled density strip, exposing it so that the most dense film (Zone X) remains paper white, and the next strip (Zone IX) is a just visible gray. A trial exposure with most contemporary enlargers (set to illuminate an $8'' \times 10''$ print) should be between 10 and 15 seconds at f-16.

The difference in value between the two highest zones is so slight that it probably will not be visible on a wet print, and the test exposure should be rinsed and dried before proceeding. When the exposure is correct, make a finished print.

Examine your own dried 10-frame proof strip. Compare the total range of values (black to white) to the range of useful, or dynamic, values in your system's photographic gray scale. Most of the tonal information your photographs can supply is found between Zones IV and VII, with the darker and lighter values giving the mid-values substance and light, respectively. There will be little or no separation between Zone I and III, and very little between Zone VIII and X.

Notes

- Candela is a scientific term that has replaced the candle in defining light intensity. Light intensity used to be defined by the amount of light that a candle (of a specific size and material) would produce when burned under specific conditions.
- 2. Middle gray refers to the Kodak 18% reflectance neutral gray card, which has a psychological value of appearing midway between black and white. It has a reflective density of .74. The 18% reflectance gray card and middle gray are interchangeable. This card offers a repeatable standard metering target, especially useful where there is no meterable subject. A problem is that some TTL meters produce correct exposures (with EI equal to ISO) when the camera's meter is measuring Caucasian skin rather than an 18% gray card, which is almost a full stop difference of exposure.

14Finishing and Protecting Prints

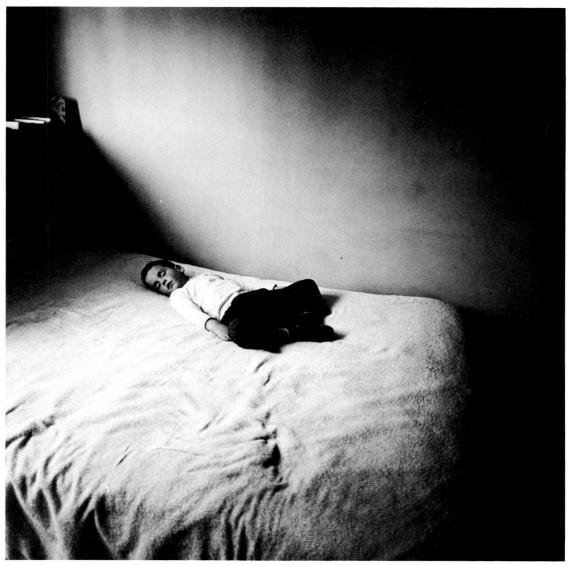

Figure 14.1 UNTITLED.
Arnold Gassan.
The sleeping boy was photographed in existing light with an exposure of one second. Less than normal development kept down the contrast in this Hasselblad 6 x 6 cm Tri-X negative. (Photo by the author)

Figure 14.2

Height and Light in Bruges Cathedral, 1907.
Frederic Evans.
The cathedrals and churches Evans
photographed were carefully studied, often
over a period of months, to find the most
revealing light.
(Library of Congress)

Justification

A significant investment is required to produce and protect a finished print, and this cost should be a consideration when chosing how to protect a photograph. The unmounted photograph is easily damaged by normal handling. The paper cracks easily and the emulsion can be scratched; fingerprints dim the surface of the protective gelatin or plastic. Many photographs need not be mounted, and for some uses mounting is undesirable; for example, prints intended for reproduction should be left unmounted, and often these pictures are not required to have great longevity. To protect the image, prints intended to be finished to the best standards and kept as long as possible are exposed with a wide (1 inch) white border. This is a buffer against inevitable damage to corner and edge, and also provides space for concealed corner mounts when the print is protected by a window-mat.

Permanence of Prints

Finished prints should be processed for permanence by fixing in two or three fixing baths carefully, neutralizing the fixer, protecting the silver image with mild selenium toning, and a careful final washing. Kodak publication no. F30, *Preservation of Photographs*, may be consulted for further information on causes of deterioration in prints and prevention of chemical damage.

Incomplete fixing leaves silver halides in the emulsion. These halides eventually "print out," and appear as color. Improper fixing will also leave silver or sulfide compounds in the emulsion, which are difficult to remove and will eventually cause the print to discolor or fade.

Two separate fixing solutions are needed to provide full removal of unused silver halides. An economical procedure is to prepare two gallons of fixer (without using the hardener) from the Kodak Rapid Fixer concentrate. Mark the bottles to indicate first and second fixer. The first gallon bottle is used for 50 8"x 10" prints and then discarded. The second bath is used for the first 50 prints and then moved to the first bottle; fresh fixer is prepared for the second bottle. After the first time, every gallon of fixer is used for 100 prints, but the second bath is always the freshest, and an effective final fix.

As you print, fix each print in the first fixer for one-half the total suggested fixing time, agitating constantly. Remove the print and place it in a tray of running water or store it in a tray of water, but change the water after every 4 or 5 prints. When you have finished printing for the day, cycle the prints through the second fixer for the second half of the total fixing time, rotating them constantly from bottom to top.

Prints cannot be rotated in fix or wash baths with print tongs without grave risk of damaging the prints. If your hands chap easily, you may have to wear rubber gloves. In any case, dry your hands between operations to prevent skin damage.

Toning for Preservation

Selenium toner can ensure permanence without color change if a 5–10% solution is used, as described in chapter 12. Sufficient selenium will be deposited in 3–5 minutes to form a protective barrier of silver selenide. Selenium toning should be done in a well-ventilated room to avoid inhalation of the toning procedure gases. The toning procedure outlined earlier can follow the regular second fix bath, or a special third fixer bath, a simple thiosulfate solution (also described in chapter 12), can be used to reduce acid carryover into the toning solution.

Figure 14.3

Print drying rack made of wooden or aluminum frames stretched with plastic window screen. The proportions of the screen permit an efficient use of space for drying standard print sizes. The frames should be separated vertically by about 2 or 3 inches.

Figure 14.4

A portable drying rack can easily be assembled from two lengths of 3/4 inch dowels, a 6-foot length of 24-inch plastic screen, and 1/4 inch nylon cord.

Different papers and paper grades will tone at different speeds. Toning should be done under a good work light so that the change in density and color can be monitored. When toning for permanence or print intensification, place an untoned wet print beside the toning tray to use as a standard of comparison. After the desired tone is reached, a very thorough wash is required in water not hotter than 70°F. The Automatic Tray Siphon is adequate if no more than 5–6 prints are washed (and the tray is a size larger than the prints), and the prints are *constantly* rotated. Wash prints for 5 minutes, empty the tray and refill with fresh water, then wash another 5 minutes.

More efficient and less tedious washing is accomplished in a print washer made with vertical plastic dividers, which keep prints separated (see figure 3.12B). Water flows in at the bottom and pushes up past the prints, but even these require attention, as the prints will cling to divider walls and must sometimes be moved to wash both front and back adequately.

Drying Prints

Prints must be dried on a physically and chemically clean surface to assure that prints are permanent, smooth, and flat. Most photographers use wooden frames with a plastic screen stapled to the frame; a rack holding several screens can be fitted under a work table, making economical use of floor space (see figure 14.3). The simplest dryer is a length of plastic window screen, stapled at each end to a dowel rod and stretched like a hammock (see figure 14.4). This can be rolled and stored when not in use.

Prints should be drained and squeegeed or sponged off before being dried. A bar squeegee, or a clean viscose sponge (the colorful grocery store sponges are good enough) is used to wipe away excess water and any dirt.

Most papers can be placed on the screens face down, but some emulsions are soft enough to take an impression of the screen. If the paper you are using does pick up screen marks, the prints can be dried face up for an hour and then turned over to finish drying. This will prevent excess curling and avoid marks. As a print dries it will usually cling a little to the screen and dry smooth, if not totally flat.

Figure 14.5

Egypt, 1852. F. Beato.

The photographer was one of the first great professional photographers to take advantage of the clarity and crispness of detail provided by the collodion, or wetplate, process.

(Private collection)

Fine prints should be handled with cotton gloves when dry, otherwise some fingerprinting is inevitable. As each print dries it should be removed from the screen and placed under a weight. Put a piece of clean, acid-free paper on a work surface to protect the face of the print, put the print face down, cover it with a piece of acid-free mount board, and then a stack of books or other similar weight. When the prints are thoroughly dry, they will remain flat if they are kept flat. Dried prints may be stored together in the black plastic bag that paper comes in.

Mounting Prints

A print that has been firmly bonded to a smooth sheet of mount board, with enough space left around the picture to isolate it from a cluttered environment, is very attractive. But when the print is mounted permanently it is hard to salvage if the mount itself is damaged. It has been argued sometimes that mounting the print does more harm than good. An alternative is to not mount the print to the board at all. An unmounted print will not be as smooth and flat as a mounted print, but a slight curve in the surface is usually not objectionable. Alternatively, prints can be made smooth and flat by dry-mounting them back-to-back with a second sheet of photographic paper (an unsuccessful version of the picture is a possible source of a backing print). The double thickness print is rigid and smooth, and it can be presented under a window mat without fear of the print curling. Cheap mounting boards should be used only for test prints because they contain sulfuric acid residues left from the paper-making process. This acid will eventually migrate to the print and destroy the silver image. (This also happens when prints are stored or interleaved in paper that is not acid-free.) Acid-free, or "archival quality" board has become generally available through mail-order distributors (see appendix 4).

TABLE 14.1

Dry-mounting and Matting Equipment

Thermostatically controlled dry-mounting press Tacking iron
Metal straightedge: 24–36"
12", 30–60° triangle
Utility or mat knife and blades
Pencil
24" ruler
Logan or Dexter Mat Cutter and replacement blades
Two- and four-ply acid-free mat board
Acid-free linen tape
Acid-free print corners
Print storage bags
Print storage boxes

Mounting Materials

Spray cement, pressure-sensitive tissue, and heat-sensitive tissues are all used to mount prints. The most permanent is heat-sensitive tissue. Seal now manufactures several dry-mount tissues, including a low-temperature material for use with RC prints. Prints used to be mounted with paste, but though library glue is chemically neutral, it unfortunately is hygroscopic, meaning that it attracts moisture. Spray cements have unknown amounts of sulfur, and though they are useful for mounting study prints they are not suitable for long-term use. Scotch brand Positionable Mounting Adhesive is convenient but not acceptable for long-term mounting, as it is very acidic, with a pH of 5.4.

Mounting a Print

Dry-mounting a fiber-based print consists of heating and pressing the tissue, the print, and the mount board together. The tissue coating melts and penetrates the print and the mount fibers. Adhesion takes place as the tissue cools. A cover sheet larger than the mount board is needed to protect the surface of the print from the heated iron or mounting press platen. The cover sheet will emboss the mount board if it is smaller. It is necessary to use a cover sheet that is acid-free in order to avoid contaminating the print and mat board.

A dry-mount press is desirable, although a household iron can be used for small prints, but prints larger than 5"x 7" inches should only be mounted with a mounting press. A mounting press consists of a thermostatically controlled, electrically heated platen, a support mechanism with controlled pressure of the platen, and a cushioned base on which to lay the print and mounting board. The thermostat should be set for the tissue being used.

Prints must be smooth and flat. If they have not been stored flat, they may be flattened quickly with the press. Place a dry print face down on a piece of acid-free board, and reach into the press with the board resting on the palm of your hand. Press the board up into the heated platen, closing the press and withdrawing your hand. You press the print up into the platen and prevent folding over the corners. Keep the press closed for 5–7 seconds. Open it, remove the print, and store it at once under a weight to cool.

Always think about what the print is in contact with; for example, it is foolish to eliminate sulfer in the processing and then work the print on cheap cardboard or newsprint. Be certain your hands are clean; avoid fingerprinting the picture or the mat; wear cotton editing gloves. The mount board may also be preheated by closing the press on it for a few seconds. Heating drives out excess moisture and helps guarantee a firm bond with the tissue.

Figure 14.6

a. An electrically heated, thermostatically controlled tacking iron is used to adhere the dry mounting tissue to the back of the print, by gently pressing the tip of the hot iron into the tissue, which melts into the print.

b. The print and mounting tissue are trimmed together, using a sharp mat knife and metal straightedge on a protected cutting surface. Right-angle cuts can be verified by using a large triangle.

c. Locate the print on the mat board and adhere the mount tissue by lifting one corner and pressing the tacking iron onto the tissue, melting it into the mat. Avoid touching the mat outside the print area as some tissue residue may be transferred. Keep the tissue smooth and flat and adhere an adjacent, second corner of tissue. Cover the print with a large piece of acid-free paper and insert mat, print, and cover in the mounting press.

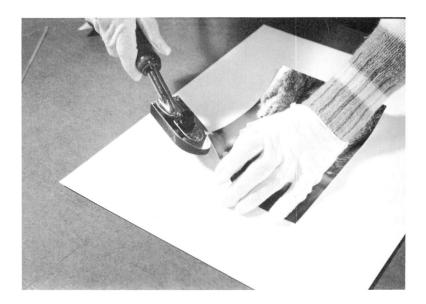

Figure 14.7
Construction of Union Station, Nashville,
Tennessee, ca. 1895.
H.C. Griswold.
Factory-made dry plates revolutionized
amateur photography and encouraged the
creation of documentary records like this
5" x 7" glass plate documentary record.
(H.C. Griswold Collection, University of
Louisville Photographic Archives)

Follow this sequence to mount a print (see figures 14.6A-C):

- 1. Place a flattened print face down on a clean working surface.
- 2. Lay mounting tissue on the print and adhere it with a stroke of a tacking iron near the center of the print.
- 3. Trim tissue and print together. Use a mat knife, triangle, and metal straightedge. Blade trimmers cut tissue badly and although rotary trimmers make a clean cut, it is difficult to cut square prints.
- Place print face up on the mat board, lift a corner, and tack the mounting tissue. Check for correct position and then tack a second corner.
- 5. Protect the print with a cover sheet and place board and print in the press. Close it for 20 seconds. Remove the newly mounted picture, and immediately place it face down on a smooth, cool, dry surface. Apply moving pressure with the palm of your hand to the back of the mat until it cools.

Protective Storage

The mounted print is protected from corner damage, but not from abrasion. Prints that are stored without interleaving (sometimes called a cover sheet) are inevitably scratched by normal handling. Soft tissues are less than desirable for interleaving; though they will not scratch the print they do hold dirt. Prints can safely be interleaved with a smooth, lightweight sheet (such as Hollinger Bond, an archival paper), which will shed dirt and also protect the print. Prints can also be protected by a polyethylene print storage bag. The bag keeps dirt and moisture from the print.

Figure 14.8A sturdy worktable has been combined with print storage drawers. Because wood is acidic, prints must be kept in plastic bags to protect them.

Best primary protection for the print is a window mat, which can be combined with interleaving and a plastic bag. Overmatting also permits you to present an unmounted print, which permits replacing the mat if it becomes soiled. A print is attached to the backing board only by corner pockets or tape hinges.

Window Mats

Mat boards are made in various thicknesses. Two-ply is usually used for the backing, with the more expensive four-ply reserved for the window mat. The board can be purchased in precut sizes (8" x 10", 11"x 14", 16"x 20", etc.) or in full sheets (either 30"x 40" or 32"x 40"), which are cut to size as needed. Examine the board to decide which surface will be seen (most matting materials have slightly different textures on each side), then cut the front and back pieces to the same size.

Mat a print by following this sequence (illustrated in figure 14.9A through F):

- 1. Measure the size of the window (usually just smaller than the image area, though a white print border may show).
- 2. Place the mat face down on a clean working surface, and draw light pencil lines for the opening.
- 3. Use a mat cutter and a metal straightedge to cut the window. The knife cuts outward on a bevel. The cut begins 1 1/2 thicknesses of the mat board *outside* the opening. (If the cut line is shorter, the window will not separate and the mat will be ruined; if the cuts are too long they will be obvious from the front.) Repeat for all four sides. The window should fall away when the mat board is lifted.

Helpful Hints

- The sharp tip of the mat cutter blade must not drag: place two pieces of cardboard under the mat to form a channel for the blade so that it contacts only the mat.
- Mat boards vary in quality and some will tend to tear, rather than cut cleanly; two knife passes may be needed, the first to score deeply, the second to open.
- · Use the heaviest straightedge you can find to guide the cutter.

All materials used in protecting the print must be acid-free. The window mat and the backing board are usually joined, but need not be if the print is to be framed. Figure 14.9D shows gummed linen tape used as a hinge; never use drafting tape or other common pressure-sensitive paper tapes. The paper is acidic, and the adhesive contains sulfer, which will often bleed and smear the mat as well.

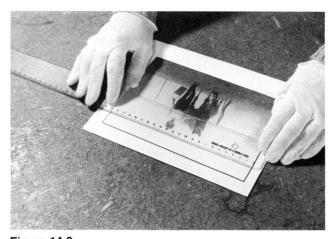

Figure 14.9

a. Measure the window mat opening carefully. This clear plastic scale is calibrated in centimeters, and is easy to read.

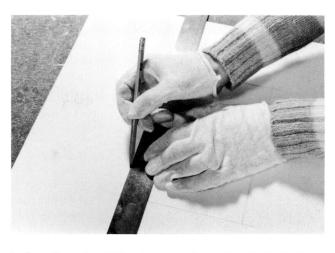

b. Draw the outline of the window mat in pencil on the back side of the cover sheet.

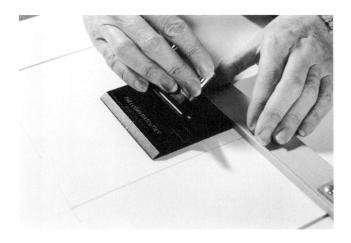

c. A Logan mat cutter (which uses a standard single-edged razor blade) is shown here being used to cut the window. An alternative to the Logan cutter is the popular Dexter mat cutter, which has a smaller blade. Note that the straightedge that guides the cutter is *outside* the window area, so that the mat edge will taper away from the print.

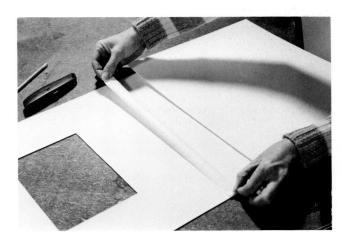

d. The cover sheet with the window is hinged to the backing board with linen tape. Pressure-sensitive paper adhesive tapes should not be used, as they dry out and also contaminate both print and mat with acid. After the tape is dry and the hinge closed, the print is correctly located under the window.

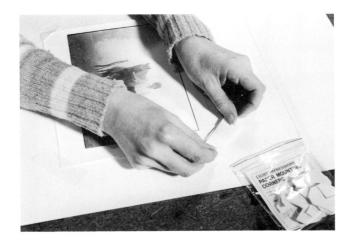

e. Acid-free paper corner pockets are folded and taped to the support board with 2-inch linen tape strips. The pockets will hold the print firmly in place and yet permit it to be removed easily if the mat or support are damaged.

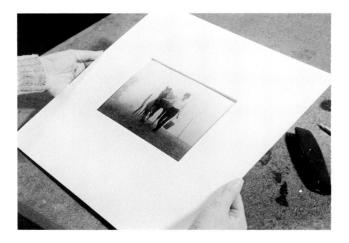

f. The finished window mat visually isolates the print and also protects it from abrasion.

Summary

Silver prints are easily damaged and must be protected from physical as well as chemical damage. Store prints in acid-free sleeves, folders, or boxes. Mount them on acid-free board and provide additional protection from abrasion with window mats.

Discussion and Assignments

The size and proportion of mats affect the photograph. Traditional mounting leaves a little more space below a picture than on the sides and top. Also, the cost of protecting and storing photographs quickly becomes sigificant, yet without proper storage prints are vulnerable and quickly lose the pristine finish that is a large part of the beauty of a photograph.

Assignment 1 Placement of the photograph on the mat affects how it looks. Make two identical vertical pictures about 5"x 7" (or crop existing pictures) and then *center* mount one on an 11"x 13" inch piece of board. Mount the second on an 11"x 14" board with the top and side spacings equal. Place them where they can be studied easily and see what effect the slightly larger space at the bottom has.

Assignment 2 Estimate how many contact proof sheets, negative sleeves, and mounted, finished prints you make a month. Using catalog prices for the following list of items, calculate the cost of protecting and storing a five-year collection of your own photographs.

- · file folders
- · ring binders
- · negative sleeves
- linen tape
- · two- and four-ply mount board
- · protective print sleeves
- · print storage boxes

Figure 15.1
UNTITLED.
Arnold Gassan.
a. Early morning light flattens the space behind the fence.

b. Late afternoon light opens the space behind the fence. Notice how little the trees in the background are changed between the two photographs because of their orientation to the light. (Photos by the author)

About Light

Light travels in straight lines in clear air; it is reflected, refracted, diffracted, or absorbed when it passes from one medium to another.

- reflection: light meeting a dense, polished surface is reradiated in another direction with little loss of energy. The angle in which the light leaves is the angle of reflection, and it is equal to the angle of incidence, the angle between the incoming light, and the reflecting surface.
- refraction: light slows down and changes directions, or is bent as it passes from one medium to another.
- **diffraction:** light is scattered when it meets small reflecting surfaces (e.g., air with dust and moisture particles).
- absorption: light is absorbed and turned to heat when it meets solids (which includes air).

Qualities of Light

It is easy to forget that the camera only makes a record of the light reflected from the subject, it cannot photograph the actual people or places or things, and the photographer needs always to be concerned with the quality of the light. Terms describing light which are important to photography are:

- · intensity
- direction
- specularity
- · source
- color

Intensity describes the amount of light. Intensity is usually measured (using photographic light meters) but outdoor sunlight intensities can often be estimated accurately enough for exposures.

Direction refers to the way the light falls on the subject, relative to the camera. Early Kodak camera instructions suggested that you make pictures when the sun was over your left shoulder as you held the camera. This guaranteed frontal lighting on the subject, which produced some modeling, or roundness, yet avoided harshness. The simple change in direction from morning to evening light significantly changes ones perception of space, as illustrated in figure 15.1A and figure 15.1B. These two figures are also examples of ambient, or existing, environmental light.

Specular light is direct radiation from a single source. Such a source is called a **point source**, and it makes very sharp-edged shadows. Specular light can come from the sun (when there is little atmospheric diffusion), or from another small source, e.g., an electronic flash. Specular light implies contrasty lighting. The opposite of specular is diffuse light, which appears to come from many directions, softening the edges of shadows and lowering contrast. Diffuse lighting is created by atmospheric moisture or dust, or by the deliberate use of screens or grids, which vary the direction of the light rays.

Light sources are the sun, fires, candles, flashlights, streetlights, and household electric lights (tungsten bulbs or fluorescent tubes). These are **steady state** light sources, and their effect on the subject can usually be evaluated by eye and measured with conventional exposure meters. Ambient lighting may be steady state and predictable, as with the sun, or it may be erratic and transient, as with lightening.

190 Chapter 15

Figure 15.2a. Specular light is harshly directional and creates sharp-edged shadows.

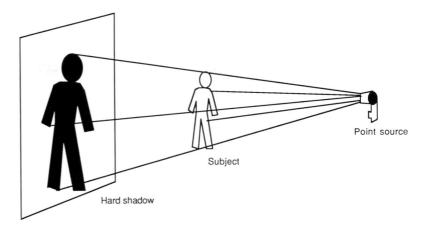

b. Diffuse light makes soft-edged shadows.

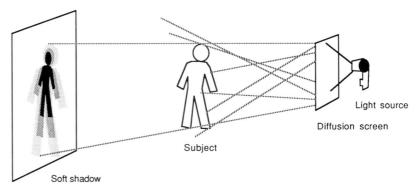

The sun is the principal continuous light source for the photographer. Sunlight is usually used as it is found, but may be modified by diffusion or reflection, and it may be supplemented by other lights. Sunlight varies in quality from specular to diffuse, and in color from deep red to vivid blue-white.

Light from flashbulbs and electronic flash units are **momentary** light sources, and sometimes these are referred to as artificial light sources. The precise effects of momentary lights can only be guessed, though studio flash units have **modeling lights**, which permit the photographer to anticipate overall effects.

Color refers to both the subjective descriptive terms we use to describe light as "cool," meaning toward the blue, or "warm," toward the red. When light color is described scientifically, a colder light is more red and a hotter light is more blue, just opposite from the emotional terms commonly used. The scientific description of light is radiation from a black body at a certain temperature measured in degrees Kelvin. All molecular motion stops at 0°K, which is also called absolute zero. Measuring visible light by physical temperature means that light ranges from deep red (about 1,800°K) to blue-violet (about 6,800°K), and the *hotter* a radiation source is, the *bluer* the light appears.

Color of the light source is important even in black-and-white photography because light sources do not have the same color temperature, films are not equally sensitive to all colors of light, and our subjective responses to the subject are affected by color.

Existing and Modified Lighting

The photographer may choose to accept the light as it exists or to modify it. Even when the existing light is accepted, the photographer can often choose how to use that light. Figures 15.3A, 15.3B, and 15.3C describe a giant saguaro from three different points of view, which are also examples of three different uses of the same light (the pictures were made within five minutes of each other, on the same roll of film). The first picture is an example of the almost flat light suggested by George Eastman, with the sun over the photographer's shoulder. Figure 15.3B shows the cactus close-up, with the sun backlighting the plant, and the third illustration shows the effect of strong side- or cross-lighting. All three of these pictures used the ambient, or environmental light as it existed; the exposure of the llford FP4 film was adjusted to the light, and the contrast grade of the paper chosen to fit the negative.

Figure 15.3 *Untitled.*Arnold Gassan.

- a. The sunlight falls over the shoulder of the photographer to produce an adequate documentary photograph, much as suggested by George Eastman a century ago. Ilford FP4 film, developed in Hobby-Pac film developer and a Leica camera with a 35mm lens was used.
- b. The saguaro up close and photographed at the same exposure as *a*. Photographing with the sun behind the cactus— but not increasing exposure— exaggerates the tonal scale.
- c. Moving eight feet to the left and keeping the same exposure, lens, and angle of view produced this photograph of the cactus. The entire roll of FP4 was developed for five minutes in Hobby-Pac, diluted one package to 650ml of water, and all prints were made on llford Multigrade paper with a grade 3 filter.

(Photos by the author)

a

Figure 15.4
Untitled.
Bärbell.
A reflector was used to control shadow values in this portrait. The strong side lighting provided excellent modulation of the texture of skin and hair.

(Courtesy of the photographer)

Strong cross-lighting is traditionally used in portraiture to reinforce the sense of texture of skin and hair, as seen in figure 15.4. Texture is also reinforced when the light is more specular than diffuse. But the big difference in lighting between the portrait of the man and the photograph of the cactus is that the portrait photographer manipulated the light, adding a **fill** light to the existing **key** light. The contrasty situation created by strong side-lighting was softened by use of a reflector to fill the shadows. The fill light both reduces the luminance range and illuminates deep shadows so that detail is preserved

Key light is the principal light and fill light is a secondary light that illuminates the shadows and reduces contrast. When the fill light is placed *on axis*, (in line with the lens and the subject) it does not make strong new shadows and call attention to itself.

Figures 15.5*A* and 15.5*B* show a portrait setting where a circular portable diffuse reflector is placed *at the camera*. This is the simplest use of a fill light, reflecting the existing light onto the scene from the axis of the camera. A simple reflector can reduce the luminance range of a contrasty scene and significantly increase shadow densities without weakening the impact of the key light.

A reflector permits you to keep the sense of the light (direction and overall feeling of specular or diffuse light), but illuminate shadows and allow normal negative development. This is important because when contrast is reduced by shortening developing time, the shadows are crushed. A reflected light meter can accurately measure the change in contrast when a reflector is used. If an incident meter is used, the change must be estimated by eye, but the overall exposure will be decreased slightly because of the added light.

Figure 15.5

a. The portrait subject, the view camera, photographer, and circular reflector (used to fill the shadows and limit contrast) are shown here.

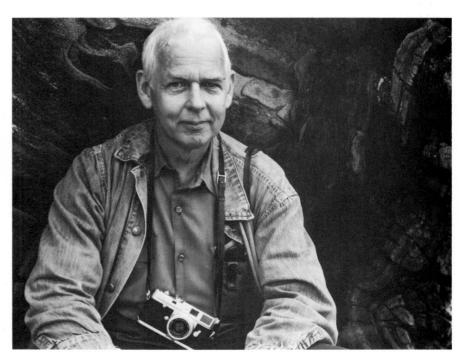

b. David Vestal.
 Bärbell.
 A reflector adds light to deep shadows and limits contrast without obviously changing the dominant light.
 (Courtesy of the photographer)

Compound Lighting

Though often the best light is a single source (which is usually sunlight), more complex lighting is frequently used to achieve effects impossible with a single light. Whether steady state or flash units are used, the principles of compound lighting are the same. A key light establishes the quality of the light. Supplementary fill light softens shadows, limits contrast, and helps define mood. Key and fill lights may be specular or diffuse, or a combination.

Lighting Ratios

Lighting ratios are a measure of the difference between key and fill lights. Strong lighting ratios can also be achieved by placing a single light source very close to the subject (as shown in figures 15.13*A* and 15.13*B*). The lighting ratio in portraiture is often measured by metering the light and dark side of the face and comparing indicated exposures. If they are the same, the ratio is 1:1; if they differ by one stop, the ratio is 1:2; if there is a two-stop difference, the ratio is 1:4, etc. Rather bland effects are produced by lighting ratios of 1:2, or less. Stronger ratios (1:3 to 1:8) are frequently used for dramatic effect. Figures 15.6 through 15.13 illustrate basic key and fill light setups. The lights are small studio flash units used with and without diffusion, as indicated in the accompanying sketches.

Momentary Lights

There are many situations where sunlight is not an available or not a suitable light. Since 1839, when the first daguerreotype was made, photographers have sought clean, portable, safe supplementary lighting. Flashpowder was invented in the 1860s, a mixture of an explosive and powdered magnesium. The explosive was ignited by a spark; it burned quickly and hot enough to ignite the magnesium, producing a burst of intense, white light. The exposure intensity and time was controlled by the amount of powder burned. Flashpowder produced dangerous sparks and a cloud of smoke, but it was portable and cheap.

Thin magnesium ribbon was put into ordinary household lightbulb and electrically ignited, and in 1929 the flashbulb was marketed. These German-invented bulbs sometimes exploded (under the pressure of the gases from the burning magnesium), but were generally safe, consistent in light output, and portable (although not cheap). Flashbulbs were a professional's choice for supplementary portable lighting from 1930 until late in the 1950s, when the portable electronic flash became economical.

Electronic Flash

Electronic flash dates from the 1930s, when Dr. Harold Edgerton perfected the use of a high-voltage electrical discharge through a rare-earth gas in a glass tube, which produced an intense white light that lasts a very short time. The color of contemporary electronic flash is approximately the same as daylight. These lights could be fired many times a second, at regular intervals, and were called **strobe** lights. Electronic flash lighting is often erroneously referred to as strobe lighting. Early flash units were bulky laboratory equipment; the portable, economical hand-held units of today had to await the development of solid-state electronic circuits and powerful small batteries, which were not available until the 1950s.

Figure 15.6

a. A single light is placed high to one side; the specular highlights in the hair and discrete shadows reveal the shape of the light.

b. Sketch of the lighting used in a.

Figure 15.7a. The previous lighting has been modified by adding a fill light on axis (directly behind and slightly above the camera) to fill the hard shadows. The key light was 5 feet from the subject, and the fill light was 15 feet from the subject, so the lighting ratio is 1:9.

Figure 15.8

Figure 15.8a. The fill light was moved up to nine feet, resulting in a lighting ratio of about 1:3.

b. Sketch of the lighting used in a.

b. Sketch of the lighting used in a.

Figure 15.9 a. A single light is placed to one side behind a simple diffuser. The diffuser is 6 feet from the model.

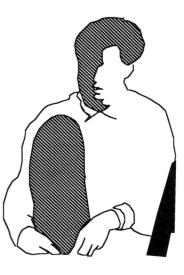

curtain.

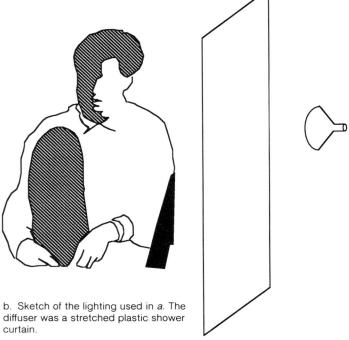

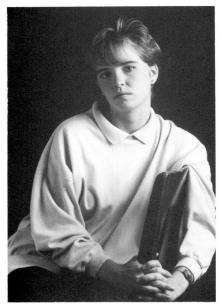

Figure 15.10
a. The single diffused light has been reinforced by a large white reflector card at left; the presence of a second directional light is quite evident.

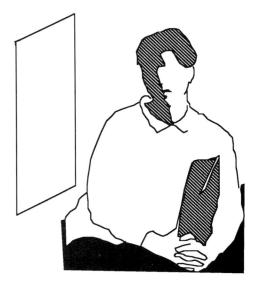

b. Sketch of the lighting used in a. The reflector was a 3' \times 4' sheet of foam-core board.

Figure 15.11

a. The reflector card has been removed and a diffuse fill light has been added on axis 10 feet from the model (behind and to one side of the camera). Notice how the model's features have been changed by the change in direction of the lights.

b. Sketch of the lighting used in a.

Figure 15.12
a. Diffused lights have been placed on both sides of the model, with the right hand slightly dominate. The directions of the light relative to the model are important and are seen in the model's eyes.

b. Sketch showing the placement of balanced diffuse lights.

Figure 15.13

a. A very simple, dramatic lighting is produced by a flash used very close to the model, pointing away from her into an umbrella. The rapid change in lighting intensity (inverse square law) and change of angle of incidence and reflection as the face curves away from the light add to the effect.

b. Sketch of the lighting for a single-flash portrait.

Synchronization

Momentary lights must **synchronized** to fire when the shutter is open. Synchronization is done by switches attached to the shutter. The light source is electrically connected to the shutter through a **PC** connecter on the side of the camera body, or a sliding contact on top, called a **hot shoe**. Older cameras may have two PC body connectors, one for **M** (flashbulb) and the other for **X** (electronic flash) synchronization, but later cameras use a single contact and have an internal synchronization switch, usually located on the shutter speed adjusting ring. The switch position is indicated by symbols: a lightbulb (for flashbulb) or jagged lightening (for electronic flash).

Between-the-lens shutters can be synchronized at any speed, but focal-plane shutters can be synchronized only at speeds in which both curtains are fully retracted, permitting the entire image frame to be exposed. The highest synchronization speed is usually indicated by a colored number on the speed adjusting ring. If a focal-plane shutter is used with flash at higher speeds, only part of the frame will be exposed. Some metal focal-plane 35mm cameras shutters will synchronize at speeds up to 1/250 of a second, while the cloth shutters are limited to 1/60 as the highest speed.

The duration of the electronic flash exposure is controlled by the internal resistance of the flash tube, or by a flash exposure control circuit, standard on most electronic flash units. These circuits respond to flash light reflected from the subject. Small camera electronic flash exposure times now range from about 1/600 to 1/50,000 of a second. The shorter speeds are a result of the automatic exposure controls shutting down the flash tube, and these very short times can produce reciprocity effect exposure errors. The closer the light unit (with its exposure sensing device) is to the subject, the shorter the exposure time will be. The effect of these very short exposures are a loss of density and less contrast. T-Max films are less sensitive to short-exposure reciprocity, but most other films will produce better contrast if developed 10% longer than normal when flash is the principal light.

Figure 15.14
Untitled.
Edward Pieratt.
Electronic flash permits the photographer to "freeze" action, even when there is little or no ambient light.
(Courtesy of the photographer)

Figure 15.15
Electronic flash synchronization closes the circuit when a between-the-lens shutter is fully open, and soon after the first focal-plane curtain has moved fully across the film.

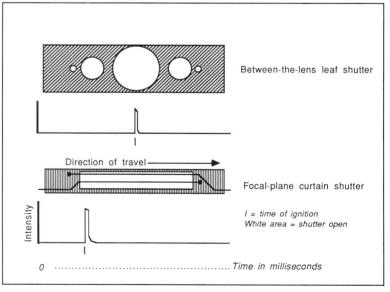

Figure 15.16

A portable flash unit takes energy from a battery and transforms it into high voltage, which is stored in a capacitor until the circuit is closed. High voltage ionizes the gas in the flash tube and when current flows, it is transformed into light. Light reflected from the target subject is used to shut off the flash light when the exposure is adequate.

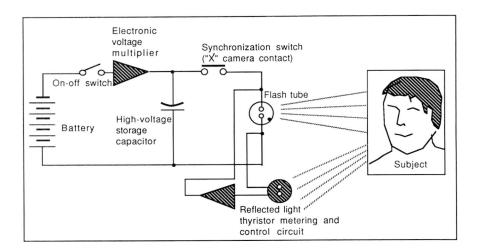

Computing Flash Exposure

Momentary light sources impose two new variables on the photographer: determining what aesthetic effect the light will have, and estimating the exact exposure required to bring the momentary light and the existing environmental light into a suitable balance. The exposure needed for electronic flash lights is determined by using a **guide number (GN)** or a **flash meter**. The flash meter is the most accurate method.

A flash meter is an electronic camera that accepts light for a given shutter interval, integrates it, and calculates an f-number. As with any meter, variations in metering method will produce variations in negative densities and the meter should never be used without testing.

Flash meters are expensive. Alternative methods of controlling exposures are using the automatic exposure control circuits and predicting exposure by using the GN. Although most contemporary hand-held electronic flash units have automatic exposure control circuits built-in, all flash units also have a GN, which can be used to predict the exposure.

The GN calculation incorporates film speed and certain environmental assumptions. Broadly speaking, a GN assumption is that the subject is in a typical American living room with an 8-foot white ceiling, beige walls, and moderately light furniture. In real life, when the ceiling is higher and the room is larger or darker, then the GN is too large and exposure tests should be made.

When estimating flash exposures, only an f-number need be calculated, because the electronic flash duration is much shorter than any standard shutter speed. To calculate the f-number needed, divide the GN by the distance in feet from the flash unit to the subject:

$$f = \frac{GN}{distance^*}$$

For example, if the GN is 220 and the distance from the flash to the person being photographed is 10 feet, then the aperture is set at f-22.

*from light to subject, measured in feet

Figure 15.17

a. As light radiates from the flash unit, it spreads, illuminating area A with four times the unit intensity with which it illuminates area B, which is twice as far from the subject.

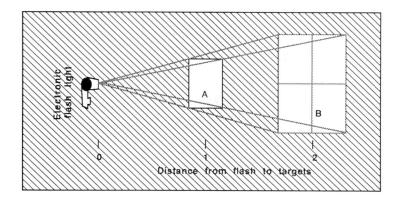

b. In this demonstration of the inverse square law, the woman closest to the camera is four feet away, while the other woman is eight feet away; this lighting ratio is the same as in a.

Inverse Square Law

Because of the **inverse square law**, objects will vary in brightness depending on their distance from the flash. The closer they are, the brighter they will appear on the print. Small changes in distance from the light source to the subject make a big difference to the exposure (or to the apparent contrast). The intensity of the light on the subject is reduced by 1/4 each time the distance from the light to the subject is doubled, as shown in figure 15.17*A*. This effect is shown in figure 15.17*B*, where the distance from the camera to the near person equals the distance between them. There is a 2–stop inverse square law change in brightness between them.

The mathematical statement of this relationship is

Intensity Range =
$$\frac{(\text{Near distance})^2}{(\text{Far distance})^2}$$

The inverse square law limits the usefulness of automatic exposure controls on the flash if there are a number of subjects in the scene being photographed. It is often wise to use bounce light under these conditions.

Bounce Light

One way to compensate for varying light-to-subject distances is to **bounce** the light. Bouncing also changes the quality of the light, since a small flash unit looks like a point source, producing specular light. When specular and diffuse light sources are mixed, the shadows from the specular source are more obvious. Specular lighting can be diffused by reflecting it. The simplest reflector is a wall or the ceiling of the room in which the picture is being made.

When flash light is bounced, the apparent size of the light source is the surface being illuminated by the flash. Pointing the flash at an 8-foot ceiling produces a patch of light about 1' \times 3'; this, in turn, becomes the apparent source of light for the subject, and is a broadly diffused light source compared to the 1" \times 3" lens on the flash. Even a 3" \times 5" file card held just behind the flash unit to reflect light toward the subject will produce enough diffusion to make a significant difference in the quality of the light (as shown in figure 15.18D).

Bouncing light sharply reduces the effective GN. This is apparent if you examine figure 15.18A and see how the light-to-subject distance has increased as a result of the bounce. If the direct distance between subject and light (at the camera) is five feet, the bounce distance (with an 8-foot ceiling) will be about eight feet. The change in intensity is intuitively obvious, but it can be estimated by using the GN formula (with a GN of 100 assumed):

$$\frac{100}{5}$$
 = f-20, or rounded = f-16

$$\frac{100}{8}$$
 = f-12.5, or rounded = f-11

The exposure correction is about a full stop. But this calculation does not allow for the absorption loss from the ceiling, which, if the ceiling were white, would be at least a half-stop (and more if it is darker). The actual correction would be closer to 2 stops, and a practical exposure would then be f–8.

The following "rules of thumb" have been validated for bounce light exposure prediction (when the flash is being considered as the *only* source of light):

- small room, white ceiling bounce: open up 1–2 stops from GN prediction (depending on light-subject distance)
- kicker card or high ceiling: open up 3 stops

Flash Balance Problems

Flash light exposures can be calculated as though the flash were going to be the only light source, or it can be calculated so that the flash is merely supplemental. The GN calculation yields an f-number that is correct if the flash is the only source of light. If the flash light is only used as fill, rather than key lighting, the exposure must be calculated twice, once for the dominant light and once for the fill light.

Use a meter to calculate the key, ambient light exposure. In the following example, unfilled sunlight is too harsh without fill light.

- · direct sunlight
- Ilford FP4, EI = 100
- . GN = 180
- subject distance = 8 feet
- · incident meter exposure = 1/125 at f-8.

Figure 15.18

a. In a small room, a flash can produce a softer quality of light if it is bounced from the ceiling and walls because of the combined effects of dispersion and diffusion.

b. This photograph was made with direct flash in a small room. Note the harshness of the lighting and the effects of inverse square law on objects at varying distance from the camera.

c. The flash is bounced from the ceiling and walls, producing an enveloping light with less contrast.

d. Untitled.

Barbara Rascher.

Harsh room light can be modified by using a small white "kicker" card behind the bounce flash.

(Courtesy of the photographer)

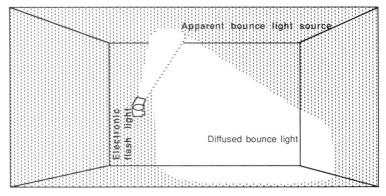

a.

. C.

d.

Exposure variations to be considered are described below.

Flash Dominate

```
f = GN/d = 180/8 = 22.5.
```

Note that there is no shutter speed in this exposure, so you might as well use your camera's standard synch speed. Also note that this is a half-stop. With black-and-white photography, round off the exposure to the next larger f-number. To see how the flash exposure would dominate, compare the calculated flash and the ambient light metered exposure:

```
Flash = 1/125 at f-22
Meter = 1/125 at f-8
Difference of -3 stops
```

The picture area not lighted by the flash would be *underexposed* three stops, or middle gray subjects would appear almost black. The flash lighting would clearly dominate.

Flash Balance

The flash exposure is calculated to produce the *same* f-number as the indicated ambient light exposure. In this example, the flash light must be adjusted to produce an estimated f-8 exposure. This could be done by reducing the light output from the flash if your unit has half- and quarter-power circuits (usually a dial that can be set to provide light for a specific f-number) or a diffusion screen that clips onto the light to spread and absorb 50% or more of the light. A homemade diffuser can be made of a piece of white facial tissue taped over the light (1–2 stops absorption). For any of these the flash and ambient exposures would be about equal.

Alternatively, the ambient light exposure could be recalculated so that the f-number was the same as that for the flash. An exposure of 1/15 at f-22 is the same as 1/125 at f-8, and there would be no problem with synchronization at the slower speed.

Flash Fill

The ambient light f-number exposure could be recalculated to a larger aperture (and longer shutter time), or the photographer could reduce the quantity of flash light (by moving it further from the subject, such as increasing the distance from 8 to 11 feet). The GN calculation would indicate that f–5.6 was the desired exposure at f–8. A more absorptive filter could be placed on the flash unit. As in the last example, the ambient light exposure could be recalculated to achieve the same result. The problem here is that few 35mm lenses will stop down past f–22.

The result of this combination is that the dominant lighting is the existing, or ambient light and the fill is from the flash. The combination of ambient and flash exposure is sufficient to produce well-lighted shadows. The key light is the existing, environmental light—the flash is just helping out.

Summary

The quality of light is determined by whether it is specular or diffuse. Environmental light can be modified by using steady state or momentary supplementary lighting. The secondary lighting can reinforce or change the ambient light quality, as well as modify luminance range or contrast.

Electronic flash is the most popular supplemental light source and the exposure can be predicted by using a guide number (GN). The flash must be synchronized to the shutter, and the upper shutter speed limit is determined

Figure 15.19a. Only ambient light was used to make this picture.

b. Flash fill was used to limit contrast but not be self-evident.

 The flash was calculated to equal the environment light exposure, producing this "over-filled" picture.

by the design of the focal-plane shutter. Exposure calculations are determined by the inverse square law or by the GN. Bounce light requires larger aperture settings because of the increased distance (as well as by absorption from reflecting surfaces). Flash can be used as key or fill lighting.

Discussion and Assignments

The work of great photographers constantly demonstrates the power of light to modify and control meaning in the photograph.

Assignment 1 Choose three photographs each by W. Eugene Smith, Mary Ellen Mark, Mark Cohen, and a photographer of your choice. Analyze how Smith uses supplementary artificial light, how Mark uses environmental light, how Cohen balances daylight and flash, and how your photographer uses light. Try to see (by examining reflections in polished surfaces, and discovering where the shadows are) where the light sources for the picture were, and whether they were environmental or supplementary lighting.

Assignment 2 Find a subject and photograph it in under at least three of these different lighting conditions:

- back lighting
- · front lighting
- · side lighting
- natural diffuse light
- · natural harsh light
- · mixed: ambient and flash dominant
- · mixed: flash and ambient dominant
- · flash lighting only

Assignment 3 Borrow an electronic flash light without learning anything about it (GN or BCPS rating) and experimentally determine a GN (for flash dominant lighting) for use in a typical living room or outdoors at night.

Assignment 4 Make a series of photographs in low-light level (at twilight, or indoors) using a correct exposure for the ambient light (with exposures of 1/4 second or longer) and flash lighting. The flash will illuminate and "freeze" the foreground action, while the rest of the scene will be recorded with some blur because of camera movement.

16 Filters and Films

Figure 16.1
UNITED NATIONS, 1951.
Charles Sheeler.
The photographer used a low camera angle, strong sunlight, and a dark red filter to dramatize the United Nations building.
(Library of Congress)

Figure 16.2
Color wheel showing the primary additive colors of light and the complementary subtractive colors of pigments.

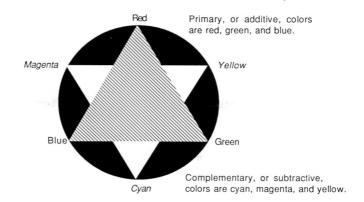

Colors and Light

Light is the visible portion of electromagnetic radiation. There are three **primary** subdivisions—red, green, and blue—from which all other colors can be compounded. When the primaries are present in equal measure we see white light. Our perception of color is a physiological function of how the eye is made. There are photosensitive rods and cones in the retina, and specialized cones that respond to only one primary color. The perception of yellow results from the triggering of red- and green-sensitive cones simultaneously.

Light is described by temperature (°K) or by wavelength in **nanometers** (1 nanometer = 0.000000001 meter). Photographic daylight (or white light) is defined as having a color temperature of 5500°K, and the complete photographic spectrum (including infrared and ultraviolet) ranges from 200 to 900 nanometers. The long-wave infrared radiation that is invisible to the eye is 700 to 900 nanometers, and ultraviolet begins at about 280 nanometers.

Red, green, and blue light are **additive** primaries, i.e., when added in equal parts these colors create white light, as was demonstrated by James Clerk Maxwell in the 1860s. A transparent colored filter transmits the color our eyes see, absorbing light from the rest of the spectrum. A *red* filter passes red light and absorbs green and blue. A *blue* filter transmits blue light most and absorbs red and green.

There are also **subtractive** primaries, which describe reflected light; these are also called **secondary** or **complementary** colors. They are cyan, magenta, and yellow. These colors control our perception of dyes and pigments, or reflected light. Subtractives are described by the colors they absorb. Colored objects illuminated by white light absorb part of that light. A red surface absorbs the green and blue light, reflecting red wavelengths. A yellow surface actually absorbs blue and reflects red and green light. Cyan can be visualized as a combination of blue and green; magenta is a combination blue and red.

Filters and Colors

A picture of strongly colored objects made in colored light will have different print values than the same objects photographed in white light. In the same way, a strongly colored object lighted by white light but photographed through a colored filter will create a different value in the negative, as compared to the same object photographed without the filter.

Filters and Films 207

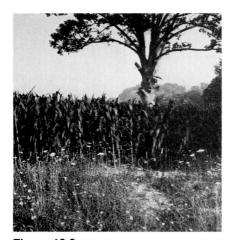

Figure 16.3a. The highlights on the mature corn and grasses in the foreground are easily transmitted by the red filter, but the deep shadows within the corn and the tree are absorbed, producing a high-contrast record. The overcast sky has approximately the same value in all three photographs as it is a source of white light, with equal distribution

of primaries.

b. A green filter produces a rather flat transcription, just separating the foliage in the foreground (which is somewhat lighter in tone) from the more yellow-green corn field.

c. A deep blue filter (Wratten 47B) transmits most of the light from the blue flowers in the foreground, and absorbs much of the light from the corn and tree. Detail, in fact, is present only because of the blue component of the diffuse sky light.

Photographic films are somewhat sensitive to most of the entire electromagnetic spectrum, including ultraviolet and infrared radiation. Colored filters that absorb parts of the spectrum are a way to photographically manipulate local values in black-and-white photographs, i.e., to make one object lighter or darker than another. A colored filter will have little or no visible effect on an overcast sky, since the cloud is almost neutral. The effect of a filter is to *lighten its own color and darken its complement*. A yellow filter, for example, will darken a blue sky, make a street warning sign lighter, and permit white clouds to be comparatively brighter in a print. The yellow filter absorbs blue light, producing less density in the negative for sky areas, but it will also lower the density for most other colors because the colors contain some diffused blue sky light.

A photographic filter is a thin piece of hardened gelatin or optically flat glass, which has been carefully colored with dyes that transmit limited portions of the photographic spectrum. Gelatin filters are excellent, low-cost solutions for the photographer. They are sturdy and lightweight. They easily pick up hairline scratches through normal handling, but they are so thin that these scratches have no effect on image sharpness. Cheap glass filters are actually a gelatin filter sandwiched between pieces of thin glass; more expensive filters are vat-dyed glass.

Photographic filters have been assigned Wratten numerical names that define their color and specific absorption spectrum. These numbers are now in general use and replace an alphabetical notation (A, B, . . . X1, X2) notation, used before the 1960s. *Kodak Filters for Scientific and Technical Uses, B–3* lists all Wratten filters, color conversion filters, light-balancing filters, safelight filters, and neutral density filters sold by Eastman Kodak Company.

Film Color Sensitivity

Most contemporary films are **panchromatic**, meaning they respond to all colors of visible light. This does not mean they respond equally to all colors of light. Most films have a lower El under tungsten than daylight because of having less red sensitivity, e.g., Tri-X loses almost half its sensitivity under

TABLE 16.1

Available 35mm Films

Most films listed are sold in 24 and 36 frame cassettes and in 100 foot rolls.

Agfa Professional	ISO 25	Very fine grain Fine grain						
	ISO 100							
	ISO 400 Fast, moderate grain							
Eastman Kodak Company								
Technical Pan 2415	ISO 25	Extremely fine grain						
Plus-X	ISO 125	Fine grain						
Plus-X Pan Prof 2147	ISO 125	Enhanced highlight contrast						
T-Max 100	ISO 100	Tabular silver, long toe	Tabular silver, long toe					
Tri-X Pan	ISO 400	Fast, moderate grain						
T-Max 400	ISO 400	Tabular silver, medium fine						
T-Max P3200	ISO 3200+	Tabular silver, moderate grain Infrared sensitive						
High-speed Infrared 2481	unrated							
cording FIIm 2475 ISO 1000+		Grainy, very high-speed						
Ortho, Type 3	ISO 8-25	High contrast						
Orthochromatic								
Ektagraphic HC Film	ISO 8-25	Same as Ortho Type 3						
liford inc.								
Pan F	ISO 50	Very fine grain						
FP4	ISO 125	Very fine grain						
HP5	ISO 400	Medium fine grain						
Fuji Film								
Neopan 400 Prof	ISO 400	Medium fine grain						

tungsten light. T-Max films are more sensitive to red than other films and this causes a red surface to print as a lighter gray when photographed with T-Max than with Tri-X.

Filter Factors

Any colored filter absorbs some light when placed over the lens, and reduces the amount of light available to the negative. The amount of light absorbed is determined by the dye density. A dark red filter will have more effect on a scene than a pale red filter, and will require a greater exposure correction when used on the camera. The increase in exposure is called the **filter factor**, which is an arithmetic multiplier.

An exposure with a filter *cannot* safely be calculated by putting the filter in front of the lens with TTL metering. This is due in part to the fact that the meter usually does not have exactly the same spectral sensitivity as does the film.

Filter factor exposure correction is calculated by multiplying the indicated exposure time by the filter factor. For example:

- yellow filter with a factor = 1.5
- · metered exposure = 1/125 sec. at f-11
- filter factor = 1.5
- · new exposure = meter exposure x factor
- $\cdot = 1/125 \times 1.5$
- $\cdot = 1/80 \text{ second}$
- · round off to 1/60 sec. at f-11
- · alternate: 1/125 second at half-way between f-11 and f-8.

Filters and Films 209

TABLE 16.2

Filter Factors and Corrections

Wratten	Filter	Filter Factors for		
Filter	Color	Daylight	Tungsten	Common Use
2B	Clear	1	1	UV absorption
8	Yellow	2	1.5	Mild sky darkening
15	Deep yellow	3	2	Progressively more
11	Yellow-green	4	4	dramatic darkening
13	Yellow-green	5	4	through this red.
23A*	Light red	5/6	2/3	Full infrared filtration
25*	Red	6/8	4/5	Color-blind film
29*	Deep blue	16/20	8/10	Clear reflections
47B	Deep blue	8	16	
Polarizing	Tan	3	3	

^{*}Use the smaller factors for T-Max films.

Comments

All filter factors are for "normal" sunlight conditions, and will change if the color temperature of the light rises or falls (goes blue or red), depending on the filter used. The factors for red and yellow filters should be doubled when photographing above 6,000 feet (to compensate for atmospheric blue shift). Filters should not be combined: the strongest will dominate and the combined effect is of neutral density plus the stronger color. Nothing is gained and sharpness is lost.

Suggested Uses for These Filters

Wratten 2B absorbs ultraviolet and blue radiation scattered by atmospheric haze (commonly replaced by so-called **skylight** filter).

Wratten 8 yellow (K2) and Wratten 15 deep yellow (G) are used to absorb blue light and darken skies; panchromatic film and the 8 filter combine to produce sky values similar to what the eye sees. Wratten 11 and Wratten 13 yellow-green filters darken skies and render foliage lighter in value. Wratten 23A, 25, and 29 are increasingly dark red filters. The first two are used to dramatically darken blue skies, and Wratten 29 is also used with infrared film (with which it has a filter factor of 1, i.e., no change in exposure). However, Wratten 15 and any of the three red filters listed can be used with infrared film, producing increasingly vivid infrared effects as the color darkens and absorption of white light increases. Wratten 47B deep blue makes panchromatic film look like the color-blind film of the last century, producing white skies and very dark foliage.

Colors to Use

There will be a sharp loss of shadow detail when the stronger yellow and red filters (Wratten 15, 23A, 29) are used with daylight because shadows are mostly illuminated by reflected blue skylight. This loss is only partially compensated by the filter factor and if shadow detail is very important, additional exposure should be considered, coupled with reduced development to limit contrast.

Yellow-green filters are the least well-known but are effective for darkening skies, while creating greater definition in foliage. Trees and shrubs do not become much lighter (as might be expected) because the greens are saturated with blue. The blue is both inherent in the leaf pigment and in the diffuse blue sky light illuminating the landscape.

A deep blue filter (Wratten 47B) can be used to simulate the effect of the color-blind films of the last century, and also to increase atmospheric effects of haze when desired.

Infrared Filters and Exposure

Infrared radiation has a very long wavelength, which requires a focusing adjustment. On most cameras, there is a dot next to the focusing mark on the lens barrel (sometimes marked **IR**), which indicates how much further the lens should be *advanced* from the nominal point of focus when infrared film is used.

Infrared poses special exposure control problems in that the light being photographed cannot easily be metered. The film is equally sensitive to blue and infrared light; if no filter is used the picture would look commonplace. When visible and ultraviolet light is filtered out, the unique world of infrared appears.

Figure 16.4
a. Untitled.
Liz Cole.
Infrared film was heavily exposed and developed to produce large grain and maximum "flare" from the model's face. (Courtesy of the photographer)

b. Untitled.
 Sharon Fox.
 Infrared film records the heat radiated by foliage so that both the foliage and the man at work appear nearly white.
 (Courtesy of the photographer)

Sharon Fox.

Neither water not the clear northwest sky in early morning light reflect the sun's heat and so they photograph as dark subjects in infrared, while the tree leaves radiate heat, and therefore appear quite light.

Infrared film does not have a standard ISO number. However, the Kodak indicated exposure should be *doubled*. The film is very sensitive to development controls, and reducing the suggested Kodak developing time by 50% will produce much smaller grain and more delicate tones. The range of grain can be seen by examining the white fence in figure 13.1, in which a very fine grain results from minimum exposure and development. Compare this to figure 16.4A in which a coarse grain structure and maximum "flare" is produced. Figures 16.4B and 16.4C are typical of the medium grain and strong contrast usually produced with infrared film.

Filters and Films 211

ch illustrating how the crystalline of a polarizing filter passes only light ating in a single plane.

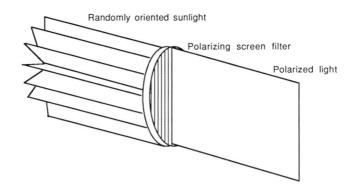

b. Typical reflections from the window prevent seeing behind the glass.

c. The reflected polarized light can be blocked by using a polarizing light filter.

A range of effects can be produced by using dark yellow to deep red filters (Wratten 15 to 29), and the choice of color determines a mix of "normal" and infrared vision. Since infrared film records both heat from the body and reflected light, portraits and nude photographs often reveal the dark tracery of veins just below the skin. Landscapes vary as the camera is pointed toward or away from the sun; toward the sun reveals a white sky, away from the sun records the now familiar intense black sky of infrared landscape, with gray-white trees (with leaves that release heat as they cool the plant).

As an alternative to placing the filter over the lens, the light may be filtered. Electronic flash can easily be filtered, and unobtrusive photographs can be made in darkness by red-filtered flash. Again, there is no dependable metering, and initial exposures must be done by trial and error.

Polarized Light

Light can be described as energy waves or energy bundles. In the wave model, the orientation of light from the sun is random: light vibrates in all directions. But light is **polarized** as it is reflected from a polished surface (glass, water, smooth rocks); the reflected light vibrates in one plane only. A polarizing filter consists of a thin layer of crystals that transmit only the light vibrating in one plane. If light from a reflecting surface is viewed through a polarizing filter, the amount of light seen will depend on the orientation of the filter, with respect to the polarized reflected light. The filter can be oriented so that the polarized light is parallel to the filter and much of the light will pass through, or the filter can be oriented at 90° and almost none of the polarized light will pass. The filter itself absorbs about 75% of the light, and so the polarizing filter has a factor of 3.

Neutral Density

Wratten no. 96 **neutral density** filters are physically identical to colored filters but absorb all colors equally. They are useful when you want to expose film at large apertures (to reduce depth of field, for example), use very fast films in intense light, or deliberately make very slow exposures in daylight (for blurred motion photographs).

The neutral density (N.D.) filter is sold in density increments of .1 and 1. By combining two filters, almost any desired density can be achieved. N.D. 0.30 has a transmittance of 50%, so N.D. 0.30 placed before the lens would be the same as closing down a full stop. N.D. 0.90 would be equivalent to closing down 3 stops, and N.D. 3.00 would be equivalent to closing down 10 stops!

Summary

White light is partly absorbed by strong colored objects, and by using filters, value changes in the black-and-white print can be created. Most contemporary films are panchromatic, i.e., they respond well to all colors of light. Films are available with special sensitivity (orthochromatic and infrared), and with a range of ISO speeds from 25 to 3000 or more. Photographic filters now have standard Wratten numbers that indicate color and chromatic selectivity. Exposures with these filters must be calculated by using filter factors (rather than metering through the filter). The factors are arithmetic multipliers of exposure time. Infrared film is exposed with a filter to remove unwanted white light.

Filters and Films 213

Sunlight is randomly vibrating light, which is polarized by reflection. Light may also be polarized by passing through a crystalline screen, called a polarizing filter. Such a filter can be used to eliminate some reflected light.

Neutral density filters absorb all colors and are used to change exposures without changing lens apertures.

Discussion and Assignments

Filters are the only way for the photographer to manipulate values within a scene without changing the lighting or physically manipulating the subject.

Assignment 1 Photographic filters are expensive, but they can be approximated much more cheaply by colored acetate (available at any art supply store). Purchase a small sheet of three colors (perhaps one primary and two mixed colors) and experimentally determine the following:

- · What is the filter factor for each?
- · What effect does each have on the gray values created when photographing an array of oranges and bananas in a green bowl?

Assignment 2 Investigate the following for yourself for several different colors of filters:

- 1. Make a TTL meter reading of a sunlit scene with a filter over the lens, and expose.
- 2. Make a TTL meter reading of the same scene without the filter, and use the filter factor to calculate the exposure. Expose.
- 3. Compare the indicated exposures and the resulting negatives.

Assignment 3 Combine a medium filter (Wratten 8 or 15) with a polarizing filter, with the idea of darkening blues and removing reflections all at the same time. What is the new filter factor? Make a hypothesis and calculate an exposure; make a test and analyze the result. Were your test negatives underor overexposed? What conclusions can you reach about combining densities and the resultant filter factors?

17 Darkrooms and Workrooms

Figure 17.1 STREET PHOTOGRAPHER. Ben Shahn.

After the invention of the tintype in the early 1850s, and until the 1940s, street photographers made inexpensive pictures using reversal processing, using the camera body as a miniature darkroom.

(Library of Congress, FSA Collection)

Basic Needs

The basic darkroom needs described earlier are light control, safe electrical connections, wet and dry spaces, clean air, and running water (if possible). Dry darkrooms are more difficult to work in, but are practical. Printing darkrooms need safelight(s), timer, enlarger, trays, chemicals, print washer, and print drying equipment.

There are literally hundreds of manufacturers of photographic equipment, but only a few make a quality product that will last. It is worthwhile to purchase equipment that is made of the most durable materials. Photo equipment must be able to tolerate the inevitable rough handling that it receives; only well-made gear will survive.

In addition to the darkroom, space is needed for print finishing and storage, good light for spotting prints, a sturdy worktable on which to cut mats and finish prints, and a dry area with moderate humidity and temperature for storing prints and negatives.

Establishing a Darkroom

Absolute darkness is desirable but not mandatory for printing. Covering windows at night with a sheet is often sufficient, although street lights close by may present a hazard. Windows may be blacked out (temporarily or permanently) with black plastic, which can be wrapped around window frames and taped or stapled in place. (Caution: all pressure sensitive tapes—including masking tape and silver duct tape, sometimes called gaffer's tape—will leave residue if left in place more than a day or two, and many tapes grip tightly enough to damage paint when removed.) Aluminum windows often have screen frames that can be lined with black plastic and put back into place, producing an effective blackout. Older wooden frame windows can be blacked out by cutting a sheet of insulating board to fit snugly in place, yet be easily removed and stored.

Ideal Darkrooms

An ideal darkroom space is a moderately heated room with a minimum measurement of $7' \times 9'$. If not already present, the room may have water service available through an adjacent wall. Electrical outlets should exist on three walls. The walls should be painted, rather than papered.

The walls of a darkroom may be any light color, both to make it a more cheerful place to work and to help you see as much as possible under safelight. However, the wall behind the enlarger should be darkened to avoid reflecting diffuse light from the enlarger onto the printing paper; contemporary enlarging papers are sensitive enough to be slightly fogged by the environmental darkroom light during printing. A rectangle can be painted on the wall behind the enlarger, or a large sheet of black construction paper stapled or taped to the wall. The wall nearest the sink should be protected from chemical splashing by a high-gloss enamel or a sheet of plastic.

The darkroom should have a single, well-fitted door that is lighttight and can be locked from the inside. If a ventilation fan is mounted in the door, the room outside should be a workroom isolated from the rest of the house and separately ventilated. A closet or other protected space should be available for chemical storage and film drying.

In an ideal darkroom, the enlarger sits on a long, sturdy table or counter, with space at the sides for timer, negatives, fresh printing paper, dodging tools, pencil, and notebook. A safelight illuminates this area, and another hangs over the developing tray. The darkroom sink should have enough space to line up the trays to process prints.

Figure 17.2

a. One view of a home darkroom where the window has been blacked out with plastic, wet and dry areas are well-separated, and dry storage space is provided by the shelves under the counters, with trays being stored under the sink.

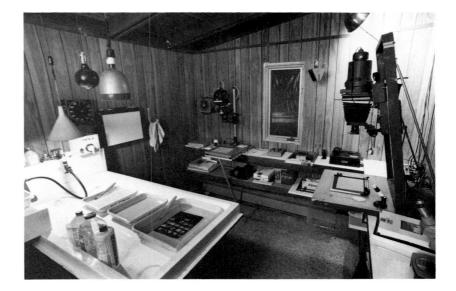

b. Air is brought into the darkroom through a fan entrance hidden behind the louvers at lower left, and is exhausted by a kitchen vent fan in the upper-right corner, above the shelf. Under-counter drying rack can dry forty $8'' \times 10''$ prints. Negative storage binders, reels, tanks, and dry chemicals are stored on the high shelf. Working light is provided by a light under the shelf, and the corkboard panels on the wall provide a print study area.

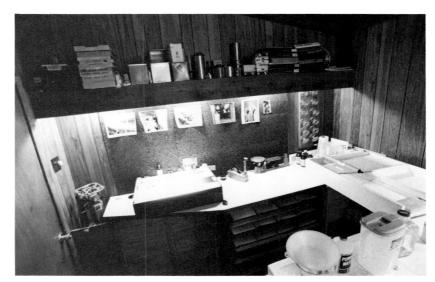

c. This home darkroom is built into unused attic space (note the slanting ceiling line). Wet and dry areas are separated by a narrow runway. Wet equipment storage is under the sink and on the pegboard behind it. Storage drawers for paper and negatives are provided under the enlarger counter.

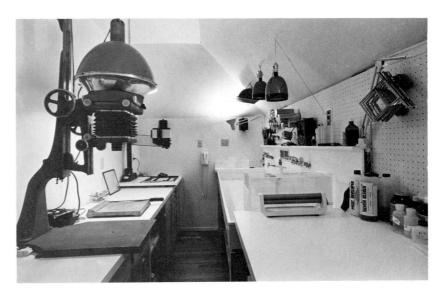

Figure 17.3
Self-portrait and My Sister.
Victoria Walker.
One of the most important uses of the photograph is as a personal inventory of family life.
(Courtesy of the photographer)

Sometimes all these needs can be met except for running water. When running water is not available, all work except final washing can be done by having a couple of large plastic buckets, one containing a supply of water for rinsing, the other a waste dump.

Work Area Considerations

When a room has been located for photographic workspace, outline solutions to these problems:

- · wet and dry areas
- · water service and drain
- · electrical switches and safelights
- · ventilation
- · film drying
- · print drying
- · print finishing and storage

The first two items on this list are interrelated: location of wet areas are often controlled by placement of water pipes and drains, but even these are easily relocated now by running temporary plastic pipes. However, it is important that you learn local code requirements before making decisions about water and drain attachments. When talking to plumbers or building code inspectors, make it clear to them that *no* photographic equipment will be *permanently* connected to the water line.

A means of mixing hot and cold water should be supplied at the sink. You may choose to purchase an expensive temperature regulated mixing unit, or simply use two "cut-off" valves (which have straight bar handles that rotate only 90° between being fully open and closed) connected to a "T" joint and terminating in a hose coupling. Either of these methods provide effective control of water temperature.

Different Darkroom Spaces

A permanent darkroom can be installed in many different spaces, and each offers unique possibilities and problems. Bathrooms, kitchens, or laundry rooms can be used both for a darkroom and their original purpose, if the social contracts with other household members can be worked out. Obviously, there is no lack of water in these rooms, and both kitchens and bathrooms often have venting fans. A difficulty is that there is usually no storage space in these rooms for equipment, and the time lost setting up and dismantling may be counter-productive.

Basement rooms are usually easy to modify, with few or no windows. Unfinished, or roughly finished walls and floors have advantages in being less easily damaged by splashed photographic chemicals. Electricity, water, and drains are usually available. Temperature variations are minimized. On the other hand, attics are difficult spaces to convert unless they are well-insulated. They also are less likely to have water or drains accessible. Darkrooms need active, rather than passive ventilation, where air is either blown into the darkroom or sucked out. Many basements receive only passive heating, and actually act as insulating airspaces for the house above. A careful decision must be made as to which way the air should move. It is usually better to pull heated air from the house, and exhaust this to the outside, especially if you live in a dry or dusty region.

When the basement ceiling is unfinished, a sheet of builder's plastic can be stapled to rafters over the whole photo work area to block dirt, or the ceiling can be sealed with standard drywall and taped. Negatives, paper, and equipment are all quickly damaged by excess humidity. Moisture can be controlled by operating a dehumidifier.

Figure 17.4

 a. Two methods of assembling a darkroom sink from plywood and standard dimension lumber

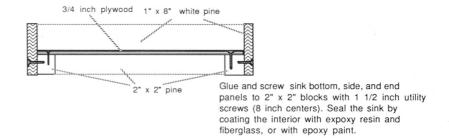

Either construction method will produce a strong, tight sink and requires little special woodworking skill.

b. Detail of sturdy leg assembly for a darkroom sink.

To make a very rigid and sturdy set of legs for a darkroom sink or print finishing table, join 2" x 4" pieces as shown at left. Using 2-3 inch utility screws and a fast-drying wood glue, interlock the three pieces at each corner.

Sinks

The photographic sink is merely a shallow tray with a drain; the size of the sink is determined by the space available and the maximum print size you expect to print. Plywood sinks can be constructed for much less money than either plastic or stainless steel sinks can be purchased. A servicable sink can be constructed from precut plywood pieces, and requires little woodworking skill. Construction suggestions are offered in figures 17.4A and 17.4B.

The height of the sink and dry work surfaces should be set to your own comfort. Tables and counters that are too low induce severe back fatigue. Standard sink and table heights are set for persons who are about 5'6" tall. If you are much taller or shorter, adjust the work surface to meet your needs. You can estimate the correct height of a sink edge (3" to 5" deep) by the following procedure: wear comfortable working shoes, stand with your arms at your sides, elbows bent so that your forearms are parallel to the floor, and hands relaxed. Have someone measure from the floor to your fingers and make this the sink height (unless the sink is more than 24" across) and make the sink 2" lower. If a wider sink is planned, it should be 2–3 inches lower.

Planning the Darkroom

The size of the available room, and the location of water and drains, doors, and windows all affect the design of your darkroom. Make a plan of the room to scale on 1/4 inch graph paper. Use a fairly large scale, e.g., 1 inch equals

Figure 17.5
Untitled.
Ezra Stoller.
Woman handler at J & L steel mill, dramatically lit by flash bulbs.
(University of Louisville Photographic Archives)

1 foot. Draw the sink, enlarger table, etc., on cutout pieces of colored card-board. Lay them on the plan as templates, moving them around until the most logical and convenient relationship is found. Draw in carefully the location of windows, doors, closets, electrical outlets—all the things that might influence your design. Imagine yourself standing and working in that space: as you turn to pick up a bottle of fixer will it be convenient? Is the closet door going to open without bumping the enlarger? Dry and wet areas should be located first. The enlarger, easel, focusing magnifier, timer, dodging tools, pencil, paper cutter, printing paper, and all dry chemicals are stored on the dry side. Any darkroom equipment that touches water is stored on the wet side. Wet objects and chemical contamination are always potential hazards in the darkroom and you might wish to define a drying area, where wet objects are placed to dry and be stored and where chemical measurement is done. This is automatically a danger area, where nothing fragile can be put down without careful consideration.

There does not have to be a big gap between the wet and dry work area; however, they should be completely separated. No matter how careful you are, eventually a graduate or a bottle will be knocked over. Assume liquids will somehow eventually leak or be spilled.

Figure 17.6
Sketch of darkroom plan with cardboard cutouts of sink and enlarger table used to plan the work area.

Figure 17.7 Lighting for the darkroom and print finishing area should be arranged so that trays and work areas are well-lit without light being in the photographer's eyes.

Electrical connections must meet local code requirements, which are established for your physical safety. Use only three-prong grounded connectors and switches. Darkroom wiring involves a number of separate circuits, none of them demanding much current. If there are not enough duplex wall outlets, you can improvise with a power distribution strip.

Safelights

Safelights and worklights should illuminate trays and prints but not be in your eyes. Safelights must be at least 4 feet from the trays to avoid safelight fog. The 5 1/2" circular safelights (commonly called a "bullet" safelight because of its shape) are convenient: one by the enlarger, one over the developer tray area of the sink, and an optional third safelight to illuminate storage areas. These lights have filters that can be changed easily for color printing or for use with graphic arts films. An OC filter is the correct color notation for all black-and-white enlarging papers. An economical alternative to separate safelights is a single-tube 48" ceiling-mounted fluorescent light with a safelight OC sleeve filter.

If color printing is anticipated, an Osram adjustable filter which can be converted for either black-and-white or color materials should be considered. For temporary darkrooms, Jobo makes an elegant battery-operated safelight that is worn around the neck.

Figure 17.8

Safelight test paper is given a fogging exposure under the enlarger to produce a just-visible controlled threshold density (area B). Area A is protected by the easel frame and will be a maximum white reference. An opaque object is placed on the paper and safelight fogging exposure allowed to accumulate. If the lighting is not safe, area C (the sum of controlled threshold exposure and fog exposure) will differ from area B and the lighting must be reduced or relocated.

Safelight Test

No darkroom should be used extensively without evaluating the safelights. The paper emulsion, like all silver emulsions, has a threshold sensitivity that must be crossed before visible changes will result. Merely laying a piece of paper on the enlarger easel for several minutes and then developing it will not evaluate the fog possible from exposure to safelights that are too bright or placed too close to the work area.

Set up the darkroom for processing prints. Adjust the enlarger as though you are going to make a contact proof, focused but without a negative. Place a piece of print paper in the enlarger easel and adjust the easel frame so a 1/2" band of paper is protected all around. Expose the paper to white light for no more than a second at the smallest aperture possible. (You can move your hand beneath under the lens to shorten the exposure.) Now lay an opaque object on the paper as shown in figure 17.8 and leave this assembly for the maximum time you would normally be handling paper under the safelight. Develop the paper for 2–3 minutes; stop, fix, rinse, and dry the print. There should be a slight, but clear difference between A and B because B is a controlled exposure, creating a slight density above threshold. If the safelights are too bright or too close to the work area there will be a small, but definite difference in density between area B and C. If area B is not visible, the safelights are appropriate to the working space.

Ventilation

Darkroom ventilation should pull chemical fumes away from you without dragging them across your face or body. Ventilation can be supplied by a darkroom fan, designed to be installed in a door or wall, and made to prevent light leakage. A vent fan can often be placed in a sheet of plywood which replaces the glazing in an outside window, darkening the room and venting it simultaneously.

A film drying area needs to be dust free and out of the traffic. In climates where dust is a problem, a small recirculating room air filter can provide effective dust control. The three darkroom dangers to negatives are dust in the air, sediment in the water, and an unstable drying line that permits films to fall or touch one another. Dust in the darkroom is frequently generated by the routine cleaning exhaust from the vacuum cleaner. Clean the darkroom floor with a broom and damp mop instead of vacuuming it. Water sediment can be removed by using a cartridge filter in the darkroom water line.

Print Drying and Finishing

Print drying frames can be built to any desired size (though the most efficient frame size is based on a 16" x 24" module). Drying frame racks can be made to fit almost any space, e.g., under a worktable or a counter. An alternative to a permanent frame is a screen hammock, consisting of a sheet of plastic window screen stapled to a piece of 3/4 inch dowel (see figure 14.4). When not in use, the screen is rolled up and stored. A 6-foot length of 24" screen will dry twelve 8" x 10" prints at a time.

A sturdy table surfaced with a scrap piece of masonite or heavy cardboard is needed for print finishing. A card table can be used to work on, but prints need to be stored flat. If storage drawers cannot be provided, archival print storage boxes can provide an economical, safe environment. Safe print or negative storage requires moderate temperatures and freedom from dust and humidity.

Summary

Basic darkroom needs are for a lighttight space and safe electrical service. Ventilation must always be provided. Water and waste can be carried in and out. Kitchens and bathrooms can be converted to temporary darkrooms, but rooms not used for anything special convert more easily to darkroom use. Plan a darkroom to allow for wet and dry areas, safe electrical service, and appropriate lighting. Print and negative drying areas must be established, and both require clean air. Safe print storage is a concern for the serious photographer.

Discussion and Assignments

When you are at school, darkrooms are usually not a problem, but when you begin to work by yourself, establishing one frequently presents a challenge.

Assignment 1 Plan in detail how you could convert a space in your present living arrangement to be used as a printing darkroom. Considerations:

- · how to achieve darkness
- · where to put an enlarger
- · where to put trays or a tray rack
- · where to find electricity
- in a dual-use space (bathroom or kitchen), with limited access times, how and where would you store equipment when it is not being used?

Assignment 2 Make the safelight test described in this chapter. If the safelight conditions are correct, increase the brightness of the safelights (by moving the lights or increasing the number of safelights) to a more comfortable level and retest. Darkrooms can be very unsafe places to work and adequate safelighting will minimize risks.

Assignment 3 You have been offered a chance to exhibit your work. Now you have to overmat and mount 45 prints, varying in size from 8" x 10" to 11" x 14", some vertical and some horizontal. The prints have to be exhibited behind glass, to qualify for insurance, but need not be framed. Figure out a standard mat size so that all of the glass can be cut the same size. Then calculate the number of storage boxes needed to protect this exhibition set before and after the exhibit.

18 Equipment Considerations

Figure 18.1
HALLOWEEN COSTUME CONTEST.
Jim Gustke.
Environmental light, supplemented by bounce flash and a 28mm lens, allowed the photographer to capture this array of children in costume.
(Courtesy of the photographer)

Basic Needs

As a working professional, in applied or art photography, a balance needs to be maintained between what is owned and what can be borrowed, rented, or leased as the need arises. New models of lenses, cameras, and lights are introduced to the market constantly; in an attempt to sell equipment, ads promise glittering new technical developments, which may not be relevant to your needs. Assess your equipment needs by deciding what kind of pictures you want to make and what kind of cameras, lenses, meters, tripods, lights, and other gear are essential.

Criteria

Before investing in a camera system, talk to several professionals and find out what they use, and why they use it. Look at their own cameras to see how they have survived professional demands. Ask the owners:

- · how often the cameras break down
- · how easily can the camera be serviced
- how sharp are the lenses
- · how does the camera and lens system handle
- · what are known problems with the system they use
- · if they were beginning anew, would they change?

Compare answers. Professionals buy into fads as often as anyone else, but certain lines of equipment are popular for very good reasons.

Decide what you can afford to buy. Perhaps you cannot get all you need at once; it is usually better to purchase a single item of the best quality and then expand on that when you can. When you purchase the best equipment available you not only minimize potential down time, but you also protect your investment.

Photographic equipment depreciates at about the same rate as an automobile; it has been jokingly said a camera and a car lose half their resale value when you take them out of the store. What is worse, some cameras have a fleeting popularity and cannot be resold easily. This is certainly true of most amateur equipment, but it does not apply equally to the better lines. The Leica, professional Nikon models, and Hasselblad cameras depreciate slowly, and can usually be resold.

Kind of Equipment

The work you do will determine what you buy. For example, if you are interested in photojournalism, it is best to have two camera bodies and at least three lenses (covering the range from wide-angle to telephoto), or two fixed-focus and one zoom lens. The separate bodies mean that critical time is not lost changing lenses, the different lenses mean that field-of-view changes can be achieved quickly.

Equipment is available in a wide range of prices and styles. Your choice of camera system is affected by what kinds of photographs you plan to make and what camera format is best for those pictures. Also, there are these mechanical criteria:

- · sturdiness of the camera body
- · dependability of shutter
- · quality of lenses

Figure 18.2
Taos, New Mexico.
Arnold Gassan.

A 150mm lens on a Hasselblad 6 cm x 6 cm format permitted selection of a relatively small area for the photograph. Because of the slight overcast, the scene was of normal contrast.

(Photo by the author)

Finally, there are money limitations and personal taste:

- · cost of equipment
- · personal response to equipment
- · current professional popularity

Often, beginning photographers have to "make do" for a time, but in the long run, equipment quality and reliability should have priority.

Figure 18.3
Untitled.
Timo Pajunin.
The 8" x 20" format was invented to photograph large public dinners, popular at the end of the 19th century. Cameras that use this film have been called banquet cameras. This film is still available from Kodak, on special order. The photographer utilized the aesthetic effect of this long format during a NEA Fellowship documentation of southern California. (Courtesy of the photographer)

Buying Used Equipment

Excellent quality used camera bodies and lenses are frequently available from camera brokers, by mail (see appendix 4), and in local camera stores (where older models are accepted in trade for new cameras). Used enlargers are harder to find, partly because there have been fewer model changes, and partly because the enlarger is not usually an item bought on impulse. Used equipment can be purchased for much less money than equivalent new merchandise.

Used equipment can often be taken from the store on a purchase memorandum, which is a mutual agreement that if the lens or camera works properly and is in good condition you have a serious intention of purchasing it. The understanding is that you will promptly expose and process film, which will permit you to evaluate the merchandise. Usually, if you are seriously considering a purchase, a store will permit you to have equipment for 24 hours to make appropriate tests.

Examining Lenses

Lenses should be examined for:

- · obvious damage to lens barrel or glass
- · mounting flanges that fit snugly and show little wear
- · adapter threads that are clean and accept filters easily
- an aperture ring that moves easily, has clean detent action
- · an aperture that is symmetrical and blades not shiny at edges
- · a lens that is clean internally, without moisture or dust
- · glass elements that are tight in the lens barrel

A simple test will check these items:

- · accuracy of focus
- · accuracy of exposure with changes in aperture
- · sharpness across the field, corner to corner
- · even covering power

A simple test of sharpness of a lens can be accomplished by photographing a full newspaper page, carefully and evenly lighted. Use a medium-or low-speed film for resolution and develop 20–30% longer than normal to accentuate contrast. Place the camera on a tripod and, if possible, raise the

mirror before tripping the shutter. Develop the film, make a full-frame print without dodging or burning, and examine it for variations in sharpness and density (especially at the center and corners).

Examining Cameras

The brass body beneath the paint will often be revealed at the edges if it has been heavily used. This is not bad, it's only an indication of use. What is important are signs of damage: dents, gouges, or new parts (which indicate rough use or a dropped camera).

A simple mechanical check of the shutter can be done by setting it at a one second exposure, then cock and trip it several times. The shutter should sound the same every time, and the blades remain open for a full second. Change the setting to 1/2 second and repeat. Repeat this for 1/4, 1/8, etc., up to 1/125th of a second. The human ear is a very sensitive instrument, and each shutter speed setting should clearly sound shorter than the preceding one, and every repetition should sound the same. Variations suggest worn escapements or bad electronics; leave the machine in the store.

Examining Meters

Meter movements are generally more frail than solid-state circuits, and all meters are easily damaged by rough handling. The solid-state circuits are damaged by excess moisture. New or used meters should be checked out very carefully before buying. Often, a selenium meter can be purchased for very little and will do an excellent job; the obvious limitation of the selenium meter is its lack of sensitivity, as compared to the battery-powered resistive meter.

When evaluating a used meter, first compare it with a known meter in both bright and dimly lighted areas. Open the battery compartment and verify that there is no corrosion. Hold and operate a meter at various angles to verify that the meter armature moves freely and correctly.

Tripods

Set up a tripod as though you were going to use it. Determine how the legs are adjusted in length, how the legs are attached to the head, how the head rotates and tilts, and how the camera is attached to the head. Place a heavy camera on the tripod, and perform the following tests:

- 1. Rap the camera lens sharply downward with your finger and see how much vertical vibration there is.
- Rap the camera lens sharply sideways with your finger and see how much rotation or play there is between the head and the legs.
- Release the head, rotate and tilt the camera, and relock the head. Note how smoothly these things were done and how easily (or hard) the head locked in place.
- 4. Shorten one leg an inch so that the tripod is leaning slightly, and relock it; let the camera stand on the tripod for 20 minutes. The leg adjustment should not creep.

228 Chapter 18

Figure 18.4 Dharan, Al Hasa, Saudi Arabia, 1947. Harold Corsini. With flash on camera, the photographer documented and abstracted the richly reflective material of the dress and the tapestry of the rug, and also noted an Arabic cultural requirement that one remove shoes even when dressed in party clothes.

(Standard Oil Collection, University of Louisville Photographic Archives)

The adjustable vertical center pole (called an elevator) violates tripod stability. When it is extended, the camera and elevator combine to make an inverse pendulum; the heavier the camera and lens, and the higher the elevation, the more inevitable is sway and vibration. Never extend the elevator any longer than absolutely necessary for maximum sharpness.

The leg attachment strongly affects stability. The best tripods have a crutch construction, in which two widely spaced arms are hinged to the body and join together to meet and form a leg of the tripod. These tripods usually have more positive and dependable adjusting locks for the lower leg than do the tripods with telescoping tubular legs. A tripod that is too light, vibrates, or is not stable is worse than having no tripod at all.

Assessing Enlargers

Used enlargers are not easily found, compared to used cameras, in part because there have been few fundamental design changes in the past 30 years, and little incentive to trade enlargers in on newer models. Except for changes in color printing lamp houses, a Beseler 4×5 made 30 years ago looks little different than a new one.

Figure 18.5

Scratching this pattern in the emulsion of an unwanted negative produces an effective focusing target for aligning an enlarger. The torn emulsion pattern is easy to evaluate across the enlarged field without the use of a grain magnifier.

Making an external assessment is easy: the baseboard must be flat, and not warped; control knobs need to be firmly attached, and have no play in them; control switches must work, and the wiring insulation must be sound. If equipment is clean and mechanically sound, examine the condenser lenses for chips, scratches, and dirt. There should be accessory condenser lenses for an Omega. Beseler enlarger motors should be operated to be sure they are working. Move the aperture control ring through the limit of motion, feeling for correct detents. Look through the lens and be sure the aperture blades are moving correctly, and that there is no fungus or dirt present.

A more difficult assessment is determining alignment faults. The enlarger negative carriage must be kept parallel to the baseboard. Some enlargers simply do not hold alignment. A simple test is to project an alignment test negative. This test does not require a darkroom, but may be done anywhere with moderate ambient light. To make an alignment negative, use any unwanted negative, and scratch a pattern into the emulsion with a needle, as shown in figure 18.5. Place this negative emulsion down in the enlarger and raise the enlarger to project about a 16"x 20" print. Focus on a piece of white paper on the easel. Study the lines in the torn emulsion at the corners and center to see if they are equally sharp. Refocus the enlarger slightly to focus on one corner, then note how much travel of the lens is required to refocus elsewhere. If there is more than 1/4" of movement required, the enlarger is significantly out of alignment and may need a lot of work.

Summary

Equipment needs should be carefully assessed. Competition and technology have rapidly improved photographic equipment. Your specific equipment needs will vary with professional choices. Cost, dependability, and personal choice will affect what you buy. Used equipment should be considered. Lenses, cameras, and meters can be evaluated with simple tests. Monopods and tripods should be used for long exposures and these, too, can easily be evaluated before buying. Small flash units can be compared, and several can be slaved to produce inexpensive, complex light. Used enlargers are less easily purchased than used cameras. They can be tested without a darkroom for alignment problems.

Discussion and Assignments

Equipment choices are almost always difficult, unless you have a lot of experience.

Assignment 1 Carefully tape a page of text from a well-printed newspaper onto a sheet of cardboard or masonite and prepare to photograph it in very even, flat light. Load your camera with Technical Pan film. Mount the camera on a tripod, and frame the sheet of newsprint so that the whole sheet fills the frame. Be sure the back of the camera and the newspaper are parallel.

Expose film at metered exposures, beginning at maximum aperture and decreasing the aperture a stop at a time. Use a cable release to trigger the shutter. If the camera has a mirror release, trip the mirror first, wait a second, and then trigger the shutter. Repeat for other lenses you own or might wish to use. Develop the film for moderate-to-high contrast. Set the enlarger for maximum enlargement, focus carefully, and make 5"x 8" test prints from the centers and corners of the maximum aperture test, and two-stops-down from maximum aperture (which should be the aperture with the overall best performance). Minimize the enlarger lens variables by moving the film a half frame before printing the details of the corners, so that the frame dividing line is in the middle of the enlarged picture.

19Applied Photographyand Photographic Arts

Figure 19.1
GRAIN ELEVATOR WITH TAR PATCHES, MINNEAPOLIS, MINNESOTA, SEPTEMBER, 1939.
John Vachon.
A documentary photograph that also describes abstract form. Vachon was a member of the Farm Security Administration staff in the 1930s.
(Library of Congress, FSA Collection)

Redefining the Photographer

A generation ago, the photographer was usually a blue-collar employee, skilled with a Speed Graphic or as a darkroom technician. Now, the photographer is a person skilled in reading, interpreting, and utilizing various imaging techniques. A contemporary professional photographer is usually competent over a range of job classifications, from the traditional darkroom technician to being a manager of a small business, an artist, an arts administrator, a newspaper editor, or faculty in a university.

In a broad sense, the old definition of a photographer as "the person with a camera" has been supplanted by a skilled visual problem solver, a person who is skilled in creating, interpreting, and managing images as key communication elements.

The silver photographic process continues to be important, but electronic camera photography, video, and graphics management of digitized images inevitably is replacing production of the traditional simple still silver picture. The production, coordination, and manipulation of traditional photography or new image forms requires similar aesthetic discipline, cultural awareness, and often the same specific craft skills.

Professional Possibilities

The opportunities for well-paid professional photographic work have increased steadily during the last four decades. You can make photographs to order for other people or use photography as a means of personal expression. You can use your knowledge of photographic processes, aesthetics, and history to provide professional services to the art or commercial photographic community. Photographers find many different ways of supporting themselves, other than making photographs for a publication or for gallery sales. Some work as photographic technicians, some work in support areas (gallerys, museums, publishing), and some teach photography.

Although photographs are made and sold as art objects, very few photographers have ever been able to make a living by producing only art photographs, and most famous art photographers have had alternative incomes. Some of the better known names who have supported themselves with professional photographic work include Ansel Adams, a commercial photographer in San Francisco; Wynn Bullock, who owned and operated a photofinishing service in San Francisco; Syl LaBrot, who was independently wealthy; Alfred Steiglitz, who inherited a photogravure company; Paul Strand, who was helped by a trust fund; and Paul Outerbridge, who inherited money. Many, if not most, well-known and widely published contemporary art photographers have teaching positions that support them and in which they are encouraged to make photographic art.

There are many varieties of professional photography: photocommunication, editorial, catalogue, fashion, architecture and interiors, portrait, advertising, biomedical, and corporate and industrial are a few specializations. The amount of special education needed for each of these varies. A photographer snapping babies with automated equipment in the supermarket can be quickly trained, but an editorial illustrator photographing famous musicians, athletes, or writers for full-page ads in consumer magazines usually has years of training and experience.

Figure 19.2
Chicago, 1977.
Barbara Crane.
Contact print from a 5" x 7" negative, exposed with a long lens and using the view camera perspective corrections. Crane is a faculty member of the School of the Art Institute, in Chicago, and has received both a National Endowment for the Arts grant and a Guggenheim Foundation grant.
(Courtesy of the photographer)

New needs for photographers arise as technology changes: many companies now commission expensive slide shows, videos, and lazer-disk productions to illustrate their products at corporate conventions, or for use in employee training. Special needs arise and disappear in the professional photography market: at the time of writing this text, there is a shortage of professionally trained medical photographers, and very few places where one can train. Future marketplace responses inevitably will create more training facilities to meet the need. The corporate annual report appeared doomed when the Securities and Exchange Commission stopped demanding companies produce them, but many corporations found these expensive, richly illustrated bulletins to be useful advertising, and they continue to hire photographers specifically for illustrating the reports.

When the economy is good, corporations tend to expand in-house photographic staffs; when there is a market drop, corporate accountants make note of rising retirement and medical benefit demands and the number of inhouse photographic staff positions declines; but then more jobs go to free-lance photographers. The independent photographer can flourish in the American economy, but only if he or she is a capable small-business manager. As well as having photographic skills, you must be prepared to cope not only with selling and advertising your own efforts, but with tax, insurance, capital amortization, rent or lease agreements, medical, retirement considerations, workman's compensation, and other business demands that being self-employed entails.

Media Labor Markets

Not long ago, a typical photographer's dream was to work for *Life*, or *Look*. In the early 1960s, just before suspending regular weekly publication, *Life* had more than 200 photography staff and contract positions. Now the popular magazines have few or no full-time staff photographers: everything is done by contract photographers. This trend reflects a long-standing European practice. *National Geographic*, a bastion of quality photographic reproduction, has steadily reduced its ranks of staff photographers to about 20 and now hires more than 50 contract and freelance photographers a year. The reasons are economic: a contract photographer presents no long-term obligation to the company.

The economic implications of this change in publishing are complex. One can make a good living through photography but the emphasis is on self-determination. Many more magazines exist now than did 20 or 30 years ago; almost 20,000 periodic publications use freelance photographs. The demand for photographs is high, but the number of fixed-salary jobs in magazine publishing is low.

Though the number of newspapers has declined, the surviving papers are investing heavily in photographic communication. The number of photographers has not increased but there has been a notable shift toward making the photograph a more effective part of the newspaper page, as new staff positions in photo editing, research, and graphics have been created. Newspapers now publish exciting photo-essays and photojournalism. Even papers with limited circulations are producing 16–page special sections reporting on regional or national problems.

Alternative Markets

The photographer may choose to sell services directly and make pictures for a client or a company, or to make pictures speculatively, which are sold through **stock** agencies. These are companies that store, catalog, and merchandize photographs. There are more than 80 stock agencies in the United States. Some are specialized, e.g., handle only aerial photographs or regional pictures, but most deal with a wide range of subject matter. For some time the stock houses wanted only color slides, but recently there has been renewed interest in excellent black-and-white photographs.

Many photographers make good livings from stock sales, but the income is unpredictable; you never know when someone will buy your pictures. A contract relationship with a stock house is entered initially by presenting a minimum number (from 300 to 1,500) photographs of publishable quality; many houses require a guaranteed additional production of 500 to 1,000 images a year to maintain that contract.

The stock agency actively brings suitable images to clients, and negotiates and collects a price reflecting the American Society of Magazine Photographers (ASMP) recommended prices for reproduction rights. After the client uses the picture, the agency regains physical possession and stores it until a new use arises, and for these services retains approximately half the fee. The reproduction fee for using photographs varies widely, depending on the use and on whether model releases are available (essential for advertising; often ignored on editorial copy).

Photo Services

There is a market need for people who know good photographs, the history of photography and of our culture, and who know how to do research. As the archives and museums fill with pictures, the difficulty of accessing the right picture to use for a TV show, textbook figure, history, or feature article increases proportionately. Time-Life, Inc. charges (in 1988) \$100 an hour to research pictures within their own collection.

Photographs are produced in far greater numbers than they are used. A professional photographer may expose many dozen frames for each picture that is printed. The need for photo editors who can filter out the dominant images from a negative strip, and find the important relationships between the individual story, the interactions between pictures, and the design of a whole page has increased. This work, like most supporting roles in the photographic community, requires extensive education. The editor must be able to understand the full cultural implications in the picture as well as evaluate it for photographic quality.

Entering the Field

Portrait, illustration, newspaper, and other photographic specialities were traditionally learned by apprenticeships, and sometimes these began in high school, with summer jobs washing and drying prints, and mixing chemicals. All of these now require college degrees. Training in these jobs rarely exposes you to larger ethical or philosophical photographic concerns, and although the practical experiences may be fascinating, there is a risk they will narrow your interests.

A humanities education, training in the visual arts, training in photographic skills, and practical experience are all needed to excel as a photographer. If you wish to be an editorial or journalistic photographer, you need to have a balance between creative seeing and journalistic excellence. In journalism, the event is foremost but the interpretation of that event is the result of visual training and cultural awareness.

Entry into any professional photographic discipline is probably best done by internship after completing most of a college degree. For example, some colleges teaching photojournalism encourage or arrange paid internships lasting a school term. There are wide variations in the demands made, but often the interns work as hard as the regular staff photographers and are given equally demanding assignments. Your own, faculty, and school reputations are at risk when internships are negotiated, and these assignments are not taken lightly. Internships vary in the length and the intention of the relationship.

Similar internships are often arranged for illustration, fashion, and product specialities as well, and what used to be apprenticeships are now subsumed in the role of photographic assistant. An assistantship will probably last from 3–5 years, and terminates when the assistant learns what can be learned. Three years is about the minimum healthy relationship. During the first year, the master is providing most of the information and much of the work is repetitive and often menial; in the second and third year, more and more often aesthetic and practical decisions are shifted to the responsible assistant and the mutual rewards justify the initial investments made by both parties. Beginning assistants are paid, though not very much. At first glance, it may look as though the pay is about equal to the minimum wage, but assistants rarely work only 40 hours a week; a 50–70 hour work week for a fixed wage is standard. The assistant is expected to work long hours, and to know how to improvise. One learns to find economical solutions within a professional format.

Figure 19.3 Untitled, 1956. Aaron Siskind.

Abstraction of rock forms on Martha's Vineyard, Maine. These followed his documentary street pictures in Spanish Harlem ("the most crowded block in the world") in the late 1930s. The photographer is noted for his work as a teacher at the Chicago Institute of Design (ID) and at the Rhode Island School of Design. He is also a founding member of the Society for Photographic Education. (Courtesy of the photographer)

It is here that school experiences become useful. Three-dimensional design skills, learned in school, are essential in translating a flat picture concept into a studio assembly to be photographed.

Education and Training

Most well-paid photographic jobs now require an undergraduate college degree. Almost all newspapers require a degree. The degree is a minimum guarantee that you, the photographer, have a working knowledge of the society being photographed; but you also need higher education because of the complex business demands inherent in being a photographer today. Computer skills are also essential in the photographic marketplace, not only because more and more processes are being controlled by specialized computer circuits, but because business software management is required to maintain adequate fiscal controls.

Academic education aside, the successful photographer must continually investigate new images and remain open to many definitions of photography. It is important to purchase and study photo and art books, viewing them critically and analytically. This kind of intense self-education is basic and

ongoing to success, in part because American primary and secondary education does little or nothing to support visual training. By and large, our training in visual literacy is extracurricular, and if you wish to be an exceptional person in the photographic area one needs to work constantly to acquire your own primary and secondary visual education.

A college-level art or visual communication program is an excellent way to acquire the knowledge that is needed to compete in the marketplace. Another important source of training and knowledge is the short-term workshop. The popular workshop system of photographic education is a very successful way of acquiring knowledge and exposure to alternative aesthetics. Short workshops are intense experiences that economically bring significant figures from art and applied photography into contact with students.

Photography in College

Photography training is available in technical schools and in traditional four-year colleges. Full-time art schools and technical schools undoubtedly demand more technical accomplishment than does a liberal-arts program, but there is a risk of becoming a photographer in love with the equipment, but one who lacks visual understanding—competent with the camera but culturally and visually illiterate. College should provide a humanities as well as a visual education. In addition, one can easily acquire the broad business knowledge needed in today's market.

Most schools cannot afford to supply small camera equipment, though many have a tradition of owning and maintaining view cameras. Photographic education is inevitably expensive because skill is acquired only through extensive use of costly equipment and materials. Photographic materials have increased in price beyond the inflation rate, in part because they are tied to the precious metals commodity market price. In order to acquire an adequate level of knowledge for entry into a professional internship or graduate school, the cost of materials for a preprofessional undergraduate photography education can be expected to equal or exceed cost-of-living expenses, especially during the second and third year of major study.

Graduate study in photography should be considered if one is dedicated to the medium. A graduate program in photography should be considered as an intensive supplement to a traditional liberal-arts undergraduate humanities major. The baccalaureate years are time spent with the humanities, followed by a one- or two-year intensive study of photo-arts or photo-communication. School experience should be a problem-solving time, where one is confronted with the limits of your own knowledge and helped to develop individual resources (research techniques, photographic skills, alternate aesthetic solutions, understanding of ethical problems in visual communication). When college experience is right, the rewards are excellent technical standards and good professional ethics. These experiences build the armature for a successful professional career.

Networking

An aspiring professional photographer should join one or more of the professional organizations available:

- · ASMP (American Society of Magazine Photographers)
- · APA (Advertising Photographers of America)
- PPA (Professional Photographers of America)
- · NPPA (National Press Photographers Association)
- · state divisions of the NPPA
- · SND (Society of Newspaper Designers)

All of these provide information for the professional, trade magazines, and networking. A few hours of conversation with experienced professionals, editors, and possible future employers will more than pay for the modest student membership dues all these organizations now offer. Professional organizations sponsor conferences and training days, which give you the chance to meet other professionals, potential employers, and teachers away from their usual work (and are therefore more relaxed).

Networking is of immense importance in the professional community. Job stability is usually linked with supervisory roles or self-employment. The general experience is that most professional photographers make three to seven career moves in the first fifteen years of their professional life. The exceptions to this are those photographers who accept industrial and corporate positions.

Presenting Yourself

Your personal style should remain personal; it is all right to be soft-spoken and laid-back, but that should not stop you for asking for feedback on your portfolio from every qualified professional you meet. At the same time, keep your portfolio current: visually literate people have excellent visual memories, and there will be a presumption that you haven't made anything new if you show an editor pictures you have shown before.

It is inevitable that you will frequently see the same people over time within a given marketplace as you learn to sell your skills, which is another way of saying *sell yourself*. The rules are the same for any presentation: your portfolio shows your ability to generate a photographic concept, to create images of quality, and to demonstrate your control of the tools and processes.

The sequence and variety of images reveal your sensitivity to how photographs interact and the range of your imagination. The portfolio itelf should be neat and presentable. If your portfolio is disorganized, it probably means you are disorganized. The details of presentation are important as these reveal whether you are a visually aware person in all things.

In professional photography, the technical quality of your work is the first thing observed by most people; after this knee-jerk response, what distinguishes one portfolio from another is quality of the visual concepts. No matter how interesting the aesthetic concept, it must be well-crafted. Your copy slides must be correct. For example, black-and-white originals are best copied on black-and-white reversal film rather than color, and color must be color-balanced for the copy lights used. If you present color that is improperly exposed, you have far less chance of being hired because it will be assumed you do not know the difference. An employer looks at all these things and then judges you. Bluntly stated, give an excuse to not hire you, and people won't hire you.

Photographic Arts

The history of photography as art in the marketplace is comparatively thin. There are ways of making a living through photographic art, though the odds are about the same as making a living as a ballet dancer or as a professional musician. There are a number of art galleries exhibiting photography today. A recent listing for New York and the surrounding metropolitan area indicated that approximately 5% of all the galleries and museums exhibit photographs. But about 20% of these are museums whose exhibits of photographic art concentrate on established, i.e., deceased, masters. All galleries that sell photography depend heavily on the sale of historical photography, 19th and early 20th century work.

Figure 19.4

Homesteader's Shake Cabin, 1910.

Darius Kinsey.

Documentary photograph made with a 8" x 10" view camera.

(Library of Congress)

Selling art photographs is difficult, but it is not difficult to have an exhibit of your photographs, provided you have a valid aesthetic concept, a body of photographs made in a particular style, and are willing to assume principal exhibition costs (opening and publicity expenses). The photograph, as any other piece of art, must be considered either as a decorative object, an aesthetically moving experience, or as a collectable commodity in which to invest. The decorative photograph is usually, though not always, sold in reproduction (e.g., as a poster, used to decorate a dorm room). A framed and matted print is rarely purchased to hang on a wall.

Collectors are interested in purchasing photographic prints that fulfill their collector's criteria, which relates to artistic concept, uniqueness of subject, use of materials, and rarity, which is why a dead 19th century photographer is more collectable than a young 20th century artist. Collectors are often institutions that are building study sets of prints and tend to purchase portfolios of prints, rather than single prints.

Some financial assistance for the art photographer is available from granting agencies. None of the granting agencies provide assistance to students pursuing a degree. The National Endowment for the Arts (NEA) has biennial grants for photographic artists. The Simon P. Guggenheim foundation offers annual grants. These grants provide roughly a year's living expenses to the artist. Both funding agencies require the petition be supported by written references from professionally qualified figures in the arts; popular

Figure 19.5
Untitled.
Arnold Gassan.
A 4" x 5" negative. The original scene was very low contrast, and extended development produced a negative that prints well on normal contrast grade paper.
(Photo by the author)

knowledge indicates that the references should be from gallery and museum officials rather than other artists. State arts councils offer grants in a range of values from a few hundred to several thousand dollars. The process of applying for any of these grants is unique to each agency, and your local arts council should be contacted for details.

Most photographic artists who wish to make images to meet their own criteria rather than the criteria of others support themselves by working in areas allied to the arts. At the time of writing this text, a shortage of persons skilled in photographic conservation and art history is seen, as a number of new regional and local museums are proposed. Few colleges simultaneously offer directed training in photography, photographic print conservation, and art history; most of the necessary education is at the graduate level and much of the training is by internship and apprenticeship.

Written criticism and historical research and writing is another allied field offering support. These jobs may be associated with professional journals or with organizations like Friends of Photography in San Francisco, or the Center for Creative Photography in Tucson. Significant writing skills and a rigorous graduate education are required.

Finally, a large number of photographic artists support themselves through teaching photographic arts in college. The minimum requirements for this are a graduate degree and experience as a teaching assistant. Here, as elsewhere in the arts, the competition is brisk and there are no assured jobs.

Summary

The photographer's social and professional position reflects a spectrum of possibilities, from blue-collar to middle-management. Most photographyrelated employment requires at least a liberal arts undergraduate degree and many positions demand a graduate degree in visual communication, photographic arts, or art history. Making a living through photographic art is not impossible, but it is risky. Photographs made for personal and commercial reasons are both marketable. Researching and writing skills acquired through learning photographic disciplines are also marketable. Portfolio presentations reveal concept, quality, and control, and are central to professional evaluations. There are many specialized photo markets, and most require the photographer be a business person with some education beyond high school; many require an advanced degree. Photographers are now involved in sales, research, and education as well as technical production. Photographic training involves education in the humanities as well as internships, and a balance between these needs to be maintained. Most specializations may best be entered through internships and apprenticeships. Professional organizations provide a rich source of network information for a young photographer.

Discussion and Assignments

Make a trial decision about the kind of photographic work you might like to do.

Assignment 1 Make appointments with two potential employers and ask what their criteria are for employment.

If you are interested in the arts, contact your state arts council and prepare a complete grant application (including an artist's statement and slide documentation of your work).

Assignment 2 If you are interested in the arts, research several years of Guggenheim or National Endowment for the Arts grants histories and discover:

- · what kind of photographic art has been supported
- · who served as jurors on the selection committees
- · where the photographers have been published

Assignment 3 Contact several large corporations in your area and learn how many photographers are employed, and what kind of duties they have.

242 Chapter 19

20 Ethical and Legal Aspects

Figure 20.1
NARCISSUS.
Connie Imboden.
The mythical concern for self-image is hauntingly evoked in this unmanipulated photograph.
(Courtesy of the photographer)

Restrictions

By and large, in our society a photographer is free to photograph what he or she wishes, but there are some limits on what can be photographed, and what can be published. Some of these limits are established by law and some by good taste. For example, under the United States Code, it was formerly considered counterfeiting to photograph American currency. Now, in certain circumstances, for certain uses, it is permitted. You can make pictures of almost anybody in a public place, unless that person is protected by the law and the public place is not one in which photographs are prohibited, or where a permit is required. Some seemingly public spaces in fact require you to obtain permission to take photographs; e.g., the New York subway and many museums.

Privacy

We each own our faces, and therefore retain the right to privacy. An amateur photographer is under fewer constraints than a professional, but either one should have permission from the person photographed or the owner of property to use photographs for sale, profit, and most public exhibitions.

The following have been legally established as violations of privacy:

- publishing a photograph of a person's face or likeness or a photograph of their property for advertising or trade, without that person's permission
- · disclosing embarrassing private facts to the public
- · using a picture to suggest a falsehood
- · trespassing to take a photograph

Permission to reproduce a photograph must be obtained by the photographer, and anyone can release the right to privacy; permission to reproduce photographs is easily obtained by having subjects sign a model release. A sample model release is shown in figure 20.2; this can be photocopied and carried for use when needed.

Not all uses of pictures require a release. No release is needed if the event is newsworthy, and in general a release is often not sought when the picture is used in an editorial, rather than advertising or trade, context. But this is a legal gray area, and the trouble of obtaining a release is small when compared to the expenses of protecting yourself in even one legal suit for invasion of privacy.

Many art and commercial photographers do use or exhibit pictures of people and buildings or other images without a release. At the least, they do so unethically, and they do so at their own financial risk. There have been several recent sizable financial settlements made to property owners whose buildings were unwisely used for advertising by photographers who thought they were photographing public property.

Intrusion and Trespass

Intrusion is legally similar to trespass: you need not step foot on another's property to be intrusive. The photographer is prohibited from being intrusive in the act of making a picture. Intrusion can be defined as making your presence evident even when you are not physically on another person's property. Intrusion is more difficult to prove legally than trespass, but it is usually unethical behavior, at the least. Photographers have been arrested for going to unreasonable lengths to produce photographs; for example, by hiring boats and using telephoto lenses to photograph someone on a private beach.

Figure 20.2

Model permission form.
Copy and carry in camera case or wallet.

PHOTOGRAPHER: ADDRESS & PHONE: DESCRIPTION OF PHOTOGRAPHS:	MODEL RELEASE DATE:
For consideration received, I give	, and in conjunction with any wording or other and that I do not own the copyright of the nd positives, together with the prints shall

Publicity and Libel

A right of publicity is retained by many people who have created a celebrity value in their name or features. Commercial use of photographs of pictures of such a person is considered subject to license contracts. This is different from being a newsworthy figure, and has been considered as a capital asset by the courts.

Libel is defined as damaging a person's reputation by communicating a false statement. For many years, a newsworthy photograph of a public figure was not suitable for liable unless it was shown to be made with reckless disregard for the truth, or was deliberately false to the reality of the situation. Obviously, a photograph can give a false impression when it is changed by cropping, but powerful distortions of the physical reality of the situation can be created by choice of lens and point of view. Libel law is now being reconsidered in the courts, and definitions of who is subject to libel may change.

Copyright

The U.S. Copyright Law was revised in 1978, and now provides protection for photographs as well as written material. Your unpublished photograph is automatically protected in this country under the copyright act if it is original work. To protect it when it is exhibited or published, the print must bear the copyright symbol ©, your name, and the year, or the phrase "Copyright (year) by (name)," where it can be seen easily. Under copyright law, you have five exclusive rights, four of which are of concern to photographers:

- · the right to reproduce the picture
- · the right to prepare derivative works
- · the right to distribute the work to the public
- · the right to exhibit in public

The definitions of most of these rights are evident, but the second in the list also means that others cannot reuse your photograph in modified form without permission. Photographs can be registered with the copyright office of the Library of Congress (Washington D.C., 20559), but whether registered or not, copyright protection for your original photographs extends for the duration of your life, plus 50 years. When photographs are made for hire, the law is a little different: the copyright protection is for 75 years from publication, or 100 years from creation (whichever is shorter). While the copyright registration does not have to be done until the work is published, if publication is considered, copyright should be completed, if only to avoid possible litigation.

Who Owns the Picture

When you make a photograph to order for a client, the client owns the pictures you make, including the negatives and all rights, unless a specific contract defining ownership has been prepared. The photographer may retain the negatives, but cannot make use of them without the customer's permission. In other words, the photographer functions as a factory that manufactures and warehouses photographs.

When the photographer works on speculation or assumes the expenses and produces the pictures for his or her own profit, however, ownership is generally considered specific to the photographer. But even then there may be an implied contract, in which ownership would revert to the model who was photographed, or to the client who used the photographs.

Because of this longstanding legal definition of ownership of photographs, it is wise to have a licensing agreement before beginning work. This kind of contract helps assure the photographer that only the usage of the pictures has been purchased, not the original photographic materials themselves.

Obscenity and Pornography

The legal definitions of obscenity and pornography are unclear at present. Our society is very confused about sex and art and photography. Ultimately, it seems that community standards prevail when defining permissible images. Where the photograph is exhibited affects a definition, as much as does the subject matter. An art gallery can show explicit nakedness and sexual relationships that might be cause for arrest if seen elsewhere. The proof is on the photographer, should the question be raised, to show that the work, taken as a whole, has serious artistic value.

Summary

A photographer may photograph freely in most places, but this is limited by rights of privacy, and definitions of trespass and intrusion. Sometimes these are hard to prove legally, and the photographer's own ethical standard prevails. A release is required for the photograph to be legally used for profit. All unpublished original photographs are protected by copyright. Whether a photograph is obscene or not is often decided by community standards, as there is no standard legal definition.

Appendixes

1

Photographic Education and Workshops

Nearly 60 colleges and universities offer graduate degrees in applied photography, photographic arts, and history of photography. Kodak publishes A Survey of College Instruction in Photography: Motion Picture, Still Photography and Graphic Arts (Kodak Publication T-17).

These regular educational programs are often supplemented by workshops (usually in the summer) that bring together professionals and students from all skill levels for short, intensive periods. They advertise largely through college and university photography and art school faculty mailing lists, and since they are seasonal, the brochures and bulletins are usually disseminated between March and May.

Workshop classes last from three days to six weeks. Most often they are not graded—the reward is the experience rather than an addition to one's academic record. Some workshops have lasted for years; others fail to catch on and quickly fade away. The following two workshops have proven themselves. The Maine workshop faculty is largely drawn from the ranks of professional photojournalists and editorial illustrators, while the California workshop inherits the photographic art tradition of Ansel Adams.

Maine Photographic Workshop, Rockport ME 04856.

Friends of Photography, 101 The Embarcadero, San Francisco, CA 94105.

2

Information

Knowing where to find information is a great help, especially when you are not quite sure what you want to ask for in the first place.

For more information on chemical hazards:

McCann, Michael. *Health Hazards Manual for Artists* (New York: Nick Lyons Books, 1985).

Safe Handling of Photographic Chemicals, (Eastman Kodak Co., Rochester, NY 14650.)

Photographic education questions can be directed to the Society for Photographic Education, P.O. Box BBB, Albuquerque, NM 87196.

Equipment catalogs themselves are excellent sources of information that often lead one to ask questions that lead in unexpected directions.

Trade photo magazines are excellent sources of information about machinery and processes. The best of these is *Photomethods*, 50 South Ninth Street, Minneapolis, MN 55804. This monthly magazine offers specific craft information for professionals and also prepares an annual "source directory," a special issue dedicated to equipment location.

Books specializing in photographic problems include:

Professional Photo Source (110 West 17th Street, New York, NY 10011; 1987.) Photographer's Market (Writer's Digest Books, 9933 Alliance Road, Cincinnati OH 45242; 1987.) Information on galleries, exhibits, and competition deadlines:

Afterimage, Visual Studies Workshop, 31
 Prince Street, Rochester, NY 14607.
 Artweek, 1628 Telegraph Ave., Oakland, CA 94612.

FYI, Center for Arts Information, 625 Broadway, New York, NY 10012. Lens on Campus, 645 Stewart Ave., Garden City. NY 11530.

New Art Examiner, 230 E. Ohio, Rm. 207., Chicago, IL 60611.

Photographers Forum, 614 Santa Barbara St., Santa Barbara, CA 93101.

Re-Views, Friends of Photography, 101 The Embarcadero, San Francisco, CA 94105. Each state has its own granting agencies for the arts, and these should be contacted directly to obtain schedules for grant application deadlines.

Legal information on photographic arts:

Caplin, Lee Evan, ed. *The Business of Art* (New York: American Council for the Arts, 1982).

Crawford, Tad. *Legal Guide for the Visual Artist*, revised edition (New York: Madison Square Press, Inc., 1985).

Mellon, Susan and Tad Crawford. The Artist-Gallery Partnership (New York: American Council for the Arts, 1981).

3

Books

In excess of 80,000 books are published each year in the United States, and of that number at least 1,000 deal with photography, or use photographs as important illustrations. The following dealers offer an important editorial service in bringing new photograpic books to your attention and providing distribution services (often at a discount from the regular bookstore price).

A Photographer's Place, P.O. Box 274, Prince Street Sta., New York, NY 10012. Amphoto, American Photographic Book Publishing Company, Garden City, NY 11530

Aperture Inc., 20 East 23 Street, New York, NY 10010 (212–505–5555).

Eastman Kodak Company, Department 454, 343 State Street, Rochester, NY 14650.

Focal Press, 80 Montvale Avenue, Stoneham, MA 02180 (617–438–8464).

Light Impressions, 439 Monroe Avenue, Rochester, NY 14603–0940 (800–828– 6216 or 800–828–9629 in New York).

Maine Photographic Resource, 2 Central Street, Rockport, ME 04856 (800–227– 1541).

Morgan and Morgan, Inc., 145 Palisade Street, Dobbs Ferry, NY 10522.

Photo-Eye Books, P.O. Box 2686, Austin, TX 78768 (512–480–8409).

Printed Matter, 7 Lispenard St., New York, NY 10013.

4

Cameras and Other Equipment

Talk to local dealers first. This offers you a chance to have hands-on experience of the equipment (and often things feel different than you expected them to, causing you to reassess equipment needs). Both new and used equipment can be purchased by mail. It is important that you know exactly what you want, how much you are willing to pay for it, how much you should pay for it, and what kind of guarantee you have of getting what you ordered. Even when the local price is higher, it is often worthwhile to pay more, considering the goodwill involved, access to service, and (with certain foreign merchandise) a valid American service guarantee. Unfortunately, a significant percentage of the more expensive cameras in this country are "gray-market," i.e., are imported without full warranty contracts.

Aristo Grid Lamp Products, Inc., P. O. Box 769, Port Washington, NY 11050.

Arkey, 238 South First Street Military 129

Arkay, 228 South First Street, Milwaukee, WI 53201 (800–862–7529).

Calumet Photographic Inc., 890 Supreme Drive, Bensenville, IL 60106 (800–225–8638 or 312–860–7447 in Illinois).

47th St. Photo, 67 West 47th Street, New York, NY 10036 (800–221–7774; in New York 212–398–1410).

Garden Camera, 345 7th Avenue, New York, NY 10001-4076 (800-223-5830).

Hartco Products Company, Inc., P.O. Box 46, West Jefferson, OH 43162–1496 (614–879–8315).

Helix, 310 South Racine Avenue, Chicago, IL 60607 (800–621–6471 or 312–421–6000 in Illinois).

Hoos Photo, 1745 Sherman Avenue, Evanston, IL 60201.

Porter's Camera Store, Inc., P. O. Box 628, Cedar Falls, IA 50613.

Zone VI Studios, Inc., Putney, VT 05346. For preservation and storage materials, as well as specialized equipment, contact:

Archivart Process Material Corp., 301 Veterans Blvd., Rutherford, NJ 07070. Hollinger Corporation, P. O. Box 6037, Arlington, VA 22206.

Light Impressions, 439 Monroe Avenue, Rochester, NY 14603–0940 (800–828–6216 or 800–828–9629 in New York).

Maine Photographic Resource, 2 Central Street, Rockport, ME 04856 (800-227-1541).

Portfoliobox, Inc., 166 Valley St., Bd. 3-402, Providence, RI 02909.

Spink and Gabor, Inc., 32 W. 18th St., New York, NY 10011.

University Products, Inc., P.O. Box 101, South Canal St., Holyoke, MA 01041.

Used photographic equipment can usually be located by examining the ads in *Shutterbug*, a monthly magazine and catalog. The address is P.O. Box F, Titusville, FL 32781.

Finally, for experimental lenses, small tools, inexpensive polarizing filters, ventilating fans, and many other useful objects, write to Edmund Scientific Company, Department 2099, Industrial Catalog #8741–2099, 101 East Gloucester Pike, Barrington, NJ 08007.

5 Chemicals

Photo chemicals can usually be purchased at a camera store. Kodak packages and sells photo chemicals in convenient quantities. The major chemical supply houses often do not sell to individuals, and when they do, there is usually a sizable minimum order required (by weight or dollar amount). If you are associated with a school, orders can often be placed through the purchasing office to one of the following:

Curtis Matheson Scientific Company Fisher Scientific Company Sargent-Welch Scientific Company VWR Scientific Canadian Laboratories Supplies, Ltd.

These major distributors have branches throughout the United States and Canada.

Small quantities of any photographic chemical, and complete processing kits for hundreds of different formulae can be purchased from a unique source: Photographers' Formulary, PO Box 5105, Missoula, MT 59806 (406–543–4534).

If your local dealer does not carry a photographic solution you wish to try, contact the manufacturer and ask for the name of the nearest distributor.

Acufine, Inc., 439 East Illinois Street,
Chicago, IL 60611.
Edwal Scientific Products Inc., 12120 South
Peoria Street, Chicago, IL 60643.
Ethol Chemicals, Inc., 1808 North Damen
Avenue, Chicago, IL 60647.
Fuji Photo Film USA, Inc., 350 Fifth Avenue,
New York, NY 10001.
Heico, Inc., Delaware Water Gap, PA, 18327.
Ilford, Inc., P.O. Box 288, Paramus, NJ
07652.
Sprint Systems of Photography, 100 Dexter

Street, Pawtucket, RI 02860. Unicolor Division Photo Systems Inc., PO Box 306, Detroit, MI 48130. 6

Metol-free Developers

Many people eventually become Metol (or Elon) sensitive and may develop a skin rash, which can be avoided by using developers that do not contain this developing agent (see table A.1).

TABLE A.1

Metol-free Developers

Manufacturer Product		Description		
Acufine, Inc.	Acufine	High-energy film developer		
	Diafine	Contrast control, two-bath film developer		
	Posifine	Paper developer		
Agfa-Gevaert	Rodinal	High-acutance film developer		
Edwal	FG-7	Fine-grain film developer		
	Platinum	Paper developer		
Eastman Kodak	HC-110	High-acutance film developer		
	Ektaflo	Warm-tone paper developer		
Ethol	LPD	Paper developer		
Ilford, Inc.	Microphen	Fine-grain film developer		
	Bromophen	Paper developer		
	llfospeed	Paper developer		
	Multigrade	Paper developer		
Sprint System	Quicksilver	Paper and film developers		

Appendixes 249

7

Packaged and Homemade Chemicals

There are few occasions now for the contemporary photographer to mix solutions from raw chemicals. The premixed, powdered, or liquid developers, fixers, and toners provide dependable and easy processing for almost any need. You may wish to experiment with the formulas listed in table A.2, or to experiment with basic developer components in order to understand more thoroughly the silver process.

TABLE A.2
Film Developers

..... Детекорого

All units of measure are metric, i.e., gram or ml units. The chemicals are listed in the order in which they are mixed (unless noted). All formulas are for a final solution of 1 liter. Start with 750ml of water (distilled is preferred) at about 125°F. Pour chemicals in smoothly, avoiding chemical dusts, and mix thoroughly with a stirring paddle. When chemicals are dissolved, add cold water to make 1 liter.

			Beutler ¹				
Chemical	D-23	D-25	D-76	POTA ²	Α	В	$D-8^3$
Elon	7.5	7.5	2.0	_	10	_	_
Sodium sulfite4	100	100	100	30	50	_	90
Phenidone—A	_	_	_	1.5	_	_	_
Hydroquinone	_	_	5	_	_	_	45
Sodium bisulfite	_	15	_	_	_	_	_
Sodium hydroxide ⁵	_	_	_	_	_	_	37.5
Sodium carbonate	_	_	_	_	_	50	_
Borax	_	_	2		_	_	_
Potassium bromide	_	_	_	_	_	_	30

¹The Beutler developer is mixed as separate stock solutions that are combined just before use. See table 9.3 for details.

²The POTA developer is an alternative to Kodak Technidol developer for Kodak Technical Pan film, which is inherently a high-contrast emulsion. This formula is also useful for other emulsions. Agitation with Technical Pan film should be reduced to two firm inversions of the tank each minute, with a development time between 10 and 14 minutes.

³D-8 is a high-contrast developer originally used for photo etching plates. It is worth experimenting with when high contrast is desired and you do not wish to purchase a large quantity of premixed developer. Normal developing time is about two minutes.

⁴The dessicated form of sodium sulfite is used. Stir thoroughly to assure that the sulfite is completely dissolved and avoid pinhole etching from this silver solvent.

⁵Sodium hydroxide is a dangerous chemical. It generates heat when mixed with water and *must* be stirred in slowly. The chemical can cause serious burns to skin and eyes. Always wear protective gear when measuring or mixing it.

8

Chemical Notes

Most of the chemicals listed in tables A.2 and A.3 are packaged in convenient sizes (if not the most economical) and sold through retail photo stores. Formulas that are not frequently used often disappear from sight. You are urged to examine older editions (dating back to the 1930s) of the *Photo-Lab Index* and other reference books for formulas that are often still useful and adapt well to modern films and paper.

TABLE A.3

Paper Developers

All units of measure are metric, i.e., gram or liter units. The chemicals are listed in the order in which they are mixed (unless noted). Print developer is rarely used in small quantities, and all formulae are for a final solution of four liters. Start with three liters of water (distilled is preferred) at about 125°F. Pour chemicals in smoothly, avoiding chemical dusts, and mix thoroughly with a stirring paddle. When chemicals are dissolved, add cold water to make four liters.

Formula Names		Ansco ¹			DuPont		
Chemical	D-72 ²	120 ³	1304	135 ⁵	54-D ⁶	59-D ⁷	
Elon	12	49	9	6.4	10.8	12	
Sodium sulfite ⁸	180	144	200	96	160	144	
Hydroquinone	48	_	44	26.4	42.4	_	
Sodium carbonate9	320	144	312	96	352	84	
Potassium bromide	8	7.2	22	11.2	3.2	16	
Glycin	_	_	44	-	_	_	

¹D-72 is very similar to Kodak Dektol developer.

²Ansco was an American film and chemical company that became Agfa-Ansco in the 1930s, and GAF Corporation in the 1950s.

³Ansco 120 is a low-contrast developer; Adams suggests it as an alternative to Kodak Selectol-Soft, used from full strength to a 1:2 dilution for 1 1/2 to 3 minutes developing time.

Ansco 130 is the only developer suggested here that uses developing agents other than Elon or hydroquinone. This developer produces very beautiful separations of shadows and clear highlights with contemporary enlarging papers. The developer darkens to a light brown color immediately after mixing, but this is not an indication of exhaustion.

⁵This is a warm-tone developer, and will produce a more brown-black image than the others. Dilute 1:1; to increase the warm-tone, increase bromide up to twice the quantity noted.

⁶A *cold-tone*, vigorous developer, used diluted 1:2. A very good developer for two-tray development, used full strength or 1:1.

⁷An alternative to Ansco 120, this is a soft working developer that is an excellent replacement for Selectol-Soft, or for use in two-tray development.

⁸The dessicated form of sulfite is used.

⁹The monohydrated form of carbonate is used.

Glossary

- **absorption** Transforming light into another energy form.
- **accelerator** Creates strong alkaline pH in developer.
- additive primary Red, green, or blue light.
- antihalation Dye absorbs light passing through emulsion, which otherwise causes secondary image (halation).
- **artificial light** Supplementary light source that modifies ambient light.
- **Automatic Tray Siphon** Print-washing aid for small numbers of prints.
- **baseboard** Support for enlarger, on which a printing paper easel is placed.
- **bleach** Transforming dark silver image into light silver salt.
- **bounce light** Light directed at ceiling or other reflector rather than directly at subject.
- **bracketing** Exposing more and less than the calculated exposure.
- **burning-in** Giving extra exposure to an area of a print to darken it.
- camera obscura Darkened room with lens in one wall.
- **candela** Term for measure of light intensity that has replaced "candle."
- **changing bag** Lighttight bag with armholes.
- **Chem-Wipes** Lint-free sheets used to wipe final rinse water from negatives.
- **clearing** Removal of unused silver salts from film or papers.
- **cliche-verre** Hand-made negative. **complementary colors** Opposing light
- and pigment colors: red-cyan, greenmagenta, blue-yellow.
- **compression** Shortened development time, which reduces contrast.
- **copyright** Protection by law for creative work.
- covering power Negative area from which an acceptable sharp image can be made
- **cutting reducer** Diminishes image density and contrast.
- **developer** Solution that transforms a latent into a visible image.

- **developing agent** Active ingredient in developer that reduces silver salt to metal.
- **developing out** Darkening of latent image in a developing solution.
- diffraction Spreading of light rays.
 dodging Preventing light from exposing an area of a print.
- **Dry-mount tissue** Heat-sensitive adhesive sheet used to bond photograph to mount board
- **Drying down** Loss of contrast and brilliance in a print as it dries after processing.
- **Dust Off** Compressed gas used for blowing dust from negatives.
- **enlarging lens** Wide-field lens designed for printing negatives.
- **expansion** Lengthened development time that increases contrast beyond normal.
- exposure Light that forms latent image on film or paper.
- **fiber base** Emulsion coated directly on paper support or clay undercoating.
- **figure** Principal area in a two-dimensional composition.
- **fill light** Secondary light source used to limit contrast.
- **filter factor** Linear multiplier of pre-filter exposure.
- **flash meter** Incident meter that integrates ambient and flash light, and calculates exposure.
- **focal length** Distance from optical center of a lens to focal plane.
- **focal plane** Plane in which parallel lines of light are brought to a point by a lens.
- **glacial acetic acid** Concentrated acid that freezes at about 50°F.
- **GN** Guide Number; used for predicting flash exposures.
- **graded contrast** Printing paper with a singular characteristic curve.
- **ground** Supporting area in a two-dimensional composition.
- **guide number** Predicts flash f-number as dividend of light-to-subject distance.
- hardening fixer Thiosulfate solution with chrome alum.
- hardness Amount of calcium in water.

- **highlights** Highly reflective surfaces in the subject that have texture or detail.
- **hot shoe** Synchronization connection attached to mounting clip on camera body.
- **HTH** Highest Textured Highlight; brightest subject area that shows detail.
- **hydroquinone** Low-energy, high-contrast developing agent; synergetic with Metol.
- **Hypo Chek** Edwal product that estimates activity of fixer.
- **indicator stop bath** Acetic acid with pH indicating dye.
- intensification Adding metallic density to negative or print image silver to increase contrast.
- **intensity** Measure of light energy impacting on film or paper.
- **intention** Planned subject of the photograph.
- inverse square law Intensity is inversely proportional to square of distance from light
- IR Infrared (below threshold of visible light).
- **ISA** Important Shadow Area; large shadowed area of subject with significant detail.
- **ISO** International Standards Organization; arithmetic number that indicates film sensitivity to light.
- **key light** Primary light source that determines overall direction of shadows.
- latent The invisible but real image in a silver emulsion, produced by exposure and made visible by development.
- **latitude** Ability of emulsion to produce a usable picture with varying exposure.
- **LFN** Edwal brand low-foaming wetting agent.
- **Liquid Orthazite** Edwal compound restrainer that causes less color change than potassium bromide to prints.
- **luminance** Amount of light, measured in candelas.
- **mat cutter** Holds blade at angle to permit cutting window mats.
- **Metol** Low-contrast, high-energy developing agent (same as Elon).
- **model release** Contract defining permissible use of photographs.

- **modeling light** Low-intensity, steady-state light on electronic flash.
- **momentary light** Light source with short duration.
- **monopod** Camera support with only one leg.
- **nanometer** Measure of wavelength of light.
- **negative** Image with values reversed from original subject.
- **neutral density** Filter that affects all colors of light equally.
- **normal contrast** Describes subject reflective range.
- **PC connector** Sensitive to all visible light. Coaxial connector for
- electronic flash synchronization. **peak action** Photograph that describes most intense moment of play in sports
- **Perma-Wash** Solution that transforms thiosulfates into soluble compounds.
- **phenidone** Hypo-allergenic, high-energy, low-contrast developing agent; replaces Elon.
- Photo Flo Wetting agent used for films.

 Photo Mount Scotch brand (3M) aerosol cement
- **Photo-Wipes** Lint-free sheets used to wipe final rinse water from negatives.
- **pictorialism** Where the printmaking is more important than the photographic subject.
- **point source** Sun or other light source that generates parallel rays of light.
- **polarized** Light vibrating in only one
- **Positionable Mounting Adhesive** 3M contact sheet adhesive.
- **positive** Image with values that parallel those of subject.
- potassium bromide Commonly used restrainer in developer.
- potassium ferricyanide Combines with silver to form soluble silver salt in thiosulfate solution.
- **pre-fix** Treatment in thiosulfate solution prior to toning or intensification.
- **prewet** Water treatment of film to minimize uneven development.

- **preservative** Chemical that protects developing agent from oxygen in solution.
- primary Color of light: red, green, or blue.printing out Darkening of silver emulsions by the action of light alone.
- **projection** Perception imposed on the photograph.
- **proportional reducer** Diminishes image density without affecting contrast.
- rapid fix Ammonium thiosulfate fixer.Rapid Selenium Toner Kodak selenium toning solution.
- reciprocity
 Exposure = time x intensity.

 redevelop
 Developing chemically altered silver during intensification.
- reducing agent Active ingredient in developing solution.
- **reflection** Reversal of light direction on impact with polished surface.
- **refraction** Change of light direction on entering another medium.
- **release** Contract permitting use of photographs.
- **replenish** Adding stock or concentrate to working solution to restore original state.
- resin-coated Polyethylene-coated paper, which isolates print emulsion from paper support.
- **restrainer** Provides bromine ions, which inhibit developing of latent image.
- safelight Light of low intensity and color that has minimal effect on photosensitive emulsions.
- **secondary primaries** Subtractive primaries: cyan, magenta, yellow.
- **shadows** Dark subject areas that are perceived to have significant detail.
- **single-shot** Solution that is used once and then discarded.
- **skylight filter** Eliminates ultraviolet; filter factor = 1.
- **snapshot** Photograph made in the instant, without planning.
- **sodium carbonate** Moderately strong alkali used as accelerator (activator) in developer.
- sodium hyposulfite First name given to thiosulfate compound used to fix negative; also called "hypo."

- **sodium sulfite** Weak alkali used as preservative in developer.
- sodium thiosulfate Used to remove unused silver from negatives and prints; "fixer" or "hypo."
- **Spotoff** Commercial silver image bleach. **Spotone** Transparent dye for retouching
- **steady-state light** Light with constant intensity over time.
- **stock** Concentrated solution that is diluted for use.
- **stock agency** Sales center for photographs made on speculation.
- stop 2:1 change of exposure; also f-stop.
 stop bath Acetic acid solution that stops print or film development.
- straight An unmanipulated photograph.
 strobe light Repeating light used to
 analyze rotary motion; misnomer for
 flash
- subtractive primary Perceived primary color of pigments: cyan, magenta, vellow.
- taxonomy threshold Classification of objects.

 Minimum exposure required to create developable latent image.
- TTL Through-the-lens metering, standard on most 35mm cameras.
- variable contrast Paper with color sensitive emulsions, one high-contrast and one low-contrast.
- water bath Tray of water in which developing tanks or trays rest (alternate: plain water solution used for development of film or paper to limit contrast).
- wet-plate A 19th century photographic process.
- **Xacto knife** A commercial knife with a small, interchangeable blade.
- **zero-balanced** Adjusting a scale so that zero mass is indicated despite the presence of a chemical tray.

Index

1401 Larimer Street, Denver 108	cassette, film 6	developing out process 40
absorption 190	Center for Creative Photography 241	developing tank 11
Abstraction 113	changing bag 11	development 6
accelerator 144	characteristic curve 128	Dharan Al Hasa, Saudi Arabia 229
acid-free mounts 182	chemical storage 143	diffraction 190
acutance 124	chemical preparation 16	diffuse density 127
Adams, Ansel 2, 90, 92, 115, 178, 232	Cheyenne Woman, 1910 114	diffuse light 190
additive primaries 207	Chicago, 1977 234	Dillard, Annie 122
Advertising, Woodbine, Iowa, 1940 102	China Cove, Carmel 75	dilutions 17, 32
aesthetics 90	Chromium Intensification of Negatives, Table	documentary photography 101, 103, 114
aesthetics of lenses 110	12.2 163	dodging (print control) 51
Agee, James 105	cliche-verre 113, 122	double-exposure 87
agitation (film and paper) 21, 34, 137	Clinton and Mae Iroller, Patrick County, Virginia,	dry-mount press 183
Alinder, Jim 4	<i>1978</i> 112	dry-mounting 62
Allie May Burroughs, 1935 116	clothes for the darkroom 2	Dry-mounting and Matting Equipment, Table
Anderson, Donald R. 155	Cohen, Mark 111	14.1 183
antihalation dye 24, 125	Cole, Liz 211	drying down 46
aperture 72	color sensitivity of film 124	drying prints 181
appendixes 247	Common Developing Agents, Table 10.3 145	DuBose, Mike 79, 105
Apple Tree, Monhegan Island, Maine, 1983 143	Common Measures for Photo Chemicals, Table	dust control (in darkroom) 42
Arnheim, Rudolf 107	10.2 142	dust spots on print 56
art photography 114	composition, photographic 91	Dust-Off 42DX 14, 84
autofocus 72	compression development 173	
Automatic Tray Siphon 35, 181	compromise contrast control exposures 177	Street, Mr. 1900. And 1900.
Available 35mm Films, Table 16.1 209	Compur shutter 83	Eastman, George 4
	Construction of Union Station, Nashville,	edge sharpness 124
halanda daab aaaaaaa 200	Tennessee, ca. 1895 185	Edgerton, Harold 194
balancing flash exposures 202	contact print uses 28, 31, 32, 32, 33, 36, 37, 135	editing 90, 102
Ballance, Steve 91	copyright 245	Egypt, 1862 182
Bärbell 193	Corner of Bud Field's House, 1935 118	El (see exposure index) 86
baryta 152	Corsini, Harold 229	Eiler, Terry 117
Baytown Refinery, Texas, 1949 97	Cotton Town, Arizona, 1940 113	electronic flash 194
Beato, F. 182	Cotton Worker, Arizona, 1942 119	Elizabeth Fletcher, ca. 1910 66
Beers Paper Contrast Control Developer	Crane, Barbara 234	Elliott, Laura 140
Formula, Table 11.2 155 Berry, Pam 7	critical judgement 109, 121 cropping the print 60	Elon (Metol) 145
Beutler Developer, Table 9.3 136	Cubism 113	Emergency Room Examination 11
Bisker, Darcy 122	Curtis, Edward S. 114	emulsion gelatin 5
Boone County, Arkansas, Rehabilitation Clients,		enlarger details 30, 229, 230
August, 1935 102	Curtis, Mel 86	Enlarging Equipment, Table 4.1 42
bounce light 202	cutting reducer 164	equipment considerations 225, 227
Bourdin, Guy 111		estimating contrast 174
Boyer, Amy 110	Dilag Figure 109	estimating negative density 128
Brady, Mathew 95	D log E curve 128	Evans, Frederic 180
Brink, Ben 131, 163	daguerreotype 90	Evans, Walker 104, 105, 116
bromide desensitization 126	damaged prints 57	exhaustion of solutions 35
Bruggiere, Francis 122	Dance Master Class 81	expansion development 173
brush spotting 58	darkroom 7, 9, 11, 15, 32, 216, 218, 219, 221, 222	exposure
Bubley, Ester 3	Darkroom Equipment, Table 1.1 10	automatic controls 8
Bud Fields and His Daughter-in-law 104	David Vestal 193	bracketing 47
Bullock, Wynn 232	density defined specular and diffuse 127	contrast control 137, 174
	density modifications 160	flash meter 200
burning-in (printing) 51	depth of field 74	for condenser enlargers 139
camera 6, 7, 8, 67, 72, 87	detents 73	index (EI) 86
camera obscura 67	developer	law 80, 170
Canal Point, Florida: 'We never lived like hogs	temperature 19, 20	printing test 44
before.' 116	choosing 135	shutter-priority 14
candela 170, 178	time 21, 130	variable contrast papers 49
Carter, Paul 118	developers 17, 141, 143, 150	exposure-development testing 132
Cartier-Bresson, Henri 111	developing agents 144	Exposure and Contrast, Table 4.2 47
Cartier Diesaon, Fierin 111	developing infrared film 211	

Framer's Reducer Solutions, Table 12.3 165 Faggen Jones and Family, 1936 104 Faggen Jones and Family, 1936 104 Faggen Jones and Family, 1936 104 Falloween Costume Contest 224 Hastings, Sci 110 Falloween Costume Contest 224 Hastings, Sci 110 Hastin Hazards, 8.5, 52.2, 145, 160 Height Hazards, 8.5, 52.2, 145, 160 Heigh			
Faggen Jones and Family, 1398 104 Fellama, Sand 190 Field Hockey 110 Fellama Sand 190 Field Hockey 110 Field Hockey 110 Health Hazards 8, 45, 62, 145, 160 Hencken, Robert 11 Herchel, Stock 11, 172 Helps Levicus halling 11, 172 Helps Levicus halling 11, 174 Herchel, Stock 11, 174 He			Laughlin, Clarence John 89, 91
Fellman, Sandi 90 field of view of lens 67 field Hockey 110 field of view of lens 67 figure filiary (ground 91 filiary		Halloween Costume Contest 224	law of reciprocity 80
Height and Light in Bruges Cathedral, 1907 180 Height and Light in Bruges Cathedral, 1907 180 Heinecken, Robert 111 Lennox, Annie 81 lend defined 66 lens test 227 Let Us Now Praise Famous Men 105 lend defined 66 lens test 227 Let Us Now Praise Famous Men 105 lens defined 66 lens test 227 Let Us Now Praise Famous Men 105 lens defined 66 lens test 227 Let Us Now Praise Famous Men 105 lens defined 66 lens test 227 Let Us Now Praise Famous Men 105 lens defined 66 lens test 227 Let Us Now Praise Famous Men 105 lens defined 66 lens test 227 Let Us Now Praise Famous Men 105 lens defined 66 lens test 227 Let Us Now Praise Famous Men 105 lens defined 66 lens test 227 Let Us Now Praise Famous Men 105 lens defined 66 lens test 227 Let Us Now Praise Famous Men 105 lens defined 66 lens test 227 Let Us Now Praise Famous Men 105 lens defined 66 lens test 227 Let Us Now Praise Famous Men 105 lens defined 66 lens test 227 Let Us Now Praise Famous Men 105 lens defined 66 lens test 227 Let Us Now Praise Famous Men 105 lens defined 66 lens test 227 Let Us Now Praise Famous Men 105 lens defined 66 lens test 227 Let Us Now Praise Famous Men 105 lens defined 66 lens test 227 Let Us Now Praise Famous Men 105 lens defined 66 lens test 227 Let Us Now Praise Famous Men 105 lens defined 66 lens test 227 Let Us Now Praise Famous Men 105 lens defined 66 lens test 227 Let Us Now Praise Famous Men 105 lens defined 66 lens test 227 Let Us Now Praise Famous Men 105 lens defined 66 lens test 227 Let Us Now Praise Famous Men 105 lens defined 66 lens test 227 Let Us Now Praise Famous Men 105 lens defined feet 105 lens		Hastings, Sid 110	Lee, Russell 97
Figure from the Underworld 89 Heraches, Sir John 122 Iens test 277 Heraches, Sir John 122 Iens test 277 Let Us Now Praise Famous Men 105 Iible (Incorporation) Iible (Incorporatio		Health Hazards 8, 45, 62, 145,160	legal problems 242
Figure form the Underworld 89 Herschel, Sir John 122 Iens test 227 Ien	Field Hockey 110	Height and Light in Bruges Cathedral, 1907 180	Lennox, Annie 81
fügure/filk/ground 91 highest textured highlight (HTH) 172 Let Us Now Praise Famous Men 105 filling ht 193 Hockey Fip 81 Let Us Now Praise Famous Men 105 filling density: film base plus log 128 developing 129, 136 hot shee (connector) 198 light 189 libe (photographic) 245 Life 102 film part of part of the p			
Millight 193			
Homesteader's Shake Cabin, 1910 240 Life 102			Let Us Now Praise Famous Men 105
developing 129, 136 hot shoe (connector) 198 light 189 light 189 light 189 light 189 lighting developing 129, 136 hyporocal distance 76 hypo 27 lash total 14 list on umber 6 hypo 27 list of 14 list on umber 6 hypo 27 list of 14 list of 156 local reduction 166 local reduction 167			
developing 129, 136 fine-grian 14 hype-focal distance 76 hypo 22 fine-grian 14 hype-focal distance 76 hypo 22 fine-grian 14 hype-focal distance 76 hypo 22 filan 14 hype-focal distance 76 hypo 22 filan 104 ratios 194 Liquid Orthazite 156 Long Exposure Reciprocity Corrections, Table 16 2 210 filter Factors and Corrections, Table 16 2 210 important shadow areas (ISA) 172 incident light meter 84 Indian Pueblo Chrunch, New Mexico 92 information in photograph 98 infrared 210 inverse square law 201 investigation 125 intensification 160 inverse square law 201 fisheye lens 67 filter Fame Test Analysis, Table 9.1 134 first 17.3 2, 167 forenover (clearing) 22 filter Fame Test Analysis, Table 9.1 134 first 17.3 2, 167 forenover (clearing) 22 filter Fame Test Analysis, Table 9.1 134 filter 17.3 2, 167 forenover (clearing) 22 filter Fame Test Analysis, Table 9.1 134 filter 17.3 2, 167 forenover (clearing) 22 filter Fame Test Analysis, Table 9.1 134 filter 18 filtrian 18 filter 18 filtrian 18 filtria			
fine-grain 14			
Span			
So number 6 latitude 14 sensitivity 124 mboden, Connie 242 important shadow areas (ISA) 172 important shadow			
Section of the content of the cont		,,	
Impovelopers, Table A 2 250		Hypo Chek (fixer exhaustion) 35	
Film Processing Time Table, Table, 23 20 Imboden, Connie 242 Long Exposure Reciprocity Corrections, Table Film Processing Time Table, Table, Table, 210 Inicident light meter 84 Lonk 102 Lond Exposure Reciprocity Corrections, Table 16 2 210 Inicident light meter 84 Look 102 Lond Fixed Film Processing Time Table, Table, Table, 210 Lond Fixed Film Processing Time Table, Table, 210 Lond Fixed Film Processing Time Table, Table, 210 Lond Fixed Film Processing Time Table, 210 Lond Film Processing Time Table, 210 Lond Film Processing, 210 Lond Film Proces			
Filter Pactors and Corrections, Table 16.2 210 important shadow areas (ISA) 172 13.1 170			
Incident light meter 84			
Inflared 210 Inflared 210 Information in photograph 98 Lundquist, Mark 16 Lundquist			
information in photograph 98			
neutral density 213 polarizing 212 skylight 210 Fisher, Gail 56 inverse square law 201 irradiation 125 Skylight 210 Fisher, Gail 56 irradiation 125 Sib 84 Five-Frame Test Analysis, Table 9:1 134 fixer 17, 32, 167 remover (clearing) 22 fixing and permanence 180 flash bub 104 Jak. Mill Building 113 Massar, Ivan 79, 113 Matthews, Kate 66 McKinley Birn Leading Betsy, 1978 117 measuring chemicals 141 Meatyard, Raiph Eugene 111			
Delarizing 212 Skylight 210 Intensification 160 Inverse square law 201 Irradiation 125 Man Ray 122 Marvin Hajder in Training 131 Matthews, Kate 66 McKinley Brim Leading Betsy, 1978 117 measuring chemicals 141 Massar, Ivan 79, 113 Matthews, Kate 66 McKinley Brim Leading Betsy, 1978 117 measuring chemicals 141 Mastyrd, Hajoh Leading Betsy, 1978 117 measuring chemicals 141 Matthews, Kate 66 McKinley Brim Leading Betsy, 1978 117 measuring chemicals 141 Matthews, Kate 66 McKinley Brim Leading Betsy, 1978 117 measuring chemicals 141 Matthews, Kate 66 McKinley Brim Leading Betsy, 1978 117 measuring chemicals 141 Matthews, Kate 66 McKinley Brim Leading Betsy, 1978 117 measuring chemicals 141 Matthews, Kate 66 McKinley Brim Leading Betsy, 1978 117 measuring chemicals 141 Matthews, Kate 66 McKinley Brim Leading Betsy, 1978 117 measuring chemicals 141 Matthews, Kate 66 McKinley Brim Leading Betsy, 1978 117 measuring chemicals 141 Meakyard, Hajoh Eugene 111 Meek, A. J. 49 meter incident light 171, 175 contrast 172 contrast 172 contrast 172 contrast 172 reflected light 171 target 84 types 84 used 228 Metol-free Developers, Table A.1 249 middle gray 171, 178 middle gray 171, 178 middle gray 171, 178 model permission form 244 modeling light 191 Mcholy-Nagy, Lazlo 113 monopod 7 montage 155 Montlero, James 144, 173 Motor Study 41 mount board 62 Grant Elevator with Tar Patches, Minneapolis, Minneapolis, Minneapolis, Minneapolis, Minneapolis, Minneapolis (Sodak viewfinder 71 mount board 62 mounting cements 183 mounting prints 180 Myers, David 120			Lundquist, Mark 16
Skylight 210 Inverse square law 201 Inverse square law 201 Irradiation 125 Sibar, Gail 56 Irradiation 125 Sibar, Five-Frame Test Analysis, Table 9.1 134 Italian Mother and Baby, Jersey Street, ca. 1889 Madden, Blake 137 Irrading 131 Massar, Ivan 79, 113 Massar, Ivan 79, 113 Massar, Ivan 79, 113 Massar, Ivan 79, 113 Matthews, Kate 66 McKinley Brim Leading Betsy, 1978 117 Measuring chemicals 141 Meatyard, Raiph Eugene 111	·		
Fisher, Gail 56 fisheye lens 67 Five-Frame Test Analysis, Table 9.1 134 fixer 17, 32, 167 remover (clearing) 22 fixing and permanence 180 flash bulb 104 flash exposure 200 flash meter 200 Fleischhauer, Carl 112 Flemming, Shiela 115 focal length 67, 79 focal ength 67, 79 focal ength 67, 79 focal plane 67 foth, Ron, Jr. 9 Foth, Sharon 211 Friends of Photography 241 Friends of Photography 241 Field full-scale negative 127 full-substance negative 127 full-substance negative 127 full-substance negative 127 Glossary 252 Glossary 252 Graet Mother of Big, Apples 91 Graven Landing Betsy, 1978 117 measuring chemicals 141 Meek, A. J. 49 meter incident light 171, 175 contrast 172 reflected light 171, 175 contrast 172 reflected light 171 target 84 types 84 used 228 Metol-free Developers, Table A.1 249 middle gray 171, 178 modeling light 191 Moholy-Nagy, Lazlo 113 monopod 7 montage 155 Moholier Agine 119 Moholy-Nagy, Lazlo 113 monopod 7 montage 155 Moholier Agine 119 Moholy-Nagy, Lazlo 113 monopod 7 montage 155 Moholier Agine 119 Moholy-Nagy, Lazlo 113 monopod 7 montage 155 Moholier Agine 119 Moholy-Nagy, Lazlo 113 monopod 7 montage 155 Moholier Agine 119 Moholy-Nagy, Lazlo 113 monopod 7 montage 156 Moholier Agine 119 Moholy-Nagy, Lazlo 113 monopod 7 montage 156 Moholier Agine 119 Moholy-Nagy, Lazlo 113 monopod 7 montage 156 Moholier Agine 119 Moholy-Nagy, Lazlo 113 monopod 7 montage 156 Moholier Agine 119 Moholy-Nagy, Lazlo 113 monopod 7 montage 156 Moholier Agine 119 Moholy-Nagy, Lazlo 113 mounting prints 180 Myers, David 120 Green River 93 Green, Jonathan 99 Griswold, H. C. 34, 185 guide number (GN) 200			Maddan Diala 107
Sis			
Five-Frame Test Analysis, Table 9.1 134 ixer 17, 32, 167 remover (clearing) 22 fixing and permanence 180 flash bulb 104 flash bulb 104 flash bulb 104 flash bulb 104 flash exposure 200 Jackson, William Henry 5, 93 fleischhauer, Carl 112 Jackson, William Henry 5, 93 fleischhauer, Carl 112 Jackson, William Henry 5, 93 fleischhauer, Carl 112 Jackson william Henry 180 flash permanence 180 flash bulb 104 flash exposure 200 flash meter 200 Jackson, William Henry 5, 93 fleischhauer, Carl 112 flemming, Shiela 115 flocal length 67, 79 flocal plane 67 flocusing target 230 floor 190 floor			
fixer 17, 32, 167 101 Matthews, kate 66 remover (clearing) 22 McKinley Brim Leading Betsy, 1978 117 fixing and permanence 180 McKinley Brim Leading Betsy, 1978 117 flash bulb 104 J&L Mill Building 113 Measy and Ralph Eugene 111 flash exposure 200 Jack O'Lantern 157 Meek, A. J. 49 flash meter 200 Jackson, William Henry 5, 93 meter Fleischhauer, Carl 112 Japanese Family Waiting Shipment to Manzanar, 1942 13 model permission for contrast 172 Flemming, Shiela 115 Jares, Tom 110 meter focal plane 67 Jares, Tom 110 meter focal plane 67 Jares, Tom 110 Meter incident light 171, 175 fouring target 230 Gog 44, 128 Kasebier, Gertrude 142 Weller, Ken 15 Fox, Sharon 211 Keifne, Ken 15 Meton-free Developers, Table A.1 249 Model gray 171, 178 model germission form 244 FSA 96 Keller, Kate 142, 159 Medigen permission form 244 Model permission form 244 FSA 96 Kelvin temperatures 207 Moholy-Nagy, Lazio 113 Moholy-Nagy, Lazio 113 full-substance negative 127 Key light 193			
remover (clearing) 22			
fixing and permanence 180 measuring chemicals 141 flash bulb 104 J&L Mill Building 113 Meatyard, Raiph Eugene 111 flash exposure 200 Jack O'Lantern 157 Meek, A. J. 49 flash meter 200 Jackson, William Henry 5, 93 meter Fleischhauer, Carl 112 Japanese Family Waiting Shipment to Manzanar, 1942 13 incident light 171, 175 Flemming, Shiela 115 Jazes, Tom 110 reflected light 171 focal length 67, 79 Jares, Tom 110 target 84 focal plane 67 tocusing target 230 tocusing target 230 fog 44, 128 Kasebier, Gertrude 142 used 228 Foth, Ron, Jr. 9 Keefner, Ken 15 Metol-free Developers, Table A.1 249 Fox, Sharon 211 Keith, Christine 11, 27 middle gray 171, 178 Friends of Photography 241 Keller, Kate 142, 159 model permission form 244 FSA 96 Kelly, Marianne 29 Moholy-Nagy, Lazlo 113 full-substance negative 127 key light 193 montage 155 full-substance negative 127 key light 193 Moholy-Nagy, Lazlo 113 Glossary 252 Klee, Paul 94 Moholirer, James 144, 173 <		101	
flash bulb 104 J&L Mill Building 113 Meatyard, Ralph Eugene 111 Meek, A. J. 49 flash meter 200 Jackson, William Henry 5, 93 meter Fleischhauer, Carl 112 Japanese Family Waiting Shipment to Manzanar, meter Flemming, Shiela 115 1942 13 contrast 172 focal length 67, 79 Jares, Tom 110 reflected light 171 focusing target 230 fog 44, 128 Kasebier, Gertrude 142 target 84 Foth, Ron, Jr. 9 Keefner, Ken 15 Molo-free Developers, Table A.1 249 Fox, Sharon 211 Keiler, Kate 142, 159 middle gray 171, 178 Friends of Photography 241 Keller, Kate 142, 159 model permission form 244 FSA 96 Keller, Kate 142, 159 modeling light 191 full-scale negative 127 Kelvin temperatures 207 Moholy-Nagy, Lazlo 113 full-substance negative 127 Key light 193 montage 155 Glossary 252 Kinsey, Darius 240 Montiero, James 144, 173 Glossary 252 Kodak system 4 mount board 62 Grish Elevator with Tar Patches, Minneapolis, Minnesota, September, 1939 232 Kodak viewfinder 71 mounting cements 183 <			
flash exposure 200 Jack O'Lantern*157 Meek, A. J. 49 meter flash meter 200 Jackson, William Henry 5, 93 meter Fleischhauer, Carl 112 Japanese Family Waiting Shipment to Manzanar, 1942 13 incident light 171, 175 Flemming, Shiela 115 Jares, Tom 110 reflected light 171 flocal length 67, 79 focusing target 230 reflected light 171 floy 44, 128 Kasebier, Gertrude 142 used 228 Foth, Ron, Jr. 9 Keefner, Ken 15 Metol-free Developers, Table A.1 249 Fox, Sharon 211 Keller, Kate 142, 159 middle gray 171, 178 Friends of Photography 241 Keller, Kate 142, 159 modeling light 191 FSA 96 Kelley, Marianne 29 modeling light 191 full-scale negative 127 key light 193 modeling light 191 full-substance negative 127 key light 193 monopod 7 full-substance negative 127 key light 193 monopod 7 Glossary 252 Kee, Paul 94 Moholy-Nagy, Lazlo 113 Glossary 252 Klee, Paul 94 Molion Study 41 mountage 155 Montion Study 41 mount board 62 mounting		IRI Mill Building 113	
flash meter 200 Fleischhauer, Carl 112 Fleischhauer, Carl 112 Fried 1942 13 Focal length 67, 79 focal plane 67 focusing target 230 fog 44, 128 Foth, Ron, Jr. 9 Fox, Sharon 211 Friends of Photography 241 Fish 396 full-scubstance negative 127 full-substance negative 127 full-substance negative 127 GN (Suiden number) 200 Great Mother 200 Great Mother of Big Apples 91 Green River 93 Green River 93 Gresen, Jonathan 99 Griswold, H. C. 34, 185 guide number (GN) 200 Jackson, William Henry 5, 93 meter incident light 171, 175 incident light 171, 175 contrast 172 reflected light 171 target 84 types 18 types			
Fleischhauer, Carl 112 Flemming, Shiela 115 flocal length 67, 79 focal plane 67 focusing target 230 fog 44, 128 Foth, Ron, Jr. 9 Fox, Sharon 211 Friends of Photography 241 FSA 96 full-scale negative 127 full-scale negative 127 full-scale negative 127 full-scale negative 127 Glossary 252 Glossary 252 Glossary 252 Glossary 252 Glossary 252 Great Mother of Big Apples 91 Great Mother of Big Apples 91 Great Mother of Big Apples 91 Gress Mother (GN) 200 Jares, Tom 110 Jares, Tom 110 Jares, B4 Jares, Tom 110 Jares, B4 Ja			
Flemming Shiela 115 1942 13 1942 1			
focal length 67, 79 Jares, Tom 110 reflected light 171 focal plane 67 target 84 focusing target 230 types 84 fog 44, 128 Kasebier, Gertrude 142 used 228 Foth, Ron, Jr. 9 Keefner, Ken 15 Metol-free Developers, Table A.1 249 Fox, Sharon 211 Keith, Christine 11, 27 middle gray 171, 178 Friends of Photography 241 Keller, Kate 142, 159 model permission form 244 FSA 96 Keller, Kate 142, 159 model permission form 244 FSA 96 Keller, Marianne 29 Moholy-Nagy, Lazlo 113 full-scale negative 127 Key light 193 monopod 7 full-substance negative 127 key light 193 montage 155 Killer 8 Montiero, James 144, 173 Glossary 252 Kinee, Paul 94 Motion Study 41 GN (guide number) 200 Kodak system 4 mount board 62 Grain Elevator with Tar Patches, Minneapolis, Minneapolis, Minnesota, September, 1939 232 Kodak viewfinder 71 mounting prints 180 Green River 93 LaBrot, Syl 232 LaBrot, Syl 232 Green, Jonathan 99 LaBrot, Syl 232 Lagen, Dorot			
focal plane 67 target 84 focusing target 230 types 84 fog 44, 128 Kasebier, Gertrude 142 used 228 Foth, Ron, Jr. 9 Keefner, Ken 15 Metol-free Developers, Table A.1 249 Fox, Sharon 211 Keith, Christine 11, 27 middle gray 171, 178 Finends of Photography 241 Keller, Kate 142, 159 modeling light 191 FSA 96 Kelley, Marianne 29 modeling light 191 full-scale negative 127 Kelvin temperatures 207 Moholy-Nagy, Lazlo 113 full-substance negative 127 Key light 193 monopod 7 Killer 8 montage 155 Montiero, James 144, 173 Glossary 252 Klee, Paul 94 Motion Study 41 GN (guide number) 200 Kodak system 4 mount board 62 Grain Elevator with Tar Patches, Minneapolis, Minnesota, September, 1939 232 Kodak viewfinder 71 mounting cements 183 grants, agencies 240 Laborer, J&L Tin Plate Department 79 Myers, David 120 Green River 93 LaBrot, Syl 232 mounting prints 180 Green, Jonathan 99 Lange, Dorothea 13, 113, 117, 119 Green, Jonathan 99 Laborer, J&L T			
focusing target 230 fog 44, 128 Kasebier, Gertrude 142 types 84 used 228 Foth, Ron, Jr. 9 Keefner, Ken 15 Metol-free Developers, Table A.1 249 Fox, Sharon 211 Keith, Christine 11, 27 middle gray 171, 178 Friends of Photography 241 Keller, Kate 142, 159 model permission form 244 FSA 96 Kelley, Marianne 29 modeling light 191 full-scale negative 127 Kelvin temperatures 207 Moholy-Nagy, Lazlo 113 full-substance negative 127 key light 193 monopod 7 Killer 8 Kinsey, Darius 240 Montiero, James 144, 173 Glossary 252 Klee, Paul 94 Motion Study 41 GN (guide number) 200 Kodak system 4 mount board 62 Grain Elevator with Tar Patches, Minneapolis, Minneapolis, Minnesota, September, 1939 232 Kodak viewfinder 71 mounting cements 183 grants, agencies 240 Laborer, J&L Tin Plate Department 79 Myers, David 120 Green River 93 LaBrot, Syl 232 Lange, Dorothea 13, 113, 117, 119 Augenting Prints 180 Griswold, H. C. 34, 185 Jalent image 6, 125 Jalent image 6, 125		04/03, 10/1/110	
fog 44, 128 Kasebier, Gertrude 142 used 228 Foth, Ron, Jr. 9 Keefner, Ken 15 Metol-free Developers, Table A.1 249 Fox, Sharon 211 Keith, Christine 11, 27 middle gray 171, 178 Friends of Photography 241 Keller, Kate 142, 159 model permission form 244 FSA 96 Kelley, Marianne 29 modeling light 191 full-substance negative 127 Kelvin temperatures 207 Moholy-Nagy, Lazlo 113 full-substance negative 127 key light 193 monopod 7 Killer 8 montage 155 Kinsey, Darius 240 Montiero, James 144, 173 Glossary 252 Klee, Paul 94 Motion Study 41 GN (guide number) 200 Kodak system 4 mount board 62 Grain Elevator with Tar Patches, Minneapolis, Minneapolis, Minnesota, September, 1939 232 Kodak viewfinder 71 mounting cements 183 grants, agencies 240 Laborer, J&L Tin Plate Department 79 Wyers, David 120 Green River 93 LaBrot, Syl 232 Montion Study 41 Green, Jonathan 99 Lange, Dorothea 13, 113, 117, 119 Griswold, H. C. 34, 185 Lage 125 Guide number (GN) 200	the state of the s		9
Foth, Ron, Jr. 9 Keefner, Ken 15 Metol-free Developers, Table A.1 249 Fox, Sharon 211 Keith, Christine 11, 27 middle gray 171, 178 Friends of Photography 241 Keller, Kate 142, 159 model permission form 244 FSA 96 Kelley, Marianne 29 modeling light 191 full-scale negative 127 Kelvin temperatures 207 Moholy-Nagy, Lazlo 113 full-substance negative 127 key light 193 monopod 7 Killer 8 Kinsey, Darius 240 Montiero, James 144, 173 Glossary 252 Klee, Paul 94 Motion Study 41 GN (guide number) 200 Kodak system 4 mount board 62 Grain Elevator with Tar Patches, Minneapolis, Minneapolis, Minnesota, September, 1939 232 Kodak viewfinder 71 mounting cements 183 grants, agencies 240 Laborer, J&L Tin Plate Department 79 Myers, David 120 Green River 93 LaBrot, Syl 232 Green, Jonathan 99 Lange, Dorothea 13, 113, 117, 119 Griswold, H. C. 34, 185 Lage, Dorothea 12, 113, 117, 119 Griswold, H. C. 34, 185 Lage, Dorothea 12, 113, 117, 119		Kasehier Gertrude 142	
Fox, Sharon 211 Friends of Photography 241 Frien			
Friends of Photography 241 FSA 96 Keller, Kate 142, 159 Keller, Marianne 29 Kelley, Marianne 29 Kelley, Marianne 29 Kelley, Marianne 29 Moholy-Nagy, Lazlo 113 M			
FSA 96 Kelley, Marianne 29 modeling light 191 full-scale negative 127 Kelvin temperatures 207 Moholy-Nagy, Lazlo 113 monopod 7 Killer 8 montage 155 Kinsey, Darius 240 Motiero, James 144, 173 Glossary 252 Klee, Paul 94 Motion Study 41 GN (guide number) 200 Kodak system 4 mount board 62 Grain Elevator with Tar Patches, Minneapolis, Minnesota, September, 1939 232 grants, agencies 240 Foreat Mother of Big Apples 91 Laborer, J&L Tin Plate Department 79 Green River 93 LaBrot, Syl 232 Green, Jonathan 99 Griswold, H. C. 34, 185 guide number (GN) 200			
full-scale negative 127 Kelvin temperatures 207 Moholy-Nagy, Lazlo 113 monopod 7 monop	0 . ,		
full-substance negative 127 key light 193 monopod 7 Killer 8 montage 155 Kinsey, Darius 240 Montiero, James 144, 173 Glossary 252 Klee, Paul 94 Motion Study 41 GN (guide number) 200 Kodak system 4 mount board 62 Grain Elevator with Tar Patches, Minneapolis, Minnesota, September, 1939 232 Kodak viewfinder 71 mounting cements 183 grants, agencies 240 Myers, David 120 Great Mother of Big Apples 91 Laborer, J&L Tin Plate Department 79 Green, Jonathan 99 LaBrot, Syl 232 Green, Jonathan 99 Lange, Dorothea 13, 113, 117, 119 Griswold, H. C. 34, 185 latent image 6, 125			
Killer 8 Kinsey, Darius 240 Montiero, James 144, 173 Motion Study 41 Glossary 252 GN (guide number) 200 Kodak system 4 Motion Study 41 Motion			
Kinsey, Darius 240 Klee, Paul 94 Klee, Paul 94 Kodak system 4 Grain Elevator with Tar Patches, Minneapolis, Minnesota, September, 1939 232 Grants, agencies 240 Great Mother of Big Apples 91 Green River 93 Green, Jonathan 99 Griswold, H. C. 34, 185 guide number (GN) 200 Kinsey, Darius 240 Kodak viewfinder 71 Kodak viewfinder 71 Mount to board 62 mount to partness 183 mounting prints 180 Myers, David 120 Myers, David 120 Myers, David 120 Motion Study 41 Motion Study 41 Mount board 62 Mounting prints 180 Myers, David 120 Myers, David 120 Mers, David 120			
Glossary 252 Klee, Paul 94 Motion Study 41 GN (guide number) 200 Kodak system 4 mount board 62 Grain Elevator with Tar Patches, Minneapolis, Minnesota, September, 1939 232 grants, agencies 240 Kodak viewfinder 71 mounting cements 183 mounting prints 180 Myers, David 120 Myers, David 120 Myers, David 120 Myers, David 120 Laborer, J&L Tin Plate Department 79 LaBrot, Syl 232 Green, Jonathan 99 Griswold, H. C. 34, 185 guide number (GN) 200			
GN (guide number) 200 Grain Elevator with Tar Patches, Minneapolis, Minnesota, September, 1939 232 grants, agencies 240 Great Mother of Big Apples 91 Green River 93 Green, Jonathan 99 Griswold, H. C. 34, 185 guide number (GN) 200 Kodak system 4 Kodak system 4 Kodak viewfinder 71 Mounting cements 183 mounting prints 180 Myers, David 120 Myers, David 120 Laborer, J&L Tin Plate Department 79 LaBrot, Syl 232 Lange, Dorothea 13, 113, 117, 119 Latent image 6, 125	Glossary 252		
Grain Elevator with Tar Patches, Minneapolis, Minnesota, September, 1939 232 grants, agencies 240 Great Mother of Big Apples 91 Green River 93 Green, Jonathan 99 Griswold, H. C. 34, 185 guide number (GN) 200 Kodak viewfinder 71 mounting cements 183 mounting prints 180 Myers, David 120 Kaborer, J&L Tin Plate Department 79 LaBrot, Syl 232 Lange, Dorothea 13, 113, 117, 119 Iatent image 6, 125			
Minnesota, September, 1939 232 grants, agencies 240 Great Mother of Big Apples 91 Green River 93 LaBrot, Syl 232 Green, Jonathan 99 Griswold, H. C. 34, 185 guide number (GN) 200 mounting prints 180 Myers, David 120 Myers, David 120 Laborer, J&L Tin Plate Department 79 LaBrot, Syl 232 Lange, Dorothea 13, 113, 117, 119 latent image 6, 125			
grants, agencies 240 Great Mother of Big Apples 91 Green River 93 Green, Jonathan 99 Griswold, H. C. 34, 185 guide number (GN) 200 Myers, David 120 Myers, David 120 Myers, David 120 Myers, David 120 Laborer, J&L Tin Plate Department 79 LaBrot, Syl 232 Lange, Dorothea 13, 113, 117, 119 Iatent image 6, 125			
Great Mother of Big Apples 91 Laborer, J&L Tin Plate Department 79 Green River 93 LaBrot, Syl 232 Green, Jonathan 99 Lange, Dorothea 13, 113, 117, 119 Griswold, H. C. 34, 185 latent image 6, 125 guide number (GN) 200 latent image 7, 125			
Green River 93 LaBrot, Syl 232 Green, Jonathan 99 Lange, Dorothea 13, 113, 117, 119 Griswold, H. C. 34, 185 guide number (GN) 200 Latent image 6, 125		Laborer, J&L Tin Plate Department 79	
Green, Jonathan 99 Lange, Dorothea 13, 113, 117, 119 Griswold, H. C. 34, 185 guide number (GN) 200 Lange, Dorothea 13, 113, 117, 119 latent image 6, 125			
Griswold, H. C. 34, 185 guide number (GN) 200			
guide number (GN) 200			
		3,	

Index 255

	- b-tb'-	
nanometers 207	photographic	projection 98
Narcissus 242	arts 239	propaganda 119
negative	collections 96	proportional reducer 164
cliche-verre 122	cycle 63	protective sheets 24
drying 22	education 238, 247	publicity and libel 244
faults 57	information 105	purposes of photograph 100
ideal 127	meaning 114	pushing film 136
identification 24	wet-plate (collodion) 5, 182	
squeegee 23	photographic content and context 112	
storing 23	Photographic Solutions, Table 2.2 17	Rainy Day in Athens 15
underdevelopment 42	photographs as truth 98	rangefinder 72
washing 22	pictorialism 90	RC paper experiment 148
Negro Cabins 97	Pieratt, Edward 83, 199	reciprocity 80, 198
Nettles, Bea 111	point source 190	Recommended Film Developers, Table 9.2 136
Newton, Helmut 111	point-of-view 116	reducing negatives 164
normal lens 67	polarized light 212	reducing prints 165
Nursing Aides Comfort Woman Dying in Nursing	Polaroid 90	reflected light meter 84
Home 140	pornography 246	reflection 190
Tiome 140	Portrait of Clarence White, ca. 1905 142	reflector 193
	Positionable Mounting Adhesive 62	reflex cameras 72
obscenity and pornography 246	•	
OC filter 221	positive 122	refraction 190
	posture 7	release (permission) 243
Ockenga, Starr 90	potassium bichromate 160	Resettlement Administration Housing, 1936–1937
On the Road, Lancaster City, 1974 4	potassium bromide 145	118
opacity 126	potassium ferricyanide 160	resolving power 124
opening 124	preservative 144	response to photograph 98
Outerbridge, Paul 232	preview viewing 74	restrainer 144
ownership of photograph 246	prewetting film 18	Rift Valley, Ethiopia 79
	primary colors 207	Riis, Jacob 101
	print	Roberts, Nancy 169
Pajunin, Timo 227	contrast control 50	Rosenblum, Naomi 99
Pamp, Barbara 41	controls 51	Rosskam, Edwin 112
panchromatic film 124, 208	development 156	Rothstein, Arthur 103, 104
paper	drying 35, 223	Roush, Tom 73
contrast grades 153	exposure 44, 135	rubber cement 62
photographic 28	local reduction 166	
warm tone 54	RC developing 33	
Paper Contrast Controls, Table 11.1 153	solutions 34	Sabbatier effect 139
Paper Developers, Table A.3 251	spotting 58	safelight 29, 221, 222
parallax 72	squeegee 36	San Ildefonso Pueblo 115
PC connector 198	storage 63, 182	Sauss, Charles 42
pentaprism 72		
•	washing time 35	Schreiber, Frederick M. 120, 143
Perma-Wash 32	wet print evaluation 46	secondary colors 207
permanence in prints 180	printing out process 40	Selectol-Soft 155
permission form 244	Printing Problems, Table 5.2 58	selenium intensification 160
permission to photograph 243	privacy (of subject) 243	Selenium Intensification of Prints, Table 12.4
pH 22	problems (print and negative) 56	167
Photo Chemical Equipment, Table 10.1 141	professional	Selenium Intensifier for Negatives, Table 12.1
photo corners 62	education 236	161
Photo Mount 62	grants 240	selenium toner 167
Photo Outfit, 1869 5	internship 236	Self-portrait 155
photogram 29	organizations 238	Self-portrait and My Sister 218
photographer (definition) 232	photographic services 235	sequencing 90
	possibilities 232	4-3
	presentations 239	
	training 238	
	training 200	

Shahn, Ben 102, 215 sharpness 74 Sheeler, Charles 206 shutter 14, 81, 82, 83 Siegel, Arthur 114 silver halides 5 single-shot chemicals 141 Siskind, Aaron 237 Sloan Sisters 55

Small Camera Contrast Control Compromises,

Table 13.2 176

Smith Feed Store, Powell, Wyoming, June, 1944

112
Smith, Henry Holmes 122
snapshot 115, 122
sodium carbonate 145
sodium hyposulfite 22
sodium sulfite 145
sodium thiosulfate 22
sodarization 129, 139
Sommer, Frederick 122
specular density 127
specular light 190
Spotoff (spot remover) 60
Spotone 58

Spotting and Mounting Equipment, Table 5.1 57

spotting prints 57

Starting Equipment, Table 2.1 14 Steiglitz, Alfred 90, 232

Steiglitz, Alfred 90, 232 stock solutions 17 Stoller, Ezra 220 stop bath 17, 22, 32 stop down 37 storing prints 185 straight photography 90, 104 Strand, Paul 90, 232 Street Photographer 215 strobe 194 subtractive primaries 207 symbolic content 118 synchronization 82, 198 Szarkowski, John 99

Taos, New Mexico 226 taxonomy 99 Technical Pan film 156 Teeling, Paul 176 telephoto lens 67, 117 temperature of solutions 32 **The Enlarger,** Table 3.2 30 The Photographer's Hand 159 Thomas, Jean 55 threshold sensitivity 129 thyristor 200 tongs paper development 34
toning prints
for preservation 180
selenium 167
sepia 168
Top of Stuart Haby's Dresser, Texas, 1945 3
transparency 126
tripods (evaluating) 228
TTL metering 6, 72, 84, 138, 169, 171
Turbeville, Deborah 111
twin-lens reflex 116
Two-tray Experiment, Table 10.4 147
types of film 124

ultraviolet light 208 Union Election, Local 600, 1938 114 United Nations 206 used lenses 227

Vachon, John 102, 232 variable contrast controls 156 view-camera 116 viewfinders 71

Walker, Victoria 219 Walt Whitman, 1864 95 washing prints 181 water 144 water bath print development 20 Weston, Edward 90 wet prints, evaluating 34 wetting agent 22 White, Minor 2 whiteners (fluorescing agents) 152 wide-angle 67 Wife of Tenant Farmer, Georgia, 1936 105 window mats 186 window of illusion 111 Winogrand, Garry 111 Wollcott, Marion Post 116 Woman Feeding Chickens, Putnam County, Georgia, 1941 117 Wratten filters 208

Young Appalachian Woman 105

zone focus 77 Zone System 178 zoom lens 70

•		

•	

	*	